1/2016

FILM CRITICISM IN THE DIGITAL AGE

FILM CRITICISM IN THE DIGITAL AGE

EDITED BY

MATTIAS FREY AND CECILIA SAYAD

RUTGERS UNIVERSITY PRESS
New Brunswick, New Jersey and London

Library of Congress Cataloging-in-Publication Data
Film criticism in the digital age / edited by Mattias Frey and Cecilia Sayad.
pages cm
Includes bibliographical references and index.
ISBN 978-0-8135-7073-0 (hardcover : alk. paper) — ISBN 978-0-8135-7072-3
(pbk. : alk. paper) — ISBN 978-0-8135-7074-7 (e-book (web pdf)) —
ISBN 978-0-8135-7364-9 (e-book (epub))
1. Film criticism. 2. Motion pictures—Philosophy. 3. Mass media—Technological
innovations. I. Frey, Mattias, editor. II. Sayad, Cecilia, editor.
PN1995.F4573 2015
791.4301—dc23 2014030640

A British Cataloging-in-Publication record for this book is available from the British
Library.

Visit our website: http://rutgerspress.rutgers.edu

Manufactured in the United States of America

CONTENTS

ACKNOWLEDGMENTS

The editors would like to thank the contributors, Leslie Mitchner and the Rutgers University Press staff, the anonymous reviewer, Peter Stanfield, and the Centre for the Interdisciplinary Study of Film and the Moving Image at the University of Kent.

Some chapters presented here have appeared previously. A different version of chapter 4 appeared in Mattias Frey, *The Permanent Crisis of Film Criticism: The Anxiety of Authority* (Amsterdam: Amsterdam University Press, 2015). Chapter 11 was originally published in *Film Ireland*, September/October 2007, 26–27, © 2007 Jasmina Kallay/*Film Ireland*. Chapter 12 was originally published in *New York Press*, 30 April 2008, © 2008 Armond White. Chapter 13 was originally published in *Sight and Sound*, October 2008, 16–18, © 2008 Nick James/*Sight and Sound*. Chapter 14 contains excerpts from the eponymous article originally published in *Cineaste* 33.4 (2008): 30–45, © 2008 Cineaste Magazine. All are reprinted by permission.

FILM CRITICISM IN THE DIGITAL AGE

INTRODUCTION
Critical Questions

MATTIAS FREY

"Today film criticism is a profession under siege." So begins—as a white text over a black screen—Gerald Peary's documentary *For the Love of Movies: The History of American Film Criticism* (2009). As the introduction to a chronicle of a profession, its tone is more or less apocalyptic. Nevertheless, Peary's take on the state of film criticism as activity and institution is hardly aberrant.

In fact, judging by the many journalistic articles,[1] regular symposia and conferences,[2] and the increasing scholarly output on the subject—which bemoan a "crisis of criticism" or mourn the "death of the critic"[3]—it might seem safe to claim that the aims, status, and institution of arts and culture criticism in general, and film criticism in particular, are, indeed, facing possible extinction. This is hardly a case of academic navel-gazing or journalistic self-indulgence; if we are to believe chroniclers such as Sean P. Means, who listed fifty-five American movie critics who lost their jobs between 2006 and 2009,[4] the threat is real.

In an era in which criticism is offered "free" to the reader without sustainable levels of online advertising, and print circulation and advertising have permanently eroded, ontological questions about the purpose and worth of criticism have become urgent. This anthology seeks to understand the current state of film criticism and how it has developed. It aims to examine the challenges and possibilities that the Internet offers to the evaluation, promotion, and explanation of artistic works, as well as digital technology's impact on film criticism as an institution and profession. How has the status of the critic changed with the development of new digital media and the transformation, consolidation, and demise of traditional media outlets? To what extent can critics—whether moonlighting bloggers or salaried writers—intervene in current popular discourse about arts and culture?

Although these questions have been the source of much journalistic discussion, academics have addressed these issues only in a piecemeal or oblique fashion. In general, film criticism—rather than film history or theory—is just beginning to receive serious scholarly attention. The reason for this lacuna is surely complex; nevertheless, the long-term goal of film studies to establish itself as a serious subject of inquiry and maintain an institutional presence at universities and other highbrow cultural institutions has meant that, for generations, scholars have attempted to distance themselves from "mere reviewers" and to differentiate their profession from journalism.

In recent years this regard has come into question, and there has been a flurry of activity surrounding film criticism. Nevertheless, these studies have mainly revolved around the biographies of prominent critics, such as Pauline Kael, or indeed collected the writings of important critics—Kael, Manny Farber, Richard Roud, and others—as primary sources.[5] Where histories of film criticism have existed, they seek primarily to telegraph broadly rather than analyze precisely; see, for example, Jerry Roberts's *The Complete History of American Film Criticism*, which speeds through more than a hundred years of writing and an even larger number of critics.[6] Raymond J. Haberski's *It's Only a Movie! Films and Critics in American Culture* presents a similarly sprawling survey of American film culture and a synopsis of the country's film critics. It dashes through a century of major events (debates about the aesthetic value of cinema; *Cahiers du cinéma* and the American "auteur theory"; the establishment of the New York Film Festival and the American Film Institute; New Hollywood and the rise of film-school directors) in a matter of paragraphs. Haberski's American story is told as a familiar, consensual, and national tale; his synoptic, monocultural approach represents the straight story of film criticism that urgently needs to be challenged.

THE CURRENT STATE OF DEBATE ON CRITICISM

Five interlocking debates, discourses that overlap and inform each other, have dominated writing about arts and culture criticism in general, and film criticism in particular, in the digital age. To survey the current debates—but also to preview the thematic emphases of this book—we need to outline the major focuses and fronts of these discourses. Each of the contributions to this volume contemplates at least one, if not all five, of these questions and their relationship to film criticism.

Should Evaluation Be a Function of Criticism or Even Its Principal Aim?

This subject is a holdover from earlier eras; it is a debate that has reemerged, especially in academic treatises on criticism, *because* of the general return to ontological and existential questions about criticism. Just as the advent of digital formats

precipitated a return to ontological debates about "what is cinema?" in the post-celluloid world, the rise of digital media and the demise of print have led commentators to reexamine the most basic questions about the purpose of criticism.

For centuries the purpose of criticism has been a subject of debate, and this is not the place to rehearse the various viewpoints in depth. For now it must suffice to say that these purposes have included education or refining the taste of the audience; personal or artistic expression on the side of the critic; creating a dialogue with an audience or enlivening a public sphere; describing, deciphering, demystifying, contextualizing, or categorizing the work or its relationship to society; or simply judging the aesthetic or entertainment value of the examined cultural product.[7]

Rather than telegraphing the history of the idea of criticism, the more pressing task here is to examine where the current debate stands and how, in fact, the ascent of digital media has inflected and energized contemporary discourses on the purpose of criticism. On this subject, although some journalists and a smattering of treatises by academics argue for an anarchy of opinion and agitate for alternative purposes for criticism (more on this in the discussion of John Carey's *What Good Are the Arts?* below), without a doubt the main theme and thrust of contemporary scholarly writing on criticism has argued that evaluation is or should be its main purpose.

In the recently published *On Criticism* Noël Carroll deploys examples from film, music, performance, and visual arts to advance the thesis that criticism's primary function is not—as is sometimes claimed—description, interpretation, the demystification of hidden meanings, or the uncovering of latent ideologies. Instead, criticism should always aim to evaluate; "criticism," according to Carroll, "is essentially evaluation grounded in reasons."[8]

For Carroll evaluation's role as the engine of the critical project should be self-understood; indeed, the original etymology of the word *critic, kritikos,* "one who serves on a jury and delivers a verdict," implies evaluation. Traditionally, "criticism has been generally aligned with evaluation."[9] Only recently have critics renounced their task to judge objects according to their aesthetic value. To substantiate how widely criticism has become decoupled from evaluation, Carroll refers to a recent poll of art critics: 75 percent maintained that evaluation was the *least* significant aspect of their professional duties.[10] Opposing skeptics' thesis that evaluation is doomed to be "subjective" and that the artist's intentions are unknowable, Carroll demonstrates that "although we do not have so-called direct access to the artist's intention, we have lots of indirect evidence for it," because most artists produce works that belong to recognized categories such as genres, movements, styles, periods, or oeuvres. According to Carroll, the function of the critic is to judge the extent to which the work achieves the artist's intention; this is the work's "success value."[11]

Carroll's treatise is informed by the vocabularies and concerns of analytic philosophy, and his disdain for the lack of rigor in ideological-symptomatic traditions and interpretation in general is well documented.[12] Nevertheless, other prominent commentators whose research and perspectives are far different have also advocated (a return to) evaluation as the most important purpose of arts and culture criticism.

Rónán McDonald, a literary scholar and major recent interlocutor in this debate, narrates the history of criticism to argue that this practice has become devalued as a social good; the reason for this, in his view, is a historical itinerary that has progressively departed from evaluation as the purpose behind criticism. This path was put into motion by the agenda of university scholars working under the auspices of cultural studies, which resolved debates about how to assess aesthetic value by driving "a steamroller over hierarchies, flattening all into indifferent practices."[13] Because of cultural studies' implication that all cultural products are equally worthy of serious inquiry, McDonald argues, they also suggest that culture is equally worthy of being ignored. Besides the object and purpose of inquiry, the very language—obscure vocabularies and jargon—that scholars have been prone to use since the heyday of cultural studies has precipitated, according to McDonald, a fundamental divergence between scholarly and journalistic criticism by which the public imagination became "immune to issues and debates" in academia.[14]

What Should Be the Nature of the Relationship between the Critic and His or Her Audience?

This question, too, has been a perennial one that has reemerged with the transformations engendered by the new media; most often, as we see in the preceding argument by McDonald, the fronts in the debate about the nature of the relationship between critics and audiences have followed from the previous question about the very function of criticism.

The exact nature of the relationship between critic and reader and the potential for the critic to *mediate* between the audience and the work has been a subject of long deliberation as, indeed, mediation speaks to the very purpose of criticism.[15] Traditionally, scholars have noted how the critic, unlike the "reader/viewer," "includes the concept of 'arbiter,' of *arbitrage*."[16] But surely, the opinions on the quality of this mediation range from educator (à la Matthew Arnold) to a more personal negotiation with the work, in the vein of Oscar Wilde.[17]

Much of the scholarship was either purely theoretical or based on more or less anecdotal evidence. More recently, researchers working with rigorous empirical methods have tested the claims that critics can function as "tastemakers" or "gatekeepers" and significantly exert influence on the success or failure of a film. The "gatekeeper" thesis has traditionally maintained that the critic

shapes the reader's reception of the film—or at least provides the preconditions or point of departure for his or her later viewing. Tested empirically, however, sociologists have doubted the extent to which critics can perform this function.[18] Wesley Shrum's study of the Edinburgh Fringe Festival, for example, concludes that, despite anecdotal claims to the contrary,[19] critics "do not have the power to 'make or break' shows"; indeed, the "visibility provided by reviews is more important than their evaluative function."[20] According to Shrum's research, which is also useful for film, the critic only has an effect on certain type of productions ("legitimate" genres such as art-house) or certain types of readers/ viewers (those who seek to refine a discriminating sensibility for art).[21]

Some strict proponents of cultural studies have questioned that there is any real distinction between critics and readers; for commentators such as John Carey, "what critics think about this or that artwork . . . is necessarily of limited and personal interest."[22] Indeed, for these believers in the absolute constructedness of the subject, all criticism is only "personal opinion." Unlike psychology and sociology of art or pure audience research (to his mind rigorous methods to account for taste), criticism is a vaguely subjective measure of the immeasurable: artistic value. It follows that works of art cannot be rigorously evaluated as "better" or "worse" than any other. In turn, Carey disputes what has been the traditional justification for a critic and his or her relationship with an audience, namely, that the critic's judgment to understand and evaluate art and his or her ability to communicate this judgment are superior to a layperson's capacity. For Carey, "to claim that our feelings are, in an absolute sense, more valuable than someone else's (as opposed to simply more valuable to us) does not make sense." If all opinions are equally valid or invalid, we cannot rationally "call other people's aesthetic choices 'mistaken' or 'incorrect,' no matter how much we happen to not like them."[23]

Pace Carey (but also the large number of bloggers who practice film criticism outside of traditional institutions and rarely theorize its practice), in today's academic deliberations over the role of the critic, the strongest current advocates a powerful critical authority figure who will guide the reader from a position of superior knowledge. Before we examine the major commentators who write in this vein, it is worth mentioning how widespread this position is in film culture. Indeed, among professional journalistic critics there is extreme anxiety about this function and about its possible loss: this mentality is the one on offer, for example, in Gerald Peary's documentary, in *Sight and Sound* and *Cineaste* dossiers on criticism (excerpts thereof are reprinted in this volume), and in the regular screeds in publications like *Variety*, such as the one that asks "Are Film Critics Really Needed Anymore . . . or Is It a Washed-Up Profession?"[24]

Contemporary academic studies of criticism mourn the "death of the critic" and call for the critic as strong authority figure, a type—they assert—that once

existed. Terry Eagleton invoked a "crisis of criticism" already in 1984, contending that "in a period in which, with the decline of the public sphere, the traditional authority of criticism has been called into serious question, a reaffirmation of that authority is urgently needed."[25] Maurice Berger's 1998 collection of prominent critics' thoughts on *The Crisis of Criticism* strikes a similarly elegiac chord: "now the critic is often expendable in the process of determining what is good art and what is bad art"; according to Berger, at the threshold of the twenty-first century "the critic has lost his or her aura of respect."[26]

But perhaps the most prominent and articulate proponent of this thesis today is McDonald, whose *Death of the Critic* argues that the role of the critic has transformed from a mediator, "a figure to whom a wide audience might look as a judge of quality or a guide to meaning," to a puppet who "confirms and assuages their prejudices and inclinations rather than challenging them."[27] Above all, McDonald advocates new "public critics" along the lines of Kael or Susan Sontag, who, he opines, do not currently exist in contemporary media and society. Charting a historical trajectory that includes the "age of criticism" and prominent professionals such as F. R. Leavis and Lionel Trilling, McDonald asserts that the early 1970s marked the beginning of the end of a period in which critical writing flourished nearly indistinguishably between broadsheets and academic journals, and critics made authoritative, evaluative pronouncements to a broad public.[28] The "death of the critic" entailed an end to a communicative mediation between a learned authority and a willing, engaged reader; since then scholarly and journalistic criticism have increasingly diverged, and the vacuum of authority has been replaced by a host of nonexpert bloggers and a dispersive field of reviewing that fails to capture the public imagination.[29]

How Have the New Media Changed Film Criticism as an Activity and Form?

If the first two debates have taken place mostly in university humanities departments, and only occasionally or indirectly been addressed by film critics working for daily newspapers or magazines, professionals have had no choice but to confront the ways in which criticism is—in a very tangible and material way—a very different activity than it was only ten years ago. If personal computers and floppy disks transformed the way that copy was written, edited, and submitted, and the early years of widespread Internet access meant that reporting from film festivals became a much more immediate affair, the arrival of Twitter, blogging, and other forms of virtually instantaneous communication have revolutionized the possibilities—and in many ways forced the hand—of those who write about film.

In the not-so-distant past, information about films—which, even skeptics such as Shrum agree is a function of criticism—was largely limited to marketing and advertising on the one hand (trailers, posters, perhaps an advance interview—all circumscribed by physical locations and times), and on the other

to the critic's notice, which would generally appear on or near the day of the film's general release. Today the viewer has a whole wealth of information to consume when and where he or she wants: the film's website, online trailers, advance reviews from other countries, even entire pirated copies of the film itself. Against this seemingly endless stream of available information, the critic must compete. This takes the form of blogs but also Twitter feeds; these days, one has the chance to read several dozen tweets of film critics as they walk out of press screenings at festivals halfway across the globe. Even if we were to accept the thesis, proposed by McDonald and others, that in the twenty-first century there are fewer or no "public critics," no one could argue with the fact that critics have become more public. Mark Kermode, Nick James, A. O. Scott, Peter Bradshaw, Leonard Maltin, Jonathan Rosenbaum, and Carrie Rickey are just a handful of the hundreds of "professional" film critics who actively tweet, let alone the thousands of "amateurs" who perform more or less the same service, if perhaps more anonymously and without salaries. We are a long way from the days of reading about films on a monthly basis (*Monthly Film Bulletin*); even traditional daily trade papers such as *Variety* and the *Hollywood Reporter* have lost ground to more innovative, even faster providers of entertainment news (e.g., Deadline Hollywood). Programmers (the British Film Institute's Geoff Andrew) and film festival directors (Edinburgh's Chris Fujiwara) tweet in their own names, and institutional accounts (the Film Society at Lincoln Center, Melbourne Cinémathèque, Viennale) communicate with stakeholders via short messages.

Today—at least as far as the straight story goes—film criticism as a form and activity (both composing and receiving) has become more amateurish, shorter, more immediate, and less considered. If we are to believe alarmists such as Andrew Keen, "today's internet is killing our culture and assaulting our economy."[30] The new media, according to this argument, are the logical extension of the unstoppable momentum of the last years of print media—less column space, more lurid illustrations, more advertisements, less pay for writers. This critique usually corresponds to one of two related discourses: a complaint about the atomization or "fragmentation" of the public sphere and, perhaps more often, bemoanings about the "dumbing down" of film criticism and its audiences.[31] This type of thinking is widespread both among journalistic critics and among academics writing on the subject. For McDonald, "the public critic has been dismembered by two opposing forces: the tendency of academic criticism to become increasingly inward-looking and non-evaluative, and the momentum for journalistic and popular criticism to become a much more democratic, dispersive affair, no longer left in the hands of experts."[32] Rather than more bloggers and a false "democratization" of critical writing, McDonald argues, erudite, authoritative critics who are able to challenge prevailing tastes and communicate to a wide audience are needed to reunite the fragmented public sphere.[33] Indeed,

even a cursory glance at the forums that accompany today's online reviews would seem to confirm the worst suspicions of *Sight and Sound* editor Nick James, who writes that these days the "culture prefers, it seems, the sponsored slogan to judicious assessment,"[34] or legendary critic Armond White's polemics about "Internetters" who "express their 'expertise,' which essentially is either their contempt or idiocy about films, filmmakers, or professional critics."[35] Take, for example, the response to Philip French's review of *Flight* (2012), published in the *Observer* and on the common website for the *Observer* and sister newspaper the *Guardian* on 3 February 2013.[36] One of the first posts made after the review, by "elmondo2012," asks of the reviewer—perhaps Britain's most famous, who has been the chief critic for the *Observer* since 1978, published several books, and was awarded an OBE for his services to the field—"Who is this French guy?" In the many instances such as these it would be very tempting to believe that there has been a permanent breakdown of any dialogue between the learned critic and the curious, respectful reader; a cacophony of voices and opinions and a malicious discourse have drowned out the "gentlemanly" tones of yesteryears.

Although some of this criticism may be justified, however, we must be careful not to simply default, once again, to the cultural pessimism of Max Horkheimer and Theodor Adorno or Jean Baudrillard.[37] These perspectives lazily assert either a conspiracy theory that an inevitable "dumbing down" is taking place, orchestrated by elites or "the system," or some sort of descent into a brave, new simulacrum and the end of history. To contend that the new forms of criticism simply mirror today's slick and evanescent popular entertainment spoon-fed to apathetic masses of an "ADD society" is reductive, condescending, and wrong. It would be a mistake not to take account of the new possibilities that film criticism in the digital age offers.

The new film criticism has often taken advantage of innovative ways to configure time and space. I have already written about the way that online reviews and tweets allow for an immediate reaction to films, a compression of the temporal cycles that used to govern films and their reception and a circumscription of even the shorter forms of capsule reviewing. But often ignored behind the "dumbing-down" rhetoric about 140-character tweets and ill-considered remarks in Internet forums is the fact that online reviews and blogs often allow for an *expansion* of space for writing. There can be a utopian design to these new forms. Whereas print columns have continued to shrink over the decades in the switch to smaller tabloid formats and to give more space to dwindling advertisement, online reviews and blogging allow at least the possibility of five-thousand-word treatises, unscathed by the machinations of rogue copyeditors or subeditors' mangled titles. Critics have the opportunity to write more and consider further aspects of the film and can also be afforded more liberties about how they write: unconstrained by house style (or politics), they might invoke informal, personal,

or other idioms that they believe best befit the object. Furthermore, unlike in the days of print, opinions can be revised. Although certain film critics made claims to the permanence of evaluation (notably Pauline Kael), many others have noted how the meaning of a film can change with time and in the course of cinema history (e.g., Andrew Sarris).[38] Online reviewing, in its various forms, allows for these revisions to be undertaken with little effort and cost. In this the new film criticism returns to the precinémathèque days: an evanescent and changeable form and activity meant to be consumed spontaneously and at best darkly remembered, rather than necessarily archived and stored permanently.

Unlike literary criticism, the new film criticism allows for a fundamental formal innovation: the new digital media finally enable film to be easily subjected to review or critique via the very same medium. Not only can online journalists include the film's trailer or a clip to illustrate an important point; these days critics can make a video review themselves. Later in this book, Giacomo Manzoli and Paolo Noto will deliberate on the possibilities and present tendencies of the online and video review form.[39]

Finally, let us not forget—looking forward to debates on the sustainability of business models for journalism and criticism and the institutional organization of professional film critics—that at the moment there is more or less free access to a huge range of film criticism, a smorgasbord of writing about motion pictures, which means that, with a simple click of the button and most often without any payment whatsoever, the thoughts of critics from Nigeria, Germany, Japan, or Brazil on any given film can be accessed. For now at least, consumers have the utopian possibilities of "Film Studies for Free," to quote Catherine Grant's popular blog.

To return briefly to what I first presented as a largely negative example—the reactions to Philip French's review of *Flight*—there is at least a measure of hope that one can take from what at first seems to be a miserable sign for the "dumbing down" of film criticism in particular and society in general. After "elmondo2012" posted a reaction, a polyvocal discussion ensued, in which the initial polemic ("Who is this French guy?") was answered ("He's one of the greatest film critics of the last half century") and debated.[40] It extended well beyond the merits of Philip French and his short review of Robert Zemeckis's film to spawn a heated discussion on the purpose and value of film critics in general. Despite the sometimes rancorous or childish tone (this *is not* a university lecture hall after all), some sort of spontaneous education took place in an ad hoc community; it enabled a dialogue that would not have been possible in the top-down "letters to the editor" era of public participation in film criticism.[41] There is at least the potential of an international public sphere, an international cinephilia in which both "professional" and "amateur" critics can communicate, debate, and discuss films, whether they live in the West or East, in the city or in the countryside.[42]

How Have New Media Changed Film Criticism as a Profession and Institution? Of all the major areas of debate, this one is perhaps the most speculative: we currently find ourselves in a transitional stage—in terms of the shift from print media to digital media but also vis-à-vis the reorganization of media companies and their business models—which has a profound and material effect on the very status of the writer-journalist-critic within this landscape.

In the first decades of the twenty-first century, media "reorganization" or "consolidation" have become two sober euphemisms for the shrinking number of newspapers and journalists and the increasing frequency by which existing media organizations have been merged under common ownership.[43] For some commentators we are witnessing not only the end of print media but perhaps even the end of a pluralistic media landscape that addressed local, regional, national, international, and niche audiences.[44] This sense of institutional crisis, which no doubt is a major factor in the present "crisis of criticism," has spawned websites such as Newspaperdeathwatch, which furnishes industry reports and statistics of the most apocalyptic kind. It is difficult to put a positive spin on the fact that newspapers in the United States hemorrhaged nearly 50 percent of their market value and 30 percent of their staff in the first nine years of the century;[45] the many large print-media groups to have become insolvent in the last few years include Canwest Global, *Frankfurter Rundschau*, Freedom Communications, the Journal Register Company, the *Minneapolis Star Tribune*, Philadelphia Newspapers LLC, the Sun-Times Media Group, and the Tribune Company.[46] Local newspapers are merging or ceasing to exist; once thriving organs, from the *Seattle P-I* to *Newsweek*, are forced to make do with a skeleton staff and an online-only presence.[47]

The publishers who remain face a fundamental dilemma: how does one incentivize readers to pay for something that they have been receiving—since the heady, early days of the Internet, when almost all newspapers rushed to put most or their entire content online—for free? The *New York Times*, *The Times* (of London), the *Wall Street Journal*, the *Financial Times*, and even the *Onion* have forms of paywalls: some require payment for all content, others for some content, and still others charge only after a certain number of articles have been called up within a certain time period.[48] Others have changed their coverage (e.g., "hyperlocalism") or the type of content that appears on the websites according to time of day (i.e., "dayparting"), offered specialized content not available elsewhere, bundled their content (e.g., subscription plus iPad), sought out sponsors, or created membership systems or groups (e.g., wine clubs, dating sites) that engender a feeling of community and exploit the relationships of trust that they enjoy with loyal readers.[49]

These business models have met with varying success, and it seems that no one sustainable model can truly fit every organization.[50] The irony—and this

reveals the situation as a business failure, rather than necessarily a fragmentation or dumbing down of the audience—is that although media companies are failing, their audiences are actually growing; the thirst for news and criticism is bigger than ever before.[51] Indeed, if we look beyond Europe and North America, worldwide and especially in Asia and Africa we actually find huge increases in print circulations and new titles.[52]

What the controversy over free-content online publications (e.g., the *Guardian*) versus paywalls ignores, however, is that even when print media consumption still dwarfed the incipient digital media, changes were taking place. Looking at the US "alternative weekly" sector, which has included the *Village Voice*, *LA Weekly*, *Chicago Reader*, and *Boston Phoenix* and has traditionally figured as one of the most important gateways of film criticism, we see that consolidation was already well under way. Already a few years into the new century, the sector was reduced by vertical or horizontal integration. As an example of the former, *Boston Phoenix* parent company Phoenix Media/Communications Group owned also the *Portland Phoenix* and *Providence Phoenix* papers, nightlife magazine *Stuff*, and a number of area radio stations, local printing facilities, and social network and dating websites. (This consolidation failed to prevent the demise of the *Boston Phoenix* in 2013.) For an instance of the latter, witness the 2005 merger of the *New Times* and *Village Voice* newspaper chains, so that the following alternative weeklies/listing magazines became part of a common ownership: *Phoenix New Times*, *Denver Westword*, *Miami New Times*, *Dallas Observer*, *Houston Press*, *SF Weekly* (San Francisco), *Cleveland Scene*, *St. Louis Riverfront Times*, *Kansas City Pitch*, *New Times Broward–Palm Beach*, *Village Voice*, *LA Weekly*, *OC Weekly*, *Minneapolis City Pages*, and the *Nashville Scene*.[53]

Not only were alternative weeklies increasingly consolidated under common ownership, switching to the tabloid format, eliminating staff positions in favor of freelancers and interns, forgoing film festival and other costly coverage—they were also (becoming) free.[54] These usually progressive, left-leaning newspapers were subsidized by their traditionally strong classified advertising but also by reserving hefty portions of ads, often in separate pull-out sections, for strippers, escorts, and other sex workers. Indeed, according to some, the influence and rise of free newspapers (including the international *Metro*, the *London Evening Standard*, and the American alternative weeklies) has been far more damaging to the business than the move to digital.[55] In any event, with the rise of Craiglist and other online classifieds this market has dried up too.[56]

These general macrotroubles in the traditional print organs of film criticism—dailies, listing magazines, and cinephile monthlies—have had a profound effect on the material microexistence of individual film critics and produced a great amount of anxiety and soul-searching about the institution and worth of film criticism. Prominent stories have been written about the *Village Voice* laying off

J. Hoberman, Nathan Lee, Michael Atkinson, and Dennis Lim.[57] "Every day," one commentator writes, "it seems there's news of a fresh kill."[58] Some of these claims have surely been overstated: when the now late Andrew Sarris was "fired" from the *New York Observer*, it initiated a number of nervous notices.[59] In reality his contract was transformed to freelance status. But perhaps more troubling than the prominent "kills" are the very many critics who featured on Sean P. Means's list. These smaller stories, results of local and regional downsizing, often mean that newspapers no longer have a film critic—that is, if those duties had not already been consigned to a national syndicated columnist like Roger Ebert years before. These cases do raise serious questions about the status and value of film and other arts-and-culture critics in our society and about the ever-present debate regarding the precise relationship between news and commentary, criticism and "reviewing," reportage and opinion—not to mention material ethical questions about stable, salaried working conditions versus freelancers, exploited interns, and the unpaid.[60] Bloggers' lack of public, visible institutional contexts (such as that which the traditional newsroom provided) have destabilized the traditional picture of the critic.[61]

Indeed, the troubles at traditional media and the rise of an "army of [unpaid] opinionated bloggers"[62] raise further fundamental queries about the profession. No matter how many people read your reviews, if you are not earning money or not enough money to feed and house yourself, is your writing a profession or a hobby? According to *New York Magazine* critic Matt Zoller Seitz, "we're fast approaching the point where criticism will become, for the most part, a devotion rather than a job."[63]

Who Can Be a Critic? Has Criticism Become More "Democratic"?

These days *anyone* and *everyone* can be a critic, a development celebrated by some and repudiated by others (see Armond White's essay herein). In the past becoming a film critic entailed an Oxbridge or Ivy League education or another form of social connection, a laborious apprenticeship of writing capsule reviews, a journeyman existence of freelancing or writing for the local media in an undesirable market, or other time-intensive efforts. Today, in a matter of minutes and at no cost, one can set up a WordPress blog and "publish" a review.[64] The Internet and the new media hold, according to journalism scholar John V. Pavlik, "the promise of a better, more efficient, more democratic medium for journalism and the public in the twenty-first century."[65] A "fragmented" but more positively polyvocal style of discourse is replacing the traditional "top-down" model and "endowing readers with agency, production and distribution capacity."[66]

Nevertheless, another persistent question remains: even though everyone can become a critic, can anyone be *read*? Despite all prescriptions from commentators such as McDonald that the authoritative critic has died (and should

be resurrected), powerful critics such as A. O. Scott and Peter Bradshaw still exist, opinion leaders who, even if they cannot "make or break" a film, can perhaps rescue it from total obscurity—in particular a film without a multimillion-dollar marketing and advertisement budget. Have the barriers to enter the profession—in yesteryear regulated by tony backgrounds, expensive educations, and networking skills deployed in physical settings such as cocktail parties—remained just as high but simply been updated to who can market themselves, network "socially" online, or manage the results of search systems, in order to collect the most "followers"? I take up this question more closely in my chapter in this book.

This issue—about which and how critics emerge in the digital order—causes us to reflect on the unexamined past of criticism and reevaluate the makeup of the profession. It was not so long ago when the British Film Institute, following a government report on a new national film policy, transplanted the editorial team of an undergraduate cinephile magazine at Oxford University to London and put them in charge of the most important organs of national film criticism, *Sight and Sound* and *Monthly Film Bulletin*.[67] In North America and Europe film critics have been predominantly white, middle class, and male. "Film criticism," as one commentator has recently demonstrated, "is one of the most gendered pathways in film culture,"[68] and we need to deal more closely with this important, but often neglected, issue. In this book Maria San Filippo and Noah Tsika examine—using both historical and contemporary examples—the ways in which a gendered, sexual, and ethnic economy is at stake and very much at the heart of film criticism as a profession and institution but also as an activity and form. New access to media has meant that niche demographics outside of the traditional dominant white patriarchy have opportunities to express themselves and that, in turn, audiences interested in these viewpoints and cultural products have points of access and communities with which to connect.

FILM CRITICISM IN THE DIGITAL AGE

This is the first book-length study of its kind; it is the first volume to address these five major, overlapping debates directly and rigorously. The chapters, written by leading experts in the field (many with a background in film criticism themselves), present these issues in a broad cultural context. Whereas most interventions hitherto have tended to pose arguments about the film criticism of a particular country or national tradition (e.g., *For the Love of Movies: The History of American Film Criticism*; *The Complete History of American Film Criticism*; *It's Only a Movie! Films and Critics in American Culture*), the Internet has no border fences or passport checks. Technological changes have dramatically altered the composition, circulation, and consumption of criticism worldwide, and this

book, for the first time, looks at this phenomenon both with transnational pan-oramic views and with close-up studies sensitive to national and regional issues.

Studies of film criticism—especially as conducted by film scholars rather than sociologists or economists—tend to examine personalities (Kael versus Sontag versus Sarris), literary styles (*The Language and Styles of Film Criticism*), or schools of interpretation (auteurists versus structuralists). As important as these procedures are—and they are surely essential to understanding the subject—they are insufficient to comprehend a phenomenon with serious and determinant cultural, medial, institutional, and economic factors. These mix-tures gesture toward the hybrid essence of film culture: it exists between pro-fession and hobby, art and entertainment, pleasure and business. The present volume is the first work to approach this topic with a comprehensive selection of appropriate methodologies. Some of the contributions engage with empirical methods and seek thereby to make larger claims about film criticism as a profes-sion. Indeed, unlike the "cult of personality" approach, this volume is very much concerned with institutional and economic analysis—how critics and criticism are organized and regulated in specific contexts and how technological change and market forces exert pressure on the shape of this practice. Another major emphasis is historical analysis. This is particularly urgent in the examination of what—for many journalistic discourses about the phenomenon of criticism in the digital age—is plied with the rhetoric of a "brave new world." Our contribu-tors look at larger historical developments and how analogous examples can help us to understand and confront present challenges. Criticism has experienced past "crises" and showed a tremendous capacity for adaptation; reviewing his-torical case studies demonstrates that, *pace* technological determinists, human influence and innovation can be decisive.[69] Finally, the following chapters take especial regard of sociocultural factors. Film criticism involves mediation between a cultural object and an audience; society and culture factor in all three segments of this communicative model and are implicated in the act of media-tion itself. The chapters examine sociocultural factors that influence and shape today's film criticism but also recognize how the opposite is also true: every film review is a political act. Common to all perspectives represented in this collec-tion is the measured assessment of both the positive and the negative impacts of the Internet and other new media.

"Part I: The Critic and the Audience" contemplates the purposes of the critic and the renegotiation of critic-audience relations in the twenty-first century. Greg Taylor begins the volume by revisiting his seminal work *Artists in the Audi-ence*. In some ways the Internet has realized the vanguard project of Manny Far-ber and Parker Tyler: in the Age of Evaluation and Facebook "likes," criticism has become equated with the very articulation of spectatorship. This is not perhaps as dire as it seems, Taylor argues, elaborating on the ideas of Carroll, McDonald,

and others. Evaluation allows us to construct and situate our self-identities among others'; the Internet provides "millions of disparate, like-minded connoisseurs the sense that they are all in this together."

Cecilia Sayad engages with and complicates Taylor's work by arguing that the dynamics of the critic and the audience are best understood as a threesome. Tracing the history of film directors' criticism and how auteurism has often structured approaches to cinema, she argues that critics and authors have always competed over interpretation and status. To appreciate the "crisis" discourse invoked here in the introduction, the overlapping triangulation of critics, audiences, *and* authors needs to be taken into account.

In turn, Daniel McNeil's contribution investigates the case of Armond White. McNeil draws on a genealogy of African American thought to demonstrate that, far from being an atavistic curmudgeon, White's agitation against bloggers and amateur pundits represents an important and misunderstood voice in the current critic-audience debate. In a world flooded with unconsidered punditry, White—and to a lesser extent other writers influenced by James Baldwin, for example, bell hooks, Elvis Mitchell, and Cornel West—reminds us "that artful critics consider it a public duty to respond to works of art honestly and to question the motives of artists and other critics."

"Part II: New Forms and Activities" examines the new modes and platforms of film criticism and the effects that new media have on professional and "amateur" critics. Following from part 1, it further considers to what extent these new forms rebalance the old opposition of "professional critics" and "amateur readers." My chapter dissects so-called democratic challenges to critical authority. Closely inspecting the aggregate review organ Rotten Tomatoes, I test the claim that such sites provide increased objectivity, access, and participation in film criticism and argue that on the whole such platforms venerate the traditional ideas of criticism and erect new barriers to enter the profession.

Drawing on the historical specificities and conditions of criticism in Italy, Giacomo Manzoli and Paolo Noto analyze another new form, online video reviews of film (vlogs), and evaluate their supposed innovation. They conclude that the new medium is applied to familiar ends: the particularly Italian "will to preserve the alleged function, and the distinctive jargon, of traditional film criticism" prevents vlog-critics from taking advantage of technological possibilities.

In her chapter Maria San Filippo considers how interactive web-based communities act as counterpublics organized around queer cinema and cinephilia and examines closely AfterEllen, the premier community of queer female "amateur critics" talking about queer women in film and television. Situating After-Ellen in the historical and institutional context of queer women's writing on film, San Filippo demonstrates how the 2006 corporate takeover of the site has led to a homonormative broadening of thematic scope and user address.

Closing the section, Noah Tsika examines a case study of a culture with limited indigenous critical traditions. Recent online Nigerian blogging—blogs written in Nigeria and among the significant diaspora populations worldwide—has filled this vacuum with an embrace of "amateur" vernaculars, much like the Nollywood industry itself.

"Part III: Institutions and the Profession" revolves around institutional groupings, examining film criticism as a professional activity within national contexts. All three contributions deploy empirical or historical research to make broader claims about the status of the critic and the purpose of criticism in the new millennium. Anne Hurault-Paupe uses discourse analysis to examine the web presence of the leading US critics' associations. The sites' historical changes and focus on their annual awards reveal how these groups seek both to legitimize themselves as highbrow connoisseurs and yet still compete with the Oscars' red-carpet glamour. This ambivalent positioning between industry discourse and amateur blogging discloses how the "crisis of criticism" has become manifest on the institutional level of professional American criticism.

Outi Hakola likewise identifies a change in critics' assessments of status. Comparing historical and contemporary surveys of professional Finnish critics and examining self-reflexive statements in the most important national critics' trade journal, Hakola concludes that perceptions of the profession's health are largely age-related. Nostalgic senior critics are more downbeat than enthusiastic upstarts, who are more adept at exploring technological innovations and less apt to consider criticism a fulltime career.

Thomas Elsaesser concludes the section by examining the purposes of criticism that have existed in the guise of Béla Balázs, Siegfried Kracauer, Edgar Morin, and Parker Tyler, and he makes a plea for their survival in the age of Twitter. Quality writing on film has always successfully addressed an audience, taken account of broader society, and maintained a personal dialogue with the reader. Regardless of form, such soulful, social criticism is necessary.

When Cecilia Sayad and I began this project, we envisioned a dialogue between film scholars and critics. We quickly found that although most of the critics primarily writing for magazines, newspapers, or blogs were keen on the idea, many were unwilling to countenance delivering a chapter without financial compensation. I mention this not as a self-reflexive footnote to the realities of scholarly publishing but as a symptomatic disclosure of the very issues that this book broaches. The divisions between salaried academic and paid-per-article writers are not simply petty rivalries and puerile suspicions: they are symbols of the very material distinctions that regulate our labor.

As a way to balance the field, we reprint a series of critics' self-reflections in "Part IV: Critics Speak." These statements were, not coincidentally, all originally published in 2007 and 2008: the worldwide recession, then just beginning to

bite, took a number of reviewers as its first "victims," which in turn catalyzed a wave of soul-searching. Besides being formatted to fit this volume, these pieces appear in their original forms, as artifacts of the crisis of criticism. Jasmina Kallay's "The Critic Is Dead . . ." was perhaps the most elegant deliberation on the issues surrounding authority and its loss in the context of studio-sponsored press screenings for bloggers and ubiquitous top-ten lists. Armond White delivered (and performed) a lesson in stylistics to fly-by-night amateur critics in his plea for professionalism, "What We Don't Talk About When We Talk About Movies." In turn, Nick James wondered in his piece, "Who Needs Critics?" Looking back at historical British debates on the purpose of the profession, the *Sight and Sound* editor-in-chief ultimately aligned himself with the tradition of Lindsay Anderson's "committed" criticism and advocated a distinctive style of writing that agitated against Hollywood hegemony. Finally, we include excerpts from *Cineaste*'s symposium on "Film Criticism in the Age of the Internet." In these passages five bloggers—Theodoros Panayides, Kevin B. Lee, Karina Longworth, the Self-Styled Siren, and Stephanie Zacharek—provided passionate counterbalances to the pronouncements of the "professionals."

NOTES

1. See, e.g., Patrick Goldstein, "The End of the Critic?" *Los Angeles Times*, 8 April 2008; Vincent Rossmeier, "Where Have All the Film Critics Gone?" *Brooklyn Rail*, June 2008, http://brooklynrail.org/2008/06/express/where-have-all-the-film-critics-gone; John Hess, Chuck Kleinhans, and Julia Lesage, "The Last Word: Fretting About Film Criticism," *Jump Cut* 52 (2010): www.ejumpcut.org/archive/jc52.2010/lastWordCriticism/index.html; Nick James, "Goodbye Mr French," *Sight and Sound*, November 2013.

2. These include the conference organized by *Sight and Sound* editor Nick James on 8 October 2008 at the British Film Institute; Giacomo Manzoli and Paolo Noto's symposium "Critica della Critica" at the University of Bologna on 31 January–1 February 2013; the inaugural BAFTSS conference in April 2013; "The Future of Film Criticism in the Internet Age" conference at King's College London, 27 November 2013; and the "Who Needs the Professionals Now That Everyone's a Critic?" conference at the Institute of Contemporary Art, London, 13 June 2014. *Cineaste* magazine has three times convened a written symposium on the subject. See, e.g., "Film Criticism in the Age of the Internet: A Critical Symposium," *Cineaste* 33.4 (2008): 30–46 (excerpts reprinted in this volume). In the interests of full disclosure: we do not deny both chronicling and thereby participating in this phenomenon. Witness our symposia at the University of Kent: "Film Criticism in Dialogue" (11 November 2010) and "Cultural Criticism in the Digital Age: Media, Purposes and the Status of the Critic" (7 June 2012).

3. See Rónán McDonald, *The Death of the Critic* (London: Continuum, 2007); and Maurice Berger, ed., *The Crisis of Criticism* (New York: New Press, 1998).

4. Sean P. Means, "The Departed—No. 55, Phil Villareal," *Salt Lake Tribune*, 7 May 2009, http://blogs.sltrib.com/movies/labels/disappearing%20critics.htm.

5. These studies include Greg Taylor, *Artists in the Audience: Cults, Camp, and American Film Criticism* (Princeton, NJ: Princeton University Press, 1999); Phillip Lopate, *Totally, Tenderly, Tragically: Essays and Criticism from a Lifelong Love Affair with the Movies* (New York:

Anchor/Doubleday, 1998); Phillip Lopate, ed., *American Movie Critics: An Anthology from the Silents Until Now* (New York: Library of America, 2006); Manny Farber, *Farber on Film: The Complete Film Writings of Manny Farber*, ed. Robert Polito (New York: Library of America, 2009); Brian Kellow, *Pauline Kael: A Life in the Dark* (New York: Viking, 2011); Pauline Kael, *The Age of Movies: Selected Writings of Pauline Kael* (New York: Library of America, 2011); and Richard Roud, *Decades Never Start on Time: A Richard Roud Anthology*, ed. Michael Temple and Karen Smolens (London: British Film Institute/Palgrave, 2014).

6. Jerry Roberts, *The Complete History of American Film Criticism* (Santa Monica, CA: Santa Monica Press, 2010).

7. See, e.g., Terry Eagleton, *The Function of Criticism: From the Spectator to Post-Structuralism* (London: Verso, 1984); for film-specific examples see Taylor, *Artists in the Audience*.

8. Noël Carroll, *On Criticism* (New York: Routledge, 2009), 5, 8.

9. Ibid., 14, 6.

10. Ibid., 15.

11. Ibid., 75, 72, 5, 53, 66.

12. See, e.g., David Bordwell and Noël Carroll, eds., *Post-Theory: Reconstructing Film Studies* (Madison: University of Wisconsin Press, 1996).

13. McDonald, *Death of the Critic*, 116, 120, 125.

14. Ibid., 134, 113.

15. For the model of reception that the reviewing process entails, see Wendy Griswold, "A Methodological Framework for the Sociology of Culture," *Sociological Methodology* 17 (1987): 12; for an assessment of how the Internet has changed the relationship between all news organizations, journalists, and their many publics, see John V. Pavlik, *Journalism and New Media* (New York: Columbia University Press, 2001), xiii.

16. George Steiner, "'Critic'/'Reader,'" *New Literary History* 10.3 (1979): 428.

17. See, e.g., Matthew Arnold, "The Function of Criticism at the Present Time," in *The Portable Matthew Arnold*, ed. Lionel Trilling (New York: Viking, 1949), 239–267; and Oscar Wilde, "The Critic as Artist," in *The Artist as Critic: Critical Writings of Oscar Wilde*, ed. Richard Ellmann (Chicago: University of Chicago Press, 1969), 340–408.

18. See Wesley Shrum, "Critics and Publics: Cultural Mediation in Highbrow and Popular Performing Arts," *American Journal of Sociology* 97.2 (1991): 351; Morris B. Holbrook, "Popular Appeal Versus Expert Judgments of Motion Pictures," *Journal of Consumer Research* 26.2 (1999): 144–155; and David A. Reinstein and Christopher M. Snyder, "The Influence of Expert Reviews on Consumer Demand for Experience Goods: A Case Study of Movie Critics," *Journal of Industrial Economics* 53.1 (2005): 27–51.

19. See, e.g., Emanuel Levy, "Art Critics and Art Publics: A Study of the Sociology and Politics of Taste," *Empirical Studies of the Arts* 6 (1988): 137.

20. Shrum, "Critics and Publics," 347.

21. Ibid., 369.

22. John Carey, *What Good Are the Arts?* (London: Faber and Faber, 2005), 167. Perhaps symptomatically, writers such as George Steiner have traditionally attempted to delineate the distinction between the "critic" and the "reader." See Steiner, "'Critic'/'Reader.'"

23. Carey, *What Good Are the Arts?* 167–168, 171, 249.

24. See Nick James, "Who Needs Critics?" *Sight and Sound*, October 2008, 16–18 (reprinted in this volume); "Are Film Critics Really Needed Anymore . . . or Is It a Washed-Up Profession?" *Variety*, 25 April 2007, www.variety.com/article/VR1117963778?refCatId=1043.

25. Eagleton, *The Function of Criticism*, 103.

26. Maurice Berger, "Introduction: The Crisis of Criticism," in *The Crisis of Criticism*, ed. Maurice Berger (New York: New Press, 1998), 4.

27. McDonald, *Death of the Critic*, 3, 7.
28. Ibid., 1, 77. See also Raymond J. Haberski Jr., *It's Only a Movie! Films and Critics in American Culture* (Lexington: University Press of Kentucky, 2001), which deploys the phrase the "golden age of criticism."
29. McDonald, *Death of the Critic*, ix.
30. Andrew Keen, *The Cult of the Amateur: How Today's Internet Is Killing Our Culture and Assaulting Our Economy* (London: Nicholas Brealey, 2007).
31. For more on the "fragmentation" discourse see Alan McKee, *The Public Sphere: An Introduction* (Cambridge: Cambridge University Press, 2005); for an analysis of the "dumbing-down" argument see Herbert J. Gans, *Popular Culture and High Culture: An Analysis and Evaluation of Taste*, 2nd rev. ed. (New York: Basic Books, 1999).
32. McDonald, *Death of the Critic*, ix.
33. Ibid., 7, 15.
34. James, "Who Needs Critics?" 16.
35. Armond White, "What We Don't Talk About When We Talk About Movies," *New York Press*, 30 April 2008, http://nypress.com/what-we-dont-talk-about-when-we-talk-about-movies. Reprinted in this volume.
36. Philip French, *"Flight," Observer*, 3 February 2013, www.guardian.co.uk/film/2013/feb/03/flight-denzel-washington-zemeckis-review.
37. See Max Horkheimer and Theodor Adorno, *Dialectic of Enlightenment*, trans. John Cumming (New York: Continuum, 1982); and Jean Baudrillard, *Simulations*, trans. Paul Foss, Paul Patton, and Philip Beitchman (New York: Semiotexte, 1983).
38. See, e.g., Andrew Sarris, "Billy Wilder Reconsidered," in *American Movie Critics: An Anthology from the Silents Until Now*, ed. Phillip Lopate (New York: Library of America, 2006), 307–311.
39. See also Pavlik, *Journalism and New Media*, xiv, for the new "storytelling devices" (video, hypermedia) that can be employed.
40. French, *"Flight."*
41. On the issue of user-generated content and its impact on professional online journalism see Alfred Hermida and Neil Thurman, "A Clash of Cultures: The Integration of User-Generated Content Within Professional Journalistic Frameworks at British Newspaper Websites," *Journalism Practice* 2.3 (2008): 343–356.
42. For more on these possibilities see Jonathan Rosenbaum, *Goodbye Cinema, Hello Cinephilia: Film Culture in Transition* (Chicago: University of Chicago Press, 2010).
43. Janet Jones and Lee Salter, *Digital Journalism* (London: Sage, 2012), 21.
44. Pavlik, *Journalism and New Media*, xiii.
45. Jeff Kaye and Stephen Quinn, *Funding Journalism in the Digital Age: Business Models, Strategies, Issues, and Trends* (New York: Peter Lang, 2010), 8.
46. Suzanne M. Kirchhoff, "The U.S. Newspaper Industry in Transition," *Congressional Research Service Report* 40700, 9 September 2010; Michael J. de la Merced, "Freedom Communications Files for Bankruptcy Protection," *New York Times*, 1 September 2009, www.nytimes.com/2009/09/02/business/media/02freedom.html.
47. William Yardley and Richard Pérez-Peña, "Seattle Paper Shifts Entirely to the Web," *New York Times*, 16 March 2009, www.nytimes.com/2009/03/17/business/media/17paper.html; Ed Pilkington, "*Newsweek* Goes Online but Leaves Lasting Print on the Newsstand," *Guardian*, 19 October 2012, www.guardian.co.uk/media/2012/oct/19/newsweek-online-only-print.
48. Jones and Salter, *Digital Journalism*, 43; Kaye and Quinn, *Funding Journalism in the Digital Age*, 36.

49. See Kaye and Quinn, *Funding Journalism in the Digital Age*, 35–53, 95, 133, 139, 143, 146; Jones and Salter, *Digital Journalism*, 47.

50. Bob Franklin, "The Future of Newspapers," *Journalism Practice* 2.3 (2008): 306–317, 312; Kaye and Quinn, *Funding Journalism in the Digital Age*, 173.

51. Kaye and Quinn, *Funding Journalism in the Digital Age*, 9, 12–13. James Surowiecki, "News You Can Lose," *New Yorker*, 22 December 2008, www.newyorker.com/talk/financial/2008/12/22/081222ta_talk_surowiecki; Kenny Olmstead, Jane Sasseen, Amy Mitchell, and Tom Rosenstiel, "Digital: News Gains Audience but Loses Ground in Chase for Revenue," The State of the News Media 2012, http://stateofthemedia.org/2012/digital-news-gains-audience -but-loses-more-ground-in-chase-for-revenue/.

52. Franklin, "The Future of Newspapers," 307–308.

53. Richard Siklos, "*The Village Voice*, Pushing 50, Prepares to Be Sold to a Chain of Week-lies," *New York Times*, 24 October 2005, www.nytimes.com/2005/10/24/business/24voice .html?pagewanted=all&_r=0.

54. Kaye and Quinn, *Funding Journalism in the Digital Age*, 19.

55. See Piet Bakker, "Free Daily Newspapers—Business Models and Strategies," *International Journal of Media Management* 4.3 (2002): 180–187; and Piet Bakker, "The Simultaneous Rise and Fall of Free and Paid Newspapers in Europe," *Journalism Practice* 2.3 (2008): 427–443.

56. Siklos, "*The Village Voice*, Pushing 50."

57. Eric Kohn, "J. Hoberman Laid Off as Chief Film Critic at *The Village Voice*," *Indiewire*, 4 January 2012, www.indiewire.com/article/264fda20-3734-11e1-97b6-123138165f92.

58. Rossmeier, "Where Have All the Film Critics Gone?"

59. For a critical assessment of these notices, which usually failed to mention that Sarris indeed still wrote for the paper, if on a freelance basis, see Dave Kehr's blog item, "Andrew Sarris Persists and Endures," www.davekehr.com/?p=337.

60. See Jones and Salter, *Digital Journalism*, 49–50; see also Laura Oliver, "Journalism Job Losses: Tracking Cuts Across the Industry," Journalism.co.uk, 3 August 2010, www.journalism .co.uk/news-features/journalism-job-losses-tracking-cuts-across-the-industry/s5/a533044/.

61. Jones and Salter, *Digital Journalism*, 1.

62. James, "Who Needs Critics?" 16.

63. Quoted in Rossmeier, "Where Have All the Film Critics Gone?"

64. Jones and Salter, *Digital Journalism*, 49. For the pejorative discourses that often critique the fact that these days "anybody with a Twitter account could have a crack," see Jones and Salter, *Digital Journalism*, 3.

65. Pavlik, *Journalism and New Media*, xiii.

66. Jones and Salter, *Digital Journalism*, 171.

67. See Mattias Frey, "The Critical Question: *Sight and Sound's* Postwar Consolidation of Liberal Taste," *Screen* 54.2 (2013): 194–217.

68. See Melanie Bell, "Film Criticism as 'Women's Work': The Gendered Economy of Film Criticism in Britain, 1945–65," *Historical Journal of Film, Radio and Television* 31.2 (2011): 192. See also Melanie Selfe, "Circles, Columns, and Screenings: Mapping the Institutional, Dis-cursive, Physical, and Gendered Spaces of Film Criticism in 1940s London," *Journal of Brit-ish Cinema* 9.4 (2012): 588–611; and, on this general issue, Antonia Lant, ed., *Red Velvet Seat: Women's Writing on the First Fifty Years of Cinema* (New York: Verso, 2006).

69. Janet Jones and Lee Salter make a similar claim for journalism; see their *Digital Journalism*, 4.

PART I THE CRITIC AND THE AUDIENCE

1 ★ THUMBS IN THE CROWD

Artists and Audiences in the Postvanguard World

GREG TAYLOR

I first began recording some of the ideas that eventually led to the book *Artists in the Audience* on a 512k dual-floppy drive DOS PC in orange type.[1] If I recall correctly, the computer and compatible printer cost me close to a thousand dollars in the late 1980s—a considerable sum for what was in fact a glorified word processor and certainly not a research tool. The critics who served as the focus of my study—acerbic B-movie aficionado Manny Farber and psychomythological Hollywood hallucinator Parker Tyler—had to be unearthed through more laborious means, though this was itself an attractive prospect insofar as their importance seemed to me to stem not simply from their apparent formative influence on those who appeared in their wake but also from the subsequent obscuring of this very influence over time. They were cult figures to me—insufficiently known, underacknowledged, and therefore deserving of serious metacritical rehabilitation. Poring through Farber and Tyler's critical oeuvres thus meant harassing used-bookstore owners and weary interlibrary loan clerks and perusing microfiche and musty bound volumes, which I recall being heavy and also difficult to position correctly on a photocopy machine. But in the end all that effort made these legendary figures seem that much more *special*, and worthy of rescue from cultural marginality, much like the movies—and unplumbed depths of movies—they had championed in their day.

Some twenty-five years later, dual-floppy DOS PCs exist only as junk—having been rendered even more useless than the manual typewriters they once replaced—and the Internet has turned cultural marginality into an increasingly puzzling concept. At the time of this writing, entering "Manny Farber" (with the

quotation marks) into Google nets some 49,000 results, which apparently takes the search engine 0.22 seconds to produce. For "Parker Tyler" the total is 60,200, which, curiously enough, happens 0.09 seconds faster. Does this make Tyler slightly more "popular"—or even more culturally "present"—than Farber? It's an interesting question. Googling "pink polka dot elephant" (again, with quotation marks intact) nets 105,000 results in 0.21 seconds, which tells us something about Google's special insight into cultural value. At any rate, however, *specialness* sure ain't what it used to be. In this seemingly postvanguard world both Farber and Tyler even have their own Facebook pages, despite the fact that Farber passed away in 2008 and Tyler has been dead for nearly forty years.

What is a "postvanguard" world? It is not a world in which the assumptions and methodologies governing cultist and camp appreciation (as detailed in *Artists in the Audience*) have become invisible, outdated, or irrelevant, as witness the lasting interest in Farber, Tyler, cult films and directors, obscure cultural objects, and mainstream cultural objects viewed through a skewed, revelatory perspective—but also (and more importantly) the larger zeitgeist of engaged spectatorship and fandom that so dominates our age and drives our all-encompassing celebratory and putatively user-driven interaction with pop culture. It is, rather, an age in which the vanguard perspective's sheer ubiquity has so colored the very fabric of contemporary Western culture that for all intents and purposes it now *is* that culture. There's no escaping it. Since the 1990s and with the dawn of the Internet age, America has gone right through empowered spectatorship and out the other side, emerging into a world where the very notion of cultural obscurity has been rendered problematic, because everyone has access to everything, every thing has personal importance to at least someone, and anyone can (in theory) share the personal importance of any thing or experience with the rest of us. The "death of Cool" doesn't mean that nothing is cool anymore, but it does mean that the playing field on which the value of cool is determined is so vast and crowded as to render that value highly relative and highly personal ("cool" rather than "Cool," perhaps), robbed of the validation and authority once granted by a single coherent counterculture that no longer exists as such. Thus, the point is not so much that cultism and camp simply exhausted themselves in their search for new material to reclaim for vanguard rehabilitation—margins still exist, both on the fringes and deep within cultural texts—but rather that the vanguard gesture of reclamation of margins has itself lost most of its potency, insofar as everyone seems to be claiming cultural authority and specialized cultural knowledge at the same time, and both are so readily available. As a result the sense of individual empowerment that once issued from such knowledge—for example, knowledge of vanguard film critics or of the works they championed—has necessarily given way to a deeper if perhaps illusory sense of shared or collective cultural mastery. So while it may

be initially disheartening to realize that the obscure song, band, radio station, movie, or critic you treasured and effectively "owned" within your small circle of like-minded friends back in the day has lost its cachet, and that thousands, perhaps millions, of others have in fact shared your rarified knowledge and taste, there is nevertheless a certain comfort in community and in the realization that user-driven cultural engagement is now a way of life.

If the Internet and related social media represent in many ways the *ne plus ultra* of empowered, creative spectatorship—and thus the ultimate realization of the vanguard project, writ large—the diffusion of vanguard ideals within the public sphere also raises the question, "What next?" What happens after artists fill the audience and after spectators are granted the means, opportunity, and encouragement to assert their active ownership of culture? And more specific for us, what happens to criticism, given the presumably compromised cultural authority of old-time expert tastemakers—and heightened cultural authority of everyone else—within this brave new world? The answer is that following art itself, criticism has now also expanded and exploded in a thoroughly unprecedented manner, to the point where anyone is capable of being a critic, and (more important) what counts as "criticism" in effect encompasses practically any form of articulated spectatorship. Because there are no longer any gatekeepers significantly regulating public expression (the Internet having revolutionized self-publishing) and because the vanguard intervention blew the walls off long-standing assumptions of taste and decorum in criticism, anyone who wishes to state anything about any cultural product now has a forum in which to do so; furthermore, that statement can legitimately range anywhere from fanboy/-girl celebration or reclamation, to a pithy Rotten Tomatoes or Metacritic or *6-Second* Moviefone review, to complex audiovisual analysis on a specialty blog. It all counts, and—most important for us here—*none* of these articulations is "uncritical"— including the expression of fandom—if only because in the postvanguard world the simple gesture of liking something or declaring it special (*pace* Warhol) is sufficient to confer on it a sense of aesthetic significance, even if (or perhaps especially because) almost no one uses the terms *aesthetic* or *art* anymore. It doesn't matter, because cultural interest and aesthetic significance are now virtually the same thing—or can be, at any rate. When I post an image of an artwork, or an intriguing photo of a sunset, trees, or waves on Facebook or Tumblr, I am in effect making an evaluative claim by expressing that this image is of value and worth sharing, offering it to the world as a reflection of my elevated taste. I can choose to add a short title or caption such as "interesting photo I came across— love the composition," but my point is that I needn't do so in order to make a critical gesture. Others—at the very least my friends, I hope—can post their own comments affirming my good taste and expressing their own, and they can then repost the image on their own Tumblr page, if they want. Then others may do

the same, and so on. This practice of posting and reposting, asserting and reaffirming, now happens millions of times every hour. And each time it happens, an instance of criticism takes place.

Readers may balk at my looseness with the term *criticism* here. Surely posting an image is not the same thing as writing a sophisticated review or analytical essay or even a journalistic blurb. And it's not. But it is an implication of aesthetic assessment, and as such it now meets the minimum requirement for a critical gesture—and thus, for an act of criticism—because vanguard cultism and camp, as they developed in the 1960s and thereafter, eliminated the need for coherent aesthetic criteria when asserting specialized cultist knowledge and liberated camp taste. Coherent aesthetic criteria could get in the way or be counterproductive and, at very least, might drag the spontaneous flamboyance of the countercultural gesture back into the mundane traditionalism of judicious assessment. And, of course, the mundane traditionalism of judicious assessment ran counter to the very spirit of the vanguard enterprise, which initially sought to promote aesthetic renewal through aesthetically aggressive engagements with presumably nonaesthetic material—here, popular movies. That cultist and camp interventions were always fundamentally aesthetic in nature is absolutely essential to our understanding of their form and function. However effaced such underlying aesthetics were in practice—they had to be, in order to make the critic the revealer of aesthetic import—and however taken for granted, buried, and ignored they variously became through subsequent popular dissemination of vanguard approaches, they nonetheless form the backbone of cultism and camp, which could not exist outside of a broadly aesthetic context. My argument in *Artists in the Audience* was that both Manny Farber and Parker Tyler assumed the validity of their own aesthetic frameworks and ideals as a given. For abstract painter Farber—a product if also harsh critic of the New York School moment—aesthetic vibrancy, vitality, grit, unpretentious rough-hewn action seemed to be appearing more authentically on the margins of American movies than in the mammoth, sleepy, middlebrow canvasses of Jackson Pollock, Robert Motherwell, and Mark Rothko. For poet Tyler—a product of the American surrealist scene—Pollock's faux-revelatory baked-macaroni canvasses were more beside the point, eclipsed in interest by the true revelations made possible by the poetic, indeed erotic, spectator's engagement with the movies in his or her midst, which could be reformed by criticism into complex American quasi-surrealist texts.

LIKE WITHOUT *WHY*—GOODNESS AND BADNESS IN AN AGE OF EVALUATION

But at least both Farber and Tyler were fully cognizant of their own aesthetic biases, biases that made engaging with popular cinema productive and fun to

begin with. For those who have surfaced in their wake, however, things have not necessarily been so obvious, in part because mainstream modernist aesthetics became so thoroughly sullied by the taint of Establishment orthodoxy but also in part because cultist isolation of vital margins and camp appreciation of the hidden riches of just about anything could rely so heavily on sheer force of gesture (the ability to claim *that* I like what I like, know what I know, see what I see) as to make oppositional spectatorship and the cultural distinction it promised seem ends in themselves.[2] No wonder the vanguard impulse caught on in such a big way: for hipsters and academic scholars alike it offered authority over the vast expanse of pop culture while playing down the very terms of aesthetic discernment, the evaluative criteria assumed but also naturalized within the vanguard gesture's assertion of rarified acumen and taste. Being a critic thus first and foremost meant mastering the gesture, which could be as easy as saying, "I think Bruce Lee movies are great works of art, much better than the films of Jean Renoir," as moderately difficult as memorizing all the major production credits of every movie and television program Bruce Lee participated in, or as complex as arguing that the formal depiction of the body in specific Bruce Lee films lends them a surprising psychosexual or psychogendered richness. Backing up the gesture with an articulation of criteria by which judgments of goodness and badness have been conferred is, in the first two cases, subject to whatever rhetorical leeway the relaxed scrutiny of the recipients of the gesture will allow and, in the third, neither relevant nor necessary because the entire issue of aesthetic goodness and badness has been buried beneath questions of ideological complicity and resistance.

My point is that even as it developed its own orthodoxies, the vanguard tradition benefited from its ability to allow one to claim cultural authority over popular works without necessarily having to argue in any coherent detail exactly *why* specific popular works were of high aesthetic quality. Indeed, this helps to explain why the approach gained such cultural traction to begin with. On the one hand it was fundamentally *counter*cultural, setting itself against dominant culture's perceived notion of "popular art"—that is, middlebrow. Yet on the other hand it could also be loose enough to accommodate any brow's desire to claim cultural distinction by appealing to pop works without mounting a complex defense of pop artistry. In offering a new, user-friendly mode of critical discernment that also allowed for fun, active engagement with popular art, the vanguard perspective was bound to threaten the authority of established popular and middlebrow critics; with the subsequent explosion of what has sometimes been dubbed Web 2.0, the toppling of the old regime began in earnest, with the firing of a host of newspaper reviewers across the United States coinciding with the rise of net-based criticism and analysis in blogs such as Ain't It Cool News, Arbogast on Film, Cinetrix, girishshambu, and the Self-Styled Siren

and the diffusion of critical gestures, shorter reviews, and personal evaluative essays alike throughout millions of other Internet sites, blogs, wikis, and social media postings across the globe. The subsequent vigorous (and sometimes alarmist) discourse in the print community surrounding the purported "death" of film criticism as an enterprise was thus to be expected, not least because it suggested an even more dire and public expression of the doomsday scenario for criticism that had already been proffered within neighboring disciplines such as visual art, literature, and music.[3] The battle was pitched in the familiar terms of young versus old, upstart versus establishment, popular versus elitist, mess versus decorum, illiteracy versus expertise, and democratic versus meritocratic; as Thomas Doherty put it, "if the traditional film critic was a professorial lecturer who lorded his superior knowledge and literary chops over the common rung of moviegoer, the web slinger was a man-boy of the people, visceral and emotional, a stream-of-consciousness spurter with no internal censor or mute button."[4]

It seems equally telling, however, that even those authoritative figures sympathetic to the shift (including those who have argued that a new Golden Age of Film Criticism is upon us) tend to celebrate in a somewhat guarded fashion, noting that while the new stuff is a decidedly mixed bag (J. Hoberman: "On the one hand, blogs are spontaneous and unedited; on the other, blogs are spontaneous and unedited"), there is still much worthwhile and intelligent writing out there to be discovered, given enough sifting and the taste required to know what makes good criticism good and bad criticism bad.[5] "Bad" criticism is assumed to be poorly written (Stephanie Zacharek: "even though film bloggers are often 'real' writers [or could be], what they're doing isn't 'real' writing"), poorly argued, and too frequently commits the cardinal sin of functioning as consumer guide or—even worse—mouthing the industry's own promotional piffle and thus implicitly performing as middlebrow apologists.[6] Superior criticism, by contrast, is independently spirited, artistically minded, thoughtful, analytical, and driven toward the continual elevation of film culture above the incessant grind of the Hollywood machine. In other words Web 2.0's new democracy may have released a torrent of fresh critical voices, but beyond that, nothing really has changed; what might have been the demise of film criticism instead becomes a reaffirmation of its guiding principles within an expanded discursive field.

Yet those who wish to hold on to such guiding principles while assiduously separating wheat from chaff are in a sense missing the point. Web 2.0's radical redistribution of critical authority didn't just add new voices to the mix—it changed the game entirely by fulfilling the vanguard dream, legitimizing all forms and articulations of evaluative critical spectatorship, from pure gesture to complex analysis. So while we can still argue about what counts as "good" criticism and "bad" criticism and deride simple, unsubstantiated evaluative responses as mindless cultural noise (Zacharek: "There's a lot of 'weighing in' going on, but

not so much actual thinking"), the fact is that this cultural noise is actually the sound of millions of people making aesthetic judgments as they have always done, except that now these judgments are memorialized within an intersubjective context in a manner impossible before the advent of the Internet and social media.[7] Furthermore, while evaluation is fundamental to criticism, criticism is usually more than just a simple evaluative claim—but in this postvanguard era it doesn't *need* to be more than a simple evaluative claim.[8] Now, even a cyber-"Like" counts. Indeed, if the vanguard impulse aggressively asserted the primacy of evaluative and often celebratory judgment over cool, sober assessment of popular works, the Internet and social media have made personal appropriation of the pop landscape a way of life, while leaving the critical justification and exploration of one's aesthetic judgments optional and open-ended. So instead of dubbing the contemporary climate a new Golden Age of Criticism, we might do even better to call it the Golden Age of Evaluation, an era of rampant, unbridled, and public aesthetic assessment of all stripes. This is an era absolutely obsessed with critical evaluation, reevaluation, and ranking of all manner of cultural products, from movies and burgers to sitcoms to superheroes.

It seems to me, then, that to examine criticism within this contemporary climate means, first and foremost, to examine varieties of articulated evaluative spectatorship. Aesthetic evaluation is not something we discuss very much, which seems odd, given its ubiquity. In part this is because evaluative response seems complex and fuzzy—and it is. In part it's also because details of evaluative response are often effaced or naturalized in taste. Often we know what we like but don't quite know why; at other times we know we like this character/performance/scene but not that one, or we decide we like elements of a work but don't really like the work as a whole. Judging badness and goodness is surely one of the most important ways in which we engage works of art on an ongoing basis and a key source of spectatorial pleasure. In fact, I would venture to guess that ongoing evaluation and reevaluation are so bound up with our experience of aesthetic objects and processes that we don't ever stop judging the quality of such objects and processes, even when we're seemingly enraptured by them. People who make (and mentor the making of) art, or indeed anything creative, find the process just as fundamental to their enterprise as well, as it's impossible to write a story or blog, compose a song, or choreograph a dance without engaging a constant and often grueling process of creating, judging, and revising. Are the ongoing evaluative assessments of a spectator in a movie theater or a composer writing a pop song fixed, objective, and definitive? No, they are provisional, relative, and flexible, subject to revision given new information or consideration. But that doesn't imply that these assessments are trivial or meaningless or that they can't *seem* objective and definitive to us, for good reasons. The standards by which we measure aesthetic success or failure serve as relative contexts—that is,

they always depend on what you expect, and what you value—but shared aims and expectations can seem pretty powerful and self-evident, especially when they take the form of basics such as unity, subtlety, and expressivity. In other words, when we decide a particular work stinks, we're making an important claim about it, and the fact that this claim is unverifiable except through inter-subjective reinforcement (your friend tweeting "OMG you're right! That movie was so bad") hardly lessens its potential truth-value.

And in this era of intersubjective reinforcement and intersubjective challenge that constitutes so much of the roar of cyberspace, the nature of that truth-value seems of particular interest. Does it lie anywhere in the work at *all*, or are all eval-uative judgments nothing more than "projections of the evaluating subject," as Leo Koerner and Lisbet Rausing put it?[9] The consensus is overwhelmingly with the latter, as when Barbara Herrnstein Smith argues that "all value is radically contingent, being neither a fixed attribute, an inherent quality, or an objective quality of things but, rather, an effect of multiple, continuously changing, and continuously interacting variables" that shape the relative and functional judg-ments of author, reader, gatekeeper, and scholar.[10] But I think we ought to tread a little cautiously here. Granted, evaluation always takes place within the personal and sociopolitical frameworks that shape taste, consolidate shared values, and feed oppositional energies, and our judgment claims about artworks are always made against complex ideological backgrounds we necessarily never fully under-stand. But the fact that our evaluative convictions can indeed feel so objective to us—to the point where we can direct an awful lot of rhetorical energy into convincing others of the objective validity of our opinions—also suggests that something else is at play. That "something else" is, in the end, the work itself, which exists as a set of qualities and relationships to which we respond in the first place. Our personal evaluative convictions spring from the subjective assess-ment of these qualities and relationships within the framework of shared cultural expectations, shared cultural and subcultural values, and (no doubt) shared neu-robiological responses to common stimuli.

Yet even if neuroscientists confirm that humans exhibit universally shared responses to certain qualities such as balance and unity, this will hardly pro-vide us a set formula for achieving artistic success by using these qualities or a machine for measuring artistic success and failure in some objective manner.[11] As Malcolm Budd reminds us, artistic value is not simply intersubjective but also fundamentally incommensurable.[12] This makes evaluation a particularly messy process, imbued not simply with social, cultural, and ideological inter-ests but with imprecision, indeterminacy, and contingency, and founded on a subtle and complex interplay between subjective and objective, individual and shared. We may ultimately engage in this activity as part of a fun or serious jos-tling for cultural authority within a class, subculture, community, or circle of

friends, but this in itself does not explain the particular ways in which we link up specific qualities in works with evaluative assessments (both specific and general) or indeed the fact that we really do seem to believe such assessments to be merited by our perception of such qualities. Unfortunately, we still lack a reliable and specific means of conceptualizing the ways in which formal elements hook up with value judgments within evaluation or the ways in which we assess a work's overall merits relative to its individual elements. We might call this the "hard problem" of evaluation studies, as it is understandably one that many writers on the subject try to circumvent. In her influential book *The Substance of Style*, for instance, Virginia Postrel suggests that in our radically pluralist "age of look and feel," our liberated subjective responses to the wildly varied sensuous surfaces of contemporary design are sort of like our responses to food.[13] This isn't simply because personal tastes that underlie subjective assessment can differ radically (I like Brussels sprouts, you don't) but also because increased exposure to aesthetic competition makes us "more sensitive to quality," so that "the more steak you've eaten, the more likely you are to discriminate among good, better, and best."[14] But Postrel has no way of telling us what makes a good steak good and a better steak better and seems to have chosen an analogy that will keep such distinctions conveniently ineffable so that (for instance) she can make the intuitively sound claim that professional designers "experience more, more varied, and more sophisticated styles than the average person," without having to spell out the precise terms of such sophistication in any detail.[15] Surely John Ford is the Peter Luger porterhouse to Richard Donner's Ponderosa chuck, but spelling out exactly how and why is not so easy, and comparing lesser buddy movies from each—say, Ford's *Two Rode Together* (1961) and Donner's *Lethal Weapon 4* (1998)—can leave one feeling a bit queasy, with Pauline Kael seemingly having the last laugh.

Still, connoisseurship as a refinement of sensibilities is not something we want to give up on too quickly. We just need to be careful not to equate elevated taste with better people—just with more informed and discriminating spectators, which is what we present ourselves to be every time we prefer Ford over Donner, this HBO drama over that one, early Fellini over late. Even if it's not enough to say that we simply know a better steak when it hits our tongue, it does seem important that we probably will have tasted steak before and that we know what we are looking for in a good steak—something juicy and tender and not dry and rubbery, a piece of beef with strong flavor but not too much fat and gristle, and so forth. To be simply blown away and left speechless by an amazing steak is obviously wonderful, but if it's not a rare occurrence, it risks making one seem cheap and easy. And for real steak lovers it is a rare occurrence. Certainly the sensation of being wholly overwhelmed by a meal—or a work of art—is one of the great joys of life, but it also tends to stymie articulate, detailed critical response; when elements of

the meal or work seem to mesh so seamlessly in support of a single voice, they start to feel less like parts and more like an indivisible whole. Sometimes it's fun to allow one's articulated evaluation to begin and end with a blanket positive assessment (as in the cyber-"Like" or the *6-Second* pan), but spectators who find any fault whatsoever with a work will probably reject seamlessness as an option and instead settle on specific defects or inadequacies that do not seem to mesh with or reinforce other more successful elements, in the process weighing and balancing individual artistic elements against each other and against the whole.

This process was already nicely summarized by Alexander Gerard in his 1759 essay on taste:

> A perfect and faultless performance is not to be expected in any art. Our gratification must in every case be balanced against disgust; beauties against blemishes: before we have compared and measured them, we can form no judgment of the work. For want of the quickness and compass of thought requisite for this, or of inclination to employ it, we often err in our decisions. . . .
>
> But a person of true taste forms his judgment only from the surplus of merit, after an accurate comparison of the perfections and the faults.[16]

Now, what Gerard could not know, and in any case would never admit, is that his persons of "true taste" are all of us, all the time. "Proper" critics like to think of themselves as elevated experts and so routinely associate the impression of seamlessness with the ignorant boobs who lack the ability to weigh parts against wholes. But they're wrong. As Simon Frith points out, "the essence of popular cultural practice is making judgments and assessing differences," which means that consumers of pop culture are no different from middle and highbrow spectators in this regard.[17] And makers of art take for granted that in striving to make their works better, stronger, they shift and shuffle aesthetic elements like so many pieces of a jigsaw puzzle; strong artworks tend to be successful and robust marriages. Instruction in art making usually follows a similar path, with editing teachers urging students to try different shot arrangements, directors asking actors to try different attacks, screenwriters dropping pages of material in order to move up plot points, all in the interest of favoring beauties over blemishes, gratification over disgust, perfections over faults. And in a particularly composite form such as narrative cinema such arrangement can be pretty nakedly on display—the acting can seem terrific at some moments but shoddy at others, the special effects spectacular but the script weak, and so on. The forces of personal history, identity, and culture that impinge on our ongoing evaluative response certainly make our take on a film or sitcom or restaurant meal extremely loaded and complex, but such response is also always rooted in our reactions to identifiable aesthetic elements and combinations.

Aesthetic evaluation is closely tied to our ongoing apprehension of parts and wholes and to our concomitant culturally, psychologically, and ideologically laden assessment of that very apprehension. To break it down simplistically, I would venture to guess that we tend to see (and seek) wholes as much as parts, and we assume that artists do the same, even as we also assume that artists must use parts to construct aesthetic wholes. And when we assess, which we do inevitably, we tend to do so both globally and locally. Sometimes evaluation begins and ends at the global, macrolevel; in these cases judgment is often summary and sharp, either positive or negative ("I just don't get that—this does nothing for me"; "I don't know what to say—this just carried me away"), because the constructive information needed for a more nuanced understanding is either unavailable or undesired. But to the extent that parts make themselves apparent, either by design or because the spectator is sufficiently informed, skilled, and/or willing to sense them, evaluation proceeds by normative assessment of those parts, of relationships between those parts, and of relationships between parts and wholes. In the end this amounts very much to an experience comparable to that assumed by the artist or artists in making the work in the first place, and in our ongoing aesthetic assessment of a work, we in a sense project ourselves "back into" the art assembly process, not actually making aesthetic choices but nevertheless feeling the efficacy of those choices in our judgment of micro, macro, and the interplay between the two. As spectators we judge the pleasure provided by an element or combination of elements, the skill, technique, ambition, originality, and richness on display, and (perhaps most significant) the appropriateness and purposefulness of elements in relation to the whole and to larger cultural and generic norms. And we do this constantly, in an ongoing give-and-take. So a film can seem dramatically lightweight and sloppy overall while one performance really stands out, or it can seem admirably ambitious and enthralling on a large scale but also loaded with material that seems excessive or unevenly presented. It can surprise us with how well it exceeds its modest ambitions or depress us with its pandering cynicism as it seeks to impress us using the least possible effort.

Some of the evaluative norms we implicitly or explicitly appeal to when assessing (for instance, the metanorm of assumed purpose, of a work's "purposive structure," as Noël Carroll puts it) may be pan-cultural, but most will be more specifically culturally driven, if not culturally determined.[18] Individual cultural norms may stress that (for instance) visual representations must be spiritually uplifting, or that stories must be comprehensible, or that musical works must adhere to certain harmonic or metrical patterns; however, it is then up to artist and spectator alike to decide how each is to create or regard the individual work in relation to these norms and thus how to judge this work's ultimate success or failure. So if assessment is normative, it's also wonderfully flexible and inventive,

so as to allow for the creative application of evaluative criteria, the relative, provisional weighing of evaluative qualifiers that are themselves not fixed in status but constantly shifting. Much of the sheer enjoyment of evaluation involves assessing these qualifiers simultaneously against each other and against the assumed purposes of the work in question in order to articulate our aesthetic response while adhering to and reinventing the rules as we go along. In practice evaluation often amounts to a sort of parlor game in which specific qualities and qualifiers trump one another in individual instances. At times the weight of one qualifier can even tip the scales, serving as an evaluative pivot that skews assessment of various other qualities. ("John Ford is a genius. *Two Rode Together* is a John Ford film. Therefore, *Two Rode Together* is a work of genius.") Of course, this is not to say that such assessments are necessarily justified or wrongheaded, though as would-be experts, you or I may very well declare them to be justified or wrongheaded, which is as it should be.

POPULAR ELITISM, MAINSTREAM QUIRK— CONNOISSEURSHIP AS EVERYDAY LIFE

In general the more expert the assessor, the more fine-grained and compartmentalized the assessment. And one thing this Age of Evaluation has proven beyond a shadow of a doubt is that we're all experts in something or other. I can't hope to tell you why some arias are more beautiful than others, but I have no doubt that several opera lovers I know could do so convincingly, passionately, and in excruciating detail. And we all know someone who can explain why *Goldfinger* (Guy Hamilton, 1964) is a better Bond film than *Goldeneye* (Martin Campbell, 1995), why the *Star Wars* films are better than the *Star Trek* films, and so on. And as geeks and superfans try more than ever to set their own connoisseurship apart from those of the posers and pretenders in their midst, areas of expertise become narrower, quirkier, more specialized. Yet the truly astonishing thing about Web 2.0 is that it accommodates, even promotes, such individuation on a massive, unprecedented scale, without necessitating homogenization (and a return to "mass" anything) and while still offering a strong enough sense of community to allow millions of disparate, like-minded connoisseurs the sense that they are all in this together. The delicate balance and complex interplay between individual and shared is a hallmark of this new age, just as it is a hallmark of evaluative spectatorship. As writer/producer/actor Felicia Day (of web series *The Guild* and YouTube's *Geek & Sundry*) puts it, "The Internet changed a lot, and the geeks owned the Internet. And now everyone owns the Internet. Everyone is able to express themselves the way they want to. What's amazing and exciting about it is that it's no longer [about ostracizing]: You can celebrate loving what you love."[19] Luckily, there's more than enough pop culture to go around. How *free* everyone

is to express themselves is another matter, though. Theoretically, of course, this freedom is total, and the rhetoric of the vanguard tradition is peppered with claims for radically liberated sensibilities, as with Jonas Mekas's "almost unlimited taste" for Stan Brakhage, Stan Vanderbeek, Howard Hawks, westerns, porn, home movies, and psychiatric films.[20] In practice, however, loving what you love is fairly normative as well, simply because it is also social, countercultural, and fundamentally conceived as bottom-up communal resistance to an overwhelming top-down force of homogenization. Here it is usually driven by cultist connoisseurship (specialized knowledge and [re]discovery of cultural objects) and/or aestheticized camp appreciation and appropriation of cultural objects we take for granted as nonart (Warhol's Campbell's Soup, Mekas's porn)—with both driven by the engine of evaluation (celebration, rankings, cool versus uncool) and set against a virtual sea of similarly active spectators.

So, ultimately this postvanguard Age of Evaluation is about much more than just assessing the aesthetic worthiness of pop culture products. Cultist and camp strategies of old and evaluative precepts alike have been harnessed to serve a much larger economy, where personal individuation/differentiation resides in productive give-and-take with social forces of community and commodification. Reed-Pop Global V. P. Lance Festerman calls this a "culture of niches," where "quirk is now mainstream," which means that if you don't have the time and energy to create your own geeky, personal expression of subcultural "Like" (say, a Batman or Spider-Woman costume for those who want to *cosplay* at Festerman's New York Comic Con), you can probably buy it from someone else.[21] This give-and-take is nothing new, strictly speaking—after all, it was Andrew Sarris's pantheon of directors in his book *The American Cinema: Directors and Directions, 1929–1968* that certified his celebrity status among a legion of film buffs of the 1970s, precisely because it provided them a means of productively engaging their own personal cultist discrimination with his, using his tastes to help refine their own.[22] But the playing field seems so much larger now, and our fellow players—so many of them!—are right up there in our faces, all the time. *Lethal Weapon 4* only scores 52 percent (and a splat) from sixty-six critics on Rotten Tomatoes' Tomatometer, though 252,886 users are slightly more generous, with 67 percent apparently "liking" it. *Two Rode Together's* three critic reviews (all positive) do not provide a strong enough pool to offer a score, but of the 736 user ratings, a mere 55 percent offered Likes. Does this mean that if we go strictly by the percentages, *Lethal Weapon 4* is the superior film, at least from an audience perspective? Of course not, but it sure is fun to consider the possibility, and that fun, in the end, is what it's all about, whether it flows from evaluation itself—from our assessment of parts and wholes against relevant aesthetic norms or (alternately) against our vague, intuitive sense of global success/failure/interest or personal relevance—or from our expression of that assessment within a larger evaluative community. In this

way connoisseurship and, indeed, aesthetic assessment are always as personal and social as they are textual, and the exploratory pleasure of attributing evaluative claims and attributes to works and parts of works tells us as much about ourselves and our cultural situation as about the objects in question. Evaluation reaffirms or challenges our relationship to our own self-identity, which is itself bound up with our relationship to culture and society; when we evaluate, we situate ourselves within the social arena of those who share and do not share our tastes, but we also try to assess and feel (genuinely feel) our complex emotional and psychological reactions. The more closely we evaluate, the more we are invited to confront our own initial taste responses, and this confrontation itself becomes a vehicle for our own ongoing self-definition, the process by which we continually pitch ourselves against the world but also against our own feelings. In the process, of course, we also learn a little more about the work in question.

Yet because such close, detailed evaluation that enriches our understanding and experience of work and self is only one option now—thanks to the ease and instant reward of the broad-stroke evaluative gesture (the cyber-"Like" and its equivalents)—we would do well to ask the obvious. Is this Age of Evaluation one in which vanguard principles have rendered tenable aesthetic standards outdated or even moot? In other words, is interest in the work *qua* work and in the precepts of traditional evaluative criticism on the wane? I think the answer to this question is "No—but . . ." "No" in the sense that as criticism becomes broadly redefined as "articulated evaluative spectatorship," aesthetic evaluation of the sort I have been describing (assessment of parts and wholes vis-à-vis evaluative norms) becomes one of a number of expressive options for the attuned spectator to pursue, and we see detailed evaluation pursued now more than ever before, mostly not in traditional print publications but in countless blogs and website user reviews. But because articulated evaluative spectatorship takes many forms, detailed criticism does now become one expressive option among many, and this point is crucial. Individuals will always express their impressions of the goodness or badness of a film, and some will express and/or argue these thoughts in considerable detail. Yet many will not, and while those who do not may be derided as insufficiently committed or expert by those who do, this in itself does not delegitimize gestural, blanket assessment or quick-and-easy, finger-snap connoisseurship. How could it, when it's part and parcel of how we as people respond to culture? As Virginia Postrel notes, "Today's aesthetic impera- tive represents not the return of a single standard of beauty, but the increased claims of pleasure and self-expression. . . . Delighting the senses is enough: 'I like that' rather than 'This is good design.'"[23] So while Alexander Gerard may have been strictly correct when he assumed connoisseurship to be an elitist enter- prise, he could not in his wildest dreams have imagined how incredibly naive such an assumption could have seemed some 250 years later, with elitism so

widely disseminated into everyday cultural practice, activated by all who might enjoy and profit by it. And today, it seems, that includes almost everybody who has an opinion and is not afraid to own it.

The personal and quixotic nature of evaluative engagement can never be understated: it is perhaps not so far-fetched to say that we create art so that we can evaluate it, even as we also evaluate art so that we can remain in touch with ourselves, and with our complex relation to the world around us. Still, my hope is that further study of the full scope of aesthetic evaluation within this key cultural moment will significantly help us to understand this moment, while contextualizing discussions about the plight of "serious" criticism. For if, as I have suggested, the current era is one of critical evaluation as a radically exploded concept—an era in which spectators feel empowered not simply to create their own culture out of the materials at hand but to actively engage in continual evaluative assessment, reassessment, celebration, ranking, dismissal, and critical exploration of every cultural object in their midst—the question of goodness, badness, and aesthetic worth of movies, television programs, video games, restaurant meals, comic books, pop songs, and all the rest does not matter less. It matters more than we ever thought. Scholars of culture and media might thus do well to consider more closely the various forms and functions of this larger economy and indeed embrace their place in it—for indeed, the academic's own expert, super-compartmentalized analytical assessment of works is nothing to be ashamed of, however effaced or disavowed it may have been in the past. The question, finally, is not *whether* scholars judge cultural objects like everyone else—of course we do—but rather *how*, and to what end(s)?

My own hope is that the study of evaluation might also prove useful in beginning to bridge the stubborn divide separating humanities-based academic criticism and the training and working methods of artists, especially as artists aren't weird strangers anymore but rather people all around us, countless millions who choose creative expression and cultural production over passive cultural consumption. As critical gestures and artistic expressions continue to drift together and conflate within popular culture, it seems high time to consider our conscious evaluative assessments more carefully, and more openly, as comparable to the choices artists make routinely in composing their works out of composed and chosen elements. And despite the academy's long-standing theoretical emphasis on the fragmentation of the text—itself a remnant of the expert critic's trope of assuming that only naive viewers or readers apprehend seamlessness—in interpretive practice we stubbornly hold to the same basic conceptions of coherence, unity, and purpose as do artists, perceiving parts in relation to other parts but also to wholes, and rooting our coherent readings in the rather generous premise that everything in the work is there for good reason. Depending on the medium, style, and work in question, a great deal of our effort as perceivers may be devoted

to experiencing and assessing part/part and part/whole relations, and certainly in more collaborative forms such as feature filmmaking, television production, music recording, and theater, the purposed "putting into play" of specific elements (often contributed by discrete agents) seems something closer to orchestrated assemblage, with the weight of each assembled element or module not lost even as we attend to a work in its entirety. In watching films, academic and casual spectators alike mimic reviewers in asking themselves questions like "Is the writing in the 'Genie with the Light Brown Hair' sequence near the beginning of Cassavetes's *Faces* (1968) up to the level of the performances?" or "Does the 143-minute length of Antonioni's *L'Avventura* (1960) blunt its potential emotional impact?" or indeed "Does Jeffrey Hunter's performance in *The Searchers* (1956) detract from the overall impact of that film?" We need to recognize that these are not just routine but also important questions, not least because as scholars we tend to avoid them in our habitual distancing from journalistic and artistic practice and our habitual deference to sacred cows. Yet we do so at the cost of denying the importance of our own thumbs in the crowd and our own relevance to the postvanguard world.

NOTES

1. Greg Taylor, *Artists in the Audience: Cults, Camp, and American Film Criticism* (Princeton, NJ: Princeton University Press, 1999).
2. For a more detailed examination of Farber, Tyler, and the history of vanguard film criticism see ibid. The role of the opposition gesture is examined more fully in my "Pure Quidditas or Geek Chic? Cultism as Discernment," in *Sleaze Artists: Cinema at the Margins of Taste, Style, and Politics*, ed. Jeffrey Sconce (Durham, NC: Duke University Press, 2007), 259–272.
3. For discussions of the demise of criticism in other art forms see James Elkins, *What Happened to Art Criticism?* (Chicago: Prickly Paradigm, 2003) and the plethora of journalistic and academic squibs on the fate of criticism referenced in the introduction to the present collection.
4. Thomas Doherty, "The Death of Film Criticism," *Chronicle of Higher Education*, 28 February 2010, http://chronicle.com/article/The-Death-of-Film-Criticism/64352/.
5. "Film Criticism in the Age of the Internet: A Critical Symposium," *Cineaste* 33.4 (2008): 33.
6. Ibid., 45.
7. Ibid.
8. For a recent strong case for the centrality of evaluation as a necessary component of criticism see Noël Carroll, *On Criticism* (New York: Routledge, 2009).
9. Leo Koerner and Lisbet Rausing, "Value," in *Critical Terms for Art History*, 2nd ed., ed. Robert S. Nelson and Richard Shiff (Chicago: University of Chicago Press, 2003), 420.
10. Barbara Herrnstein Smith, *Contingencies of Value: Alternative Perspectives for Critical Theory* (Cambridge, MA: Harvard University Press, 1988), 30.
11. Thus, as Alan H. Goldman rightly notes, "if there were principles linking objective properties to goodness in art, and if these principles were epistemically accessible," not simply would "artists . . . no longer need to be artists"—as they could "create good art without having any aesthetic sensibility, simply by following the rules"—but "opposing evaluations by highly

educated and equally competent critics would [also] be inexplicable." Alan H. Goldman, "There Are No Aesthetic Principles," in *Contemporary Debates in Aesthetics and the Philosophy of Art*, ed. Matthew Kiernan (Malden, MA: Blackwell, 2006), 304.

12. Malcolm Budd, *Values of Art: Pictures, Poetry and Music* (London: Penguin, 1996), 42–43.

13. Virginia Postrel, *The Substance of Style: How the Rise of Aesthetic Value Is Remaking Commerce, Culture, and Consciousness* (New York: Harper Perennial, 2004), 99.

14. Ibid., 7.

15. Ibid., 9.

16. Alexander Gerard, *An Essay on Taste (1759), Together with Observations Concerning the Imitative Nature of Poetry* (Delmar, NY: Scholars' Facsimiles and Reprints, 1963), 138–139.

17. Simon Frith, *Performing Rites: On the Value of Popular Music* (Cambridge, MA: Harvard University Press, 1996), 16.

18. Noël Carroll, "Art, Intention, and Conversation," in *Intention and Interpretation*, ed. Gary Iseminger (Philadelphia: Temple University Press, 1999), 101.

19. Felicia Day, "Geek Out!" *Time Out New York*, 10–16 October 2013, 9.

20. Jonas Mekas, *Movie Journal: The Rise of a New American Cinema, 1959–1971* (New York: Collier, 1972), 62.

21. Day, "Geek Out!" 8.

22. Andrew Sarris, *The American Cinema: Directors and Directions, 1929–1968* (New York: E. P. Dutton, 1968).

23. Postrel, *The Substance of Style*, 10.

2 ★ CRITICS THROUGH AUTHORS

Dialogues, Similarities, and the Sense of a Crisis

CECILIA SAYAD

The seventieth issue of *Cahiers du cinéma* (April 1957) made history for publishing André Bazin's warning, in "On the *politique des auteurs*," that auteurism risked promoting an "aesthetic personality cult."[1] A lesser known, but equally interesting, fact about this particular volume is that it also displayed one of the magazine's most daringly auteurist statements. It appears under the "Brief Notes" section and reads: "The *Cahiers du cinéma* thanks Alfred Hitchcock, who has just shot *The Wrong Man* exclusively to please us and prove to the world the truth of our exegesis."[2] The note's provocatively (or perhaps naively) narcissistic tone is material proof of early auteurism's idiosyncrasies, but, most important, it reframes Bazin's concerns as it begs the question of whose personality was actually being turned into the object of cult—that of the auteur or that of the critic?

A similar desire for confirmation of critical stances, this time within academic circles, can be identified in Adam Simon's 2000 documentary on horror films (*The American Nightmare*), in which interviews with scholars and filmmakers are edited together to match critical discourse with authorial intention. Testimonies by Carol Clover, who in the 1980s redeemed the slasher's sexual politics by celebrating the heroic qualities of the "final girl,"[3] echo in *Halloween* director John Carpenter's humorous statement: "I didn't mean to put an end to the sexual revolution, and for that I deeply apologize." Likewise, George Romero and Wes Craven admit drawing from news images of the civil rights riots and the Vietnam War to create horrific scenes in *Night of the Living Dead* (1968) and *The Last*

41

House on the Left (1972), respectively, thereby endorsing scholarly readings of the films as political allegories.[4]

This reliance on directors' statements raises questions about the role that an intending author has played in film criticism and how this figure is in fact related to the critic. Now that viewers' comments and Internet forums seem to have shaken the professional foundations of criticism, it is worth asking if the reliance on authorial discourse is a sign of a crisis of confidence on the part of the critic or if it is, on the contrary, a symptom of his or her sense of authority—as well as autonomy.

The notion of "crisis" is key in the debates about criticism in the Internet era, with new and amateur forms of critical writing made possible by the appearance of alternative venues for movie reviews threatening to divest critics of authority and raising questions about the importance and the feasibility of criticism as a profession.[5] Yet the challenges to the critic's authority and legitimacy are not new; we can actually trace them back to the first attempts to define film as an art form. The transformations brought about by the digital age did not create, but recontextualized, a "crisis" that has always shaped the writing of film criticism.

This chapter revisits historical debates in the criticism of cinematic works to focus on one particular aspect of this crisis: the relationship between the figures of film critic and film author. This overview informs my hypothesis that today's concerns about a presumed democratization of movie reviewing raise the same issues about the critic's authority, reach, and function that arose from the very notion, articulated many decades ago, that there is such a thing as a film author.

The forty-three-year gap separating the *Cahiers* note from Simon's documentary shows that the search for dialogue, and sometimes agreement, with the authorial stance is a recurring feature in criticism. In an editorial for the May 2013 issue of *Sight and Sound* Nick James claimed that "films were better when filmmakers felt themselves obliged to be a part of a conversation about cinema that took account of critical thinking."[6] But this very longing for either unison in critical and authorial discourses or constructive debate also reminds us of the fact that these figures compete with each other. Indeed, the tensions between author and critic are as old as the terminology that defined them as separate entities, however blurred their respective functions have proven to be. Iconic examples such as Oscar Wilde's "The Critic as Artist" and Jean-Luc Godard's declaration that his early incursions into film criticism had been a form of filmmaking have reverberated in opposite critical movements.[7] At one end we have the self-expressing writing dismissive of authorial intention and film artistry that characterizes vanguard criticism—with particular emphasis on cult and camp. At the other we identify the penchant for combining criticism with practice among the *Cahiers* staff—which continued long after New Wave icons François Truffaut, Godard, Eric Rohmer, Jacques Rivette, and Claude Chabrol traded the typewriter for the

camera and includes André Téchiné, Pascal Bonitzer, and Olivier Assayas. Old practices associated with vanguard and auteur criticism inform this chapter's study of the tensions between creativity and analysis. Far from asserting or challenging the authority of either the author or the critic, I investigate the centrality of the former to the latter's understanding of his or her function, which our digital age has put under serious scrutiny. Indeed, digital's impact on the relationship between these figures goes beyond the potential that Twitter and Facebook accounts or personal web pages has to intensify the communication between them. Digital technology's most interesting contribution to the relationship between critics and auteurs lies in its ability to highlight the shared traits of their respective functions. As I argue at the end of this chapter, digital has the potential to turn the critic into a "filmmaker" and vice versa. The critic's growing deployment of the video essay—in academia, the press, and the blogosphere[8]—is matched by the auteur's promotion of aesthetic tastes through social networks and personal websites.

THE QUESTION OF STATUS

The artistic validation of cinematic works is central to the history of film criticism. Raymond J. Haberski's *It's Only a Movie! Films and Critics in American Culture*, Antoine de Baecque's *Cahiers du cinéma: Histoire d'une revue* and *La cinéphilie*, Greg Taylor's *Artists in the Audience*, and Peter Stanfield's *Maximum Movies—Pulp Fictions*, for example, address, in their own ways, the discrimination between high and low art that haunts discerning views about the status and value of film.[9] It is therefore not surprising that from the moment directors were singled out as distinctive voices in the collectively produced objects that we call film, they have occupied center stage in discussions about the role of critics. It is not just that the recognition of film artistry could potentially elevate the work of the critic. But the presence or absence of a self-expressing subject is also central to the ontology of film and, consequently, to the very function of critics.

Hollywood is as central to the beginnings of film criticism as it is to the current discourses on the crisis that assails this profession. The very studio system that in the eyes of many could potentially forgo the critic to rely principally on publicity and marketing was in the past the source of inspiration for different critical trends: one that saw critics as the interpreters of art and another that saw them as mediators of mass culture.[10] The histories of cult and camp criticism by Greg Taylor and of pulp culture by Peter Stanfield show a dismissal, on the part of so-called vanguard critics writing from the 1940s through the 1960s, of those attributes that for auteurists would characterize film as art—namely, uniqueness, timelessness, and universality. Cultism stresses the critic's capacity to select objects that either are produced by Hollywood but have little merit or

that simply lie outside of the industry; camp privileges "poorly controlled texts," which prove "more rewarding than the tightly managed artwork" for a critic (and an audience) wishing to appropriate these texts for their own use.[11] The idea of pulp, similarly, rejects traditional values, trading uniqueness and permanence for seriality and ephemerality.

Critics like Lawrence Alloway, Otis Ferguson, Robert Warshow, and Manny Farber and artists like Richard Hamilton and Eduardo Paolozzi celebrated the film-viewing experience's "kinetic immediacy," as well as the notion that a movie would be "worn out and forgotten before the audience had even left the cinema."[12] They rejected the requirements for temporal endurance, originality, and thematic and stylistic complexity that defined a certain conception of art deemed "bourgeois." Stanfield and Taylor describe precisely an open war against a so-called middlebrow culture, in a radical break with the establishment whose roots were in the avant-garde. It is not by chance that this vanguard criticism had strong ties with the art world: Alloway came from the Independent Group of artists and intellectuals in Britain during the 1950s and was first an art critic; Farber was a sculptor and a painter.

Attuned to the rejection of mainstream values characteristic of the artistic movements of the first half of the twentieth century (from Dadaism to surrealism and, later, pop art), these critics battled notions of "good taste" associated with a mainstream, middlebrow culture that catered to the bourgeoisie. Taylor claims that to vanguard critics the art produced in postwar America "seemed to have compromised the purity of its constituent influences and aesthetics in a bid for cultural acceptance and financial success." Articulated years later as "midcult," a term coined by Dwight Macdonald, the middlebrow constituted "formula-bound mass culture gussied up in an all-out effort to pass as highbrow, tackling Serious, Universal Themes and indulging in Sophisticated Stylistic Effects."[13] Among vanguard critics the rejection of the middlebrow resulted in a refusal to elevate film's cultural status, in a preference for the unpretentiousness of genre movies over what was deemed the pseudo-intellectual merits of art films—cultivating, that is, the marginal status of popular cinema and proposing a radical cultural politics for film criticism. So whereas the *politique des auteurs* articulated in the 1950s shook the system by daring to liken popular entertainment and high culture, leveling low and high arts, the vanguard criticism that preceded and then overlapped with it celebrated the distance between the two and chose the low over the high.

It is worth remembering, however, that the *politique des auteurs* did not simply embrace the idea of artistry in filmmaking—it did not even invent it.[14] The innovation brought about by the Young Turks of *Cahiers du cinéma* lay in the objects to which they ascribed artistry: Hollywood productions deemed commercial and of minor cultural relevance. In fact, the *Cahiers'* earlier articulations of cinematic

authorship reveal an approach similar to the one advocated by the vanguard crit-
ics: like them the *politique des auteurs* admired the visual impact and the energetic,
physical filmmaking characteristic of popular genres. What sets these critical
stances apart is precisely their understanding of what film is—art for the first
group (Godard compared Hitchcock to Louis Aragon)[15] and popular culture for
the second.

Yet it is important to keep in mind that for auteurists the notions of origi-
nality and timelessness dismissed by vanguard criticism were not attributes of
films but of directors. In fact, such notions were in many ways at odds with the
popular aspects of the movies they endorsed. Whereas for auteurists repetition
(or recycling) indicated the presence of a thinking artist, in Stanfield's account of
pulp it stood for film's radical rupture with mainstream culture. Their divergent
takes notwithstanding, both auteurists and vanguardists placed the critic at the
center of the construction of meaning (on which more later). And however dif-
ferent their understandings of the role of directors, each of these critical move-
ments shaped their function in relation to this figure.

One of the earliest articulations of the auteur "policy" appears in Truffaut's
1955 "*Ali Baba* et la 'politique des auteurs,'" a redemption of Jacques Becker's
commercial enterprise *Ali Baba et les quarante voleurs* (*Ali Baba and the Forty
Thieves*, 1954), which constituted a deviation from the director's "artistic" pro-
ductions. In his appraisal of Becker, Truffaut evoked writer Jean Giraudoux to
advocate that "there are no works; there are only authors,"[16] praising the director's
technical competence in spite of the failures of his commercial "sellout." Any fail-
ures in *Ali Baba*, Truffaut suggested, resulted from the collective nature of film-
making, which ultimately involved the interference of an excessive number of
professionals, overshadowing Becker's individual contribution. Truffaut finally
elevated Becker to the status of auteur on the merits not of *Ali Baba* itself but of
previous works, bringing to film criticism the practice of using the whole of an
artist's oeuvre as an evaluative tool—and with it the requirement for expertise.

In Truffaut's eyes *Ali Baba*, like *The Wrong Man* a few years later, confirmed
the beliefs of the *politique des auteurs*.[17] The *Cahiers'* "policy" and its articulation
by Andrew Sarris as an "auteur theory" in 1962 assigned the critic the function
to scrutinize a director's works in order to discern between auteurs and non-
auteurs.[18] Only the close reading of all films by a single director allows for his
or her ascension to the auteur pantheon, and this task lies with the critic.[19] In
the late 1960s, auteur structuralists would propose that an auteur resulting from
the identification of elements of style and themes is a critical construct—in
Dudley Andrew's articulation of that movement this auteur is a voice to be iso-
lated "within the noise of the text." Rather than individual human beings, these
auteurs were better understood as sets of stylistic patterns and themes, indeed as
structures that we name "'von Sternberg,' 'Fuller,' 'Cukor,' and so on."[20]

But however active early auteurists might have been in the elevation of the directors they admired, they still sought the real person behind the film—the very same person whose intentions would potentially stand in the way of vanguard critics' expression of their own ideas about the movies. The series of interviews published in the *Cahiers* (which I discuss in the next section) actually complicates the common attribution of formalism to the *politique*—by Bazin, in his attempt to redeem the tastes of his *Cahiers* protégés from the condemnation of a supposedly right-wing politics, as well as by the *politique*'s critics in the early 1960s (for example, Penelope Houston and Richard Roud).[21] Although on the one hand the young 1950s *Cahiers* generation might have conveniently ignored the politics of the American films they endorsed, on the other hand their desire to hear from the people who made these films did not conform to the formalist notion that the text is autonomous and that meaning bypasses authorial intention. If anything, these interviews show that the director was still very much an element in the *politique*'s critical discourse.

LONGING FOR THE AUTHOR

The tension between authors and critics mentioned at the beginning of this chapter does not necessarily result from the predispositions of certain individuals or critical movements; this tension is actually a given if we consider that any act of interpretation or analysis constitutes a form of rewriting or re-presenting an existing work, even when the ultimate goal is to evaluate it (which is, after all, the task of criticism, as Greg Taylor pertinently observes in this volume and as Noël Carroll does elsewhere).[22] The evaluation process and criteria are at the core of criticism, and to many they are necessarily subjective. Penelope Houston stated that "there is no such thing as entirely objective, unbiased criticism; there is only critical writing (and not a great deal of it at that) which aspires to this condition."[23] Pauline Kael warned Sarris that "criticism is an art, not a science."[24] This is not to say that criticism has not endured a short-lived attempt to "objectivize" its methods—the very pages of *Cahiers* that were once covered with exaltations to individual geniuses would also propose, first, a Brechtian criticism (promoted by Bernard Dort in 1960)[25] that would privilege the film's politics over the auteur's subjectivity and, later, a "scientific" scrutiny of the contexts of production and the language of film inflected by Marxism (promoted by Jean-Louis Comolli and Jean Narboni in the 1969 editorial that marked a shift in the magazine's critical line, moving away from auteurism and toward politics).[26]

But the *politique des auteurs* was openly passionate and subjective in its tastes, inciting a readership defined in terms of either wanting to join or stay clear from a "team": among others the Hitchcocko-Hawksiens (Georges Sadoul's rather pejorative nickname for the Young Turks), the Mac-Mahon group, the "Hustoniens"

dismissed by Truffaut et cie. In Truffaut's "Aimer Fritz Lang" (To love Fritz Lang), published in January 1954, the critic openly promotes an unconditional devotion that is not very different from star fandom. "We must love Fritz Lang," Truffaut writes, "salute the opening of each of his films, rush to see them, watch them time and again, and impatiently wait for the next one."[27] This "amour fou"—James Nare- more's description of the motivations behind the politique des auteurs[28]—is evi- dent also in Jean Douchet's self-reflexive article for a 1961 issue of Cahiers devoted exclusively to criticism, similarly titled "L'art d'aimer" (The art of loving). The crit- ic's activity, Douchet suggests, involves a "tireless search" for a balance between passion and lucidity.[29] In his contribution to the same issue Fereydoun Hoveyda states, "The critic talks as much about the film he saw as about himself."[30] Yet this explicitly subjective stance did not preclude argumentation, however biased. Godard's review of A Time to Love and a Time to Die (1958) might be unasham- edly personal ("I am going to write a madly enthusiastic review of Douglas Sirk's latest film, simply because it sets my cheeks afire"),[31] but Rivette's celebratory "The Genius of Howard Hawks" is at once personal and grounded in close readings, as he announces in his opening lines: "The evidence on the screen is the proof of Howard Hawks's genius: you only have to watch Monkey Business to know that it is a brilliant film. Some people refuse to admit this, however; they refuse to be satis- fied by proof. There can't be any other reason why they don't recognize it."[32]

Irrespective of the degree to which criticism may be grounded in illustrative examples, analysis, or theoretical frameworks, it is for the most part the vehicle for the communication of opinions and therefore inevitably self-expressing. Taylor's assessment of the writings of Manny Farber and Parker Tyler since the 1940s, for example, highlights precisely the personal tone of their reviews, whose openly subjective perspective preceded the auteurists' biases (as discussed in the next section). So criticism may be subjective and openly personal, but it still has to come to terms with the creator of the object of appreciation. Behind every description or assessment of a work lurks the intention of the work's maker (be it an individual, a group, or an industry). Movements like New Criticism or structuralism were, when not openly dismissive, at least skeptical about autho- rial intention. In the realm of film, camp appreciation was simply oblivious to it, as Taylor's aforementioned argument about the camp critic's love for "poorly controlled texts" illustrates.[33] But even when intention is discredited, the author's figure remains a lingering presence—be it as public persona, marketing strategy, or performer.[34] Regardless of the critic's (and reader's) attitude toward it, the author's voice inevitably haunts the work as something to be either considered or ignored.

The politique des auteurs chose to consider it. The Cahiers writers might have been so certain of their own critical abilities as to both create a pantheon of auteurs and control membership to it, but they cared deeply about the directors'

views. Antoine de Baecque sees in the interviews by the *Cahiers* critics of the 1950s a new, serious approach to filmmakers, one that would query the auteurs on their methods and worldview rather than ask for anecdotes about the shoot or the stars. On the contrary, this *"politique de l'entretien,"* as de Baecque calls it, constituted a dialogical form of criticism, one in which critics were open to intellectual interchanges with makers, longing for accessing both the auteurs and their methods intimately.[35]

This approach to directors was not new. De Baecque tells us that in 1948 William Wyler had reportedly admitted to feeling exhausted after a long interview with Bazin, Jean-Charles Tacchella, and Roger Thérond: the critics put Wyler's methods under scrutiny, asking questions with a degree of detail and precision that was light-years from the director's experience at Hollywood press conferences. This "opportunity" to talk seriously (and critically) about one's work was, however, the privilege of those filmmakers displaying the magazine's stamp of approval, and for this reason the interviews displayed a respectful attitude toward the director, reinforcing the reverential tone that was typical of the *politique des auteurs*. In their interchanges with Abel Gance for *Cahiers* 74 Truffaut and Jacques Rivette advertised that the magazine only interviewed the filmmakers they endorsed, their policy being to never embarrass their guests or make them uncomfortable.[36]

Truffaut's famous conversations with Hitchcock offer a clear insight into the role of auteurs in establishing the critic's function. In the early 1960s, and after becoming a New Wave icon, Truffaut undertook a series of interviews with the British director that would result in a book "elevating" Hitchcock's status to that of serious "artist."[37] Published first in 1966 as *Le cinéma selon Alfred Hitchcock*,[38] these dialogues revealed what many saw as a talent for entertaining on the director's part to be a well-thought-out theory about suspense and, most important, about the specificities of creating suspense through film techniques. The book appeared in English as *Hitchcock/Truffaut: The Definitive Study of Alfred Hitchcock by François Truffaut*, and was republished in 1983, three years after Hitchcock's death and a year before Truffaut's own premature demise. In his introduction to this revised edition Truffaut describes *Vertigo* (1958) as "a work of maturity and lyrical commentary on the relation between love and death." In regard to the British director's oeuvre, Truffaut claims that "while the cinema of Hitchcock is not necessarily exalting, it invariably enriches us, if only through the terrifying lucidity with which he denounces man's desecrations of beauty and purity." He later concludes, evoking the *politique des auteurs*: "If, in the era of Ingmar Bergman, one accepts the premise that cinema is an art form, on a par with literature, I suggest that Hitchcock belongs—and why classify him at all?—among such artists of anxiety as Kafka, Dostoevsky, and Poe."[39] The presumed formalism of the Young Turks in the 1950s might have openly dismissed the films' politics, but

it was not a complete dismissal of meaning, as Houston, discussing the *Cahiers*, would suggest in her reprimand that "cinema is about the human situation, not about 'spatial relationships,'"[40] or in Roud's assertion that where *Cahiers* privileged form, *Sight and Sound* would choose content.[41]

The conversations between Truffaut and Hitchcock established a situation in which a young critic-director tested concepts against a sacred monster of the pantheon he had helped create in the first place. Rather than circumscribe the critic's function to the construction of Hitchcock as self-expressing filmmaker through either passionate eulogies or the detailed analysis of films, Truffaut sought the director's intentions, offering himself as both a catalyst and a vehicle for Hitchcock to verbally articulate what Truffaut had always believed to be conscious choices—as well as to illuminate elements about which Hitchcock was not necessarily aware, as when he discusses the connection between the director's films and his dreams.[42]

Truffaut's interest in Hitchcock's subconscious reflects an understanding that critics should scrutinize not only texts but also their creators' subjectivity—the French notion of mise-en-scène, for example, relies on the idea that the film's style is the mirror of the auteur's inner self, echoed in Pierre Marcabru's statement, in 1961, that "all mise-en-scène takes us back to the man."[43] A year later, Sarris's articulation of the *politique* into an "auteur theory" would promote "interior meaning" as a valid category to identify a true author,[44] only to be mocked by Kael, who contended that interior meaning was a "mystique—and mistake."[45] In 2013, *Cahiers* editor-in-chief Stéphane Delorme, responding to Tony Rayns's obituary for Nagisa Oshima in *Sight and Sound*, proposed that what characterizes an auteur is not just style but "gesture," which he defines as a way of looking and, furthermore, as something that "is not simple," that "has to be named," to then conclude that the task of the critic is "to name the gestures in their singularity."[46] Turned into the object of criticism, the auteur thus positions the critic as psychoanalyst, as Hoveyda had suggested back in the early 1960s when he argued that the critic's function is to bring to light the auteur's unconscious as manifested in the film text.[47]

Despite the nine years separating Truffaut's series of interviews from the *Cahiers* note on *The Wrong Man*, these two examples show that these dialogues between critics and authors were also meant to assert the former's views. Truffaut's interviews would prove to the skeptics that the Master of Suspense was more than a skillful entertainer. We could also argue that rather than showing that the Hitchcock promoted by the *Cahiers* was more than a critical construct, these interviews dramatized the very act of construction, an act in which the critic is not the sole agent but actually shares control with the director. This is especially true where Hitchcock is concerned, for he was the prototype of a filmmaker actively crafting his own public image in rather theatrical ways: from

turning his own silhouette into a logo mark with the opening of the *Alfred Hitch-cock Presents* series (1955–1965) to his signature film cameos. But the very choice to designate a book of interviews as a "definitive study" calls attention to Truffaut's dialogical approach to criticism—even if, by editing the conversations and complementing them with his own writings on Hitchcock, Truffaut ended up having the final word.

DISMISSING THE AUTHOR

To be sure, auteurists did not always rely on interviews to assert their opinions, but they were not too prudish to speak, for example, about Hitchcock the man. Their structuralist descendants, on the contrary, would prefer to discuss "Hitch-cock" the construct. The inverted commas would have equally served some of the vanguard critics—albeit for different reasons. A quick glance at *Negative Space*'s table of contents could lead a reader unaware of Manny Farber's collected reviews to take him for an auteurist—the volume features articles on Howard Hawks, John Huston, Preston Sturges, Frank Capra, Don Siegel, Samuel Fuller, Michael Snow, Jean-Luc Godard, Luis Buñuel, Raoul Walsh, Nicolas Roeg, Werner Herzog, Rainer Werner Fassbinder. The same impression could befall the reader who comes across passages such as, "Huston's art is stage presentation, based on oral expression and static composition"; "The Huston trademark consists of two unorthodox practices—the statically designed image (objects and figures locked into various pyramid designs) and the mobile handling of close three-figured shots"; or "But the deep quality in any Hawks film is the uncannily poetic way an action is unfolded."[48] This stress on filmmakers is, however, by no means auteurist, as attests the opening of "The Subverters" (1966):

> One day somebody is going to make a film that is the equivalent of a Pollock painting, a movie that can be truly pigeonholed for effect, certified a one-person operation. Until this miracle occurs, the massive attempt in 1960's criticism to bring some order and shape into film history—creating a Louvre of great films and detailing the one genius responsible for each film—is doomed to failure because of the subversive nature of the medium: the flash-bomb vitality that one scene, actor, or technician injects across the grain of a film.[49]

The references to the world of fine arts (Pollock, the Louvre) are very much in tune with Farber's artistic sensibility (his attention to space and composition, for example, as well as his own background in painting and sculpture). But where auteurists would not hesitate to isolate Hitchcock's inputs and compare him to Aragon (Godard) or Kafka, Dostoevsky, and Poe (Truffaut), Farber, on the contrary, drew attention to the collective nature of filmmaking, and perhaps

the accidental nature of what we see on the screen. In the conclusion to "The Subverters" Farber says,

> One of the joys in moviegoing is worrying over the fact that what is referred to as Hawks might be Jules Furthman, that behind the Godard film is the looming shape of Raoul Coutard, and that, when people talk about Bogart's "peculiarly American" brand of scarred, sophisticated cynicism they are really talking about what Ida Lupino, Ward Bond, or even Stepin Fetchit provided in unmistakable scene-stealing moments.[50]

In his articulation of cult and camp criticism, Taylor indicates that if uniqueness was at stake, it was largely (though for cultists not exclusively) the territory of critics. Cultism claimed the power to construct a film taste independent from the norms dictated by mainstream culture, a marginal canon. Like auteurism, "Cult criticism places a high value on connoisseurship; it glorifies the critic-spectator's heightened ability to select appropriately, and tastefully."[51]

In turn, the camp critic (or, in Taylor's words, "the critical *camp* spectator") was less selective and "revel[ed] in the interpretation/transformation process while often placing little stake in the initial selection of mass objects." Camp seized film criticism for the expression of the critics' own worldviews—"'everything will serve his purpose,' because here the pleasure of criticism lies in forcibly remaking common culture into personal art."[52] If in the 1950s and 1960s auteurists sought consistency in the works of directors, in the 1940s Tyler's camp criticism celebrated precisely those failures resulting from a lack of authorial control—not what leads us to sense an authorial presence but what signals authorial absence. So whereas Sarris discussed the combination of "technical competence," "distinguishable personality," and "interior meaning,"[53] camp criticism had sought movies that were "aesthetically *out* of control, an entertaining maelstrom of meanings and sensations that could be shaped only from without and after the fact, by the properly attuned critical spectator."[54]

Less important than the critic's self-expression, the authority of the film director loses ground to the authority of the film critic in these protoauteurist vanguard practices. The 1940s thus sees two opposing tendencies: while in France Alexandre Astruc was asserting the directors' capacity to express themselves through the merging of camera and pen, in the United States critics like Farber and Tyler were oblivious to authorial intention, ascribing to themselves the power to legitimize works and extract meaning from them, privileging the critic's pen over the director's camera. If the love for genre movies on the part of the *politique des auteurs* bore a cult attitude, the auteurists diverged from their American counterparts in that they sought the auteur in the mise-en-scène. Early instances of camp (and sometimes cult), on the contrary, searched a group

of films in which the absence of an auteur (or of a style) would allow critics *and* spectators to creatively construe the film's meaning. The interviews promoted by the *Cahiers* writers displayed a desire for an author, for an interlocutor at the origin of the film's meaning who could dialogue with both critics and spectators. Farber and Tyler, conversely, were utterly unconcerned about authorial intention in their early writings.

Yet, in spite of vanguard critics and the structuralist charges that followed in the mid-to-late 1960s, the institutionalization of art cinema placed the auteur at the center of criticism. Tyler would change his dismissive attitude toward the author when the ascension of the art film in the 1950s confronted him "with a filmmaker who seemed more authentic artist than anonymous cog in the Hollywood dream machine," forcing the critic to "leave the movie camp to the vulgar and fashion-conscious in order to pursue a far more serious, even Arnoldian discernment of Great Works."[55] The extracts from Farber's writings reproduced earlier show that, in fact, directors have remained a looming presence even in the work of auteur skeptics. At any rate, cultism has strong connections with auteurism—the *politique des auteurs* also advocated a cult taste for supposedly minor genres such as the western, film noir, the gangster film, and the war film. Sarris, the American auteurist par excellence, was equally known as a cultist: his "auteur theory" was in many ways the underpinning of his preference for commercial and marginal cinemas.

THE PERSISTENCE OF AUTEURISM

Though the academic critique of auteurism was partly informed by considerations about the realities of collective modes of production on the one hand and the structuralist and poststructuralist questioning of a subject's ability to express him- or herself on the other, in the realm of criticism it boiled down to questions of taste. In Houston's challenges to the politically "uncommitted" approach that characterized the *Cahiers*, she blames it partly on the magazine's preferences: "A lot of this comes from the *Cahiers du cinéma*, along with the list of admired directors. And it is this list itself, as much as the way in which films are discussed—don't look to these reviews for analysis, but rather for a series of slightly breathless statements—that underlines fundamental divergences of viewpoint."[56] These divergences lay in the opposition between a humanistic and a cultist sensibility—the opposition that explains why, in Houston's words, "Violence on the screen is accepted as a stimulant and anything which can be labeled as slow or sentimental is suspect."[57] As early as 1960 Roud had warned that "it was only a question of time before their [the *Cahiers'*] system of rationalizing personal quirks and fancies should produce such a crypto-fascist and slightly nutty approach to the cinema."[58] In her legendary attack on Sarris's transposition of the *politique* to American soil

Kael challenged the auteur theory as harshly for its "intellectual diddling" as for its habilitation of "mindless, repetitious commercial products—the kind of action movies that the restless, rootless men who wander on 42nd Street and in the Tenderloin of all our big cities have always preferred just because they could respond to them without thought."[59] Stanfield reminds us that John Simon condemned the "fallacies of auteurism that gave greater value to the 'atrocious' work of Edgar G. Ulmer and the 'abysmal' direction of Samuel Fuller than it does to films that attempt to deal genuinely and openly with profound matters."[60] In the end the auteur was clearly at the origin of this divisive question of taste, in a culture that differentiated between Hitchcocko-Hawksiens and Hustoniens. It was not just directors, however, that led such polarizations. Personal preferences have also called for the affiliation with critics, opposing, for example, "Paulettes" to "Sarrisites."[61] The critic's name can be as subject to the practices of cult as that of the auteur—something that extends Bazin's aforementioned warning against the *politique des auteurs'* "personality cult" to the realm of criticism.

More than half a century has passed since Bazin's admonition, and the auteur is still central to academics and critics—both in publications devoted exclusively to film and in the daily press. Take, for example, Peter Bradshaw's review of Guillermo del Toro's *Pacific Rim* (2013) in the *Guardian* on 12 July 2013, which, like the historical examples examined in this chapter, refers to an auteur working for the studio machine. It would not be too far-fetched to attribute Bradshaw's expectations to auteurism when he notes that "only when Ron Perlman (star of the *Hellboy* films) shows up in a cameo do you remember that this is, at least notionally, a Guillermo del Toro movie." Bradshaw lacks, however, the forgiveness that Truffaut had shown when he defended Jacques Becker's commercial enterprise in "*Ali Baba* et la 'politique des auteurs,'" but that may be because Bradshaw is not so taken by del Toro as Truffaut was by the director of *Casque d'or* (1952) and *Touchez pas au Grisbi* (1954). "I have been mixed about Del Toro in the past," says Bradshaw, "enjoying the ferocity and bite of the *Hellboy* pictures and his *Blade 2*. I found the much-swooned over *Pan's Labyrinth* overrated, but it had a real inventiveness not obvious here." Most important is the expectation that the Mexican auteur's work mirrors his inner life, evident in the *Guardian* critic's speculation that "maybe director and co-writer Del Toro took this job in a detached, impersonal spirit and it can't fully be considered one of his films in that authorial sense."[62] The implication is that genuine expression produces better results. In online forums such as "a_film_by," neoauteurists have founded virtual, international communities to mitigate their (perceived) exclusion from mainstream film culture and academic discourse.[63] The new vulgar auteurism initially associated with the *Notebook* magazine featured on the MUBI website conveys a sense of marginalization within auteurism itself as it celebrates the work of action genre filmmakers neglected by mainstream criticism (Paul W. S. Anderson, Michael Bay, John M. Chu).[64] This

desire to "treat 'unserious' cinema seriously" evokes both the early *politique des auteurs* and cult criticism.[65] Auteurism not only persists but has also found a new life in digital media.

It is true that the survival of the auteur has come at a cost, as this figure has been constantly refashioned: being first imagined as a genius against the system, then as structure, marketing strategy, or a performer of sorts. While the auteur's mutability has protected it against extinction in the realm of theory, in practice its endurance among critics and viewers is proof of the need to trace films back to a palpable source—a real human being, regardless of the distance between his or her psyche and the depicted world. No matter how conscious we are of the intricacies of film production, we "long" for the auteur, as Dana Polan argues in "Auteur Desire" (2001)—something to be blamed on "the obsession of the cinephile or the film scholar to understand films as having an originary instance in the person who signs them."[66]

This desire for the auteur is ironically treated as guilty pleasure in Dudley Andrew's "The Unauthorized Auteur Today" (first published in 1993). "Breathe easy," he says, "*Epuration* has ended. After years of clandestine whispering we are permitted to mention, even to discuss, the auteur again."[67] Even if we agree that the director's contribution is neither exclusive nor uncorrupted, that intentions might be inaccessible and that originality is a romantic fallacy, the auteur remains very much a central part of criticism. In Nick James's aforementioned 2013 editorial, written on the occasion of his attendance at a film festival in Bari, he praised the direct communication between filmmakers and critics at the event, thanks to the "absence of intervening publicists." James nostalgically remembers a time of "respect for film as a culture that involves conversation between makers and critics" similar to the dialogues that configured a "*politique de l'entretien*" at *Cahiers*.[68]

What is interesting in James's editorial is that he sees the critic and the auteur as codependent—as if the survival of a thinking film culture depended on the dialogue between these two figures: "auteurism has also waned because the sort of casual contact between filmmakers and critics that I've been eulogising here is slowly being erased from film life," and "conversations between the two professions sustained the culture of cinephilia once it was established."[69] The crisis in criticism springs from a fear that the critic may be disposable, unnecessary when it comes to giving us access both to the film and to the author—whose presence via personal websites, Twitter accounts, or blogs could potentially forgo professional critics and mainstream media. Social networks and personal websites may indeed promise a direct line of communication—including that between critics and authors. Anyone with a Twitter account can reply to a tweet by Oliver Stone, Michael Moore, or Ron Howard—whether the reply will get a reaction and produce a conversation is a different matter, as social media etiquette is rather lenient toward unanswered messages. The informality and direct access

promised by instant messaging and websites' message boards is weighed down by the fact that, except for video chats, one can never be 100 percent sure of the identity of the person at the other end. In the case of celebrity critics and authors it would be naive not to suspect that assistants update websites and respond to posts on their behalf.

What James seems to long for, however, is a different kind of authorial intervention, one that reveals the author as a thinking entity rather than a media "character." Drawing from Alain Badiou's notion that "films represent the thinking process to such an extent that they can be said to 'think' themselves," James wonders: "should critics be a part of the conversation that creates the 'thinking' film?"[70] To this I would add a second question: how does digital technology change the critic's and the author's ability to engage in a conversation about film?

More significant than digital's impact on the direct communication between film critics and authors, as I stated earlier, is how it highlights these figures' shared characteristics. Critics now have the option to use film images as vehicles for criticism. The video essay is indeed an emerging form of criticism and scholarship, turning the critic and the academic into a filmmaker of sorts—not trading criticism for practice, like many *Cahiers* writers have done but deploying film extracts to either illustrate and support interpretation and analysis or, indeed, as the very material for communicating critical thinking. Godard's dictum that writing criticism is a form of filmmaking thus becomes literal. The Society for Cinema and Media Studies' *Cinema Journal* and the MediaCommons have recently inaugurated a peer-reviewed periodical devoted to videographic film and moving image studies titled *[in]Transition*. In the words of editor Catherine Grant, "The full range of digital technologies now enables film and media scholars to write using the very materials that constitute their objects of study: moving images and sound."[71] The MUBI website abounds in video essays, and major newspapers like the *Guardian*, the *New York Times*, and *Libération* feature video reviews on their home pages, extending to writers the ability to deploy images that was once the exclusive domain of critics working for television.

The reverse is also true: social media turn filmmakers into "critics." In his contribution to this volume Greg Taylor proposes that the very act of sharing an image, a video, or a piece of music in social networks constitutes an act of evaluation. When Oliver Stone or Michael Moore tweets or retweets news items, images, or video excerpts produced by other directors, they are performing what Taylor calls a critical gesture—the personal websites by both directors actually feature sessions devoted to things they simply like or find worth sharing.[72] If some believe that the digital has turned everyone into a critic, directors might as well be as much a part of this phenomenon as the general public.

The promises of digital technology's "democratization" of criticism can thus be discussed also in terms of the director's (as well as the audience's) ability

to share views on various matters. However, this has not yet been seen as that which makes the auteur a central element of this prevailing sense of a crisis. Critics will forever disagree on specific auteurs (Woody Allen and Clint Eastwood, for example, seem to enjoy more prestige in France than in the United States or Britain), but directors no longer polarize criticism with the same intensity that they did in the 1950s and 1960s. This century's controversial questions in criticism have moved away from individual auteurs to tackle the "deaths" of film and of the critic. So what is the relevance of the auteur in all this?

The historical examples contemplated in this chapter show that the auteur was pivotal in the critical journey to culturally validate film as either art or mass entertainment, as well as to assert tastes. In trying to account for the role of auteurs in the construction of meaning, critics were also defining their own place in film culture as either interlocutors or appropriators of authorial voices. The aforementioned 1961 issue of *Cahiers* on criticism presented thirty-eight professionals with a questionnaire that sounds very familiar to contemporary ears, asking, among other things, "Do you consider that the criticism of cinema should be carried by people more or less specialized than their counterparts in the areas of literature, arts, music, gastronomy, etc.?"[73] So the challenges to the critic's expertise and professionalization predate the Internet by decades, after all. The crisis, as the above examples have shown, is permanent, and its requirement for adaptation is what keeps things alive—for auteurs and critics alike.

NOTES

1. André Bazin, "On the *politique des auteurs*," *Cahiers du cinéma* 70 (1957): 2–11, repr. in *Cahiers du cinéma, the 1950s: Neo-Realism, Hollywood, New Wave*, ed. Jim Hillier, trans. Peter Graham (Cambridge, MA: Harvard University Press, 1985), 257.

2. Jean Béranger, Charles Bitsch, Jacques Doniol-Valcroze, André Martin, and Luc Moullet, "Petit journal," *Cahiers du cinéma* 70 (1957): 40. Antoine de Baecque has also reproduced and discussed this note in Antoine de Baecque, *Cahiers du cinéma: Histoire d'une revue* (Paris: Éditions Cahiers du cinéma, 1991), 1:87. Unless stated otherwise, all translations from the French are mine.

3. See Carol J. Clover, "Her Body, Himself: Gender in the Slasher Film," *Representations* 20 (1987): 187–228.

4. See, e.g., Robin Wood, "Introduction to the American Horror Film," in *Movies and Methods*, ed. Bill Nichols (Los Angeles: University of California Press, 1985), 2:195–219; Sumiko Higashi, "*Night of the Living Dead*: A Horror Film About the Horrors of the Vietnam Era," in *From Hanoi to Hollywood: The Vietnam War in American Film*, ed. Linda Dittmar and Gene Michaud (New Brunswick, NJ: Rutgers University Press, 1990), 175–188; and Adam Lowenstein, *Shocking Representation: Historical Trauma, National Cinema, and the Modern Horror Film* (New York: Columbia University Press, 2005), 111–143.

5. See the many nervous statements about film criticism as a profession referenced in this book's introduction.

6. Nick James, "A Culture of Talk," *Sight and Sound*, May 2013, 9.

7. Oscar Wilde, "The Critic as Artist," in *The Portable Oscar Wilde*, ed. Richard Aldington and Stanley Weintraub (New York: Viking Penguin), 51–137. See the *Cahiers du cinéma* interview with Jean-Luc Godard published in *Jean-Luc Godard par Jean-Luc Godard*, vol. 1, ed. Alain Bergala (Paris: Cahiers du cinéma: Éditions de l'Etoile, 1998), 215.

8. See the discussion of online video criticism by Giacomo Manzoli and Paolo Noto in this book's chapter 5.

9. See Raymond Haberski Jr., *It's Only a Movie! Films and Critics in American Culture* (Lexington: University Press of Kentucky, 2001); Antoine de Baecque, *Cahiers du cinéma*, vols. 1 and 2; Antoine de Baecque, *La cinéphilie: Invention d'un regard, histoire d'une culture, 1944–1968* (Paris: Fayard, 2003); Greg Taylor, *Artists in the Audience: Cults, Camp, and American Film Criticism* (Princeton, NJ: Princeton University Press, 1999); Peter Stanfield, *Maximum Movies—Pulp Fictions: Film Culture and the Worlds of Samuel Fuller, Mickey Spillane, and Jim Thompson* (New Brunswick, NJ: Rutgers University Press, 2011).

10. For a discussion about the current importance of criticism to the commercial success of movies see the *Variety* poll "Are Film Critics Really Needed Anymore . . . or Is It a Washed-Up Profession?" *Variety*, 25 April 2007, http://variety.com/2007/scene/people-news/are-film-critics-really-needed-anymore-or-is-it-a-washed-up-profession-1117963778/; and Yago García, "Singuen influyendo las críticas de cine?" *Cinemanía*, 8 June 2013, http://cinemania.es/noticias-de-cine/siguen-influyendo-las-criticas-de-cine. I would like to thank Nuria Triana Toribio for directing me to this article.

11. Taylor, *Artists in the Audience*, 52.

12. Stanfield, *Maximum Movies—Pulp Fictions*, 4.

13. Taylor, *Artists in the Audience.*, 20, 27.

14. The notion of the director as artist had been expressed in the French impressionists' emphasis on film's expression of subjectivity, in early avant-garde filmmaking, and in Alexandre Astruc's 1948 analogy between the director's camera and the writer's pen, synthesized in the *caméra-stylo*—the idea that a director is as able to express a unique worldview as a writer. See Alexandre Astruc, "The Birth of a New Avant-Garde: La caméra-stylo," in *The New Wave: Critical Landmarks*, ed. Peter Graham (London: Martin Secker and Warburg, 1968), 17–23.

15. See Colin MacCabe, *Godard: A Portrait of the Artist at Seventy* (New York: Farrar, Straus and Giroux, 2003), 74.

16. François Truffaut, "*Ali Baba* et la 'politique des auteurs,'" *Cahiers du cinéma* 44 (1955): 47.

17. Ibid.

18. See Andrew Sarris, "Notes on the Auteur Theory in 1962," *Film Culture* 27 (1962–1963): 1–8.

19. This requirement does not always apply, however. It is not uncommon to see art house directors being treated as auteurs from the very beginning of their careers, even if the solidification of their names might indeed depend on their ability to sustain the stylistic and thematic consistency usually associated with the notion of the auteur.

20. Dudley Andrew, "The Unauthorized Auteur Today," in *Film and Theory: An Anthology*, ed. Robert Stam and Toby Miller (Malden, MA: Blackwell, 2000), 21.

21. See the letter that Bazin wrote to Georges Sadoul in de Baecque, *La cinéphilie*, 183–184. See Penelope Houston, "The Critical Question," *Sight and Sound*, Autumn 1960, 160–165; and Richard Roud, "The French Line," *Sight and Sound*, Autumn 1960, 166–171. For an insightful discussion of Houston and Roud's opposition to auteurism see Mattias Frey, "The Critical Question: *Sight and Sound*'s Postwar Consolidation of Liberal Taste," *Screen* 54.2 (2013): 194–217.

22. See Noël Carroll, *On Criticism* (New York: Routledge, 2009).

23. Houston, "The Critical Question," 160.

24. Pauline Kael, "Circles and Squares," *Film Quarterly* 16.3 (1963): 14.

58 CECILIA SAYAD

25. Bernard Dort, "Towards a Brechtian Criticism of Cinema," *Cahiers du cinéma* 114 (1960): 33–43, repr. in *Cahiers du cinéma, the 1960s: New Wave, New Cinema, Reevaluating Hollywood,* ed. Jim Hillier, trans. Jill Forbes (Cambridge, MA: Harvard University Press, 1986), 236–247.

26. Jean-Louis Comolli and Jean Narboni, "Cinema/Ideology/Criticism," trans. Hugh Gray, in *Film Theory and Criticism: Introductory Readings,* 5th ed., ed. Leo Braudy and Marshall Cohen (New York: Oxford University Press, 1999), 752–759.

27. François Truffaut, "Aimer Fritz Lang," *Cahiers du cinéma* 31 (1954): 54.

28. See James Naremore, "Authorship and the Cultural Politics of Film Criticism," *Film Quarterly* 44.1 (1990): 17.

29. Jean Douchet, "L'art d'aimer," *Cahiers du cinéma* 126 (1961): 33.

30. Fereydoun Hoveyda, "Autocritique," *Cahiers du cinéma* 126 (1961): 45.

31. Jean-Luc Godard's review of *A Time to Love and a Time to Die* in *Cahiers du cinéma* 94 (1959), quoted in Naremore, "Authorship," 15.

32. Jacques Rivette, "The Genius of Howard Hawks," *Cahiers du cinéma* 23 (1953), repr. in *Cahiers du cinéma, the 1950s: Neo-Realism, Hollywood, New Wave,* ed. Jim Hillier, trans. Peter Graham (Cambridge, MA: Harvard University Press, 1985), 126.

33. Taylor, *Artists in the Audience,* 52.

34. See reconfigurations of the ideas of authorship in Timothy Corrigan, *A Cinema Without Walls: Movies and Culture After Vietnam* (New Brunswick, NJ: Rutgers University Press, 1991); Andrew, "The Unauthorized Auteur Today," 20–29; Rosanna Maule, *Beyond Auteurism: New Directions in Authorial Film Practices in France, Italy and Spain Since the 1980s* (London: Intellect, 2008); and Cecilia Sayad, *Performing Authorship: Self-Inscription and Corporeality in the Cinema* (London: I. B. Tauris, 2013).

35. de Baecque, *Cahiers* 1:128.

36. Ibid., 128, 129.

37. See de Baecque's discussion of this in *La cinéphilie,* 119–133.

38. François Truffaut, *Le cinéma selon Alfred Hitchcock* (Paris: Editions Robert Laffont, 1966).

39. François Truffaut and Helen G. Scott, *Hitchcock/Truffaut: The Definitive Study of Alfred Hitchcock by François Truffaut* (New York: Simon and Schuster, 1984), 20.

40. Houston, "The Critical Question," 163.

41. Roud, "The French Line," 168.

42. See Truffaut, *Truffaut/Hitchcock,* 260.

43. Pierre Marcabru, "Il reste un homme," *Cahiers du cinéma* 126 (1961): 29.

44. Sarris, "Notes on the Auteur Theory in 1962," 7.

45. Kael, "Circles and Squares," 20.

46. See Stéphane Delorme's response in "Taking Issue: In Search of the Auteur," *Sight and Sound,* June 2013.

47. Hoveyda, "Autocritique," 45.

48. Manny Farber, *Negative Space: Manny Farber on the Movies,* exp. ed. (New York: Da Capo, 1998), 33, 29.

49. Ibid., 184.

50. Ibid., 186–187.

51. Taylor, *Artists in the Audience,* 15.

52. Ibid.

53. See Sarris, "Notes on the Auteur Theory in 1962," 6–8.

54. Taylor, *Artists in the Audience,* 51 (emphasis in the original).

55. Ibid., 69.

56. Houston, "The Critical Question," 163.

57. Ibid.

58. Roud, "The French Line," 171.

59. Kael, "Circles and Squares," 20.

60. Stanfield, *Maximum Movies*, 34.

61. Thomas Doherty, "The Death of Film Criticism," *Chronicle of Higher Education*, 28 February 2010, www.chronicle.com/article/The-Death-of-Film-Criticism/64352.

62. Peter Bradshaw, "*Pacific Rim*—Review," *Guardian*, 11 July 2013, www.theguardian.com/film/2013/jul/11/pacific-rim-review.

63. "The primary focus of this group is on film as art, from an auteurist perspective." See "Group Description," a_film_by, https://groups.yahoo.com/neo/groups/a_film_by/info.

64. In the creators' words MUBI is "curated online cinema bringing you cult, classic, independent, and award-winning movies" in more than two hundred countries, and includes an online film magazine named *Notebook* that publishes criticism in the form of texts, images, sounds, and videos. See "About," MUBI, https://mubi.com/about; and "About Notebook," MUBI, https://mubi.com/notebook/about.

65. Calum Marsh, "Fast & Furious & Elegant: Justin Lin and the Vulgar Auteurs," *Village Voice*, www.villagevoice.com/2013–05–22/film/fast-and-furious-vulgar-auteurs/.

66. Dana Polan, "Auteur Desire," *Screening the Past*, 1 March 2001, www.latrobe.edu.au/screeningthepast/firstrelease/fr0301/dpfr12a.htm.

67. Andrew, "The Unauthorized Auteur Today," 20.

68. James, "A Culture of Talk," 9.

69. Ibid.

70. Ibid.

71. Catherine Grant, "[in]Transition: Editors' Introduction," *[in]Transition*, 4 March 2014, http://mediacommons.futureofthebook.org/intransition/2014/03/04/intransition-editors-introduction.

72. See chapter 1, page 25, in this volume. For examples of these filmmakers' "critical gestures" see www.oliverstone.com/things-i-like; and www.michaelmoore.com/try-this-on.

73. See "Enquête," *Cahiers du cinéma* 126 (1961): 48.

3 ★ "THE LAST HONEST FILM CRITIC IN AMERICA"

Armond White and the Children of James Baldwin

DANIEL McNEIL

I want to be an honest man and a good writer.

—James Baldwin (1955)

A good film critic needs to know the subject, care about the subject, write well about the subject, and be honest.

—Armond White (2004)

As the presiding chair of the New York Film Critics Circle (NYFCC), Armond White hosted its annual gala and seventy-fifth anniversary celebrations on 11 January 2010. During the ceremonies he delivered a characteristically provocative speech that warned the gathering of actors, journalists, and publicists about a specter haunting film culture: Rotten Tomatoes and other Internet sites that cater to "adolescent taste" and the Hollywood hype machine. More pointedly, he implored his peers to honor the personal conviction and cinematic literacy of their predecessors (critics like Pauline Kael, one of his mentors, and Frank S. Nugent, the first chair of the NYFCC) in order to "uphold the dignity and significance of film criticism" and provide a vital alternative to online commentators who caricatured independent professionals as crazy, contrarian cranks.[1]

White continued his war of position against Rotten Tomatoes in his columns for the *New York Press*, taking aim at Internet "hordes" who ridiculed the need for "mature thought," and online "avengers" who demanded that critics respond

FIGURE 3.1. Armond White: "I want to get people to think. Thinking is rare but crucial." (Photo credit: Chris Whitney, 2000)

to "movies like thrill-hungry teenagers, colluding with commercialism."[2] As a result it is not entirely surprising that Rotten Tomatoes stopped providing links to White's reviews after the print edition of New York Press was discontinued on 1 September 2011. Nevertheless, the justifications for White's removal from the site were somewhat risible. For while representatives of the site initially claimed that they just needed more time to review and add City Arts—the publication White had joined as editor and lead film critic in 2011—the site's editor-in-chief later claimed that White was absent from its list of "Top Critics" because White's "[print] outlets do not have a significant reach outside of New York City."[3] He did not mention White's ability to use social and digital media to connect with readers across the globe. He did not acknowledge the widespread belief that White was a "troll" who praised "bad" films that failed to receive positive reviews from more than 40 percent of the approved critics on Rotten Tomatoes—such as Transformers 2 (Michael Bay, 2009) and Transporter 3 (Olivier Megaton, 2008)—and pilloried "good" films that were certified fresh with more than 80 percent of the critics on the Tomatometer, such as The Dark Knight (Christopher Nolan, 2008) and Toy Story 3 (Lee Unkrich, 2010).[4] Nor did he cite the possible influence of a petition set up to ban White from Rotten Tomatoes because his "overly political" reviews were thought to be "screwing up the Tomatometer."[5]

Bloggers have been more forthcoming about their satisfaction with the decision of Rotten Tomatoes to limit one of the outlets for White's "sneering," "snarky," and "abrasive" reviews.[6] Even tenured professors have joined the howls

of White's online detractors when they try to bridge the worlds of academia and journalism, as David Bordwell suggests that people may only read Armond White in order "to have their tastes tested," and Adrian Martin considers White's work to be an exercise in "unargued bluster."[7] Although Martin enjoyed White's trenchant criticism for *Film Comment* and other publications in the late 1980s and early 1990s, he claims that White's vituperative reviews and essays for *New York Press* reveal the "problems of any self-styled maverick who once hurled his provocative bombs from the margin of culture, but now finds himself at its centre." That is to say, Martin believes that White's reviews in the digital age are based on superficial analysis and "inflammatory rhetorical procedures" that stem, in part, from "his intriguing political profile [as a] progressive (black, gay, a supporter of edgy pop culture) and a 'post 9/11' conservative, taking his adversaries to task for their lack of religious education, or their 'kneejerk liberalism.'"[8] Indeed, Martin has not only declared that White is a bad joke and a bad writer who thinks that pleasure and thinking are in opposition; he has also derived pleasure from online articles and comments that refuse to take White seriously as a film critic.[9]

More recently, White's peers in the NYFCC have also acted against a man they considered a "gay African-American fundamentalist-Christian aesthete" consumed by rage.[10] On 13 January 2014 White became the first person to be expelled from the NYFCC after allegations that he had heckled Steve McQueen and called the filmmaker an "embarrassing doorman and garbageman" at the NYFCC annual gala held one week earlier. If the controversy surrounding White had largely been limited to New York social circles and entertainment blogs in 2010, his alleged heckling in 2014 was subject to a cacophony of tweets, online forum posts, and opinion pieces that cast him as a shameful performance artist who erroneously believed that he was the last honest film critic in America.[11] Joshua Rothkopf, presiding chair of the NYFCC, felt compelled to call an emergency meeting, and a majority of those in attendance agreed with the motion that White's public display of contempt for McQueen demonstrated a serious breach of professional integrity.

This chapter considers how White's digital-age notoriety results from the long-standing concerns of his print journalism: he has consistently challenged "robotic consumers" and "obliviots" trained to accept Hollywood junk, the middle-class values and assumptions of his fellow critics, and "elitist-nihilists" in academia and the art world in the hopes of promoting honest, imaginative, uplifting, and humanistic art.[12] Put another way, an examination of White's ethics and aesthetics over a forty-year career (from his beginnings in the *South End* in Detroit in 1972 to New York–based publications such as the *City Sun*, *New York Press*, *First of the Month*, and *City Arts* and his more recent sorties for the *National Review* and *Out* magazine) allows us to identify White's critique of Rotten Tomatoes as a battle against mediocrity rather than one against digital

communication. The irony of White's dismissal from the NYFCC stems from his perennial emphasis on professionalism, honesty, and craftsmanship—and a trenchant refusal to accept the second-rate opinionators whose "work" digital technologies now broadcast and spotlight. For while White is deeply indebted to the likes of Kael and Nugent, he also believes that editors in the predigital age tended to settle for mediocre critics rather than risk hiring outstanding candidates who might challenge the narrow range of opinion in middlebrow newspapers.[13] In a career that has produced thousands of reviews and essays evaluating film, theater, music, music videos, live concerts, comedians, photographers, and artists, White is most productively read as a child of James Baldwin, another gay African American aesthete who shocked white liberals, conservatives, and radicals with his intellectual ra(n)ge: both bodies of work are fundamentally concerned with promoting ethical professionalism, identifying complicity with powerful interests, and ferreting out hypocrites—because of, but also despite, new media, technologies, and trends.

Born in Harlem in 1924, James Baldwin distinguished himself as a popular Pentecostal preacher before he left the pulpit in his late teens and converted to a "different theatrical (and, some would say, religious) arena" as a novelist, playwright, and cultural critic.[14] As an essayist he was well known for his ability to bear witness to uncomfortable truths with dreadful objectivity, homiletic spirit, and romantic flair, and one finds his cultural criticism repeatedly dissecting liberal guilt and other topics of interest to African American audiences; providing sensitive portrayals of transcendent and empathetic artists who work within a predominantly white, liberal, and bourgeois public sphere; and inspiring young Americans to become honest people and good writers. Building on these three interlinked strands of Baldwin's cultural criticism, this chapter provides some provisional markers for Armond White's career as a film critic inspired by James Baldwin's radical commentary about "the movies, race, and American society in general."[15] The first section documents White's critique of liberal ideology and black opportunists in countercultural public spheres, focusing on his reviews of film and culture for the Detroit-based student newspaper the South End and the City Sun, a weekly newspaper published in Brooklyn between 1984 and 1996 that had the tagline "New York's most authoritative Black weekly newspaper." The second section of the chapter records White's lingering suspicions about the prominence accorded to so-called black public intellectuals who only played at offering subversion and dissidence while writing for liberal journals and newspapers. These protracted battles preview the infighting and positioning endemic among digital-age critics. The third and final section of the chapter addresses White's response to the advent of the digital during his tenure at New York Press between 1997 and 2011, arts editor for City Arts between 2011 and 2014, and contributor to Out and National Review since 2014. In doing so, it reflects on the

rhetoric White has used to promote his own work as an experienced, Columbia-educated film critic against the "thumbs up, thumbs down" approach of "gamers," "fan boys," and amateur bloggers on social media, Internet radio, and podcasts.[16]

"SPEAKING TRUTH TO POWER":
THE BLACK PUBLIC SPHERE

James Baldwin lived and worked outside the United States for much of his life and did not follow American psychologists who viewed shame as a dangerous, painful, and ugly feeling that was less rational than guilt. In contrast, he tended to address shame as a means to allow us to face history,[17] reflecting an engagement with Francophone philosophers and poets who considered the emotion to be necessary in the fight against bourgeois figures invested in narratives of white guilt and white innocence.[18] But some of Baldwin's lacerating sound bites about the "virtuous sentimentality," "cowardly obtuseness," and "guilty eroticism" of white liberals who privileged guilt as a modern, legalistic concept that secures social bonds and solidarity also reflected African American exceptionalism. After all, Baldwin suggested that "Negroes do not, strictly speaking, exist in other countries," and he believed that Malcolm X's African American idiom made his rhetoric about untrustworthy liberals more relevant and articulate to the people he served than Frantz Fanon, the well-known French wartime hero, Martiniquan exile, and Algerian freedom fighter whose *Wretched of the Earth* had sold approximately 750,000 copies in the United States by 1970.[19]

Born in Detroit in 1953, Armond White received a formal education from Central High School, the oldest secondary school in Detroit, but he learned as much outside the classroom by studying the protest ethic of working-class, unionized communities, heeding the lessons of a civil rights movement that addressed the connection between spirituality, culture, and politics. After several years in which his parents' Pentecostal beliefs meant that White was unable to go to the cinema and could only watch broadcasts on Canadian and American television, his faith in film was awakened by a school trip to view a screening of *Camelot* (Joshua Logan, 1967) and by his encounter with a copy of Pauline Kael's *Kiss Kiss Bang Bang: Film Writings, 1965–67*. By 1972 he had joined the ranks of the *South End*, a newspaper that sought to be the voice of all oppressed peoples tired of "the drivel of the establishment bourgeois press,"[20] and developed a distinctive form of criticism that expressed pessimism of the mind (devastating critiques of craven commercialism and black sellouts) and optimism of the will (loving celebrations of creative artists who transcend race and manage to assert their particular brand of humanism on the screen). All this fed his hopes of saving children who grew up with television shows like *Happy Days* and were unable to judge what was true and glorious in movies.[21]

White's columns for the *South End* established his contempt for art that seemed immune to the climate of fear and suspicion in America after Watergate. He had little time for films like *One on One* (Lamont Johnson, 1977), which seemed to put the audience back in a "docile, pre-70s, cheery, patriotic attitude of trusting gullibility—to deny the truth we should have learned."[22] In the pages of the *South End* White cast himself as a critic crusading for truth against blockbusters that catered to infantile tastes for cheap thrills and distraction, dishonest nostalgia that failed to acknowledge the humanity of black people in the American past, and shallow blaxploitation films. For example, White depicted *Star Wars* (George Lucas, 1977) as prosaic trash for "illiterate, insensitive, and unintelligent . . . suckers, dummies, ass-holes, morons, perverts"; *The Class of '44* (Paul Bogart, 1973) as a dreary portrait of bourgeois adolescence; and *Sweet Jesus, Preacherman* (Henning Schellerup, 1973) as trite blaxploitation that defamed black people and the religious organization that had held them together.[23] In opposition to hacks and sellouts who suggested that criminals and prostitutes were the fulfillment of black dreams onscreen, White considered it his moral duty as a critic to "encourage films that honor the basic ideas of the black experience . . . belief in God, belief in family, self-trust, growth from the past and loyalty."[24] White's crusade meant that he encouraged filmmakers to take inspiration from figures in literature, music, or popular culture who acted with style, humor, control, and constant relevance to the way black people live their lives with personal conviction (such as Muhammad Ali).[25] It also meant that he championed sensitive, humane work that reflected black consciousness, which he associated with a state of mind and staunch opposition to racism and other forms of social injustice rather than skin tone.[26] Consequently, White's admiring review of *Sounder* (Martin Ritt, 1972) highlights the ability of its white Jewish director to work with black writers, actors, and composers to produce a film with "real Black consciousness" that should inspire "filmmakers . . . to give up [films featuring black characters that are] . . . trash . . . condescendingly 'worthwhile,' or inconsequentially abrasive."[27]

If White's highest praise was for movies, like *Sounder*, that he considered entertaining and serious, he was also influenced by Pauline Kael's sympathy for beautiful, harmless trash. Although the documentary *Wattstax* (Mel Stuart, 1973) may not have offered White any revelatory social or political insight, he was content with a film that was "inoffensive and immensely enjoyable."[28] Similarly, *Handle with Care* (Jonathan Demme, 1977) reminded White that "good movies can be made without 'meaning' and without insulting the audience . . . [that] popcorn moviemaking is not totally corrupt," and he was not immune to the trashy charms of *The Deep* (Peter Yates, 1977) that led to long shots of Jacqueline Bisset diving underwater in a wet T-shirt.[29] He even found solace in the beauty of the Bond girls who exposed the "bland-blond Roger Moore" in *The Spy Who Loved Me* (Lewis Gilbert, 1977).[30]

Along with his distaste for the privilege granted to blue-eyed actors, White also reflected Kael's polemical attacks on European art films that she deemed boring and pretentious. He found historical films like *The Nelson Affair* (James Cellan Jones, 1973) to be unimaginative and suited for television rather than the kinetic medium of the movies.[31] He could also accuse American filmmakers of indulging in "artsy-fartsy bullshit" and lambasted Robert Altman, one of his and Kael's favorite auteurs, for directing a "hushed, portentous, schematic, and obscure" film like *3 Women* (Robert Altman, 1977).[32] It bears repeating that such rhetoric doesn't necessarily mean that White places pleasure and thinking in opposition. It signifies, rather, White's long-standing desiderata that movies offer some "frivolity, dance, humor," that moviegoers could find "entertainment in the most profound intellectual and emotional stimulation," and that artful critics could turn to Kael and other iconoclasts when people with credentials were all too "often stale writers or writers with a dour, academic approach."[33] As Geoff Dyer remarked of John Berger, an English art critic, novelist, painter, poet, and Marxist, White's method is "radically illuminating rather than systematic . . . investigative, exploratory and provocative rather than definitive. . . . While lacking in procedural rigor . . . his concern is with opening up new freedoms, clearing new paths."[34]

After his graduate training in fine arts at Columbia University and his immersion in a New York punk scene that connected him to "questioning, daring, visionary" and "exciting" UK artists who rejected imperialism, White developed an idiosyncratic style that was all-American and internationalist in his articles on arts and culture for the *City Sun* and *Film Comment* during the 1980s.[35] He was primarily interested in resisting the "sentimental indulgence," "venal sentimentality," "treacly emotions," and "weak nostalgia" that shaped the "white liberal condescension" of so many films about black suffering in America.[36] White's review of *A Soldier's Story* (Norman Jewison, 1984) provides an early example of his critical opposition to liberals who paraded their opposition to crass forms of overt racism and savored depictions of articulate individuals who happened to have black skins. His concise response to the film noted its inability to keep up with the artistic advances heralded by a black-consciousness movement that defined blackness as a matter of mental and political orientation rather than pigmentation,[37] a consciousness that provided an important counterpoint to American critics who praised the "craftsmanship" of a Canadian director who encouraged whites to identify with the struggles of African American professionals seeking to "penetrate" middle-class environments.[38] They also anticipated Philip French, a British film critic who described the "rigid pro-establishment thinking" of a film that gave most of its sympathy "to a pathetic, Queeg-like monster, and none to the [militant black] man who struck back,"[39] and Elvis Mitchell, another child of Detroit born in the 1950s, who expressed concerns about the

"slightly condescending, old-school-liberal slant" of Jewison's films when he was employed as a film critic for the *New York Times* between 2000 and 2004.[40]

Rather than promote assimilationist dreams, White's reviews in the 1980s tended to question minorities who sacrificed the meaning of their lives before the altar of "America's dominant ideology: the heterosexual White boy," challenge the idea that blue-eyed beauty was an all-American ideal, and lament Hollywood's failure to appreciate the humanity of nonwhite characters.[41] Aside from the "WASP fantasy" of *Stand by Me* (Rob Reiner, 1986) and the "elitist tendencies" of *Hannah and Her Sisters* (Woody Allen, 1986),[42] White also challenged superficial forms of black nationalism that played on white guilt in order to boost the numbers of nonwhite faces in America's privileged caste. He did not, for example, accept a phony ideal of brotherhood that assumed Spike Lee's melanin levels meant that he should replace Norman Jewison as director of a biopic of Malcolm X (which was based on the *Autobiography of Malcolm X* and the screenplay about the black revolutionary that Baldwin wrote between 1968 and 1972). In contrast, White depicted Lee as a commercial token who put on a good show as maverick for white liberals like Roger Ebert, who repeatedly praised Lee's films, revealed a liberal perspective on the "state of race relations in America," and used the royal *we* to describe the "Western standards" of himself and his imagined readers.[43] From Lee's advertisements for Nike—in which he diluted the revolutionary content of black consciousness into Mars Blackmon, a "friendly, nonthreatening emblem" taken from his film *She's Gotta Have It* (1986)—to the "dishonest nostalgia" of *X* (1992), White tended to align Lee with the Hughes brothers and other African American directors who spearheaded a "hiphop exploitation era."[44] While White appreciated independent artists who were willing to bite away at the racism, classism, patriarchy, and homophobia of the mainstream media, he did not hide his antipathy for Lee and "white negroes" who had just learned to bark at the Hollywood system.[45]

Combining the frustration he felt about Jewison's inability to perceive the artistic advances of black consciousness and Lee's role in films that exploited racism and the revolutionary possibilities of hip-hop, White's review of *Coming to America* (John Landis, 1988) is perhaps the best example of his desire to encourage serious and progressive readings of blackness in the 1980s. The loaded title—"Who's Coming Out of Africa? The Man Who Lost His Roots"—alluded to the liberal politics of films such as *Guess Who's Coming to Dinner* (Stanley Kramer, 1967), in which a black doctor on the verge of winning a Nobel Peace Prize is eventually considered worthy of marrying a white woman, and *Out of Africa* (Sydney Pollack, 1985), a film that focuses on white experiences of love and loss in the midst of colonial Kenya. The body of the essay indicts Eddie Murphy, the star and cowriter of *Coming to America*, for his complicity in the ongoing forms of antiblack racism that treat darker-skinned African American

women and the African continent as grotesque objects for the amusement of men in the overdeveloped world. Highlighting a scene in which Murphy attends a tacky female beauty pageant in which the contestants parade under banners that read "BLACK AWARENESS RALLY," White suggests that Murphy "confuses a political meeting with a sex show" and considers "the very idea of Black politics or the political expression of Black pride ... absurd." In White's diagnosis the comedian and actor born in 1961 is a casualty of the 1970s—"that period of arrested social advancement for Black people"—who is unable to consider the possibility of any subversion or resistance to the system of white supremacist capitalist patriarchy. Put more bluntly, White affiliates Murphy with "the least enlightened rappers" and the "simplicity" of a "TV generation" who think that the free market is capable of acting as a guide for all social action.[46]

Murphy's response to White's review revealed his investment in neoliberal conceptions of value. He bought 34 percent of the *City Sun's* advertising space to publicize an open letter in which he claimed that the box-office success of *Coming to America* proved a resonance with the desires of the black community. He also implied that African Americans did not want to waste their time reading complex reviews that pushed politics and history. The stakes of the debate were clear to White, whose rebuttal to Murphy emphasized the importance of an impartial black point of view that stood outside of white-dominated forms of film, television, and journalism. According to White, critics had a responsibility to comfort the afflicted and afflict the comfortable—even if "asking people to examine any item of pop culture that is presented for their pleasure is to risk being called an 'attacker,' or 'uncharitable' (charity for multi-millionaire Murphy!)."[47]

White's caustic comments about liberal sentiment and neoliberal opportunists were accompanied by revealing reflections about creative artists who had no trust or place in the "straight middle class world."[48] White's reviews noted the importance of filmmakers such as Melvin Van Peebles, who assaulted the "white bourgeois filmgoing experience" in *Sweet Sweetback's Baadasssss Song* (1971); Samuel Fuller, who "clashed with the bourgeois taste of the National Association for the Advancement of Colored People" in *White Dog* (1982); and Lionel Martin, who used "satire and sincerity" to tease the audience of Public Enemy's "Night of the Living Bassheads" into imaginative discussions of power, privilege, and politics.[49] Yet while White appreciated Public Enemy's collaborations with visionary directors, he was wary of didactic or naive expressions of masculine power that threw away the baby of a civil rights movement with the bathwater of its middle-class agendas.[50] In sum, White's essays repeatedly called on the creative and courageous spirit of worldwide movements for democratic change after World War II and sought to cultivate politically informed acts of pleasure that could subvert, resist, and anticipate a system of white supremacist capitalist patriarchy. They held the following truth to be self-evident: that the "fairest,

most sensible pictures of society must come from its minorities and subcultures," and "unco-opted, non-mainstream moviemakers who respect differences in people."[51]

"REVIEWERS DON'T NEED TO BE OMNISCIENT— SENSITIVITY WILL DO": BLACK PUBLIC INTELLECTUALS

Although James Baldwin was frustrated by the maudlin tales and treacherous accounts of blackness that pervaded Hollywood in the 1960s and 1970s, he retained a belief that black actors such as Sidney Poitier could smuggle moments of honesty into an American culture industry.[52] Armond White developed a similar approach to cultural criticism in the 1980s and 1990s when his reviews developed sensitive portrayals of pop artists who could convey multifaceted portraits of blackness to audiences that were politically active, historically informed, and critically alert. This approach dovetailed with a reflective engagement with the purpose of criticism as a dialogical pursuit performed by a professional who should be beyond reproach of self-promotion and complicity with powerful interests and institutions. While denouncing "sell-outs," White championed artists who "spread out" to reach a wider audience without compromising their talent or their community.[53]

After Baldwin's death in 1987, debates about the ethics and aesthetics of black public intellectuals often reflected the anxieties and influences of middle-class blacks who had graduated from college after the enactment of landmark pieces of civil rights and affirmative action legislation. While literary and cultural critics tended to debate the relevance of cultural and postmodernist theory to Black Studies in academic venues,[54] editors of liberal newspapers and magazines were primarily interested in finding piquant writers who could update the famous discussion of double consciousness that W. E. B. Du Bois developed at the dawn of the twentieth century. Henry Louis Gates Jr., a professor at Yale, Cornell, and Duke before joining Harvard in 1991, was one of the most prominent black public intellectuals to straddle academia and the left-liberal media. In 1990 he was heralded as "Black Studies' New Star" in a *New York Times Magazine* article in which he used quotations from James Baldwin to justify his calls for multicultural education.[55] In 1993 he received a George Polk Award for Social Commentary after penning articles for the *New York Times* in which he lambasted Afrocentricity as a movement filled with "black demagogues and pseudo scholars" and interpreted an assortment of televisual and video narratives relating to O. J. Simpson, Rodney King, Los Angeles rebellions, and rap music videos for a predominantly white audience.[56] Concurrently, bell hooks emerged as a well-known black public intellectual who could translate feminist theory and a consumer culture that marketed misogynistic rappers as revolutionary outlaws for a

nonacademic audience.[57] If Gates and hooks didn't exist, they might have been invented by editors of the *New York Times, Village Voice, Atlantic Monthly, New Yorker,* or *New Republic.*

Armond White used characteristically blunt language to address the hype surrounding African American academics, artists, and cultural critics who aroused the interest of liberal, Afrocentric, and bohemian readers. He depicted Gates as an Uncle Tom who appropriated the revolutionary ideals of Baldwin and a civil rights generation to set himself up as a celebrity academic and Head Negro in Charge.[58] He depicted hooks as a rabble-rouser who recounted "personal abuse without a sense of personal guilt or public shame" and hankered after academic stardom with "ludicrous arrogance."[59] He also antagonized Afrocentric and black womanist audiences that supported *Daughters of the Dust* (Julie Dash, 1991)—the first feature film by an African American woman distributed theatrically in the United States, which explored the African folkways of the Gullah culture of the sea islands off the coast of South Carolina and Georgia— by claiming that the film reflected a "Black bourgeois fantasy of refined cinema" and "ideological nostalgia" that failed to address the cultural vitality and lived experiences of American cities.[60] Younger cultural critics who were marketed as incisive commentators on the music of "urban America"—such as Nelson George (born 1957) and Michael Eric Dyson (born 1958)—fared little better than Gates (born 1950), hooks (born 1952), and Dash (born 1952) in White's polemical accounts. Rather than repeat publicity kits that hailed George and Dyson as crusading intellectuals who provided insight into the ethics and aesthetics of African American youth culture, White dismissed them as shallow, noisy race hustlers who offered trite accounts of rappers and cultural icons for the benefit of ill-informed audiences.[61] Furthermore, White has associated the liberal leanings of Gates, Dyson, et al. with the careerism and opportunism of Barack Obama and other "post-soul" individuals born after the 1950s. Given this constellation, it is no surprise that White has evoked Cornel West, Princeton professor, honorary chair of the Democratic Socialists of America, and another child of Baldwin who has emerged as a vocal critic of Obama and a so-called "Obama plantation" of pliant African American intellectuals.[62]

"DEBASED AND DESKILLED":
DELIBERATIVE DEMOCRACY IN THE DIGITAL AGE

In the final years of his life Baldwin called for African American artists and critics to save children from media representations that would make the black experience "irrelevant and obsolete."[63] After the demise of the *City Sun* in 1996, White sounded similar alarms about the various threats to black consciousness while working as an arts critic for *New York Press* and *City Arts.* His reviews

have continued to indict outdated film critics who assume that whiteness and "all-American looks" are synonymous terms.[64] Regularly offering a dissenting opinion to the juries at film festivals in Cannes, Venice, and Sundance, White has also denounced films that pander to the anxieties of a "white bourgeoisie" and create "Third World bogeymen."[65] That said, White's reviews are unlikely to offer hymns for a racially blended, commercially co-opted brave new world in the digital age. They are far more likely to question the corporate forms of multiculturalism that depend on transparent forms of tokenism to maximize global box-office revenues.[66] For if the hype surrounding black celebrities and black public intellectuals played a critical role in White's cultural criticism in the 1980s and 1990s, his twenty-first-century reviews have repeatedly delivered critical sorties against the legacy of a "thumbs up, thumbs down" approach to movie reviewing that is indelibly associated with Roger Ebert and *At the Movies* (a television series Ebert cohosted with Gene Siskel between 1986 and 1999 and with Richard Roeper between 2000 and 2006). Indeed, White has described Ebert as a superficial reviewer given to blather, gibberish, and "simple-minded . . . attacks,"[67] and he provides a pointed rejoinder to white, middle-class film critics who claim that Ebert was "universally revered" at the end of his life.[68]

Bloggers have retorted that White's remarks reflect the bitter whine of a nostalgic writer unable to develop a successful brand that could win rewards and recognition from mainstream society. They presume that White's critical comments reflect his longing for "the golden era when the mainstream cared what [professional] film critics thought."[69] Yet such remarks are clear, simple, and wrong. A deeper understanding of White's background might help bloggers understand why a humanist critic has little time for reviewers who respond to films like a Roman noble at the Coliseum. Further reading of the articles White has produced over his forty-year career might also help them appreciate his refusal to wax nostalgically about a time in which the voices of white, middle-class professional film critics were largely unchallenged in the American public sphere. Even a quick perusal of White's online articles may allow bloggers to acknowledge his appreciation for popular artists, such as Steven Spielberg and Michael Jackson, who are able to produce works of originality, truth, and beauty that transcend racism and reveal an empathetic understanding of other cultures.

In the digital age White has continued to praise radical humanists who have managed to subvert liberal pieties and neoliberal cant. For example, White expresses admiration for Wes Anderson's witty and humanistic explorations of childhood, privilege, and whiteness in his reviews and podcast appearances. He does not follow hipsters who farcically adopt the language of 1960s radicals in order to sneer at Anderson's twee portrayals of "white boy privilege" and "shy away from . . . Anderson's confrontation with selfishness, hurt, and love."[70] White's recent essays and public lectures also refuse to adopt the predictable,

politically correct lines of liberals about the gross misogyny of hip-hop music. Noting that music videos offer space for experimental art that is not esoteric or elitist, White has chosen to extol creative artists, such as Mark Romanek, the director of the music video for Jay Z's "99 Problems," who mixes "harshness and lyricism" in order to subvert "hip hop cliché" and show how New Yorkers actually live.[71] Revealingly, White's online reviews have also aligned Eddie Murphy with Adam Sandler, Bernie Mac, and other "soulful beings" who "lambast homophobia," "liberate macho rigidity," and smuggle some witty, humane, and uplifting portrayals of ethnicity and class into comedic films.[72] In fact, he has praised *A Thousand Words* (Brian Robbins, 2012), a Murphy vehicle that became a whipping boy for film critics and received a zero percent rating on Rotten Tomatoes. He considered Murphy's film to be far superior to *Argo* (Ben Affleck, 2012), the recipient of the Best Picture Oscar at the Eighty-Fifth Annual Academy Awards.

Bloggers have predictably used White's treatment of *A Thousand Words* and *Argo* to caricature a contrarian who claims that widely praised films are bad and much maligned films are good.[73] It is easier to belittle White as a crank than to ask any critical questions about the biases of Academy members who grant awards to *Argo*, which not only celebrates the ingenuity of Hollywood producers and the CIA but also reduces the families and cultural backgrounds of Iranian characters to stereotype and cliché. It is easier to dismiss White as a melancholic who longs for the golden age of film criticism than to explore the personal and professional biases that inform his decision to praise Murphy's "personal Hollywood critique."[74] Yet we may have deeper questions to debate about intelligent design and artistic evolution if we acknowledge White's willingness to use Murphy's mature performances in the twenty-first century as a "St. Paul or Malcolm X or Frantz Fanon story of political or moral conversion."[75] Such willingness to chart Murphy's transformation—from an entertainer who expressed virulent forms of homophobia, misogyny, and antiblack racism in the 1980s, to a self-reflexive commentator on the excesses of American media in the twenty-first century—reveals White's steadfast belief in the power of Christian theology, black consciousness, and humanistic art to inspire critical reflection and personal responsibility.

As we increasingly consume film via DVDs, Netflix, and illegal downloads, it is tempting to treat White's elegies for cinema and the civil rights movement as a testament to his failure to keep pace with a digital revolution. Yet it is also possible to read his contemporary reviews, promoted on social media sites such as Facebook and Twitter, as a means to complicate and exemplify a generation of African American critics born in the 1950s who were inspired by the work of James Baldwin and came of age after civil rights legislation in the 1960s altered the racial architecture of the United States. For White provides incisive extensions to the public pronouncements of bell hooks, a writer who believes that cultural critics can see what others do not and develops articles and film

reviews that aim to bring academic debates about race, class, gender, and sexuality to the patrons of public libraries and bookstores. He offers a more strident tone and register to the carefully constructed civility of Elvis Mitchell: the film critic and host of the long-running KCRW public radio show *The Treatment*, which extracts insights from major artists, filmmakers, and entertainers. And White's work as an "honest intellectual" can be pursued further with reference to Cornel West's hopes for "prophetic intellectuals" who can inspire nonmarket values of love, care, kindness, service, solidarity, and the struggle for justice. So, rather than rely on stock quotes that cast White as a cruel, curmudgeonly luddite striking back against online bloggers and privatized consumption, we may need to talk more—not less—about his affiliation with cultural critics who take up the spiritual quest of James Baldwin to be honest writers and good people. In a digital age in which we are surrounded by a cacophony of voices unwilling, or unable, to publish independent reflections about the film industry, Baldwin's children remind us that artful critics consider it a public duty to respond to works of art honestly and to question the motives of artists and other critics.[76]

NOTES

1. Armond White, "Do Movie Critics Matter?" *First Things*, April 2010, www.firstthings.com/article/2010/04/do-movie-critics-matter. Also see Armond White, "Why Kael Is Good for You," *Columbia Journalism Review* 50.6 (2012): 53–54.
2. Armond White, "Discourteous Discourse," *New York Press*, 28 September 2010.
3. Germain Lussier, "Has Armond White Been Kicked Off Rotten Tomatoes?" /*Film*, 15 November 2011, www.slashfilm.com/armond-white-kicked-rotten-tomatoes/. Eric Randall, "Why Armond White Wasn't Our Most Cantankerous Critic," *Atlantic Wire*, 16 March 2012, www.theatlanticwire.com/entertainment/2012/03/why-armond-white-wasnt-our-most-cantankerous-critic/49997/.
4. Roger Ebert, "Not in Defense of Armond White," Roger Ebert's Journal, 14 August 2009, www.rogerebert.com/rogers-journal/not-in-defense-of-armond-white. Ebert's desire to label White a "troll" was based, in no small part, on an "eye-popping link supplied by Wes Lawson" to a blog that compared "good movies according to Armond" and "bad movies according to Armond." See Maryann Johanson, "Question of the Day: Is Armond White a Troll," Flickfilosopher, 17 August 2009, www.flickfilosopher.com/2009/08/question-of-the-day-is-armond-white-a-troll.html. This table is often cited by "Armond-haters," but it should be treated with caution because it fails to acknowledge nuance (when, for example, White praises the aesthetics of a film and laments its ethics) and misinterprets White's responses to certain films. To give two revealing examples: it assumes that White considers *Terminator Salvation* (McG, 2009) a "good movie" even though his review considered it "junk" and "over-valued schlock," and it claims that White labels *Tropic Thunder* (Ben Stiller, 2008) a "bad movie" despite White's belief that the film showed "keen insight" in its scrutiny of media icons and symbols. See Armond White, "*Terminator Salvation*," *New York Press*, 21 May 2009; and Armond White, "Reel War Is Hell," *New York Press*, 20 August 2008.
5. "Ban Armond White from Rotten Tomatoes," *Petition Spot*, 12 December 2009, www.petitionspot.com/petitions/banarmondwhite.

6. Vince Mancini, "2010: The Year in Armond White Quotes," Filmdrunk, 29 December 2010, http://filmdrunk.uproxx.com/2010/12/2010-the-year-in-armond-white-quotes; "Filmbrain," *Girish*, 14 December 2005, http://girishshambu.blogspot.com/2005/12/2005-ten-favorite -films.html; "Film Criticism or Op-ed Piece: Armond White and the Smugness of Torture Vic-tims," Filmbrain, 29 June 2006, www.filmbrain.com/filmbrain/2006/06/film_criticism_.html.

7. David Bordwell, "In Critical Condition," David Bordwell's Website on Cinema, 14 May 2008, www.davidbordwell.net/blog/2008/05/14/in-critical-condition/; Adrian Martin, review of *American Movie Critics: An Anthology from the Silents Until Now, Film Quarterly* 60.2 (2006): 48–51.

8. Adrian Martin, "Superbad Critic," De Filmkrant, June 2008, www.filmkrant.nl/av/org/ filmkran/archief/fk300/engls300.html.

9. Adrian Martin, "Illuminating the Shadows: Film Criticism in Focus," Mary and Leigh Block Museum of Art, Northwestern University, 4 May 2012, http://jabba.at.northwestern .edu/podcasting/block/Illuminating_the_Shadows_Critics_and_scholars.mp3.

10. Owen Gleiberman, "Why Armond White Got Kicked Out of the Critics Circle," *Enter-tainment Weekly*, 13 January 2014, http://insidemovies.ew.com/2014/01/13/armond-white -kicked-out-of-ny-critics/.

11. See, e.g., Sean O'Connell, "Shame on the New York Film Critics Circle for Keeping Armond White Around," CinemaBlend, 7 January 2014, www.cinemablend.com/new/Shame -York-Film-Critics-Circle-Keeping-Armond-White-Around-40986.html; Michael Arbeiter, "With His NYFCC Heckling, Armond White Is No Longer a Critic, but a Bully," Hollywood .com, 7 January 2014, www.hollywood.com/news/movies/56732891/armond-white-heckled -steve-mcqueen-12-years-a-slave-nyfcc?page=all.

12. Armond White, "The Brad Bird Project," *New York Press*, 25 August 1999; Armond White, "Obliviots, or Shallower into Solipsism," *City Arts*, 28 January 2014.

13. Steven Boone, "In a World That Has *The Darjeeling Limited*, Sidney Lumet Should Be Imprisoned! A Conversation with Armond White, Part 1," *Big Media Vandalism*, 10 December 2007, http://bigmediavandal.blogspot.ca/2007/12/in-world-that-has-darjeeling-limited.html.

14. Cassandra M. Ellis, "The Black Boy Looks at the Silver Screen: Baldwin as Moviegoer," in *Re-viewing James Baldwin: Things Not Seen*, ed. Daniel Quentin Miller (Philadelphia: Temple University Press, 2000), 190.

15. Boone, "In a World That Has *The Darjeeling Limited*." Although White is often lampooned by film critics, his review of the music video for Michael Jackson's "Black or White," which he considered "superior to any short or feature film released [in 1991]," received the Twenty-Fifth Annual ASCAP Deems Taylor Award for music criticism. See Armond White, *Keep Moving: The Michael Jackson Chronicles* (New York: Resistance Works, 2009), 19, 96. White's reflections on race and American society in general have also been well received by some cultural critics. See Eric Lott, "Public Image Limited," *Transition* 68 (1995): 50–65; John Demetry, "Nobody's Perfect," *Revolution to Revelation*, 14 December 2007, http://johndemetry.blogspot.ca/2007/ 12/nobodys-perfect.html; and Steven Boone, "Ten Armond White Quotes That Shook My World," *Slant*, 10 December 2007, www.slantmagazine.com/house/2007/10/white-power-ten -armond-white-quotes-that-shook-my-world.

16. "Armond White," Ron Bennington Interviews, 16 September 2011, http://ronbennington interviews.com/2011/09/16/armond-white/.

17. James Baldwin, *Collected Essays* (New York: Library of America, 1998), 11, 320, 412; James Baldwin, "The White Man's Guilt," *Ebony*, August 1965; James Baldwin, Nathan Glazer, Sid-ney Hook, Gunnar Myrdal, and Norman Podhoretz, "Liberalism and the Negro: A Round-table Discussion," *Commentary* 37.3 (1966): 25–42; Rebecca Aanerud, "Now More Than Ever:

James Baldwin and the Critique of White Liberalism," in *James Baldwin Now*, ed. Dwight A. McBride (New York: New York University Press, 1999). On shame and guilt in American social psychology see, e.g., June P. Tangney and Ronda L. Dearing, *Shame and Guilt* (New York: Guilford Press, 2004).

18. See, e.g., Jean-Paul Sartre, *L'être et le néant: Essai d'ontologie phénoménologique* (Paris: Gallimard, 1943); and Aimé Césaire, *Discours sur le colonialisme* (Paris: Présence africaine, 1955).

19. Baldwin, *Collected Essays*, 302, 404; Malcolm X, *The End of White World Supremacy: Four Speeches by Malcolm X* (New York: Merlin, 1971), 137; William Van Deburg, *New Day in Babylon: The Black Power Movement and American Culture, 1965–1975* (Chicago: University of Chicago Press, 1992), 60–61.

20. Editorial, *South End*, 28 September 1972.

21. Armond White, "New 'Sinbad' Does," *South End*, 25 July 1977.

22. Armond White, "*One on One* Equals Zero," *South End*, 11 August 1977.

23. Armond White, "Regression of Movie Art Award Winner," *South End*, 21 July 1977; Armond White, "*Class of '44*," *South End*, 12 April 1973; Armond White, "*Sweet Jesus, Preacherman*," *South End*, 29 May 1973.

24. Armond White, "REAL Black Movies Needed," *South End*, 20 November 1972. See also Armond White, "Hollywood Meets the CAB," *South End*, 8 November 1972; Armond White, "Shape of Things (Black) to Come," *South End*, 21 November 1972; Armond White, "Sold/Soul Brother," *South End*, 6 December 1972; and Armond White, "Means to an End," *South End*, 4 May 1973.

25. Armond White, "Ali, the Greatest," *South End*, 25 May 1977.

26. Armond White, "Movies from Other Media," *South End*, 26 January 1973.

27. Armond White, "*Sounder*: Above and Beyond," *South End*, 12 January 1973.

28. Armond White, "Cultural Exposure," *South End*, 5 March 1973.

29. Armond White, "*Citizen's Band*: Amusing Mania," *South End*, 19 May 1977; Armond White, "*The Deep*: Shallow Slurs," *South End*, 5 July 1977.

30. Armond White, "Spy Flick Dazzles, but Bombs," *South End*, 14 July 1977.

31. Armond White, "*The Nelson Affair*," *South End*, 19 April 1973.

32. Armond White, "*3 Women*: Altman Atrocity," *South End*, 5 May 1977.

33. Armond White, "East Surpasses West," *City Sun*, 1 April 1986; Armond White, "Use and Abuse of Movie Power," *South End*, 1 September 1977; Armond White, "Nouvemania: New Look at American Culture," *South End*, 6 November 1975.

34. Geoff Dyer, *Ways of Telling: The Work of John Berger* (London: Pluto, 1986), 146–147.

35. Armond White, "Looking at the Underside," *City Sun*, 15 October 1986; see also Armond White, "The Child's the Image of the Man?" *City Sun*, 13 November 1985.

36. Armond White, *The Resistance: Ten Years of Pop Culture That Shook the World* (New York: Overlook, 1995), 179, 182, 199, 266; White, "Looking at the Underside."

37. Armond White, "*A Soldier's Story*: Pro and Con," *City Sun*, 25 September 1984.

38. Howard Kissel, "*A Soldier's Story*," *Women's Wear Daily*, 11 September 1984. Also see Daniel McNeil, "Nostalgia for the Liberal Hour: Talkin' 'bout the Horizons of Norman Jewison's Generation," *Canadian Journal of Film Studies* 21.2 (2012): 115–139.

39. Philip French, "*A Soldier's Story*," *Observer*, 17 March 1985.

40. Elvis Mitchell, "Black Actors: Locked Down or Locked Out?" *New York Times*, 19 March 2000.

41. Armond White, "The New-Wave Stereotypes," *City Sun*, 16 July 1986; Armond White, "Whoopi Goes for the Gold," *City Sun*, 8 April 1987; Armond White, "Keeping the Film Faith," *City Sun*, 7 September 1988.

42. Armond White, "Rob Reiner's WASP Fantasy," *City Sun*, 3 September 1986; Armond White, "Woody Allen Redeems Himself," *City Sun*, 25 February 1987.

43. Roger Ebert, *Awake in the Dark: The Best of Roger Ebert* (Chicago: University of Chicago Press, 2006), 75–81, 167–169, 184, 218, 224.

44. White, *The Resistance*, 321, 348; Armond White, "Beyond Malcolm X: African-American Cinema in the 90s," New York Public Library for the Performing Arts, 29 April 1993; Armond White, "Camera Ready: Hip Hop and the Moving Image," in *DEFinition: The Art and Design of Hip Hop*, ed. Cey Adams and Bill Adler (New York: HarperCollins, 2008), 104.

45. Armond White, "*White Dog*: A Moral Metaphor Causes Uproar," *City Sun*, 24 July 1991.

46. White, *The Resistance*, 95–96.

47. Wayne Dawkins, *City Son: Andrew W. Cooper's Impact on Modern-Day Brooklyn* (Jackson: University Press of Mississippi, 2012), 152–156.

48. White, *The Resistance*, 80.

49. Ibid., 26; Armond White, liner notes to *White Dog* (Criterion Collection DVD, 2008); Armond White, "Official History of Music Video," *New York Press*, 1 August 2007.

50. White, *The Resistance*, 103.

51. Armond White, "Life on the Fringe," *City Sun*, 9 July 1986; Armond White, "Culture Pruning," *City Sun*, 30 July 1986.

52. Baldwin, *Collected Essays*, 408.

53. Armond White, "On the Road with Tracy Chapman," *City Sun*, 23 November 1988.

54. Trey Ellis, "The New Black Aesthetic," *Callaloo* 38 (1989): 233–243.

55. Adam Begley, "Black Studies' New Star: Henry Louis Gates Jr.," *New York Times*, 1 April 1990.

56. Henry Louis Gates Jr., "Black Demagogues and Pseudo Scholars," *New York Times*, 20 July 1992.

57. bell hooks, *Outlaw Culture: Resisting Representations* (London: Routledge, 1994).

58. White, *The Resistance*, 309.

59. Armond White, "Documentary Dreams; Harlem Is, but Black Ain't," *City Sun*, 1 November 1991; Armond White, "Jim Crow Gives Birth to Jimmy Hollywood," *City Sun*, 27 April 1994.

60. White, *The Resistance*, 149, 270, 273.

61. Ibid., 255, 429–430; Armond White, "History Gets Lost in *The Matrix*," *First of the Month*, June 2003.

62. Donovan Slack, "Everyone Wants to Be Us," Politico, 8 August 2012, www.politico.com/politico44/2012/08/obama-everyone-wants-to-be-us-131495.html; Chris Hedges, "The Obama Deception: Why Cornel West Went Ballistic," Truthdig, 16 May 2011, www.truthdig.com/report/item/the_obama_deception_why_cornel_west_went_ballistic_20110516/. Also see Randall Kennedy's indictment of Michael Eric's Dyson for a narcissistic critique of Obama based on "the long delay of an invitation to the White House." Randall Kennedy, *Persistence of the Color Line: Racial Politics and the Obama Presidency* (New York: Vintage, 2011), 260–261.

63. Baldwin, *Collected Essays*, 493.

64. Armond White, "*Bourne Identity; Bad Company*," *New York Press*, 18 June 2002.

65. Armond White, "3 Backyards," *City Arts*, 21 March 2011; Armond White, "Bitch-Slapstick," *City Arts*, 20 September 2013; Armond White, "The Expendable Other," *New York Press*, 28 December 2005.

66. Armond White, "Cinema Armondiso." *New York Press*, 7 December 2004; Armond White, "XXX," *New York Press*, 20 August 2002.

67. Armond White, "The Beat-Em-Ups," *City Arts*, 6 September 2013.

68. Mark Kermode, *Hatchet Job: Love Movies, Hate Critics* (London: Picador, 2013), 89, 109.

69. David Chen, "Armond White," /*Film*, 20 July 2010, www.slashfilm.com/armond-white-i-do-think-it-is-fair-to-say-that-roger-ebert-destroyed-film-criticism/.

70. "New York Film Festival," *GreenCine Daily Podcast*, 12 October 2007, http://daily.greencine.com/archives/004701.html; Armond White, "What We Don't Talk About When We Talk About Movies," *New York Press*, 30 April 2008; Armond White, "Yellowy Submarine," *New York Press*, 7 December 2004; Armond White, "Binocular Vision," *City Arts*, 22 May 2012.

71. Armond White, "The Wall Came Tumbling Down," *New York Press*, 18 May 2004.

72. Armond White, "The Black Natural," *New York Press*, 14 September 2004; Armond White, "A Groin Slapper," *New York Press*, 11 June 2008; Armond White, "Petty Larceny: *Tower Heist*'s Low-Down Concept," *City Arts*, 2 November 2011.

73. Christopher Rosen, "Armond White's Better-Than List; or, Film Criticism as an *Onion* Article," *Huffington Post*, 9 January 2013, www.huffingtonpost.com/christopher-rosen/armond-white-better-than-list-2013_b_2440817.html.

74. Armond White, "Better-Than List," *City Arts*, 9 January 2013.

75. Armond White, "*A Prophet*," *New York Press*, 24 February 2010.

76. Armond White, "'Spite' Lee Puts the Brakes on Unity," *City Sun*, 2 October 1996.

NEW FORMS
AND ACTIVITIES

4 ★ THE NEW DEMOCRACY?

Rotten Tomatoes, Metacritic, Twitter, and IMDb

MATTIAS FREY

In January 2013 film critics reacted with apoplexy to *The Impossible* (2012), the disaster movie starring Naomi Watts and Ewan McGregor. The source of the reviewers' outrage was not the script, performances, or aesthetic, however. Indeed, the write-ups of the film itself were generally good. The criticism focused pointedly on the marketing campaign and, above all, the poster. The latter featured twenty four- or five-star recommendations and seven excerpts from positive notices; rather than reviews exclusively from broadsheet, tabloid, television, or radio critics, however, the longest and most prominent quotations came from "@browning_33," "@katie_m_kelley," and "@lisamegan4"—that is, Twitter users, not professional critics.

In the *Daily Telegraph*, chief film critic Robbie Collin demanded, "Who needs film critics? Not the advertising agency promoting *The Impossible*. The latest print advertisement for Juan Antonio Bayona's visceral tsunami drama features no approving quotes from well-known reviewers."[1] This disturbed Collin because the film had garnered many glowing notices in quality publications, including the *Daily Telegraph* itself. For Collin the advertising campaign represented the "plausible next step after street teams, brand ambassadors, and undercover marketing"; it functioned as part of an "insidious, long-term agenda" hatched by producers. "The people behind *The Impossible*'s campaign have probably reasoned that normal cinema-goers would be very amenable to the idea of their opinions appearing in print," Collin opined. "If an online recommendation could be plucked from the ether and propelled to national stardom, both the volume and gusto of such recommendations might well increase."[2] Writing on the

Guardian website about the same topic, top UK critic Peter Bradshaw worried that this case caused film critics to "have just endured another blow to their fragile self-esteem," even worse than distributors' common practice to "slather their posters with adoring quotes from reviewers, along with the traditional migraine-rash of stars."[3]

The passionate sentiments marking the reception of *The Impossible*'s poster disclose a fundamental anxiety about the status of the critic. As broached in the introduction to this book, in the heated debates surrounding arts and culture criticism in the digital age, one of the major fault lines regards the new "democracy" of criticism. Proponents praise the way in which blogs, Internet forums, and other new forms potentially allow anyone to become a film critic; professional critics have often complained about the way that this has eroded their "gatekeeper" function and "dumbed-down" writing about film and sometimes even compared the new "democracy" to an "anarchism" of criticism. For *Variety*'s Anne Thompson, in a programmatic statement entitled "Crix' Cachet Losing Critical Mass," young cinephiles these days "can't name a working critic besides [Roger] Ebert," and they can recognize him only because of his television presence.[4] Unlike in the halcyon days of Andrew Sarris and Pauline Kael, Thompson submits, today the younger generations "don't read newspapers and never will." Preferring to be spoon-fed information from studios' marketing departments, they "check out film rankings at Rotten Tomatoes or Metacritic and dip into some reviews, but they haven't found a particular film critic they trust to steer them straight."[5] Thompson quotes *Newsweek* reviewer David Ansen, who sums up the consensus: "It is scary. . . . It's a lot like a return to the hard old days when I was growing up when anyone could be a critic and they'd take somebody off the sports desk. It's a profound diss to the knowledge and expertise of a lot of good critics out there."[6]

Ansen's claim—that, unlike in the past, today "anyone [can] be a critic"—is stipulated as fact by both the defenders of traditional critics' function and status, as well as by the new tweeters and Internet anarchists. Despite the widespread agreement, however, the present chapter will put this very claim into question. In a critical assessment of leading new portals of digital criticism, this chapter appraises their assertions of "democracy" and parses their discursive origins. Using Rotten Tomatoes as a case study, I outline the site's claims to produce a more democratic experience of criticism and evaluate the extent to which it and similar sites represent challenges to, or simply perpetuate traditional notions of, "authority" in criticism. Ultimately, I will conclude, the fears of the old guard—which sees these sites as radical attacks on their cultural authority—are misplaced. Although some democratization is achieved in terms of access and broader participation in critical discourse, in crucial ways sites such as Rotten Tomatoes, in fact, venerate traditional criticism and its gatekeeping hierarchies and erect new barriers for potential "citizen-critics" to enter the profession.

"DEMOCRACY" DISCOURSES

To understand the democratic discourses that animate both the new digital portals for film criticism and the often passionate reactions against these platforms, we need to untangle and examine the two interlocking constituent parts at work in the contemporary debate: (1) critics' traditional anxiety about cultural authority and the relationship between critic and reader and (2) widespread rhetoric about the capacity of the Internet to provide democratic access to information and to promote freedom, community, and an expanded and inclusive public sphere.

As outlined in the introduction to this book and evinced by statements such as Ansen's, today's critics feel undermined by bloggers and other "citizen journalists" because of the way in which the practice of criticism by "anyone" degrades the professional distinction of working critics.[7] Nevertheless, this sentiment is hardly novel and did not begin with the introduction of new media or the World Wide Web. The anxiety about the status and cultural authority of the critic is as old as the profession itself.[8]

Indeed, elsewhere I demonstrate that—contrary to those who see the Internet as the first stage in the erosion of critics' status—the rehearsal of cultural authority and the anxiety over its erosion have been a permanent feature of metacritical deliberation and have, perhaps more than any other issue, determined the course and trajectory of the history of film criticism.[9] Before Rónán McDonald's 2007 *Death of the Critic*, before Maurice Berger's *Crisis of Criticism* (1998), before even Terry Eagleton's book-length plea (from 1984) that "in a period in which, with the decline of the public sphere, the traditional authority of criticism has been called into serious question, a reaffirmation of that authority is urgently needed,"[10] even before all of these pronouncements about the imminent death of the influential, mediating public critic, there were many others. As I detail in depth, from the very first film critics, including the early trade press through the postwar leading organs of film criticism, the worry over a loss of status, as well as the "dumbing down" of film criticism, has continually reappeared in remarkably consistent language.[11] Raymond J. Haberski's history of American film criticism has demonstrated how the crisis over critic's cultural authority in the early years of cinema paralleled the panic about cinema as a "democratic art," that is, the barriers to the acceptance of cinema as a legitimate art form.[12] In sum, critics have *always* thought their position tenuous and undermined: the Internet is merely the latest in a long line of threats (French auteurism, television, syndication) to their cultural authority.

To wit, if one-half of the current crisis over criticism is in fact a perpetual complaint, the other half—and the trigger point of the current crisis—derives from recent innovations. We might call this the "digital democracy" discourse. It claims that the Internet, as a technology and platform, is in itself fundamentally

democratic;[13] criticism that appears on the Internet is, by extension, more democratic than previous print and other "old media" forms.

Lincoln Dahlberg identifies three basic types of arguments about the possibility of the Internet to enhance democracy. The "communitarian" argument stresses the potential of the Internet to enhance "communal spirit and values," provide avenues for participation in virtual communities, and build connections between people who share similar values, interests, or concerns. The second type of claim, the "liberal individualist," emphasizes how the web can assist "the expression of individual interests" and enable people to access political information and to be able to "express views directly to elected representatives." Finally, the third "deliberative" camp argues, along neo-Habermasian lines, that in contrast to the communitarian and liberal individualist models, which are based on prediscursive expression of shared values or private interests, "decentralized communications enabled through Web publishing, electronic bulletin boards, e-mail lists, and chat rooms does seem to provide public spaces for rational-critical discourse," that is, a potentially democratic public sphere.[14]

I will return to Dahlberg's terminology and others' research into the Internet democracy discourse later. I introduce it here in order to outline the terms of debate but also to begin to dispute the a priori argument that the Internet is—as a technology and platform—necessarily democratic. The initial enthusiasm for the Internet, and now its various exponents—whether Twitter, Facebook, blogging, etc.—may simply be the newest iteration of a perennial phenomenon in the history of communication: the history of discourse about previous communication technologies reveals similar claims to democratization.[15] With the invention and introduction of "every new distribution medium, be it the telegraph, radio, television or now the internet and mobile phones," Janet Jones and Lee Salter remind us, "there are always those who say that things will never be the same again; but the change is rarely quite as radical as pundits first prophesise [sic]."[16]

Elsewhere, I have surveyed the major outlets of the new digital criticism, which I group under four broad categories: (1) online film reviews of traditional print news media and web-only film reviews produced in the institutional context of a magazine or journal (these range from A. O. Scott's notices for the online versions of the New York Times to "amateur" organs such as Everyone's a Critic [EaC] and Front Row Reviews); (2) sites that, although primarily designed to communicate information about films, also provide forums for users to comment on them, including Internet Movie Database (IMDb), Ain't It Cool News, Deadline Hollywood, and CHUD; (3) social media that are nevertheless used (by critics, "professional" or otherwise) as a means to evaluate films (these include Facebook and, above all, Twitter); (4) the so-called aggregate sites, which collate a broad range of critics' views and use an algorithm to provide a

single rating of a film. This last category includes Rotten Tomatoes, Metacritic, Movie Intelligence Review, and the Movie Review Query Engine.[17]

Sites from all four of these categories make some claims to a more democratic spirit and function of criticism (e.g., Twitter's 140-character tweets or the way that Ain't It Cool News supposedly "threatened the Hollywood system of film marketing because individual users could post reactions to early test screenings").[18] I want to focus in depth, however, on the aggregate sites and in particular on Rotten Tomatoes. With 55 million page views and 11.6 million unique visitors monthly it is the most popular such site; its 6.1 million US users per month make it the 203rd most visited website in that country, a popularity that sees it on par with major airlines such as Southwest and retailers such as Macy's.[19] In the following section I closely analyze the site, its functions, and its utopian assertions to offer a more perfect, democratic criticism.

ROTTEN TOMATOES

Rotten Tomatoes maintains a home page (www.rottentomatoes.com) that features news, trailers, and photo galleries of films on release or in development. Nevertheless, the main focus of the site is the individual pages of films. In many ways this parallels IMDb, and in recent years Rotten Tomatoes has moved consistently in this direction: the individual film sites now feature a short plot description, information about the cast, photos, trailers, and so on; the subtitle of the home page is now "Movies Trailers Reviews," which bespeaks the new branding as a one-stop location for film information. Nevertheless, the information side of Rotten Tomatoes is still much less detailed and comprehensive than IMDb. Here the clear priority is the criticism, in contrast to IMDb, where reviews are collected as an archive of hyperlinks to external sites. According to founder Seth Duong, the page layouts were designed to recall "movie ads in newspapers"[20]—the very sort of promotional materials we saw in the case of *The Impossible* and a selection of reviews (varying in number but approximately twenty-six), which appear as approximately thirty-word quotations (usually zingers that encapsulate the critic's original review in a pithy way), an embedded hyperlink to the original review, the critic's name and affiliation, and an icon of either a red, "fresh" tomato or a green, "rotten" one. Many more such reviews can be accessed with a click, and users may also sort and filter reviews by whether they are positive or negative or written by a "Top Critic" or by one of the users' favorite critics, so-called "My Critics."

One key feature of Rotten Tomatoes and its marketing is the so-called Tomatometer. It measures aggregate evaluation by calculating the percentage of "Approved Tomatometer Critics" who recommend the film. A red tomato indicates that the film is "fresh" and has achieved at least 60 percent positive reviews;

a green tomato denotes a "rotten" film that has failed to register above 60 percent. Films with a Tomatometer ranking above 75 (and that meet certain other criteria) receive the superior distinction of "Certified Fresh." These metrics are displayed prominently on all of the individual film pages. Even in the various news stories and other lists the Tomatometer rating appears beside the film title. Tomatoes, fresh and rotten, are key metaphors and symbols throughout the site. The site allows app developers to embed Rotten Tomatoes content into their programs; the logo and "Certified Fresh" icons are also available for export under certain conditions.[21]

According to the website, "Approved Tomatometer Critics" are reviewers who "fit within a set of standards—mostly from accredited media outlets and online film societies. . . . We use the same list of critics to evaluate each movie. This way, we can insure that the Tomatometer is consistent and unbiased. This also prevents studios or fans from affecting the Tomatometer by submitting only positive reviews to us from sources not on our approved Tomatometer list."[22]

The "set of standards" that approved publications must meet includes ranking as a top-one-hundred daily US newspaper, top-one-hundred weekly US newspaper, top-one-hundred magazine, or top-ten entertainment-based publication—in terms of circulation measured by the Audit Bureau of Circulations, the Magazine Publishers of America, and the Association of Alternative Weeklies. According to the site, applications for "international publications will be made on a case-by-case basis, with input from local Rotten Tomatoes editors when applicable."[23] Television, radio, and exclusively online venues for criticism must satisfy similar requirements in terms of broadcast reach or number of hits per month.[24] In addition, approval for individual critics depends on another set of hurdles, such as working for a Tomatometer-approved publication for at least two years or being a member of an approved society of film critics.[25]

In addition to the hurdles necessary to become an "Approved Tomatometer Critic," Rotten Tomatoes makes further distinctions among its approved critics: these were earlier referred to as the "Cream of the Crop" and now simply as "Top Critics." The evaluations of this elite inner circle of reviewers carry a heavier weighting in the Tomatometer algorithms and in the "Certified Fresh" designation; films may only be rated as such when the release receives at least 75 percent on the Tomatometer and has been reviewed by forty or more critics, including five Top Critics.[26] Who is a Top Critic, and by which formula is this status determined? According to the website,

> Top Critic is a title awarded to the most significant contributors of cinematic and critical discourse. To be considered for Top Critics designation, a critic must be published at a print publication in the top 10% of circulation, employed as a film critic at a national broadcast outlet for no less than five years, or employed as a

film critic for an editorial-based website with over 1.5 million monthly unique visitors for a minimum of three years. A Top Critic may also be recognized as such based on their influence, reach, reputation, and/or quality of writing, as determined by Rotten Tomatoes staff.[27]

The metrics behind the Tomatometer, the various accreditation hurdles to participate in this metrics, the "Certified Fresh" label, the concept of the "Top Critic," but also the ability of registered members to mark their favorite critics ("My Critics"), illustrate the core function of Rotten Tomatoes and also speak to its claims to a more rigorous approach to cinemagoing and film criticism. Rotten Tomatoes' statement of its purpose sums up these issues succinctly:

> Life before RT and our Tomatometer was fairly tough when it came to organizing weekends of movie watching at the local Cineplex. Sure, we could rely on our local critics or word of mouth, but where was the consensus? Why should we rely on a single critic who may have a particular taste in film different from ours? Couldn't we organize and collect all of the reviews from various sources (newspaper, online, magazines) and average them into a single score? We could and did.[28]

This statement reveals the site's self-understanding and contains claims to democratize film viewership and film criticism, but it also previews the major contradictions to these claims. In the following subsections I critically analyze the three interlocking claims to more "democracy": Rotten Tomatoes aims to overturn traditional media hierarchies and promote a more democratic experience of film culture by offering (1) a more *objective* experience of criticism; (2) greater *access* to a more diversified selection of criticism; and (3) an increased degree of *participation and community*.

Objectivity

In the above quotation—and indeed in the copious regulations regarding the accreditation of critics and news media in the Tomatometer that precede it—the emphasis is on consensus: the novelty of Rotten Tomatoes to deliver not the subjective musings of an arbitrary local critic but rather the quotient of opinions about any given film. The technical procedures that feed into the Tomatometer bespeak a scientific "objectivity" to the algorithm. Unlike in the days when only local newspapers and a handful of national news media or specialty entertainment magazines might be available to any given potential film viewer (particularly if he or she did not live in a major metropolitan area), Rotten Tomatoes promises to overturn hierarchies by providing a supposedly objective survey. Aggregation—and this is a key tenet of broader rhetoric on new media,[29] not just of film criticism aggregate sites or Rotten Tomatoes—allows readers a more democratic experience of culture.

Tamara Shepherd has written critically about this development. She notes that Rotten Tomatoes' "database tends to flatten out some of the hierarchical distinctions."[30] Shepherd's assertions are based on concepts of hierarchy and distinction as understood through the sociological studies of Pierre Bourdieu. She suggests that the coexistence of national, prominent critics (such as the *New York Times'* Manohla Dargis) with reviewers from local press (*Bangor Daily News*) or online spheres (Film Freak Central; eFilmCritic) means that "for the casual RT user, the differences between these sources may not be readily apparent."[31] Not only does Rotten Tomatoes provide a "scientific" survey of opinions that disregards cultural distinctions among media; it is thereby also unhinging the traditional hierarchies of the authoritative critic and the passive "follower."

Here we see how the site is indeed explicitly pitched against the ideas of *Variety* critic Anne Thompson outlined at the beginning of this chapter. To rehearse very briefly her complaint: Thompson maintains that her film students no longer consult Kael and Sarris or other public, authoritative critics who might "steer them straight,"[32] that is, inform them about what they ought to be watching and why—an idea about the purpose of criticism that dates back at least to Mathew Arnold. Instead, they "dip" into Rotten Tomatoes and form ad hoc alliances with any critic, regardless of his or her background, training, or publication status.

A recent Rotten Tomatoes feature would seem to confirm the thesis that the site intends a significant democratization of the relationship between "professional critic" and "lay audience." In March 2013 Rotten Tomatoes heavily advertised an app. Supported by popcorn manufacturer Pop Secret, the program interfaced with Rotten Tomatoes and enabled users to determine which critics most consistently share their taste in film. The advertisement's tagline—"Are You like These Critics? Or Are They like You?"—plays on, and upends, traditional notions of authority and democratization.

Nevertheless—in contrast to the rhetoric and self-positioning of Rotten Tomatoes but also to Thompson's jeremiad and the spirit of Shepherd's analysis—in many ways the site is neither "objective," nor does it truly democratically flatten hierarchies. Indeed, I would argue that in an age where supposedly critics are dead and opinions are meaningless (to paraphrase two doomsayers from polar opposite ends of the spectrum on this issue normally, Rónán McDonald and John Carey),[33] Rotten Tomatoes remains entirely anachronistic in its *veneration* of critics and criticism. Unlike IMDb, or even *Variety*, Rotten Tomatoes is a celebration of criticism and actually validates the basic tenet of the critical project: that critics' judgments can and should matter to the reception and consumption of film and other cultural products.[34]

Although much of Rotten Tomatoes' rhetoric and the concept of the Tomatometer subscribe to ideas about objectivity, the criteria for *becoming* a critic featured on the site—and, following from this, the ability to influence the

outcome of the ultimate Tomatometer rating—is hardly a free-for-all. The entire section of "strict criteria"—and the detailed information and language used by Rotten Tomatoes to explain these criteria—suggests an old-fashioned attention to cultural authority.[35] Far from putting the *New York Times* and *Bangor Daily News* on the same level, the concept of the "Top Critics" and the fact that a number of them must confirm a positive rating in order for the film to be "Certified Fresh" suggest, rather than a move toward democratization or anarchy of opinion where hierarchies are suspended, a sacralization of the traditional gatekeeper function of certain authoritative (and, in practice, usually print) critics. This distinction would not be made on the external review sites of IMDb, nor would it be readily apparent to someone performing an Internet search to find reviews of any given film. Looking closely at the explanation of who is accredited to become a Tomatometer critic and especially Top Critic, we see a final sentence that defies the general rhetoric of democracy: "A Top Critic may also be recognized as such based on their influence, reach, reputation, and/or quality of writing, *as determined by Rotten Tomatoes staff.*"[36] This methodology represents a major inscription of traditional, subjective gatekeeping.[37] The Tomatometer is certainly not a scientific algorithm—and that is precisely what makes it a triumph and reinforcement of traditional ideas about the authority of critics and criticism.

Furthermore, through the "My Critic" function and the Pop Secret app, the site actually does provide the means to find a critic to "steer you straight" à la Thompson and in a way that is potentially even more slavish. With a few clicks of the mouse the reader can instantly access and "follow" the critic or critics whom he or she feels most corresponds to his or her taste; the user is provided with an instant archive of the chosen critic's writings. Research suggests that, rather than creating the feared fragmentation of information, the algorithms of search engines and aggregators actually narrow and consolidate the number of news outlets that users consult.[38] Based on this "winner-take-all" logic, it would not be far-fetched to predict that—*pace* Thompson, McDonald, et al.—Rotten Tomatoes might actually create new public, authoritative critics.

Access

The second broad democratic claim that Rotten Tomatoes makes regards its ability to provide greater "access" to a more diverse selection of criticism. Indeed, in the broader rhetoric of digital democracy associated with the Internet, the question of access has been primary. As theorist Zizi Papacharissi summarizes, "by enabling greater access to more information, net-related technologies would at least provide citizens with the tools with which to develop informed viewpoints."[39]

In other words, rather than "rely[ing] on a single critic who may have a particular taste in film different from ours," Rotten Tomatoes promises to provide

easy access to a wide spectrum of information and critical viewpoints. The argument—again, one that is typical of the rhetoric of digital democracy[40]—is that if readers are given access to a wide range of criticism, they themselves are better able to form their own opinions and make decisions. This once more points to how Rotten Tomatoes purports to liberate the user from the influence of the authoritative, single critic. Rather than pedagogical insights or the search for an evaluative "truth," Rotten Tomatoes wants to provide a "consumer guide." According to Stephen Wang, one of the site's primary designers, "there's a mistaken impression that the Tomatometer is a quality rating telling you how good a movie is. Actually, I like to think of it as a *confidence* meter—the percentage likelihood that you'll enjoy a movie."[41]

Tamara Shepherd argues that Rotten Tomatoes' easy access merely represents an example of what Henry Jenkins calls "convergence culture"; it is, in her opinion, a major way that "film criticism is being repackaged under the terms of a new media economy."[42] Shepherd criticizes "the rhetoric of newness and obvious promotional elements of RT," which she says makes it conflatable with industry discourse. Ignoring the concept of "Top Critic," she notes how the selection of reviews is organized according to the default criterion of publication date, criticizes the reduction of entire reviews to taglines, and takes issue with the Tomatometer's foregrounding of "numbers" over quality. She suggests that the site reduces criticism to "marketing instruments and consumer advice."[43]

I disagree with many of Shepherd's suggestions, which recapitulate the "dumbing-down" discourse. In particular, I dispute that Rotten Tomatoes' promotion represents any fundamentally novel development. There is in fact a long history of promotion in film criticism. Indeed, there is a strong tradition of "promotion" discourse among the most highly regarded and distinguished critics, from Siegfried Kracauer and André Bazin to Manny Farber and Jonathan Rosenbaum. What makes these critics' promotion palatable in the minds of many, however, is their advocacy of Roberto Rossellini, Rainer Werner Fassbinder, Michael Snow, or Abbas Kiarostami—that is, filmmakers and films with artistic intensions—not *The Avengers* (2012) or *Scary Movie 5* (2013) or other productions of primarily commercial or entertainment value.

Nevertheless, I agree with Shepherd that, in light of some commercial realities, we need to parse Rotten Tomatoes' claims that access is a priori democratic. Even putting aside the significant question of who even has the physical means to use the Internet or the fact that the site provides "access" almost exclusively to North American English-language criticism, we must recognize the research findings that indicate how commercialization is a major obstacle to digital democracy.[44] Rotten Tomatoes is a for-profit company, not a public service, and its ownership history has no doubt inflected its ultimate priorities. In 2004 Rotten Tomatoes was bought by IGN Entertainment, a conglomerate of (especially

male-oriented) websites, including TeamXBox, GameSpy, and AskMen; IGN was subsequently acquired by News Corporation, that is, Rupert Murdoch and Twentieth Century Fox, for $650 million.[45] In 2010 Rotten Tomatoes was sold to Flixster, an online movie discovery service, which in 2011 was then acquired by Warner Bros.[46] Via these processes of integration Rotten Tomatoes can now focus its news section on tie-ins to Warner Bros. films. Indeed, business analysts interpreted Warner Bros.' acquisition as a symptom of studios' efforts to "encourage people to buy movies."[47]

In this context we need to think critically about how the democratic access that Rotten Tomatoes purports to achieve is at least mitigated by the commercial roles that the site, as a subsidiary of Flixster and of Warner Bros., has in promoting cinemagoing and film consumption. Although Rotten Tomatoes can be used as a reference tool for historical releases, examining the home page shows that the site functions primarily to acquaint viewers with new releases both in theaters and on DVD; it briefly branched out into a television program à la *Siskel & Ebert*.[48] Indeed, although the layout of reviews is the prime novelty and draw, Rotten Tomatoes functions as a "one-stop shop." Users can place films in rental queues on Netflix; check showtime listings and buy cinema tickets; watch trailers or look at publicity images; and read news on celebrities, the industry, and the latest information about upcoming films. In creating this kind of access, Rotten Tomatoes competes not only with Metacritic and Movie Intelligence Review; it is also profiling itself against IMDb, individual RSS and Twitter feeds, Deadline Hollywood, *Variety*, and so on. In many ways the logic is connecting people who want information—rather than necessarily explicitly seeking "criticism"—about a certain film. According to one of its founders, "Rotten Tomatoes occupied a position of being the decision-making point for many moviegoers when figuring out what they wanted to watch in theaters."[49]

Participation and Community

The final democratic claim that demands scrutiny is that of community participation. The celebratory rhetoric of digital democracy asserts that the Internet broadens the public sphere and encourages participation, which once again "challeng[es] the monopoly of traditional elites."[50] Rather than the old top-down model of authoritative critic teaching the passive consumer, champions of the Internet argue that it can provide egalitarian two-way communication and "afford online conversations a degree of *reciprocity*, which can truly help connect citizens of democracies."[51] Rotten Tomatoes subscribes to this rhetoric of digital democracy: because the potential film viewer is not bulldozed by the subjective opinions of arbitrary local critics or hegemonic national authorities, he or she can potentially enjoy a more communal experience of film culture. Rotten Tomatoes represents another iteration of how virtual communities renegotiate

physical, cultural, and geographical forms of proximity and overturn tyrannies of the "local" in order to encourage social interaction.

One important instantiation of this claim is a feature on the pages of individual films where readers' (i.e., not "accredited Tomatometer critics") own reviews can be accessed. They share the same format as the critics' write-ups (short capsule review tagline with the full notice accessible by click). What counts against these "Audience Reviews" as supporting Rotten Tomatoes' claims to any radical increase in community participation, however, is their position. They are subordinated to the critics'—both in literal position in the layout of the page and quantitatively (only two are provided after the approximately two dozen critics' notices). Furthermore, the distinction in name—"Audience Reviews"—defines these commentators precisely *not* as citizen journalists but rather primarily as spectators. Once again, critics—professional critics as determined by Rotten Tomatoes' "strict criteria" and "staff"—clearly remain at the top of the hierarchy.

The most important instantiation of this claim is the site's user forums. They allow users to comment on individual films, as well as trends in film culture; Shepherd cites these as major examples of the "democratization" thesis.[52] Indeed, in general, online forums have been heralded for the way in which they cultivate "a participatory culture among media audiences, thus inserting a bottom-up consumer-driven element to the traditionally top-down process of creating media content."[53] On some level these discussion forums—not unlike their equivalents on IMDb and other sites—do provide a measure of user interaction and community. But it is clear that these exchanges—which deliberate (as one thread is entitled) on the "Awful Green Screen" CGI technology in *Oz the Great and Powerful* (2013)[54]—do not live up to the utopian hopes of digital democracy proponents. Although they might "draw attention to particular issues" and "spark deliberation at local, national, and global levels," and have in a literal sense "stimulated debate and protests," as deliberative democrats such as Dahlberg would advocate, the quality of debate often fails to maintain "respectful and reflexive deliberation."[55] The case of *The Dark Knight Rises* (Christopher Nolan, 2012) is symptomatic. Rotten Tomatoes suspended user comments on the film after a number of threatening, misogynistic, and otherwise derogatory remarks were made toward critics who delivered negative notices. The incident led the site to consider removing the function altogether.[56]

Rotten Tomatoes' role as a virtual community must be considered to offer at best what Dahlberg terms "a 'weak' form of democratic participation" rather than the "strong" model of rational-critical discourse.[57] The lack of reflexivity and respectful listening leads Shepherd to see the "democratized" forum and other user-derived content on the site less as a true "community" in the utopian sense than as a form of what Henry Jenkins calls "participation"—in other words, "open-ended consumption practices shaped by 'cultural and social protocols.'"[58]

Another way to see the communitarian function of Rotten Tomatoes—rather than any sort of deliberative democracy—is as a homogenous "community of interest," where "members' interests, values, and prejudices are reinforced rather than challenged," or simply as an ad hoc social network.[59] The association with Flixster, a social networking site for "discovering new movies" and "meeting others with similar tastes in movies" would seem to confirm this.[60] Indeed, rather than a "democratic" or "deliberative" public sphere, Rotten Tomatoes provides a platform—almost in the vein of a dating site—to find "consensus" and seek the "like-minded." For all Shepherd's (and others') talk of "heterogeneity" and "fragmentation,"[61] Rotten Tomatoes magnetizes the homogenous (people who like what you like) in order to find more appropriate cultural products to consume. The task aligns preferences: whether between users and critics who have similar tastes (through the Pop Secret app and the "My Critics" function) or, of course, user-to-user interaction via the forum. It is in many ways a niche form of Facebook, and, like that company, both Rotten Tomatoes and parent company Flixster deploy users' registration data as a way to sell advertisement.

Examining advertisers' data on Rotten Tomatoes reveals that the site attracts a very homogenous—and very lucrative—demographic. The site's users are largely male, middle-class (university and graduate school), in the eighteen-to-thirty-four age bracket, and childless.[62] This high-consuming profile group reveals why the IGN consortium of male-heavy websites found Rotten Tomatoes attractive. Although Shepherd's claim to race may be overstated—empirical data suggests that there is a larger than proportional share of Hispanic and Asian American users—based on this demographic, it is difficult to disagree with the spirit of her assessment that the "glimmer of 'democratization' provided by RT ultimately serves to paper over its presumable maintenance of traditional hierarchies of gender, race, and class."[63]

CONCLUSION

In sum, Rotten Tomatoes lessens some hierarchies. Its perhaps greatest contribution is to reduce the geographic boundaries that local media have traditionally encountered;[64] before Rotten Tomatoes and the other new portals of criticism, it would have been difficult to imagine someone from California or Nigeria reading a critic from the *Bangor Daily News*. Furthermore, it surely provides—with some not inconsiderable exceptions mentioned above—superior ease of access to a greater diversity of film criticism.

Nevertheless, it hardly enables an anarchy of criticism nor truly undermines critics' profession and status. It venerates the activity and worth of the traditional critic. The democratic prospect of community can only be understood along the lines of a social network of like-minded consumers, rather than the

utopian model of a "deliberative democracy" or "public sphere" in Dahlberg's sense. Indeed, the site actually reinforces the "top-down" authority of critics: in form, layout, and functionality it subscribes to the idea that viewers should base their consumption decisions on *critical* discourse rather than on advertisement or "word of mouth."[65] Far from denigrating film criticism, Rotten Tomatoes promotes it, exposing potential spectators to this mode of writing; the site supports it in the competition it has always faced from informational discourses, including official marketing, news stories on films, and so on.

Criticism as defined by Rotten Tomatoes must be understood as part of a promotional-informational discourse, an often unacknowledged function of criticism since its beginnings and one that is presently precipitating (and has traditionally caused) considerable anxiety among commentators. I submit that—rather than any empirically real "democratization"—the problem and source of the apparent horror on the part of Thompson, McDonald, et al. actually has to do with a disagreement over the ontology of criticism, that is, that Rotten Tomatoes implies a different *purpose* for film criticism. Even Shepherd bemoans the fact—following the research of others such as Shyon Baumann—that "professional film reviews may have begun as artistic criticism, but today primarily serve as a kind of *Consumer Report*."[66] The claim is that Rotten Tomatoes is "dumbing-down" criticism by moving from critical, informed analysis or evaluation to simple "promotion."

Surely, Rotten Tomatoes (and other related sites such as Twitter or IMDb) provides a "training" in traditional critical discourses and forms and therefore "democratizes" criticism somewhat as an activity that may potentially be practiced by a broader public. Nevertheless, it merely changes rather than eradicates the barriers to entry required to practice criticism as a *profession*. Briefly, "barriers to entry" is the phrase that economists use to describe obstacles that impede or prevent entry into a market; they use the concept to explain why some markets might be prone to monopolies or other inefficiencies.[67] The barriers to enter into diamond manufacturing might include the high start-up costs of equipment purchase and advertising, the expenses and risks to access scarce materials, and the economies of scale or customer loyalty that established companies such as DeBeers enjoy. In other industries and businesses the barriers to entry may take a different form. To become a taxi driver in New York, for example, the prospective cabby must have one of the city's official medallions, which are regulated in number and expensive to obtain; many countries require practitioners of law or medicine to pass exams and/or acquire licenses.[68]

There have been utopian ideas about the ways in which the Internet has lowered the barriers to entry for the citizen-critic. "Anyone" with a keyboard and Internet connection can set up a blog within minutes and become a critic. To be sure, the costs to disseminate criticism have been dramatically reduced in the

digital age.[69] Nevertheless, the barriers to entry have shifted from production to filtering; speaking has become easier, but being heard is more difficult than ever.[70] It is true that there are now millions of blogs; commentators are theoretically correct to claim that any one of these *could* be accessed for free by billions of Internet users. But, as Matthew Hindman reminds us, these assumptions—after all, the basis of professional critics' fears—are misleading: "The Internet does provide any citizen a *potential* audience of billions, in the same way that *potentially* anyone can win the lottery." In reality, however, web traffic to blogs is minuscule: for every one million bloggers, only a few dozen "have more readers than does a small-town newspaper."[71] For every citizen-critic who achieves a measure of success, ten thousand will toil in obscurity as voices in the wilderness, critics speaking but not being heard.

In many ways the potential and problems of the new film criticism resemble the development of digital film production in the 1990s: the utopian hopes surrounding the availability of digital cameras and the ability to edit a film on a PC, and the ultimate challenges regarding generating an audience in a market flooded with amateur filmmaking. Even if some traditional barriers to entry have been overcome, Twitter users and other online critics—without access to traditional, dwindling jobs—have to self-advertise and self-promote. This poses a new barrier to entry; economists have shown how, because of "brand loyalty" (in this case to the late Roger Ebert, Peter Bradshaw, one's local newspaper, and so on), "new rivals, seeking to sell as much as existing firms, may need to advertise more than existing firms (or offer some other compensating advantage)."[72] This, in turn, gestures toward the conclusions of Matthew Hindman in his studies of political blogs; in spite of the rhetoric of digital democracy, when based on readership (rather than the actual number of outlets/blogs), thus far the Internet has actually reduced plurality and made the dominant players even more important.[73] This fact might comfort the critics who reacted with such indignation to *The Impossible* and its poster. "Digital technologies create a public space," according to Zizi Papacharissi, "but do not inevitably enable a public sphere."[74]

NOTES

1. Robbie Collin, "Who Cares What Twitter Critics Think?" *Daily Telegraph*, 18 January 2013, www.telegraph.co.uk/culture/film/film-blog/9810807/Who-cares-what-Twitter-critics-think.html.
2. Ibid.
3. Peter Bradshaw, "How Twitter Users Became the Industry's Favourite Critics," *Guardian*, 16 January 2013, www.guardian.co.uk/film/shortcuts/2013/jan/16/twitter-users-film-industrys-critics. For more commentary on the *Impossible* poster see Gillian Orr, "Movie Posters: 'Great Film!'—Dave from the Internet," *Independent*, 9 January 2013, www.independent.co.uk/arts-entertainment/films/news/movie-posters-great-film-dave-from-the-internet-8444967.html.
4. Anne Thompson, "Crix' Cachet Losing Critical Mass," *Variety*, 7 April 2008, 12.

5. Ibid.

6. Ibid., 23.

7. See also Sarah Crompton, "Critics Are Important—Even in the Blogosphere," *Daily Telegraph*, 11 January 2013, www.telegraph.co.uk/culture/tvandradio/9795521/Critics-are-important -even-in-the-blogosphere.html. As my introduction indicates, this sentiment is widespread and oft-repeated.

8. See Mattias Frey, *The Permanent Crisis of Film Criticism: The Anxiety of Authority* (Amsterdam: University of Amsterdam Press, 2015); Cecilia Sayad also examines this phenomenon in this volume's chapter 2.

9. See Frey, *Permanent Crisis*; Mattias Frey, "The Critical Question: *Sight and Sound*'s Postwar Consolidation of Liberal Taste," *Screen* 54.2 (2013): 194–217; Mattias Frey, "*Filmkritik*, with and Without Italics: Kracauerism and Its Limits in Postwar German Film Criticism," *New German Critique* 120 (2013): 85–110.

10. Rónán McDonald, *The Death of the Critic* (London: Continuum, 2007); Maurice Berger, "Introduction: The Crisis of Criticism," in *The Crisis of Criticism*, ed. Maurice Berger (New York: New Press, 1998), 4; Terry Eagleton, *The Function of Criticism: From Spectator to Post-Structuralism* (London: Verso, 1984), 103.

11. See Frey, *Permanent Crisis*.

12. Simultaneously, his book is symptomatic of the "crisis" discourse in the way that Haberski ultimately argues that critics have indeed lost critical authority since the 1970s and that this fact is the cause of the "increasing irrelevance of the meaning of art." See Raymond J. Haberski Jr., *It's Only a Movie! Films and Critics in American Culture* (Lexington: University Press of Kentucky, 2001).

13. See, e.g., Barry N. Hague and Brian D. Loader, eds., *Digital Democracy: Discourse and Decision Making in the Information Age* (London: Routledge, 1999); Zizi Papacharissi, *A Private Sphere: Democracy in the Digital Age* (Cambridge: Polity, 2010); and Matthew Hindman, *The Myth of Digital Democracy* (Princeton, NJ: Princeton University Press, 2008).

14. Lincoln Dahlberg, "The Internet and Democratic Discourse: Exploring the Prospects of Online Deliberative Forums Extending the Public Sphere," *Information, Communication and Society* 4.4 (2001): 615–633, esp. 616–618; see also Papacharissi, *A Private Sphere*, 113.

15. Hindman, *Myth of Digital Democracy*, 5.

16. Janet Jones and Lee Salter, *Digital Journalism* (Los Angeles: Sage, 2012), vii.

17. See Frey, *Permanent Crisis*, 127–129.

18. See Kimberly Owczarski, "From Austin's Basement to Hollywood's Back Door: The Rise of Ain't It Cool News and Convergence Culture," *Journal of Film and Video* 64.3 (2012): 3–20, 4.

19. See "Rottentomatoes.com Traffic and Demographic Statistics by Quantcast," Quantcast, www.quantcast.com/rottentomatoes.com.

20. Tim Ryan, "An Oral History of RT, Part One: The Beginning," Rotten Tomatoes, 23 June 2008, www.rottentomatoes.com/m/rumble_in_the_bronx/news/1736415/an_oral_history _of_rt_part_one_the_beginning/.

21. See "Rotten Tomatoes: Licensing," Rotten Tomatoes, www.rottentomatoes.com/help _desk/licensing.php.

22. "Who Are the Approved Tomatometer Critics?" Flixster, http://flixster.desk.com/ customer/portal/articles/62675-who-are-the-approved-tomatometer-critics.

23. "About Critics," Rotten Tomatoes, www.rottentomatoes.com/help_desk/critics.php. Although this link is no longer operational, the page can be retrieved by entering this URL into the Wayback Machine (http://archive.org/web/) or other Internet archives.

24. For example: "Online publications must achieve and maintain a minimum 500,000 unique monthly visitors according to comScore, Inc or Nielsen Net Ratings and reviews must

have an average length of at least 300 words. Publications must also show a consistent standard of professionalism, writing quality, and editorial integrity across all reviews and articles. Lastly, site design and layout should also reflect a reasonable level of quality and must have a domain name specific to the property" (ibid.).

25. Ibid.

26. "Reserved for the Best-Reviewed Films, the Certified Fresh Accolade Constitutes a Seal of Approval, Synonymous with Quality." See "Rotten Tomatoes: Certified Fresh," Rotten Tomatoes, www.rottentomatoes.com/help_desk/certified_fresh.php.

27. "About Critics."

28. See Rotten Tomatoes' Facebook page: "Rotten Tomatoes—Info: Facebook," Facebook, www.facebook.com/rottentomatoes/info.

29. See Papacharissi, *A Private Sphere*, 153–154.

30. Tamara Shepherd, "Rotten Tomatoes in the Field of Popular Cultural Production," *Canadian Journal of Film Studies* 18.2 (2009): 26–44, 34.

31. Ibid.

32. Thompson, "'Crix' Cachet Losing Critical Mass," 12.

33. Shepherd does cede this point: "RT paradoxically offers both an alternative to, and reinforcement of, traditional movie criticism through its exploitation of the Internet's participatory potential" ("Rotten Tomatoes in the Field," 37).

34. See the introduction to this volume.

35. Even Shepherd admits that the "site determines to establish aesthetic credibility through alternate means" ("Rotten Tomatoes in the Field," 35).

36. "About Critics" (emphasis mine).

37. For more on how gatekeeping remains a critical part of the dissemination of information in the digital age, see Hindman, *Myth of Digital Democracy*, 12–13.

38. See ibid., 38–57, esp. 56.

39. Papacharissi, *A Private Sphere*, 120.

40. See, e.g., Hindman, *Myth of Digital Democracy*, 2–3, 6.

41. Quoted in Tim Ryan, "An Oral History of RT, Part Three: Ripe Tomatoes," Rotten Tomatoes, 15 July 2008, www.rottentomatoes.com/m/mean_girls/news/1736815/an_oral_history_of_rt_part_three_ripe_tomatoes/ (italics in original).

42. Shepherd, "Rotten Tomatoes in the Field," 34. On convergence culture see Henry Jenkins, *Convergence Culture: Where Old and New Media Collide* (New York: New York University Press, 2006).

43. Shepherd, "Rotten Tomatoes in the Field," 29, 35.

44. See Hague and Loader, *Digital Democracy*, 9; Hindman, *Myth of Digital Democracy*, 9; and Papacharissi, *A Private Sphere*, 120, 123.

45. "News Corp. Acquires IGN for $650 Million," *Bloomberg Businessweek*, 10 September 2005, www.businessweek.com/stories/2005-09-10/news-corp-dot-acquires-ign-for-650-million.

46. Mark Sweney, "Warner Bros Buys Rotten Tomatoes Owner Flixster," *Guardian*, 4 May 2011, www.guardian.co.uk/media/2011/may/04/warner-bros-rotten-tomatoes-flixster.

47. Dawn C. Chmielewski, "Warner Bros. Buys Social Network Flixster, Parent of Rotten Tomatoes," *Los Angeles Times*, 5 May 2011, http://articles.latimes.com/2011/may/05/business/la-fi-ct-flixter-20110505.

48. See "The Rotten Tomatoes Show," *Current*, http://current.com/shows/the-rotten-tomatoes-show/. Although this link is no longer operational, the page can be retrieved by entering this URL into the Wayback Machine (http://archive.org/web/) or other Internet archives. Highlights from the show are available on YouTube; see, e.g., www.youtube.com/watch?v=m3cSgJp2fSE.

49. Tim Ryan, "An Oral History of RT, Part Two: Dotcom Daze," Rotten Tomatoes, 3 July 2008, www.rottentomatoes.com/m/e_dreams/news/1736808/an_oral_history_of_rt_part _two_dotcom_daze/.

50. Hindman, *Myth of Digital Democracy*, 6.

51. Papacharissi, *A Private Sphere*, 122 (italics in original).

52. Shepherd, "Rotten Tomatoes in the Field," 29.

53. Papacharissi, *A Private Sphere*, 65.

54. "*Oz the Great and Powerful*—Movie Forum—Rotten Tomatoes," Rotten Tomatoes, www .rottentomatoes.com/m/oz_the_great_and_powerful//forum/?threadid=328154726.

55. See Dahlberg, "The Internet and Democratic Discourse," 622, 620.

56. Dave Itzkoff, "Rotten Tomatoes Halts Comments on 'Dark Knight,'" *New York Times*, 17 July 2012, http://artsbeat.blogs.nytimes.com/2012/07/17/rotten-tomatoes-halts-reader -comments-amid-dark-knight-furor/.

57. Dahlberg, "The Internet and Democratic Discourse," 620, 623.

58. Shepherd, "Rotten Tomatoes in the Field," 38–40.

59. Dahlberg, "The Internet and Democratic Discourse," 618; see also Papacharissi, *A Private Sphere*, 62–63; and Hague and Loader, *Digital Democracy*, 12.

60. "Flixster," Wikipedia, http://en.wikipedia.org/wiki/Flixster.

61. See Shepherd, "Rotten Tomatoes in the Field," 39: "online film criticism contributes to fragmentation (not cohesion) of specific (not general) audience markets"; see also Hindman, *Myth of Digital Democracy*, 9.

62. See "Rottentomatoes.com Traffic and Demographic Statistics by Quantcast."

63. Shepherd, "Rotten Tomatoes in the Field," 41.

64. See Hindman, *Myth of Digital Democracy*, 89.

65. Cf. Shepherd, "Rotten Tomatoes in the Field," 33.

66. See ibid., 41. See also Shyon Baumann, *Hollywood Highbrow: From Entertainment to Art* (Princeton, NJ: Princeton University Press, 2007).

67. Harold Demsetz, "Barriers to Entry," *American Economic Review* 72.1 (1982): 47–57, esp. 47.

68. Ibid., 47.

69. Hindman, *Myth of Digital Democracy*, 13, 86–87.

70. Ibid., 13, 16–17, 19.

71. Ibid., 101, 128.

72. Demsetz, "Barriers to Entry," 50.

73. Hindman, *Myth of Digital Democracy*, 101.

74. Papacharissi, *A Private Sphere*, 124.

5 ★ THE PRICE OF CONSERVATION

Online Video Criticism of Film in Italy

GIACOMO MANZOLI AND PAOLO NOTO

In "Are Web-Cinephiles the New Barbarians?"—which appeared in a blog of *Il sole 24 ore*, the most prestigious business newspaper in Italy (the financial version of *Corriere della sera* or the Italian equivalent of the *Wall Street Journal* or *Financial Times*)—Vincenzo Scuccimarra outlines the usual preconceptions concerning web criticism—including accusations of amateurism, incompetence, superficiality, use of invective, and a predilection for personal taste. The article highlights two points supporting an optimistic approach toward the supposedly new state of affairs in criticism. First, Scuccimarra urges us to challenge the "authoritative" quality of film criticism. According to him Italian "official" criticism (performed by the national mainstream press, including TV) is marked by the following deficiencies: exclusion ("Film ratings are confined to an Indian reservation"), cliché ("[The critics] seem unable to stimulate readers"), obscurity ("Esoteric language"), resistance "to newcomers," subjectivity ("A broad combination of opinions"), unreliability ("Friendly acquaintances among the people, institutions, and companies they are supposed to judge"), and obsolescence ("Hopeless cult from the catacombs").[1]

Second, popular websites (e.g., mymovies.it, movieplayer.it, cinemaitaliano .info, cinematografo.it, cinecittanews.it, screenweek.it), as well as historical magazines that have recently added online versions (e.g., cineforum.it), may not only offer the same quality reviews found in traditional newspapers but also provide their readers with a significant amount of information, allowing for the development of a variety of perspectives, independently of the critic's point of view.

They may also become sociologically "disinterested," having no personal interest to pursue, and thus look at the cinema "through the sane eye of outsiders."[2]

The development of web criticism might be controversial, but, *pace* Scuccimarra, it has also been seen to have brought about a critical *nouvelle vague* that is more accessible, enlightened, vibrant, genuine, and connected to the present. Recent academic contributions (with respect to Italian film reviews) seem to follow the same trend, presenting the new web criticism as a true "assault on the caste,"[3] or the incestuous social group of film critics.

This chapter provides a historical perspective on the supposed radical divergence between print criticism and web criticism in Italy. We analyze the conditions in which Italian critics operate, and through the case study of the Italian reception of *Pacific Rim* (Guillermo del Toro, 2013) we ask whether web film criticism, especially in the form of vlogs widely spread among younger generations, is genuinely innovative. It seems to us that continuity prevails over rupture, that is to say that the will to preserve the alleged function, and the distinctive jargon, of traditional film criticism makes its new form immune to the possibilities provided by digitization.

THE PRESENCE OF ITALIAN CRITICISM

In "The Existence of Italy" Fredric Jameson revises traditional periodizations of film history through Italy's role in anticipating or delaying the main cinematographic events arising elsewhere in Europe, explaining how the country's peculiar cinematic history undermines the common dynamics of period theory.[4] This phenomenon applies also to film criticism.

Criticism gained authority under fascist propaganda, with the foundation of a national film school, the Centro sperimentale di cinematografia, in 1937. Criticism still managed to embrace a plurality of values and ideas, however, combining film reviewing, theoretical speculation, artistic performance, and promotion of the so-called cinematic art. The combination of these different areas (also linked with the development of neorealism) calls attention to the intersection of a range of fields, but what we intend to discuss here is the foundation of Italian film culture in a broader sense.

To understand the implications of the Centro sperimentale di cinematografia to film culture in Italy, it is necessary to identify some of the figures associated with the school. They include general director of cinematography Luigi Freddi, who promoted a distinction between auteur-elitist cinema culture and popular cinema culture; Luigi Chiarini, director of the Venice Film Festival until 1968, considered to be the main authority in Italian cinema long after Mussolini and notable for his "diplomatic" adherence to fascist ideology; Umberto Barbaro, a lecturer inspired by Marxist theory; and a variety of outstanding intellectuals

like Giuseppe De Santis and Michelangelo Antonioni, who after reading *Bianco e nero* and later *Cinema* understood the need to analyze (and reposition) cinema on a cultural level before turning it into practice.

These events developed under Benedetto Croce's persuasive aesthetic insights,[5] which affected all aspects of early twentieth-century Italian culture. Croce's ideas overlap with György Lukács's theory about the predilection for realism—the artist's urge to describe humankind in its complexity, based on historical contradictions and social dynamics.[6] Above all, the crucial influence of Antonio Gramsci and Theodor Adorno contributed to the cryptic debate over film criticism and film aesthetics in the Italian postwar period.[7] According to this thinking, critics were perceived as "organic" intellectuals, that is to say functional experts who aim to empower the masses through a radical critique of consumer society and cultural industry. Critics perform their commitment on the basis of technical and theoretical skills, connecting artist to audience, thus acknowledging the artist's intention and disclosing his or her "secret" to the audience.

The situation leads to three consequences already noted and denounced at the time. First, whereas critics and film directors are not perceived as having the same function (they are better kept apart, since one is in charge of assessing the other's performance), the critic and the author belong to a common political process (ideologically speaking), which results in a combination of practices and in a particular kind of proximity. They are placed within the same institutional framework and share equivalent economic and social interests. When in *La ricotta* (1963) Pier Paolo Pasolini has Orson Welles say "The producer of my film is also the owner of your newspaper," he is both stating a fact and describing the historical background of most critical debates.

Second, a common project leads the critic (and often the film director, although the latter has to face box-office responses) to an understanding of his or her role within a vocational-pedagogic "Jiminy Cricket framework" defined, for instance, by Fausto Colombo, who draws from Collodi's Pinocchio metaphor to refer to intellectuals who judge and preach from the outside.[8]

Finally, the described dynamic follows a pyramidal pattern (supported by secondary features such as publishers' circulation and influence) able to provide the cultural community with a selection of local opinion leaders, among whom national opinion leaders are selected in a process that recalls the fight for recognition of representative political strategies. Despite expressing democratic consent, such a process is arranged as an investiture, a form of ordination. Those who hold such privileged positions are likely to embrace (in writing and behavior) the typical attitudes of a charismatic leader.

Eccentrics are also part of the picture. These dynamics can be illustrated by two extreme examples. On the one hand we have the Italian "critic-writer" commonly perceived as "conservative," whose relationship with readers is marked

by his or her unquestionable status.[9] Here the lack of attention to ideology is balanced by stylistic flourishes (in the form of digressions), taste, and eccentricity. Success is achieved through the overlap between the points of view of critics and readers, resulting in the need to satisfy the common opinion (the *doxa*) perceived as trivial by the aforementioned "organic" intellectuals.[10] On the other hand we find pragmatic criticism on a large scale, performed by the anonymous reviewers of the Centro cattolico cinematografico.[11] Here subjective taste issues are drastically reduced, while the critic works on a strictly framed system, inspired by ideologies and performing an act of manipulation and selection that gradually turns into moral censorship. This form of pragmatic criticism is nevertheless an early example of collective intelligence and critical community practice, however organized and supervised. It follows that the ideal Italian film critic would be partly an ideologist and partly an educator constantly challenged by the constraints of an interested commissioner.[12] Only such a figure would be able to embrace the challenges brought upon film criticism since the 1960s.

AFTER THE END

The forms of traditional film criticism that persist in contemporary Italy still provide a model in a country pervaded by a significant critical divide. To understand the background of Italian web criticism, we must first analyze the events starting in the 1960s and ending a decade later. Being under strong political pressure at the time (culminating in a series of protests), criticism developed within the stable context of a modern cultural industry. Meanwhile the practices that would later define criticism in the digital era begin to take shape.

We have grouped such instances into three categories, linking the qualities that define general criticism and its *habitus* (as Pierre Bourdieu may call it)[13]—or the ways in which social groups naturally engage in situations in order to pursue strategic interests.

The Praise of Passion and Decline

Television constitutes an important aspect of our analysis of Italian film criticism. There has been a perceived transformation from "paleotelevision" (state monopoly television, which is reassuring, family-focused, and pedagogic) to the "new television" (a hybrid of public and private systems that has developed since the end of the 1970s).[14] The development of new private channels has destroyed the monopoly of two state TV channels, bringing about an unprecedented range of film offerings on television. Consequently, both the film industry and cinematic practices started to decay. Yet Italians were provided with a wider and richer film selection, exacerbated by the domestic distribution of VHS tapes. Film viewing was hence defined by the user's individual selection, away from the

guiding principles of technological innovation (in movie theaters) and cultural value (cine-clubs). The Italian viewer could at last become omnivorous, watching more films than ever before, albeit not at the cinema. The debate about the death of cinema took a variety of forms and included at least one fundamental truth. Modes of film distribution (and thus of experience) integral to social and ritual experiences were reviewed, while audiences' selecting skills improved, as they were increasingly motivated to organize their own viewing preferences based on individual taste and interest.

Undoubtedly, this change of scenery also forced criticism to rethink its function. What once belonged to niches (such as cinephilia) and elitist avant-gardes became suitable to fulfill new viewers' expectations. The "wise" critic who embraced the role of cultural operator on the basis of a set axiology and a traditional knowledge of cinematographic culture was gradually replaced by a new figure, the social man, a cultural *viveur* extremely competent but with a passionate detachment, peculiarly virtuous in its expression. For example, in *Prima della rivoluzione* (*Before the Revolution*, 1964) Bernardo Bertolucci asked his friend critic Morando Morandini (later author of the definitive Italian cinema dictionary) to play himself, making him celebrate a New Wave cult movie (*Red River*, Howard Hawks, 1948) by invoking the famous 360-degrees of morality. In the 1970s and 1980s the role of the cinephile critic was embraced by Enzo Ungari (with Bertolucci he wrote, in 1987, the script for *The Last Emperor*), who called himself a "devourer of films"[15] and stated with the same enthusiasm his predilection for Michelangelo Antonioni and Russ Meyer.

Such critical disposition, which led to different cinephile journals in the 1990s (*Amarcord, Nocturno, Sentieri selvaggi*, and others), exploded with the dissemination of digital criticism and enabled the invasion of the traditional cinematographic art "fortresses," for example, through the screening of B movies during the Venice Film Festival. Nevertheless, what we highlight here is how this passionate and cinephilic approach to "revaluation" represents a strategy to indirectly broach cultural and audience studies otherwise ignored in the Italian context, which in general has favored mass culture theory over popular art (for the reasons pointed out). No wonder the only scholar who has regularly researched cinema audiences and box office for forty years, Vittorio Spinazzola, has been a professor of literature whose works have often been considered eccentric.[16]

Words and Pictures

When television became the central point of film distribution, the vehicle for criticism shifted to video, consequently adapting the critic's language, topics, and functions to the new context. Television also produced the springboard for a dominant form of web criticism: vlog or online video reviews. To illustrate the evolution of Italian criticism, we have to mention four emblematic figures. Film

critic Claudio Giorgio Fava was an eminent figure tasked to educate via the communication of official (pedagogic) knowledge. He appeared as a kind of neutral anchorman on public service television from the 1970s, wearing a suit and tie (sometimes a bow tie) and displaying a formal, intellectual approach, being informative while also adding ironic asides that strengthened his relationship with the general audience. Fava was very cautious, never excessive. His purpose was to "serve" the viewer.

Such an approach also characterizes critic Vieri Razzini, who nonetheless appeared to be less formal (if only to stress his status as intellectual rather than anchorman). Razzini's critical comments were more rigorous than Fava's, and he shows remarkable knowledge about cinema history and the 1950s and 1960s *Cahiers du cinéma*'s teachings on the *politique des auteurs* and the importance of mise-en-scène (which have deeply influenced film education in Italy).

Enrico Ghezzi's character is more informal. He has become a sort of icon of the third state channel revolution carried out under executive Angelo Guglielmi.[17] Although criticism has only a marginal presence on television, the latter provided ground for linguistic experiments, and Ghezzi was perceived as a pioneer: using techniques such as low resolution, black and white, and deliberately poor lip synching. His passionate and cinephilic approach is informed by auteurism, but his discussions became increasingly complex, including topics in film philosophy (Gilles Deleuze) and poststructuralism (Jacques Derrida, Guy Debord, and others).[18] Ghezzi appears constantly struck by the eroticism of the sentimental cinematic experience and celebrates indeterminacy, confusion, and vanity, thus leading to polarized reactions. His increasingly esoteric discourse has been either acclaimed or rejected. His defenders may appear as followers of a cinephilic religion holding Ghezzi as the star of Italian film criticism, yet he elicits opposing reactions, such as accusations of being a deceiver. He has also inspired parodies, which simultaneously celebrate Ghezzi's iconic status. One of the most famous, performed by mainstream comic Corrado Guzzanti, presents Ghezzi as an illiterate child engaged in a YouTube-vlog review. This sketch suggests that Ghezzi's experiments have foreshadowed digital criticism's modes of self-representation based on improvisation and an amateur's ethic (this despite Ghezzi, who is also an Italian state television executive, being part of the official sphere).

Moreover, whereas Berlusconi's commercial television (he is still a major Italian producer, distributor, and broadcaster) never cared about critical sophistication, Sky channels have for years invested in Gianni Canova, who combines sobriety and rigidity with passionate and cinephilic touches. He wears a dark suit with a turtleneck sweater, which has become a sort of uniform for Italian *engagés*, and embodies, in many ways, the updated and enlightened version of the traditional figure of the critic as militant activist. He is unquestionably smart, elegant,

a smooth talker, and a passionate defender of his artistic tastes (also on an ethical level); he is in many ways a cultural missionary.

Canova promotes a rather traditional conception of cinema, although he is open to both technological and stylistic innovations. His open mind can be attributed to his academic education, which enhanced a perception of cinema as existing on multiple platforms (including TV series and new media). He is professor of Cinema History at IULM University of Milan, and as a critic he prudently displays a theoretical background (including cultural studies), seeming to promote an approach to stardom based on deference and respect rather than unconditional devotion.

While Ghezzi and Canova are still active (although relegated to peripheral, generalist television), film criticism on Italian TV is gradually fading, losing space to talk-show programs led by eccentric and antithetic characters such as the outrageous Marco Giusti or the soothing yet soporific Gigi Marzullo, both of whom prefer to hold a marginal position, giving visibility to a variety of characters whose critical practice is just an excuse to perform niche cultural entertainment for specific audiences (classified primarily by age). This empty space is being occupied by vlogs.

Conflicts of Interests

Italy is marked by various networks of conflicting interests. Film criticism (and any kind of media criticism) has no longer been perceived as a profession since the 1980s, when the first complaints appeared about the limited number of critics on local and national newspapers and the gradual replacement of professional (fairly compensated) critics with less qualified writers willing to work for free.[19]

As indicated in the introduction and Outi Hakola's chapter, the debate over criticism in the digital age has often focused on the decline in quality that may result from this situation. But the fundamental issue is of a different nature. Indeed, considerable savings and solid family structures (Italian society's foundation) have forced some to work with no remuneration, but such a fragile system calls for other forms of compensation.

To put it simply, film expertise is not a requirement. In many cases film criticism is just a showcase that might give access to properly acknowledged and well-paid positions in the cultural industry. The most representative (and innocent) example of this is the critic's access to university teaching, which is also rare, considering the limited number of academic posts (currently there are nearly none). In contrast, critics entering other areas of activity in the film sector are far more numerous. As a result of acquired influence and networks, many have reached (or wish to reach) relevant positions in the management of festivals, local film commissions, ministry commissions responsible for public funding, television programming, broadcasting, film advertising, and so on.

The results are predictable. On the microlevel we find critics judging films or directors they have themselves selected for a festival. In addition, these films are sometimes financed by public committees for which critics work as consulting members. Similarly, recalling Pasolini, there are films produced or distributed by the same owner of, or which advertise in, the newspapers critics write for. The odds for direct or indirect influence are clearly very high—not to mention the recurring political turmoil, which is indeed a pervading characteristic of Italy and gives rise to embarrassing situations (everyone knows that three-time prime minister Silvio Berlusconi is also a TV tycoon). On the macrolevel we find a narrow-minded and self-referential environment where struggles for the imposition of taste, aesthetic, and ideology (bearing in mind that no critic is ever sharp, detached, and absolutely neutral toward his or her topic of interest) are replaced by a standardized and monotonous debate dominated by assent. Other effects derive from the decline of the critical institution and its increasing detachment from the audiences it is supposed to communicate with. It is not just a matter of integrity; it is a matter of predictability and utility.

The daunting scenario contained in the preceding three subsections explains the resistance and expectations that mark the development of digital criticism. On the one hand we find the corporate defense of high-profile critics, although this is usually omitted from negative accounts of the decline and depreciation of the profession resulting from the proliferation of amateur criticism. On the other hand there is hope that the transformations of the critical landscape could lead to a plurality of approaches independent (as Scuccimarra states) from the aforementioned network of interests and relations. From an analytical and historical perspective it may be quite enlightening to understand how the conceptual patterns and representations on which Italian film culture is based have adjusted to the digital era. In what way has *habitus* been reformed or reintegrated, and how have changes in the media introduced new critical needs and traditions capable of producing new opportunities? Finally, it behooves us to wonder about a potential reconciliation with moviegoers necessary for the survival of film criticism as independent and free, assuming that we still consider film criticism to be a useful institution, requiring skills not necessarily available to all.

PACIFIC RIM

The Italian vlog reviews of *Pacific Rim*, produced mostly by nonprofessional critics and shown on YouTube, are useful in underscoring what remains the same in old and new forms of film criticism. Del Toro's film was released in Italy on 11 July 2013, during the least promising season for cinema releases in the country, and grossed about €3 million in six weeks.

Pacific Rim is a good case study for several reasons. It is a popular and enter-
taining film—something Italian critics are customarily unfriendly toward—and
should therefore help to highlight the major differences between the criti-
cal approach of both skeptical professionals and enthusiastic nonprofession-
als. Also, and in partial contradiction to this, being directed by Guillermo del
Toro, *Pacific Rim* generated auteurist expectations that often cause online video
reviewers to assert a specific idea of cinema and the function of the author in
genre cinema—a notion that proves to be rather normative. Moreover, as is
apparent from the vlogs under scrutiny here, *Pacific Rim* appeals to two different
age groups: the "digital natives" in their twenties, and the thirty-five- to forty-
year-old cinephiles who experienced the aforementioned revolution in public
service and private broadcasting in the 1980s and 1990s, as well as the resulting
changes in the video criticism of film led by figures like Ghezzi and Canova.
Finally, this film presents a dense network of intertextual links with other mov-
ies and cultural products (especially comics and anime series), thus making the
interpretative task of expert online video reviewers particularly challenging.

Our analysis focuses on four key features of the reviews: the setting and the
mise-en-scène, the use of intertextual references, the argumentative style, and
the propagated "idea of cinema." Our hypothesis is that these reviews put into
question the allegedly sharp distinction between professionalism and amateur-
ism, which has been traditionally accepted and is confirmed not only by the
aforementioned example of Scuccimarra but also by qualitative research into
online texts based on so-called sentiment analysis, the method used to deter-
mine the attitude and opinion expressed by a person about a particular topic in
an online text.[20] We also demonstrate that the tools provided by digital technolo-
gies (especially the opportunity for critics/users to create videos with their own
hands) are not deployed to propose new forms of criticism based on the creative
rewriting of the texts but to rebuild a traditional image of the film critic as an
expert primarily engaged in the "struggle for recognition."[21]

The analyzed vlogs have been found through YouTube's search engine, via
a standard keyword search (Pacific Rim + videorecensione [video review] +
ITA), and then following the links suggested by YouTube. We arrived at four-
teen results: the reviews have diverse durations, ranging from two to fifty-one
minutes, and explore the opportunities provided by video language in various
ways. In fact, they display different degrees of sophistication at the levels of the
text and production values—identified in the use of audio/video editing, the
presence of extracts from *Pacific Rim* or from other films mentioned, and the
presence of paratextual markings such as opening and ending titles. The videos
also have different ways of "staging" the critics' performances, often framing
them in a distinctive setting. Before delving into the analysis of these videos, it is
worth noting that the best results in terms of popularity (18,449 views but also

722 "Likes") are achieved by a long review with a very low level of formal elaboration, devoid of a distinctive setting, clips, and paratextual markings.[22]

Setting and Intertextual Competences

The first element of interest in these video reviews is the framing of the amateur critics' performances by means of the décor, costumes, and positioning of the "actors" onstage. Venom and Big Dude of WideMovieTv wear T-shirts with the logo of their channel as a uniform,[23] and so does the critic of chemiguardo,[24] while the reviewers at AlkaDaveWS[25] and MoviememesOriginal[26] have T-shirts that bear witness to their cinephilic passions, with images respectively taken from (or inspired by) *Green Lantern* (Martin Campbell, 2011), *Army of Darkness* (Sam Raimi, 1992), and the *Star Wars* saga.

Mise-en-scène and the presence of "talking" objects also signal these critics' association with fan communities. The two reviewers of WideMovieTv show off (and never drink from) two mugs adorned with images from cult movies of the 1980s—*Ghostbusters* (Ivan Reitman, 1984) and *The Goonies* (Richard Donner, 1985)—with an image of *Pacific Rim* in the background. Aldo Jones shot his video in a conventional living room but with a video projector clearly visible in the background.[27] Simone Mancini uses a backcloth with oriental patterns, seemingly matching the film being reviewed.[28] The critic of chemiguardo speaks before a panel that collects pages of black-and-white manga (in his channel he comments on Japanese comics, as well as films). In one case the absence of cinephile references and the presence of other objects onstage are negatively received in the comments section. This happens to the two young critics of DSReviews95,[29] to whom a viewer complains about the presence of a punching bag in the background ("But should the punching bag behind you mean that 'We are nerds discussing giant robots, yet we are much cooler because we box'?").[30] In the case of cavernadiplatone, who talks enthusiastically of the film, the autograph by Yoshiyuki Sadamoto, the character designer of *Neon Genesis Evangelion* (Hideaki Anno, 1995–1996), an anime widely recognized as one of the inspiring sources of *Pacific Rim*, is placed in the foreground.[31]

It is curious that the resources made available by digital technology (the possibility of including film material, commenting on the images in voice-over, comparing different texts) are scarcely used or not used at all. An exception is Thomas TH,[32] whose review resembles the video essays that remain "comfortably in the explanatory mode," as described by Christian Keathley.[33] He builds his video as a commentary of intertextual references, supporting his claims with clips purposely selected from classic anime series such as *Mobile Suit Gundam* (Yoshiyuki Tomino, 1979–1980), *Mazinger Z* (Yugo Serikawa et al., 1972–1974), and *Magne Robo Gackeen* (Tomoharu Katsumata, 1976–1977). In other cases the images, although displayed, are hardly ever commented on, and the

intertextual references deployed to produce positive or negative judgments are expressed only verbally.

It seems that the impact of digital media's radical innovation was not entirely expected. In the Italian video reviews of *Pacific Rim* digitization does not foster analysis, as predicted by Laura Mulvey, for example.[34] Thanks to digital technology, the films being criticized and analyzed have become partially attainable, to take up a notion proposed by Raymond Bellour in the 1970s, but this seems of little interest to these critics, who keep using gadgets, quotes, and clips as instruments in order to "mimic, evoke, describe" the text, rather than to analyze it.[35]

These appropriated film images work in the same way as intertextual references: rather than having an explanatory function ("Let me explain B because I know A"), they authenticate the critic's expertise ("I can talk of B because I know and/or own A"). Sometimes the expertise and the right to express an idea acquire a biographical and existential quality, thus outlining a kind of communicative circuit that encompasses the critic, the spectators, and the director: "I grew up watching Japanese robots (Grendizer, Gundam, Mazinger, Daitarn), and so did many of you, and so did Guillermo del Toro, director of *Pacific Rim*, therefore what he does in this film is attuned to the way I, and consequently you, enjoy it" (ComingSoonTube).[36]

Setting, mise-en-scène, and intertextual competence make these reviews play that "struggle for recognition" that is typical, according to Jonathan Roberge, of every act of criticism and that drives these stances toward performance rather than toward analysis:

> As a matter of fact, the "agency" dimension of criticism is . . . fundamental and has generated many commentaries over the years. In very few words, it is all about a substantial struggle for recognition. . . . The medium or the format is not exactly relevant here, it could be in a book or in a more specialized journal. By the same token, the topic or the subject is irrelevant; be it music, gadgets, literature, architecture, and so on. In all circumstances, critics are necessarily engaged in a series of justifications about their legitimacy to discuss the justification of others.[37]

From this point of view, and bearing in mind that *Pacific Rim* is but one example, it seems to us that the scenario described by Christian Keathley does not completely apply. It is undoubtedly true, as we will see, that "the forms that criticism takes—its rhetorical and presentational modes—are largely unchanged." Nevertheless, it is not always the case that "criticism is rendered primarily in the explanatory mode, offering interpretation, analysis, explication; the films function as objects of study that the guiding critical language will illuminate." Nor is it true that "the full range of digital video technologies enables film scholars to write using the very materials that constitute their object of study."[38] In short,

according to Keathley, digital innovations allow critics to become authors, fol-
lowing a process similar to that theorized by Alexandre Astruc with the idea of
the *caméra-stylo* in relation to directors.[39] Digital thus rewrites both the history
of cinema and the treated text. From these examples it seems to us that critics,
instead, become performers capable of using the reviewed film as a pretext for
the expression of certain ideas or, rather, *continue* to be performers, as were some
of their senior colleagues.

Which Idea of Cinema?

The arguments used in the reviews, and the idea of cinema that they propagate,
make these videos difficult to define in terms of oppositions between traditional
and innovative or professional and amateur. A recent study based on the meth-
odology of sentiment analysis, for example, has outlined four different genres
of written film reviews online, distinguished by content, vocabulary, and prag-
matic strategies but also by different degrees of professionalization: "Critic
movie reviews tend to be lengthy and comprehensive, covering most aspects of
the movie (storyline, director, cast, etc.). User reviews tend to be informal and
more explicitly emotional, and not all aspects of the movie are analyzed. Discus-
sion board users interact and respond to one another directly, and sentiments
are expressed using stronger language and tend to sound personal. In blog post-
ings, bloggers may discuss multiple topics and discussion of a topic may be inter-
spersed among other topics."[40]

In the video reviews dedicated to *Pacific Rim*, one can find all these charac-
teristics intertwined. The language used is often colloquial, if not vulgar, and
reviewers are quite rude in the way they address hypothetical interlocutors,
anticipating their reactions and sometimes mocking their possible reactions, as
they would on a discussion board or in a live conversation:

> If you are not entertained by a fucking giant robot that beats a giant monster, then
> to me you are a person without a soul, you're a jerk. (AlkaDave)[41]

> I had such an erection that, although I was in the fourth row, I was nearly getting
> to the screen like a snake. (victorlaszlo88)[42]

> Fuck you assholes! I'm a fan of anything that can thrill me! Pay respect to giant
> robots that unlike you matter to people's lives! (cavernadiplatone)[43]

The reviews, nevertheless, are by no means limited to this type of joking threats
or sexist remarks;[44] they attempt in every case, and regardless of their length, to
address the widest possible array of issues relating to the film, thus responding

indirectly, and sometimes directly, to the question about whether the film is worth the price of the ticket.

Among these issues, as frequently happens in evaluative criticism, the plot of the film dominates, and for most of their duration these reviews turn out to be script analysis. Critics with negative opinions argue with complex explanations that the plot is incoherent and that the psychological motivations of the characters are not sufficiently detailed (WideMovieTv),[45] that there are too many implausible moments (Aldo Jones),[46] or that the plot is simply absent (Simone Mancini).[47] Those who like the film, on the contrary, do so despite the weak plot, maintaining that, all in all, it is a minor flaw:

> The script is a bit of a shame, the plot is a bit so-so and the characters are a bit pointless. But who is stupid enough to search for thoughts and sentiments? (chemiguardo)[48]

> If you're seeking profundity, insight, sentimentality, or any psychological research or psychological investigation of the character or of the rest, well, this is the wrong film. (lorensca12)[49]

Even more unexpected and to some extent old-fashioned than the focus on narrative coherence is the auteurist approach: *Pacific Rim* is almost always assessed as a Guillermo del Toro film. In these reviews the author invites expectations, thus informing the viewing experience. "For us, getting in the cinema to watch *Pacific Rim* meant going to see a film by Guillermo del Toro, and not merely a movie based on special effects," confesses Big Dude of WideMovieTv,[50] while the equally disappointed Aldo Jones announces: "I have to give you very bad news: Guillermo del Toro is finished," arguing further that the film was like "seeing Pink Floyd cover Gigione's songs" (Gigi D'Alessio, a popular Neapolitan singer).[51]

What emerges is thus a rather traditional way of reading popular and entertaining cinema, leaning on the modernist concept of the author as a genius against the system,[52] as well as a redeemer of poor and predictable screenplays transformed by the power of mise-en-scène:

> The plot is very simple, a linear plot, banal, but it turns you on because del Toro ... is a director who knows his stuff. (Lex Polymar in AlkaDaveWG)[53]

> Del Toro has made a considerable conceptual and directorial effort, so that he was able to make sense of a plot that any other director would squander on the action scenes. (victorlaszlo88)[54]

Pacific Rim is a film by Guillermo del Toro and that's enough to know that it will be a good movie. (cavernadiplatone)[55]

It is not surprising, then, that even though these considerations are expressed with all the resources of contemporary digital culture and in a colloquial register, their underlying idea of cinema is rather pedantic, based on a neat ontological opposition between art cinema and entertainment. Those who review *Pacific Rim* on YouTube often specify they do not consider it a film with aesthetic ambitions, but this sort of disclaimer, although ironically stated, ends up reiterating a rather outmoded distinction between high and popular culture as ultimately separate fields:

It is not Hamlet, it is a film about robots, otherwise we'd rather see *The Seventh Seal*. (Lex Polymar in AlkaDaveWG)[56]

What's important to me as a spectator is that I got the destruction that I had been promised, but it is not only a simple and coarse destruction, because this is anything but a coarse movie. It can definitely be, maybe, a light-hearted movie, because we are not watching *Citizen Kane*, of course. (victorlaszlo88)[57]

This reasoning is sometimes pushed to extremes in order to express a kind of nostalgia for an art cinema that is purportedly no longer alive:

It feels as if we have seen a sideshow. . . . The issue raised by a similar 200-million-dollar film is that it seems that the cinema in its deepest sense, the real cinema, the cinema created through a real, 100% search for images, narrative, meanings—to put it simply, something like *Citizen Kane*, the highest a film can aspire to be—in fact it seems that that cinema, those films, the beautiful cinema, has died over the years. (MoviememesOriginal)[58]

CONCLUSION

This sample indicates that film criticism on YouTube indeed remains film criticism, following the broad definition given a few years ago by Geoffrey Nowell-Smith: "A form of writing applied to works of art which pursues the general through the particular and is not ashamed to be subjective in its choices of particulars and in the generalization it hazards on the basis of that choice."[59] According to Claudio Bisoni, the web and the digital do not guarantee that the style and language of traditional criticism will be challenged; they will not reinvent criticism's assessment tools but instead provide—in Italy as in other countries—opportunities through which "those who do not have access to certain cultural

institutions are allowed to reproduce the dynamics found elsewhere: being the expert, playing the role of indisputable authority, enjoying intellectual prestige, and so on, in a kind of pop reappropriation of the "expert" paradigm.[60] The expressive side of these reviews is not realized, as described by Keathley, in the genre of the video essay, with the rewriting of the text or the history of cinema, but through performances that stand out as moments of an incessant "struggle for recognition." And we can add that, in this context, certain deep-rooted features of the Italian culture we have described in the first part of this chapter interplay with much broader processes of transformation that have been affecting the mediascape and consequently the function of criticism.

Nothing particularly new then: video reviewers do what their predecessors did twenty or thirty years ago, only with greater technological competence and intermedial awareness but perhaps also with a rather outmoded take on the relationship between art and genre cinema. This failed, or halfhearted, transformation seems facilitated by an Italian cultural milieu in which the lack of separation between political sphere, aesthetic responsibilities, and evaluation has historically made it difficult to unambiguously identify a mediating role for film criticism. YouTube and digital culture as a whole can therefore neither damn nor heal Italian criticism but provide it with more opportunities to take into consideration and possibly to capitalize on.

NOTES

1. Vincenzo Scuccimarra, "Cinefili della rete: I nuovi barbari?" *Il sole 24 ore*, 18 September 2013, http://vincenzoscuccimarra.nova100.ilsole24ore.com/2013/09/cinefili-della-rete-i-nuovi -barbari.html. All translations from Italian are by the authors, unless otherwise stated. In this essay "video criticism" and "video review" refer to film criticism performed on and disseminated by video—rather than the evaluation of video-based works. The same applies to "vlog criticism." The authors have discussed and defined together the overall structure of this chapter. Giacomo Manzoli has written sections 1–3, Paolo Noto sections 4–5.
2. Ibid.
3. See, e.g., Maria Cristina Russo, *Attacco alla Casta: La critica cinematografica al tempo dei social media* (Recco: Le mani, 2013). The same idea is at the core of many of the essays in Roy Menarini, ed., *Le nuove forme della cultura cinematografica: Critica e cinefilia nell'epoca del web* (Udine: Mimesis, 2012).
4. Fredric Jameson, "The Existence of Italy," in *Signatures of the Visible* (New York: Routledge, 1992), 155–229. On the same topic see also Gloria Lauri-Lucente, "Period Theory in the Film History of Fredric Jameson," in *Le età del cinema: The Ages of Cinema*, ed. Enrico Biasin, Roy Menarini, and Federico Zecca (Udine: Forum, 2008), 63–71.
5. See Benedetto Croce, *Breviario di estetica: Quattro lezioni* (Bari: Laterza & figli, 1913).
6. See György Lukács, *The Historical Novel*, trans. Hannah and Stanley Mitchell (London: Merlin, 1962).
7. For the influence of Gramsci and Adorno on Italian film criticism see Giacomo Manzoli, *Da Ercole a Fantozz: Cinema popolare e società italiana dal boom economico alla neotelevisione, 1958–1976* (Rome: Carocci, 2012), 31–39.

8. Fausto Colombo, *La cultura sottile: Media e industria culturale italiana dall'Ottocento a oggi* (Milan: Bompiani, 1998), 76–122.

9. A perfect example of the "critic-writer" is Giuseppe Marotta, author of many novels and screenplays (among them *Carosello napoletano*, 1954, and *L'oro di Napoli*, 1954), who was in charge of the film review section of the *Corriere della sera* and was considered one of the most influential and dreaded film critics during the 1950s.

10. By "organic" we refer to Gramsci's description of critics who do not perceive their work as significant in itself but only functional to a higher degree of justice. See Antonio Gramsci, "Gli intellettuali e l'organizzazione della cultura," in *Quaderni dal carcere* (Turin: Einaudi, 1975), 6–12.

11. The Catholic views on any single Italian or foreign film featured in Italy have been published in *Rivista del cinematografo* since 1929. The Centro cattolico cinematografico was founded in 1935. Annually from 1936 until the 1990s, the center published a book titled *Segnalazioni cinematografiche* (film reviews), including the final judgment about every movie. These books were like bibles, establishing what was worthy of screening in the five thousand film theaters of the Catholic Church.

12. A perfect case study would be the relationship between the leaders of the Italian Communist Party (Partito comunista italiano) and some of the most influential critics, like Guido Aristarco or Mario Alicata, including the well-known debates about controversial movies such as *Senso* (Luchino Visconti, 1954) or *Il gattopardo* (*The Leopard*, Luchino Visconti, 1963). The "*Gattopardo* affair" was recently analyzed in Alberto Anile and Maria Gabriella Giannice, *Operazione Gattopardo: Come Visconti trasformò un romanzo di "destra" in un successo di "sinistra"* (Recco: Le mani, 2013). For a broad treatment of the issue see Stephen Gundle, *Between Hollywood and Moscow: The Italian Communists and the Challenge of Mass Culture, 1943–91* (Durham, NC: Duke University Press, 1995).

13. Much of Pierre Bourdieu's work revolves around the key concept of *habitus*. Here we refer particularly to Pierre Bourdieu, *Distinction: A Social Critique of the Judgment of Taste*, trans. Richard Nice (Cambridge, MA: Harvard University Press, 1984).

14. See Aldo Grasso, *Storia della televisione italiana* (Milan: Garzanti, 2004), 321–345.

15. Enzo Ungari, "Confessioni di un mangiatore di film di provincia," in *Schermo delle mie brame* (Florence: Vallecchi, 1978), 9–23.

16. Vittorio Spinazzola, *Cinema e pubblico: Lo spettacolo filmico in Italia, 1945–1965* (Milan: Bompiani, 1974). In the last decade audience studies have also developed in Italy. See, for example, Mariagrazia Fanchi and Elena Mosconi, eds., *Spettatori: Forme di consumi e pubblici del cinema in Italia, 1930–1960* (Rome: Fondazione scuola nazionale di cinema, 2002); and Mariagrazia Fanchi, *Spettatore* (Milan: Il castoro, 2005). On the lateness of Italian film studies in approaching this question see Alan O'Leary, "After Brunetta: Italian Cinema Studies in Italy, 2000 to 2007," *Italian Studies* 63.2 (2008): 279–307.

17. The third channel was founded in 1979 and soon perceived as revolutionary since it was directly run by the Italian Communist Party, almost to highlight its political legitimacy in the democratic scene.

18. For more on Ghezzi's critical approach see Enrico Ghezzi, *Paura e desiderio: Cose (mai) viste, 1974–2001* (Milan: Bompiani, 1995).

19. Claudio Bisoni, *La critica cinematografica: Metodo, storia e scrittura* (Bologna: Archetipolibri, 2006), 52–55.

20. Jin-Cheon Na, Tun Thura Thet, and Christopher S. G. Khoo, "Comparing Sentiment Expression in Movie Reviews from Four Online Genres," *Online Information Review* 34.2 (2010): 317–338, http://dx.doi.org/10.1108/14684521011037016.

21. Jonathan Roberge, "The Aesthetic Public Sphere and the Transformation of Criticism," *Social Semiotics* 21.3 (2011): 440, http://dx.doi.org/10.1080/10350330.2011.564393.

22. "MovieBlog-278: Recensione *Pacific Rim* (SENZA SPOILER)," www.youtube.com/ watch?v=SFpuYyiNERw.

23. "Recensione—*Pacific Rim* (2013)," www.youtube.com/watch?v=VTi3479n120.

24. "*Pacific Rim*—RECENSIONE FILM," www.youtube.com/watch?v=GWkw9TOlon4& feature=c4-overview&list=UU3xktvKEiWFtxSrN6SR16NA.

25. "*Pacific Rim* || Recensione || AlkaDave ft. Lex Polymar || ITA ||," www.youtube.com/ watch?v=zd87Dit3qkA.

26. "RECENSIONE FILM—*Pacific Rim*," www.youtube.com/watch?v=A52BnoHuTwM.

27. "*PACIFIC RIM*—La (NON)Recensione che a molti non piacerà by Aldo Jones," www .youtube.com/watch?v=SAJMhuCHGas.

28. "*Pacific Rim*—Recensione 3," www.youtube.com/watch?v=Tf8Hv8_QKe8.

29. "*Pacific Rim* | Recensione DS Reviews ITA | HD 720p | *SPOILER* |," www.youtube .com/watch?v=pSN5IHxDHLI.

30. Rastaumbe, comment on "*Pacific Rim* | Recensione DS Reviews ITA | HD 720p | *SPOILER* |."

31. "*Pacific Rim*—L'omaggio al genere Mecha VS Kaiju," www.youtube.com/watch?v= ICTBGZNW5Uk.

32. "*PACIFIC RIM*: la Videorecensione," www.youtube.com/watch?v=bC8ppeVnECU.

33. Christian Keathley, "La caméra-stylo: Notes on Video Criticism and Cinephilia," in *The Language and Style of Film Criticism*, ed. Alex Clayton and Andrew Klevan (Oxon: Routledge, 2011), 180.

34. See Laura Mulvey, *Death 24x a Second* (London: Reaktion, 2006), 144.

35. See Raymond Bellour, "The Unattainable Text," *Screen* 16.3 (1975): 26.

36. "*Pacific Rim*—la video recensione di ComingSoon," www.youtube.com/watch?v=R2mIi -ensME.

37. Roberge, "The Aesthetic Public Sphere," 440.

38. Keathley, "La caméra-stylo," 179.

39. See Alexandre Astruc, "The Birth of a New Avant-Garde: La caméra stylo," in *Film and Literature: An Introduction and Reader*, ed. Timothy Corrigan (Upper Saddle River, NJ: Prentice-Hall, 1999), 158–162.

40. Na, Thet, and Khoo, "Comparing Sentiment Expression," 318.

41. "*Pacific Rim* || Recensione || AlkaDave ft. Lex Polymar || ITA ||."

42. "MovieBlog-278: Recensione *Pacific Rim* (SENZA SPOILER)."

43. "*Pacific Rim*—L'omaggio al genere Mecha VS Kaiju."

44. Although the gender aspect goes beyond our focus, we must note that all the video reviews of *Pacific Rim* we have found are performed by male critics, and in preparing this chapter we have found only a few videos by Italian female critics on YouTube.

45. "Recensione—*Pacific Rim* (2013)."

46. "*PACIFIC RIM*—La (NON)Recensione che a molti non piacerà by Aldo Jones."

47. "*Pacific Rim*—Recensione 3."

48. "*Pacific Rim*—RECENSIONE FILM."

49. "Impressioni a caldo su: *Pacific Rim* (No Spoiler) (Ep.5)," www.youtube.com/watch?v= R735QR2HM1c.

50. "Recensione—*Pacific Rim* (2013)."

51. "*PACIFIC RIM*—La (NON)Recensione che a molti non piacerà by Aldo Jones."

52. See, e.g., Jean-Loup Bourget, "Social Implications in the Hollywood Genres," *Journal of Modern Literature* 3.2 (1973): 191–200, repr. in *Film Genre Reader*, ed. Barry K. Grant (Austin: University of Texas Press, 2003), 51–59.

53. "*Pacific Rim* || Recensione || AlkaDave ft. Lex Polymar || ITA ||."

54. "MovieBlog-278: Recensione *Pacific Rim* (SENZA SPOILER)."

55. "*Pacific Rim*—L'omaggio al genere Mecha VS Kaiju."

56. "Pacific Rim || Recensione || AlkaDave ft. Lex Polymar || ITA ||."

57. "MovieBlog-278: Recensione *Pacific Rim* (SENZA SPOILER)."

58. "RECENSIONE FILM—*Pacific Rim*."

59. Geoffrey Nowell-Smith, "The Rise and Fall of Film Criticism," *Film Quarterly* 62.1 (2008): 12.

60. Claudio Bisoni, "La critica cinematografica tra la sopravvivenza dell'expertise e la logica di Google," in *Le nuove forme della cultura cinematografica*, ed. Roy Menarini (Udine: Mimesis, 2012), 23.

6 ★ BEFORE AND AFTER AFTERELLEN

Online Queer Cinephile Communities as Critical Counterpublics

MARIA SAN FILIPPO

This chapter considers how interactive web-based communities act as critical counterpublics organized around queer cinephilia, using as its seminal case study AfterEllen. Founded in 2002 by Sarah Warn, a Wellesley College graduate with a master's degree in theological studies from Harvard, and updated daily since that time, AfterEllen became *the* premier community (online or otherwise) of early twenty-first-century queer women talking about queer women in film representation and culture. Conceived and designed to facilitate global access and user interaction while forging a discursive sphere around a localized identity-based virtual community, AfterEllen offers a vital example of contemporary media fan-activism fostering a "glocal" cinephile community alongside a queer counterpublic. As an influential pioneer within a media blogosphere that has paved the way for more queer film critics and coverage of queer filmmaking in major media outlets, AfterEllen has also served as a catalyst for women's and queer public meditations on popular culture more broadly. This has been seen both in online forums such as Autostraddle, Bustle, CherryGrrrl, Feministing, Jezebel, Velvetpark, and xoJane and in "pop-up" virtual communities such as that generated by the "It Gets Better" queer youth campaign founded in 2010 by sex columnist and educator Dan Savage. By examining the technological, economic, and ideological tactics that nourish these digital communities of cinephiles and media activists, I aim to understand and promote their counterpublic potential for queer women and new media subcultures, as well as their value for scholars

of queer studies and media studies. Of chief importance to my examination will be a consideration of how AfterEllen coverage transformed following its 2006 acquisition by cable channel Logo, the first advertising-supported commercial channel devoted exclusively to BGLTQ "lifestyle" programming, whose parent company is the international conglomerate Viacom, owned and controlled by media magnate Sumner Redstone. By sifting through AfterEllen's archival record, I aim to track its changing representational politics around film and queer discourse specifically as it shifted from independent to corporate ownership and the ensuing consequences for cinephile communities *and* queer communities, virtual and otherwise, in the digital age.

BEFORE AFTERELLEN: A GENEALOGY OF QUEER WOMEN'S FILM CRITICISM IN THE UNITED STATES

I begin by locating AfterEllen within a genealogy of US film criticism written by critics and fans in queer women's periodicals since the late 1940s, when the pseudonymous Lisa Ben (an anagram for "lesbian"), née Edythe Eyde, a secretary at RKO Studios in Hollywood, began editing and distributing a newsletter titled *Vice Versa*.[1] This lineage is acknowledged in an admiring—if self-congratulatory—ode to the early lesbian press by AfterEllen editor Malinda Lo published on the site in 2005, proclaiming that "indeed, the proliferation of online forums such as AfterEllen's own is simply a high-tech extension of those carbon-copied issues of *Vice Versa* that Lisa Ben used to pass out at the local lesbian bar."[2] Consisting of nine issues of ten to twenty pages apiece produced between June 1947 and February 1948, *Vice Versa* has been digitized in its entirety and is available through the Queer Music Heritage website.[3] Ben's editorial statement, titled "In Explanation," in the June 1947 inaugural issue announces to readers, "This is *your* magazine," and assures potential contributors that their identities could remain anonymous, while a follow-up statement in issue 2 exhorts readers "But, puh-leeze, let's keep it 'just between us girls,'" establishing *Vice Versa* as both a safe *and* exclusive space.[4] This latter call for—and branding through—exclusiveness will continue to be a contested marker of "authenticity" for periodicals such as AfterEllen and the works they cover, as we will see in the particularly loaded case of promotion given to *The L Word* (Showtime, 2004–2009) and its reality-style offshoot *The Real L Word* (Showtime, 2010–present). In her inaugural statement Ben goes on to describe *Vice Versa*'s raison d'être in noticeably indignant terms:

> Yet, there is one kind of publication which would, I am sure, have a great appeal to a definite group. Such a publication has never appeared on the stands. News stands carrying the crudest kind of magazines or pictorial pamphlets appealing

to the vulgar would find themselves severely censured were they to display this other type of publication. Why? Because *Society* decrees it thus.

Hence the appearance of VICE VERSA, a magazine dedicated, in all seriousness, to those of us who will never quite be able to adapt ourselves to the iron-bound rules of Convention.[5]

This premiere issue, authored solely by Ben, featured a lengthy review of the film *Children of Loneliness* (Richard C. Kahn, 1934), also released under the title *The Third Sex* and adapted from Radclyffe Hall's popular lesbian (or cross-dressing) novel of 1928, *The Well of Loneliness*. Apparently made without the direct participation of Hall, produced and distributed by independent Jewel Productions (whose other releases include *Girls for Sale* and *Love Slaves of the Amazon*), with a cast devoid of recognizable stars and a director who specialized in serial westerns, *Children of Loneliness* was hardly a prestige production. Clearly it was the film's connection to Hall's novel and its probable exploration (if not endorsement) of nonnormative lifestyles that led Ben to select it for coverage. Throughout its run *Vice Versa*'s selection of creative works to review ranged from the highbrow (Jean-Paul Sartre's *No Exit*) to the lowbrow (lesbian pulp fiction), making this late pre-Code-period film an unsurprising inclusion in *Vice Versa* despite its raggedy credentials and exploitation-style publicity campaign, which Ben's review scorns as "gaudy pictures outside the theatre displaying scantily-clad girls in amorous poses." Yet "the reporter" (as Ben refers to herself) subsequently admits she "remained to view it twice, because of the unusual nature of the film," and ultimately appears disappointed by there being "not the slightest demonstration of affection between two women displayed upon the screen, aside from a brief flash of one girl with her hand upon the shoulder of another, a casual gesture indeed" (9). In this and other assessments Ben reveals a simultaneous desire for and aversion to these Sapphic scintillations, a conflicted take on the cultural eroticization of lesbianism that we will see echoed in AfterEllen reviewers' wariness of pandering to straight (male) audiences as much, if not more than, to gay (female) viewers. As *Vice Versa*'s first film review, Ben's assessment of *Children of Loneliness* also sets the tone for a politicized gay criticism, proclaiming the film's not-so-latent homophobia and transphobia in terms that nonetheless appear still inscribed by social understandings of "normality": "The references to homosexuality as a 'weakness' and an 'evil' are an insult and an abomination to any clear-thinking and right-minded person, whether normal or a member of what is so aptly referred to as the 'third sex'" (10). Apart from its peevish cataloging of homoeroticism and its political protestations, the bulk of the five-page *Children of Loneliness* review consists of plot synopsis, which is telling in its spoiler-filled assumption that readers will not have occasion to see the film—or perhaps that its surprises need not be preserved, given that it "in no

way resembled the book upon which it was purportedly based" (9). While displaying the same stubborn fidelity to literary sources that characterizes so much of the popular response to film adaptation (for gay-themed films and otherwise), Ben also could be said here to perform, through her retelling, nascent forms of practices that have come to be known collectively as "fan production," including recaps, fan-subs, and slash fiction. She dwells on sequences likely to resonate with her anticipated audience, singling out those most sympathetic to the experience of sexual minorities:

> And then, in what your reporter considers to be one of the few really poignant and natural scenes in the entire film, Paul looks enviously at his servant:
> "*You* can have a girl. *You* can be married. *You* can—have—children." (12)

Reproducing dialogue and tonality presumably from memory, Ben orients her review around the film's forbidden relationships rather than lingering on the conclusive killing off by suicide of Paul that serves as a warning to the other nonconforming characters (and viewers) at film's end. What pleasure she does seem to find in the film consists of these moments of pathos-filled identification alongside her recounting of scenes in that Bobby, the female character labeled a "gender invert," proves nearly insuppressible in her devotion to coworker Eleanor; with tongue-in-cheek derision, Ben describes the overdetermined killing off (by acid thrown in her face) of Bobby, whereby "Vanquished Bobby's death shriek provides a background for [Eleanor and Dave's] first kiss, as 'true love' triumphs" (11). In embittered conclusion Ben dismisses the film as "a vicious piece of propaganda" that shows homosexuals "as a depraved, fiendish, and drunken lot," ending on a plea for more favorable portrayals that also finds its echo in the media visibility campaigns touting "positive images," of which AfterEllen along with the Gay and Lesbian Alliance Against Defamation (GLAAD) remains a primary advocate.

I choose to linger on *Vice Versa* at length not only because of its significance as the heralded "first" American-based periodical dedicated to lesbian and bisexual women's cultural criticism but also to demonstrate its establishment of a template for this identity-based critical approach.[6] In this, the inaugural issue, we can already glimpse the traits and tropes that continue to characterize much of queer cultural criticism in the twenty-first-century digital realm:

1. Personalized address by a reviewer whose credentials are more informed by gay/queer self-identity and experiential cultural knowledge than by professional qualifications or disciplinary expertise.
2. Selection for review of cultural works explicitly referencing lesbian or lesbian-suggestive content prioritized above the works' prestige and/or popularity as

defined by culturally dominant taste and industry indicators, and with that selection encompassing diverse texts through transmedia coverage of print, audio, and screen works.

3. Critical treatment of works emphasizing content over style, with focus given to scenes pertaining to sexual identity and same-sex relationships, sometimes irrespective of their prescribed weight within narrative considerations or resolutions, and frequently accompanied by fan production, including community-minded recaps, fan/tasy speculations, and transformative rereadings.

4. Address to a presumed preconstituted community of like-minded and -identified readers, reinforced through assurances of authenticity and safety, as well as exclusivity marked by "insider" references and "by us, for us, about us" discourse.

5. Active solicitation of reader contributions across formats, including creative submissions, letters to the editor, and commentary.

6. Advocacy for "positive images" with accordant wariness about, or effacement of, less politically correct character types and sensationalistic subject matter, including, most notably, the regarding of sex scenes as alternatively pejorative for their prurience or affirmative for their nonnormative appeal and visibility.

7. Politicized discussion of potential implications for gay identity and rights, with a mostly unquestioned assumption of media representation's substantive influence on "real world" concerns.

This template and *Vice Versa*'s legacy were further fortified when, in 1956, the cofounders of lesbian community advocacy group Daughters of Bilitis, Phyllis Lyon and Del Martin, began monthly publication and national distribution of *The Ladder*, which would remain in circulation with the support of fellow homophile organizations Mattachine Society and ONE Inc. through 1970. Similar in format and production to *Vice Versa*, its contributors also relied on pseudonyms, and each issue was mailed in a deliberately nondescript brown paper cover. Under different editors *The Ladder*'s political edge waxed and waned in subsequent years, taking on the bold subtitle *A Lesbian Review* only to fall apart amid contentious negotiations around editorial content and direction, as well as the questioned alliance with the burgeoning feminist movement. While Janet Meyers's "Dyke Goes to the Movies" column appears to be a recurring feature in the table of contents viewable online, unfortunately I am unable here to examine archival holdings of *The Ladder* in order to parse more closely the coverage it gave film throughout the publication's run.

A number of local and theme-focused queer women's periodicals emerged in the 1970s and 1980s, propelling the emergence of a print publication that dominated the national readership in the decade leading up to the launch of

AfterEllen in 2002. Originally released in 1991 under the title *Deneuve*, glossy lesbian monthly *Curve* deserves a solid share of the critical credit for establishing a market for the production and distribution of films made predominantly by queer women and for the queer women's audience. With promotion and demand for such films surging from the 1990s on thanks to the proliferation of BGLTQ film festivals such as the MIX New York Queer Experimental Film Festival and the Outfest Gay and Lesbian Film Festival in Los Angeles, "gay ghetto" films became increasingly attainable for home viewing, first through mail order outlets such as Wolfe Video, then gradually through rental outlets, and now primarily through digital distribution channels such as Netflix. Again, I am unable to examine *Curve*'s record of film criticism here, though its significance is evidenced through its continuing presence on physical and digital newsstands alongside the more stalwart but less lesbian-focused *Advocate*. The key point here is that, like *Vice Versa* and *The Ladder* before it, *Curve* foreshadows AfterEllen's initial editorial strategy of prioritizing coverage of "small" films featuring explicit lesbian/queer content over bigger-profile Hollywood fare whose creators and target audience are less demonstrably queer-identified. Thus the perception of any individual film's "authenticity" in authorship, viewer address, or anticipated/demonstrated reception seems to dictate preferential treatment, and more affirmative reviews seem to greet films featuring explicitly identified queer characters and positive representations of queer individuals, relationships, and communities.

THEORIZING AND ACCESSING THE QUEER-FAN-FILM-CRITIC-DIGITAL-COUNTERPUBLIC

The importance of "authenticity" has been a consistent trope of writing on queer-themed films and other cultural works, often evaluated by the degree to which the text demonstrates its proximity to the "real" in regard to production, representation, reception, and social context.[7] A notable example pertaining to films as disparate as lesbian indie *Go Fish* (Rose Troche, 1994) and hard-core "dyke" pornography concerns references made to the mechanics of lesbian sex and the congruent address (or lack thereof) to a straight viewership through the auspices of education, titillation, or both.[8] In tension with this marker of representational realness, with its radical aesthetic and lack of mainstream commercial cachet, is the political investment in realness as a signifier of identity-based sanctioning. In his study of the process by which marginalized groups are "brought within the public sphere's purview," Eric O. Clarke identifies this "attribution of 'authenticity' to lesbian and gay publicity proxies—the 'good homosexuals' of contemporary visibility politics" as the third of three interpenetrating modes that work to reinscribe the public sphere's inclusionary promise while disguising

that "inclusion entails fundamental *transformations* in a group's self-identified interests."[9] A chief question I will address pertains to these competing interests—representational authenticity conforming to the values and interests of a queer counterpublic, against that of political viability in the interest of inclusion within the public sphere—and how AfterEllen manages these interests over time. While never a forum for radical politics, and always offering (to some degree) endorsement of media-based entertainment commercially produced for corporate profit, AfterEllen's independence positions it, both literally and figuratively via its pre-2006 structure, on the dividing line between public and counterpublic spheres.

In turning to the digital era, then, my aim is to examine how this template for queer film criticism transitions through (and thus transcends) medium, from Ben's print 'zine to Warn's website, and, furthermore, how AfterEllen negotiates the continuation of this legacy of lesbian/queer film criticism in an age of media conglomeration and homonormativity.[10] How is AfterEllen's transition from independence to corporate ownership following its acquisition evidenced by an examination of its archival record of film journalism, and what are the implications for web-based film criticism's potential as a queer counterpublic?

My understanding of queer counterpublics derives from the significant work performed by queer cultural theorist Michael Warner, who defines *public* as an "indefinite audience rather than a social constituency," which "comes into being only in relation to texts and their circulation," whereas *counterpublics* are publics

> defined by their tension with a larger public. Their participants are marked off from persons or citizens in general. Discussion within such a public is understood to contravene the rules obtaining in the world at large, being structured by alternative dispositions or protocols. . . . This kind of public is, in effect, a counterpublic: it maintains at some level, conscious or not, an awareness of its subordinate status. The sexual cultures of gay men or of lesbians would be one kind of example, but so would camp discourse or the media of women's culture. . . . Participation in such a public is one of the ways by which its members' identities are formed and transformed.[11]

Central to my consideration of AfterEllen then and now is this question of its counterpublic potential and contours, alongside the question of its potential expiration date in terms of its viability as a counterpublic. As Dick Hebdige argues in *Subculture: The Meaning of Style* (1979), "dissident subcultures inevitably face two kinds of incorporation: commodification . . . and ideological dilution [that] ensures that the potential threat to the dominant culture posed by the subculture is 'trivialized, naturalized, domesticated.'"[12] After a certain degree of public sphere infiltration and cultural transformation, does self-recognition as a queer counterpublic necessarily begin to prove disabling or disingenuous?

Every bit as important as evaluating this self-recognition from the perspective of the counterpublic's dominant voices—Warn's and her successor's editorial staff as well as Logo's managerial oversight postacquisition—is that of After-Ellen's collectively voluble and productive readership. In her 1993 ethnography *Star Gazing: Hollywood Cinema and Female Spectatorship*, still a significant model for media reception study, Jackie Stacey analyzes primary documentation (fan mail, questionnaire responses) by female-identified moviegoers whose reports on their relations to film stars reveal nuances more complex, layered, and varied than cinefeminism's psychoanalytically derived model of identification "as analogous to early psychic developments."[13] The multiplicity of processes concerning fantasy and practice that Stacey observes leads her to formulate a taxonomy of star-fan formations that characterizes the creator-user-fans of AfterEllen as they go about reading, reviewing, and creating site content and engaging with one another in encounters with and dialogue about the AfterEllen "star system." More recently, media scholar Suzanne Scott has built on Henry Jenkins's foundational work on "aca/fandom" and participatory culture to ponder the "rigidly gendered" distinctions between fan text production alternately termed "affirmational" and "transformative."[14] In short, affirmational fans are "sanctioned" by the industry because they are willing to "enter into a 'collaborationist' relationship with both the text and its producers, one that is ultimately more monologic than dialogic, and that facilitates the fan's industrial incorporation as a promotional agent. Conversely . . . 'transformational' fandom [is] 'all about laying hands upon the source and twisting it to the fans' own purposes,' neatly aligning contemporary 'transformational' fandom with the resistant tendencies celebrated in the first wave of fan studies."[15] While the latter is an apt description of the largely women-authored slash fiction produced from the late 1960s on, some AfterEllen creators and fans (also overwhelmingly women-identified) engage in the former type of "collaborationist" sensibility when it comes to reviewing and discussing "authentically" lesbian/bisexual-authored and -themed films that, like more heteronormative "bodice-rippers," "women's weepies," and "chick flicks" before them, are associated with a "gay ghetto" not unlike the ghettoized cult of femininity. Still other AfterEllen creators and fans are not so quick to spurn the transformational fandom that characterizes slash, with this model of fandom eventually flourishing on AfterEllen, enabled through onsite components such as vlogs and vidding.[16] In the interest of leveling hierarchies that doubtlessly remain even within a queer counterpublic, I will be considering the totality of these fan labor practices and products as a constitutive part of AfterEllen's archival record.

With this theoretical armature I move into my archival examination of After-Ellen's first decade with my focus on analyzing the site's representational politics at the intersection of discourses on film and queerness. It must be acknowledged that AfterEllen, as its titular reference to TV personality Ellen DeGeneres

suggests, has never been exclusively or even primarily focused on cinema or the film industry and that (as we will see) coverage of film has been a waning if consistently present element of the site's content. For example, the fan practice of recapping television shows has developed into one of AfterEllen's most prominent features, often given highlighted positioning on the home page, but because recapping of films is infrequent, I see the practice overall as critical to my discussion only insofar as it serves to overshadow the site's erstwhile promotion of film.

I am particularly interested in AfterEllen's transformation from an individually owned entity from 2002 through 2006 to its acquisition by Logo/MTV (itself a holding of media conglomerate Viacom), under which it continues to operate today. Other significant organizational transitions, though none as substantive for my purposes as its corporate acquisition, include Warn's cofounding of Erosion Media LLC with partner Lori Grant in 2005 and their subsequent launch of brother-site AfterElton, Warn's being named executive producer at Logo following the 2006 buyout, and Warn's resignation in 2009, when former actor-filmmaker Karman Karman was named editor-in-chief. As a consistent if not devoted reader of AfterEllen, I had the casual impression and initial hypothesis that whatever political intent and counterpublic potential the website displayed during its formative years were significantly if not wholly undermined by its new corporate profile. Yet I worked to remain objective in my analysis to accommodate the potential finding that AfterEllen's evolution does not demonstrate so neatly cleaved a distinction between its independent and corporate eras. To perform the rigorous examination necessary to illuminate the timing and degree of its representational transformation in whatever amount, I have elected not to rely on AfterEllen's own archive but rather to consult the potentially less-biased record cached at the Internet Archive, an independent nonprofit Internet library founded in 1996.[17] Its collections, sustained through data and financial donations, are searchable via the Wayback Machine engine, which regrettably excludes heftier image files and remains incomplete despite its present 372-billion-page catalog of website "snapshots" dating from 1996.[18] The primary evidence referenced here was culled exclusively from my assessment of the Internet Archive cache; to acquire a representative sample of manageable scope, I accessed the first cached page of every June and December from 2002 through the present.

Because this chapter serves as a segment of a larger study of AfterEllen's history and an analysis of its representational tropes across screen media, what follows is limited in its sampling of evidence and projected findings to the specific question pertinent to this volume on film criticism in the digital age. Representational and discursive strategies I peruse are multifold and nonuniform and will, I hope, generate a rhizomatic, if necessarily still rather rudimentary, mapping of AfterEllen's site identity. The above taxonomy of traits and tropes established by *Vice Versa* as a template for lesbian film criticism will set the standard against

which I measure my observations. Regarding personnel, site authorship will be ascertained via writers' bios and self-identification of both "official" contributors and providers of user-generated content, be they affirmational—in Scott's terminology, "collaborationist" (promotional, reverential, and aspirational)—or transformative (critical, satirical, political). Information on the site's finance model is unsurprisingly more opaque, but transparent appeals for external funding, donations, and sponsorship, along with apparent displays of advertising, are assessed. Above all the vicissitudes of site content are appraised, first, for the appearance or avoidance of particular journalistic genres or formats: feature articles, columns, reviews, interviews, polls, recaps, forums, lists, blogs, vlogs, and so on. The subjects chosen for coverage also are clearly of note: which films (or television series, books, etc.) are included, of what historical, global, and aesthetic scope; whether publicly "out" performers or artists are disproportionately highlighted (and what the site's outing policy, if any, appears to be); to what degree un/underrepresented groups receive inclusion; how the site articulates its perspective regarding political notions of visibility, identity politics, and positive images; and ultimately what bias, if any, is evident post-2006 toward promoting Viacom-owned properties.

THE INDIE YEARS: AFTERELLEN AS THE NEW LESBIAN BAR ON THE CYBERSCENE

AfterEllen's appearance online in 2002 was accompanied by an unsigned mission statement titled "About AfterEllen," proclaiming in part that "this site is designed to provide an alternative voice [to then-current online discussions of media representation] by taking a commonsense, everywoman approach to critiquing the subject, based on the belief that lesbian and bisexual visibility in entertainment and the media is important and has progressed, but still has plenty of room for improvement."[19] The statement, likely authored by Warn, has remained in shortened but largely consistent form since and is noteworthy for the description of its discursive voice in populist terms that value accessibility and inclusiveness for its "everywoman" constituency. The statement's syntax works further to put forth a moderately politicized position for change that acknowledges success while urging additional reformation through an identity-based rhetoric of visibility that seems to imply a remove from more radical reinventions of media form and industry structure touted by feminist and queer critics within academe and other venues of "serious" arts criticism. AfterEllen's long-term tagline, "Because Visibility Matters," one of the only unchanging aspects of the site's banner until it was removed in 2010, reinforces this. As its name also suggests, AfterEllen singles out the media event most heralded as the emergent influence of homonormativity on American entertainment culture and in so doing acknowledges

DeGeneres's highly publicized 1997 coming out as both celebrity and fictional character (on her self-titled ABC sitcom) to be both indicative of, and model for, present and future progress.[20] But turning to regard its more connotative signifiers, the sizable shift in aesthetic appearance and content throughout the site but particularly on its home page belies the consistency and politicism that Warn's statement confers.

For nearly the whole of its run so far, AfterEllen carried a descriptive label prominently posted on its home page banner proclaiming its mission to provide "Reviews and Commentary on the Representation of Lesbians and Bisexual Women in Entertainment and the Media." Only in 2013 this descriptor was replaced with a newly designed AfterEllen logo, leaving its promotional mission less foregrounded but presumably believed to be clearly enough signified at this point simply through the site's title. Not even at its inception was AfterEllen privileging film; in June 2002, shortly after its launch, cross-media coverage already constituted its home page in a format that remained consistent through its independent phase for its prioritizing of television, followed by film, with slightly less focus given to personalities, print, and music. "Movies" (the choice of term signals less artistry than "film" or "cinema") has remained a mainstay of the site's home page layout, always appearing next to the consistently top-billed "Television."

Clearly there was reason and willingness to criticize Hollywood's treatment of lesbian/bisexual women in AfterEllen, and early articles displayed a healthy skepticism. In reporting the studio green-lighting of Angela Robinson's feature film *D.E.B.S.* (2004), a result of the acclaim it received as a short film touring on the gay festival circuit, AfterEllen speculates, "Will *D.E.B.S.* make it to the big screen with its lesbian storyline intact, or will Hollywood turn it into another *Fried Green Tomotoes* [sic]?"[21] While her *Vice Versa* review of *Children of Loneliness* demonstrated Lisa Ben's readiness to criticize lesbian-themed films made by Hollywood for a general audience, AfterEllen quickly established its willingness to take lesbian filmmakers to task; a June 2002 article titled "Lesbian Filmmaking 101: Dumbing It Down" begins with a stern admonishment: "Clearly, few lesbian writers/directors paid attention in high school English when the rule 'Show, Don't Tell' was explained. Of all mediums, film is best designed to do just that, yet lesbian filmmakers and screenwriters routinely ignore this basic rule in favor of scripts that have 'insert monologue on Official Lesbian Cause here' peppered throughout. . . . If you took out all the cause-related dialogue from *Go Fish*, for example, you'd only have a ten-minute movie."[22]

This willingness to criticize even sacred cows of lesbian independent filmmaking such as *Go Fish*, and on the grounds both of aesthetic finesse and polemicizing, signals a noteworthy turn away from the primarily promotional approach to film criticism that constrained so much of the gay press at that time and still

AfterEllen.com

Reviews and Commentary on the Representation of Lesbians and Bisexual Women in Entertainment and the Media

| Home | TV | Movies | Print | People | Polls | About |

Featured in TV

The Best Show You Never Watched (And Why You Should Have)

"You'll do anything to protect your image, won't you? Perfect Jessie, who couldn't possibly be in love with a girl."

This accusation by 16-year-old Grace in a recent episode of the critically acclaimed (and just-canceled) television drama "Once and Again" finally verbalized the issue 15-year-old Jessie had been struggling with for months - and marked an historic moment in television. (more)

Featured in Print

That was Then, This is Now

There's nothing wrong with preparing young lesbians for the difficulties they may encounter in coming out, but it would be nice if there were also some Young Adult books that didn't make it appear that lesbians were *destined* for a life of hardship, physical harm, and/or career-ending discrimination. (more)

Featured in Movies

The Right Time: Lesbian and Bisexual Characters in Black Movies

The attitudes of straight African Americans towards black lesbians and bisexual women *have* changed over the last twenty years - but you would never know it from watching movies produced by and for the black community.

It's not enough for black writers/directors/producers just to render black lesbians invisible, they also have to use them as a joke to remind straight black women to toe the feminine line. (more)

Featured in People

Six Degrees of Sandra Bernhard

Throw a rock in a crowded lesbian bar and you're bound to hit someone who's slept with Sandra Bernhard - at least, that's the perception you get from the media. (more)

*Want to submit an article? View Guidelines in About the Site.
Suggestions or Feedback? comments@afterellen.com*

FIGURE 6.1. AfterEllen as it appeared in its inaugural year, 2002.

FIGURE 6.2. AfterEllen in 2014.

today. So, too, did AfterEllen (or, at least, Warn) prove ready to praise works by male filmmakers with ambiguous if not dubious lesbian credentials; a 2003 issue rapturously reviews lesbian cult film *Bound* (Andy and Larry Wachowski, 1996) despite its producer (Aaron Spelling) and a fervent following among straight men.[23] In a related vein AfterEllen demonstrated an enduring eagerness, at least during its independent era, for humorously political commentary compiled within a "Satire" page, accessible via a link that appears on the home page banner starting in 2002.[24] Directed primarily at foes of queer-friendly representation, from relatively benign Hollywood—a fake report about actor Ben Affleck being cast in films for his ability to convert his lesbian costars, in a dig at his previous efforts in *Chasing Amy* (Kevin Smith, 1997) and *Gigli* (Martin Brest, 2003)—to more truly threatening forces looming unabated ("Religious Conservatives Burn Lesbian Novels, No One Cares," reads one such headline, bitterly).[25]

Even apart from its satirical pieces, AfterEllen has consistently addressed these types of cultural and industrial slights, big and small, at the cost of queer visibility. A 2010 feature explicitly rebuked *ABC News* for a "Most Famous Lesbian Scenes on Film" segment it ran in advance of the premiere of *Black Swan* (Darren Aronofsky, 2010) because it was discovered to have been penned by a nonlesbian.[26] AfterEllen's coverage of queer media's intersections with racial and ethnic difference is present from its earliest phase (a 2002 feature titled "The Right Time: Lesbian and Bisexual Characters in Black Movies" under the byline "Lesly S."), remains visible during the acquisition period (a 2006 article addresses the lack of visibility of black butch lesbians), and continues today in the heavy promotion given lesbian films made by women of color, such as *Pariah* (Dee Rees, 2011).[27] Not surprising, given its increasingly "glocal" reach, AfterEllen also continues to promote the work of international lesbian filmmakers, recently giving laudatory mention to directors such as Céline Sciamma (France) and Zero Chou (Taiwan).

Also in its nascent period AfterEllen actively encouraged reader interaction with the introduction of polling, designated with its own page on the site circa 2002; in yet another jab at certain lesbian filmmakers one such question asked, "What was the worst 'popular' lesbian movie ever?"[28] In the interest of stimulating more complex lesbian films, AfterEllen's polling practice could be considered a prototypical form of web-based activism that has pejoratively been called "clicktavism." Film education, or at least appreciation, appears to be a significant goal in AfterEllen's history, especially in its earliest years, when it would regularly review films from earlier time periods (admittedly this may have been partly attributable to its relatively small staff's need to create content quickly and efficiently). In 2004, for example, AfterEllen's home page prominently featured reviews of *Heavenly Creatures* (Peter Jackson, 1994) and *Fire* (Deepa Mehta, 1996).[29]

Yet even at this early phase of AfterEllen there is evidence of the site's increasing willingness to promote recent films, however lackluster, made "within the

community" and to entertain shallower sensibilities; in the same month it ret-rospectively honored *Heavenly Creatures* and *Fire*, the site also affectionately reviewed a straight-to-DVD lesbian romantic comedy titled *Mango Kiss* (Sascha Rice, 2004) and recycled the "A Lesbian Thanksgiving" feature that offered rec-ommendations for (lesbian-themed) "sappy romantic comedies, cheesy feel-good dramas, and classic teen movies."[30] In June 2006 the site displayed the same breadth of film coverage and treatment. An article featured on its home page pro-moted the first US DVD release of BBC film *Portrait of a Marriage* (1990), with shorter reviews devoted to the recent queer-themed film festival Newfest and two acclaimed independent lesbian features with "serious" story lines, *Water-melon Woman* (Cheryl Dunye, 2006) and *Gypo* (Jann Dunn, 2005). This seri-ousness, however, was tempered by reviews of lighter-weight romantic comedies *Imagine Me & You* (Ol Parker, 2005) and *Loving Annabelle* (Katherine Brooks, 2006).[31] My point in enumerating the range of films given attention has relevance for what came both before and after AfterEllen. Whereas lesbian film criticism predating AfterEllen lacked the resources to be comprehensive in its coverage (in the case of *Vice Versa* or *The Ladder*) or elected to steer clear of any films not explicitly lesbian-themed and preferably lesbian-authored (in the case of *Curve* and *Girlfriends*), film reviewing on AfterEllen encompassed those types of films, as well as recent and classical commercial and cult works, the vast bulk of which were made largely by and for men both within and outside of Hollywood. See, for example, AfterEllen's good-sported embrace of films such as *Bound* and *Femme Fatale* (Brian De Palma, 2002), and its proclivity for promoting "guilty pleasures" of the variety featured on its "Top 10 Lesbian Vampire Flicks List."[32] Yet the evidence presented here fails to give as vivid an impression of just how nondiscriminatory AfterEllen has become as the scope and size of its content has grown, given that the more surprising entries for promotion and coverage come from television and the contemporary enthusiasm for reality shows.

The aforementioned question of AfterEllen's heavy promotion of *The L Word* didn't begin with the Logo acquisition (Showtime, the premium cable channel on which *The L Word* aired, was owned by Viacom until December 2005, when it became part of newly split-off parent company CBS Corporation). In 2004 a disclaimer stating "NOTE: AfterEllen is not affiliated with Ellen DeGeneres or *The L Word*" appeared along the bottom of AfterEllen's home page and was only removed in 2013. At the time of the acquisition, Warn posted a statement describ-ing the transition while assuring readers of its continuing impartiality: "And while we will continue to report on Logo's LGBT entertainment programming, as we have in the past, we are still committed to unbiased coverage of *all* enter-tainment that promotes gay and lesbian visibility."[33] This reliance on disclaimers reveals that what seemed self-evident to site viewers was also acknowledged by site creators: the degree to which *The L Word* and AfterEllen acted as symbiotic

forces for one another's success. However fortuitous this mutually beneficial bargain, it seems fair to say that their respective successes had much to do with one another. Again, for the purposes of this chapter's devotion to discussing AfterEllen's *film* criticism, I will hold off on my extended discussion of this close coupling between site and show—though it deserves mention even here for the sustained self-interest AfterEllen exhibited in involving itself with the Showtime hit and its also sizable social networking offshoot OurChart and spin-off reality series *The Real L Word*. But because Logo TV is largely uninvolved in producing or distributing film content (though it did release Maria Maggenti's *Puccini for Beginners* theatrically in 2008), the question of how its acquisition has affected AfterEllen's film reporting is less vexed than that of its television programming.[34]

More important for this segment of my study is that parent company Viacom maintains control of Paramount Pictures Corporation, which it acquired via merger in 1983. Clearly there is nothing like the suspect bent toward promoting Paramount products as is noticeable in the promotion of Logo, MTV, and Showtime shows. As of this writing, for example, AfterEllen's "Movie" page spotlights across its "Trending" banner three recent releases that are explicitly lesbian themed (albeit two of which are courting controversy on this count)—*Blue Is the Warmest Color* (Abdellatif Kechiche, 2013), *Concussion* (Stacie Passon, 2013), and *Passion* (Brian De Palma, 2012)—but also gives prominent coverage to holiday season favorite *American Hustle* (David O. Russell, 2013), for which neither film nor filmmaker seems to warrant mandatory coverage by a lesbian media site.[35] The considerable promotion with which AfterEllen greeted Steve Antin's *Burlesque* in 2010 might seem more easily explainable given that it starred queer allies Cher and Christina Aguilera in what promised to be a camp extravaganza (if box-office disappointment).[36] Yet here, too, rather than needing obvious markings as lesbian themed to justify its prime billing, such lesbian-*un*suggestive content was buttressed by adjoining stories with unassailable lesbian credentials: an interview with out lesbian actress Ellen Page and a review of the collected works of experimental lesbian filmmaker Barbara Hammer.[37] What is most surprising here is that in the wake of competition from similarly lesbian-themed site Autostraddle alongside the sheer diversification of websites covering media and entertainment, AfterEllen has reacted not by doubling down on its niche branding as a lesbian-specific site but by casting its net so wide as to make it increasingly difficult to discern AfterEllen's precise identity.

While it could be argued that some of this broadening is attributable to the way in which queerness increasingly permeates even mainstream media, the more convincing explanation is that AfterEllen is broadening its scope and address in the interest of financial prudence. Whether that perception will be proven valid remains to be seen. Posting trailers for films such as *Red Dawn* (Dan Bradley, 2012) and *Lincoln* (Steven Spielberg, 2012) with links to find theatrical showtimes

through Nextmovie, as the site did beginning in 2012, is a rather bald-faced bargain to repurpose AfterEllen for mass promotion and mainstream appeal.[38] In an all-too-revealing change of the long-standing site tagline "Because Visibility Matters," the unveiling in 2010 of a new tagline, "The pop culture site that plays for your team," acknowledges the broader expanse of media coverage though more emphatically focuses on the "popular," while less blatantly referring to its lesbian and bisexual readership even as its affirmation of the "team's" playful interests are privileged above more serious and potentially unappealing critical analysis. In other words present-day AfterEllen hasn't lost its bent for covering and even probing queer representation; it is just laxer about *which* films it includes and thus about (queer) cinephilia. Its coverage of "movies" remains ever more comprehensive, but their treatment gets more frivolous and less identity-based. While there were gossipy items appearing on AfterEllen in its infancy (a 2002 link in the "Movie News" column buzzed "[Christina] Ricci to get naked with [Charlize] Theron in *Monster*"), AfterEllen's tabloidish tendencies have been enabled by the addition of elements to its interface such as the "Afternoon Delight" blog, a daily roundup of superficial news items of the "Pink's New Baby" and "Ellen and Portia's House Put on Market" variety posted in June 2011.[39] In conclusion, the corporate acquisition of AfterEllen did not result in a transparent transition to nakedly shilling Viacom product so much as it sparked the more insidious integration of nonqueer content onto the site in such a way that promotes all media conglomerates' cross-promotional interests at the cost of AfterEllen's initially niche-driven interests in promoting specifically queer interests in media. This inevitable shift into homonormativity is precisely what Eric Clarke points to as constituting the tail end of a counterpublic's viability.

Meanwhile, the digital transformation of queer film criticism as represented in AfterEllen's transformation raises a somewhat more curious issue pertaining to user-generated content, fan labor, and what has been morosely called "the death of the film critic."[40] Where AfterEllen featured editorial articles and reviews on its home page for much of its run, the past few years have seen the marked influence of user-generated content, with increasing prominence to threads such as "Active on Forum" and "The Hottest Stories" that tally user participation and corral viewers toward interactive entry points. A final question, for which the comparison with other chapters in this volume could yield an answer, is to what degree do AfterEllen's critical tendencies adhere to or depart from that of film criticism in the digital age more broadly? It is not without some dismay that, in gazing over AfterEllen's current landscape, I find its attention to film criticism less rigorous and predominant, so I am hopeful that the situation is sunnier, cinephilically speaking, on those sites that (unlike AfterEllen) privilege film culture more centrally or are unburdened by identity politics, no matter how loosely construed.

NOTES

I wish to thank the planners and attendees of two academic conferences where I delivered a talk that generated this chapter: the Media in Transition 8 conference at the Massachusetts Institute of Technology in May 2013 and the Mediating Public Spheres Symposium sponsored by the Five College Women's Studies Research Center in April 2013.

1. *Vice Versa's* reporting remained unsigned; Eyde did not use "Lisa Ben" until later, in writing for subsequent lesbian publication *The Ladder*.
2. Malinda Lo, "Back in the Day: *The Ladder,* America's First National Lesbian Magazine," AfterEllen, 1 November 2005, www.afterellen.com/back-in-the-day-the-ladder-americas-first -national-lesbian-magazine/11/2005/. Candace Moore also suggests the importance of *Vice Versa's* film criticism column as a lens for a proto-queer reading of media. See Candace Irene Moore, "L Words: TV's New Queer Lexicon" (PhD diss., UCLA, 2010), 20–31.
3. *Vice Versa,* June 1947–July 1948, www.queermusicheritage.us/viceversao.html.
4. *Vice Versa,* June 1947, 1; *Vice Versa,* July 1947, 2.
5. *Vice Versa,* June 1947, 1; subsequent references to this issue are cited parenthetically by page number in the text.
6. The July 1947 issue of *Vice Versa* features another film review covering the French feature *Club de femmes* (Jacques Deval, 1936), set in a women's residence and also more than a decade old but in rerelease at the time of Ben's review. See *Vice Versa,* July 1947, 12–15. I have written about this genre of "women's institution film" as constituting a prevalent narrative means for the negotiation of "compulsory monosexuality" elsewhere. See Maria San Filippo, *The B Word: Bisexuality in Contemporary Film and Television* (Bloomington: Indiana University Press, 2013), 129–150.

 Only one other film review, of the more solidly Hollywood-credentialed Carole Landis–Adolphe Menjou identity-switching comedy *Turnabout* (Hal Roach, 1940), also in theatrical rerelease at the time of Ben's review, appeared in *Vice Versa's* nine-issue run. While the reason for the film reviews' disappearance is unclear, it seems likely due to Ben's dependency on reader submissions (which she actively solicited) and her own creation of content.
7. See Julie Levin Russo, "'The Real Thing': Reframing Queer Pornography for Virtual Spaces," in *C'Lick Me: A Netporn Studies Reader,* ed. Katrien Jacobs, Marije Janssen, and Matteo Pasquinelli (Amsterdam: Institute of Network Cultures, 2007), 239–252.
8. See Lisa Henderson, "Simple Pleasures: Lesbian Community and *Go Fish,*" in *Chick Flicks: Contemporary Women at the Movies,* ed. Suzanne Ferriss and Mallory Young (New York: Routledge, 2008), 132–157. See also Jennifer Moorman, "Gay for Pay, Gay For(e)play: The Politics of Taxonomy and Authenticity in LGBTQ Online Porn," in *Porn.com: Making Sense of Online Pornography,* ed. Feona Attwood (New York: Peter Lang, 2010), 155–167.
9. Eric O. Clarke, *Virtuous Vice: Homoeroticism and the Public Sphere* (Durham, NC: Duke University Press, 2000), 9, 12.
10. The term *homonormativity* was popularized by cultural historian Lisa Duggan to refer to a sexual politics "that does not contest dominant heteronormative assumptions and institutions but upholds and sustains them, while promising the possibility of a demobilized gay constituency and a privatized, depoliticized gay culture anchored in domesticity and consumption." See Lisa Duggan, "The New Homonormativity: The Sexual Politics of Neoliberalism," in *Materializing Democracy: Toward a Revitalized Cultural Politics,* ed. Russ Castronovo and Dana D. Nelson (Durham, NC: Duke University Press, 2002), 179.
11. Michael Warner, *Publics and Counterpublics* (New York: Zone, 2005), 55–57, 66.
12. Dick Hebdige, quoted in Robert McRuer, *Crip Theory: Cultural Signs of Queerness and Disability* (New York: NYU Press, 2006), 174.

13. Jackie Stacey, *Star Gazing: Hollywood Cinema and Female Spectatorship* (London: Routledge, 1993), 134.

14. *Aca/Fan* is a term Henry Jenkins popularized and defines as "a hybrid creature which is part fan and part academic . . . [whose objective is to] find a way to break cultural theory out of the academic bookstore ghetto and open up a larger space to talk about the media that matters to us from a consumer's point of view." Henry Jenkins, "Who the &%&# Is Henry Jenkins?" *Confessions of an Aca-Fan*, undated, http://henryjenkins.org/aboutmehtml.

15. Suzanne Scott, "Revenge of the Fanboy: Convergence Culture and the Politics of Incorporation" (PhD diss., University of Southern California, 2011), 31–32. See also Henry Jenkins, *Textual Poachers: Television Fans and Participatory Culture*, rev. ed. (New York: Routledge, 2012).

16. *Vlog* refers to video blogs or web-based content whose authors use embedded or linked video as the foundation for disseminating information. *Vidding* is a term for the fan labor practice of creating new works based on the reediting or "mash-up" of one or more original texts with the intention to reveal and celebrate queer meaning or to provide a comically irreverent rereading.

17. See https://archive.org/. I'm grateful to Julie Levin Russo for making me aware of this valuable research tool.

18. The links to the Wayback Machine correspond to the URL of the pages in question as they appear in the archive; the referenced article may only be viewable in this original form through a search using the Wayback Machine.

19. "About AfterEllen.com," AfterEllen, 1 July 2002, http://web.archive.org/web/20020701004553/http://AfterEllen.com/about.html.

20. For more on this event's significance see Anna McCarthy, "*Ellen*: Making Queer Television History," *GLQ* 7.4 (2001): 593–620.

21. Sarah Warn, "*D.E.B.S.* the Movie: Will the Lesbians Stay in the Picture?" AfterEllen, 20 June 2003, http://web.archive.org/web/20030620142139/http://www.afterellen.com/Movies/debs.html.

22. Sarah J., "Lesbian Filmmaking 101: Dumbing It Down," AfterEllen, 8 June 2002, http://web.archive.org/web/20020608085143/http://AfterEllen.com/Movies/Rules.html. While no masthead appears on the site at this point, the article's byline, "Sarah J.," likely refers to Sarah Warn, née Jellen.

23. The subsequent revelation that one of *Bound*'s fraternal cowriter/directors, Larry (now Lana) Wachowski, identifies as transgender only serves to legitimate further the pair's inaugural effort. Sarah Warn, "Review of *Bound*," AfterEllen, 14 June 2003, www.afterellen.com/review-of-bound/06/2003/.

24. The Satire page appeared irregularly in the site's early years, before being converted to a blog titled "Fake Gay News" that survived the Logo acquisition but disappeared shortly thereafter. A link to the blog, which also carried the Logo Online brand, sported the tagline "because real gay news is too damn depressing." Home page, Fake Gay News, 5 December 2006, https://web.archive.org/web/20061101212615/http://www.fakegaynews.com/.

25. "Ben Affleck to Seduce Lesbian Jenifer Garner in Upcoming *Daredevil*"; "Religious Conservatives Burn Lesbian Novels, No One Cares," AfterEllen, 9 December 2002, http://web.archive.org/web/20021209043317/http://AfterEllen.com/satire.html.

26. Jamie Murnane, "The Most Famous Lesbian Scenes on Film, as Decided by a Nonlesbian," AfterEllen, 2 December 2010, www.afterellen.com/the-most-famous-lesbian-scenes-on-film-as-decided-by-a-non-lesbian/12/2010/.

27. Lesly S., "The Right Time: Lesbian and Bisexual Characters in Black Movies," AfterEllen, June 2002, http://web.archive.org/web/20020802221227/http://www.AfterEllen.com/Movies/

blackmovies.html; Allison Bland, "Tasha, 'The L Word,' and Black Butch Lesbians in Film and Television," AfterEllen, 13 March 2007, https://web.archive.org/web/20070528200859/http://www.afterellen.com/TV/2007/3/blackbutchlesbians.

28. "Poll," AfterEllen, 1 June 2002, http://web.archive.org/web/20020628091358/http://www.AfterEllen.com/polls.html.

29. Malinda Lo, "Review of *Heavenly Creatures*," AfterEllen, 2 December 2004, https://web.archive.org/web/20041207043450/http://afterellen.com/Movies/122004/heavenlycreatures.html; Malinda Lo, "Review of *Fire*," AfterEllen, 6 June 2004, https://web.archive.org/web/20040606110338/http://afterellen.com/Movies/fire.html.

30. Kris Scott Marti, "Review of *Mango Kiss*," AfterEllen, 29 November 2004, http://web.archive.org/web/20041129134518/http://www.AfterEllen.com/Movies/112004/mangokiss.html; Malinda Lo, "A Lesbian Thanksgiving," AfterEllen, 23 November 2004, http://web.archive.org/web/20041206174254/http://www.AfterEllen.com/Movies/112004/thanksgiving.html.

31. Karman Kregloe, "Review of *Portrait of a Marriage*," AfterEllen, 1 June 2006, https://web.archive.org/web/20060614181556/http://www.afterellen.com/Movies/2006/6/portrait.html.

32. Malinda Lo, "Top 10 Lesbian Vampire Flicks," AfterEllen, 31 October 2006, http://web.archive.org/web/20061106142454/http://AfterEllen.com/Movies/2006/10/vampire.html.

33. Sarah Warn, "Letter from the Editor: Announcing Our Acquisition by Logo," AfterEllen, 5 June 2006, http://web.archive.org/web/20060611120508/http://www.AfterEllen.com/About/logo-letter.html.

34. Logo, like other cable entities (and including its Viacom-owned sister channels Comedy Central, MTV, and Nickelodeon), is increasingly moving into making its programming content available for download and on demand.

35. The trending lesbian-themed films appeared on the banner during the week of 16 December 2013, https://web.archive.org/web/20131204011847/http://www.afterellen.com/movies/. *American Hustle* was reviewed during the same week, https://web.archive.org/web/20131214211107/http://www.afterellen.com/.

36. See the multiple features and interviews devoted to *Burlesque* in November 2010, https://web.archive.org/web/20101203105207/http://www.afterellen.com/movies.

37. Dorothy Snarker, "Ellen Page Talks Feminism, Film, and Fame in Hollywood," AfterEllen, 6 April 2010, https://web.archive.org/web/20101207035651/http://www.afterellen.com/blog/dorothysnarker/ellen-page-talks-films-feminism-and-fame-in-hollywood; Trish Bendix, "An Interview with Barbara Hammer," AfterEllen, 8 March 2010, https://web.archive.org/web/20101207023752/http://www.afterellen.com/people/2010/3/barbara-hammer.

38. "Trailers, *Red Dawn* and *Lincoln*," AfterEllen, 7 December 2012, https://web.archive.org/web/20121121071826/http://www.afterellen.com/movies/.

39. The link to the *Monster* article appears on 1 December 2002, https://web.archive.org/web/20021213132255/http://www.afterellen.com/movies.html; Pink's birth announcement and mention of DeGeneres and Portia di Rossi appears in an "Afternoon Delight" column written by Bridget McManus and titled "Pink Has Baby Girl, Olivia Wilde Signs Up for 'The Words,'" AfterEllen, 3 June 2011, https://web.archive.org/web/20110606064353/http://www.afterellen.com/afternoon-delight-2011-06-03.

40. See, e.g., Roger Ebert, "Death to Film Critics! Hail to the CelebCult!" Roger Ebert's Journal, 26 November 2008, www.rogerebert.com/rogers-journal/death-to-film-critics-hail-to-the-celebcult.

7 ★ ELEVATING THE "AMATEUR"

Nollywood Critics and the Politics of Diasporic Film Criticism

NOAH TSIKA

When Roger Ebert, in many ways the quintessential symbol of a sustained journalistic film criticism, died in April 2013, eulogies quickly spread across the globe. In Nigeria they tended not only to acknowledge Ebert's status as a beloved writer but also to celebrate his longtime championing of black African and diasporic cinemas. At the same time, many of these eulogies managed to suggest that maybe, just maybe, Nigeria would one day generate its own iconic movie critic, one who could cut to the heart of local productions and communicate to readers their "real" value. Writing for *YNaija*, which describes itself as "the Internet newspaper for young Nigerians," Nnaemeke Ijioma paid tribute to Ebert, quoting his familiar conception of film criticism, acknowledging his influence on multiple generations of journalists, and lamenting the lack of any local heirs to his cherished critical throne.[1] Such a lamentation is not limited to the dimensions of cross-cultural imitation, however; it is not simply a reflection of some of the effects of a Western cultural and media imperialism, of which Roger Ebert, as a globally syndicated columnist, was inescapably a part.[2] It is also an indication of the need for a celebrity critic to emerge, as a clarifying force, from the confusions and controversies of Nigeria's contemporary mediascape.

One of the chief challenges of Nollywood studies has been to determine the exact jurisdiction of the term *Nollywood* itself. Local linguistic divisions have contributed to this difficulty, particularly with the informal partitioning of southern Nigerian film production into Bini, Igbo, Yorùbá, and English/Pidgin

sectors. The question of which of these sectors is "deserving" of the Nollywood label is, however, swiftly becoming archaic, especially with rapid increases in the subtitling and streaming of southern Nigerian films. Popular websites like iROKOtv, AfriNolly, and iBAKAtv provide the broadest possible definition of *Nollywood*, grouping all manner of southern Nigerian film productions according to the moniker—and even including films that are shot in Britain and the United States using southern Nigerian funding sources and personnel. Clearly, then, *Nollywood* is a capacious term. As a largely Lagos-based, multilingual, multicultural enterprise, the industry generates close to two thousand Nigerian films each year—more, perhaps, than any one critic could possibly evaluate.[3] Nevertheless, Ijioma and other Nigerian journalists have consistently called for the cultivation of a local Ebert—someone with "the knowledge, the panache, the boldness and professionalism of [a] proper film critic."[4] Without such a figure how might Nigerians "sieve through the myriad of video releases that assail our eyes every day?" As Ijioma suggests, putting his own spin on Ebert's professional self-description, "The critic is like a guide, pointing the direction to the stars . . . and the black holes, too."[5]

To complain that there are no legitimate film critics in contemporary Nigeria is to suggest an extremely limited conception of criticism. Certainly, such Nigerian television programs as *VHS* and *The Glo G-Bam Show* both regularly address new film releases, as well as broad trends in music, dance, and stand-up comedy. Yet like an increasing number of Nigerian television shows, they are emphatically sponsored affairs, more demonstrably committed to supporting the bottom lines of their corporate parents than to proffering critical opinions. *The Glo G-Bam Show*, for instance, is a production of the Nigeria-based Globacom, currently West Africa's top telecommunications provider, and it consistently— even brazenly—bears Globacom's corporate stamp, especially in its coverage of those films that Globacom has sponsored, such as Kunle Afolayan's 2011 romantic comedy *Phone Swap*. Whatever their corporate origins, *VHS* and *The Glo G-Bam Show* provide consistent coverage of the southern Nigerian entertainment "scene," furnishing "objective" production information about a variety of films and, in so doing, perhaps equipping viewers with some of the tools necessary for their own private forms of film criticism. To cobble together a critical stance from the strands of facts, figures, and official press releases condensed in a biased television broadcast is not, however, the kind of critical project that Ijioma appears to have in mind. When he declares that there are currently no Ebert-style film critics in Nigeria, Ijioma is obviously discounting televised commentators, upholding the written word over the spoken. But lest he seem to have represented an exclusive commitment to print journalism—a sort of gold standard unsullied by other, "lesser" media—it is important to remember that Ebert was, in fact, the cohost of a long-running, widely syndicated television series,

the source of his famous, shared "thumbs-up, thumbs-down" model of succinct judgment. Ijioma acknowledges this history, but for him it suggests less a bastardized, commodified form of film criticism (as Pauline Kael called it) than a means through which Ebert was able to quickly and accessibly disseminate his critical acumen to the broadest possible public.[6]

Nearly four decades after *Sneak Previews*—the first series that Ebert cohosted with Gene Siskel—premiered on PBS, the blogosphere has arguably far surpassed television as a mechanism for promoting, defining, and criticizing films. This is no less true for blogs that begin life in a country like Nigeria, where broadband access is relatively limited and burdened further by frequent electricity blackouts. In the past five years I have encountered a total of sixty Nigerian blogs devoted to film analysis. (There have undoubtedly been—and there will undoubtedly be—many more.) If no Nigerian blog has become a galvanizing force affecting local modes of film production and consumption, that is not necessarily because Nigerian bloggers lack the kind of commitment to critical judgment that Ijioma sees in Roger Ebert. A more likely explanation is a persistent lack of local awareness of blogs, which, in Nigeria, can be difficult to find without critical guidance or access to a stable search engine and which must contend with limited broadband services and habitual blackouts. There are also, of course, the nagging matters of language and literacy—questions about whether a blog can reach the widest readership in English or in, say, Yorùbá or Igbo, and about whether *written* criticism is at all practical in a place where a sizable percentage of the population cannot read. However, just as the cultural impact of Siskel and Ebert can be gauged through American films that directly reference the duo (such as *Welcome to Hollywood* [Tony Markes and Adam Rifkin, 1998] and *Jiminy Glick in Lalawood* [Vadim Jean, 2004]), the influence that Nigeria's cinema-centered blogosphere has exerted on local modes of media production can be seen in a variety of Nollywood films. These include Lancelot Oduwa Imasuen's 2011 drama *The Celebrity*, in which the actress Uche Jombo plays a public figure who worries about "blog-based gossip," and Ubong Bassey Nya's *BlackBerry Babes* (2011), *Return of BlackBerry Babes* (2011), and *BlackBerry Babes Reloaded* (2012), in which glamorous young women wield smart phones while singing the praises of such sites as NaijaGists, NigeriaFilms, and the blogs *This Is Nollywood*, *Nollywood Spotlight*, and *Nollywood Rave*, all of which maintain a discernible commitment to analyzing film content.

While it might seem axiomatic to suggest that the blogosphere has democratized the art of film criticism, blurring the lines between amateur and professional, inner-directed prose and the practice of "writing for the public," the effect of such democratization on movie-minded African diasporas has not been adequately acknowledged. This chapter focuses on recent efforts to fuse various forms of film criticism in order to maintain and celebrate Nollywood's

transnational appeal. Created in 2010, NollywoodCritics began as a website devoted to digitizing the writings of salaried film critics—those working for a variety of Nigerian print publications. More recently, however, the website has come to embrace lay film critics from around the world, whose voices it positions not simply as crucial vernacular counterbalances to "professional" prose forms but also as reflections of Nollywood's truly global appeal. Based in Houston and Atlanta—but also in London and Paris—the nonprofessional film analysts who regularly contribute to NollywoodCritics are also voting members of the Nollywood and African Film Critics Association, a group whose annual awards honor achievements in African cinema.

Nollywood offers a crucial context for exploring film criticism in the digital age. While the industry's birth is most often traced to 1992 (and the release of Kenneth Nnebue's remarkably successful, Igbo-language *Living in Bondage*), its expansion into one of the world's leading producers of feature films was coterminous with the later development of the blogosphere as a dominant source of film criticism. Ironically, the efforts of NollywoodCritics to ensure the diasporic success of Nollywood through its far-flung and nonprofessional film critics have lately confronted the pressures of the so-called New Nollywood Cinema. A movement marked by big-budget "professional" productions and ever-evolving commercial aspirations, the New Nollywood Cinema seeks to dispense with any semblance of the amateur in its attempt to redefine and "professionalize" Nigerian media for the purposes of global consumption.[7] Its exponents tend to be ideologically opposed to the "amateur"-dependent NollywoodCritics, even though they share the website's goals of expanding and promoting Nollywood's global reach. In other words the operative assumption appears to be that nonprofessional film critics will confer on their objects of analysis precisely the kind of "amateurishness" that practitioners of the New Nollywood Cinema are so famously trying to shake; to be seen as "skilled," a film must therefore be associated (even as the subject of vitriolic critique) with seasoned, salaried reviewers.[8] NollywoodCritics is thus positioned at the discursive and practical crossroads of old and new, professional and nonprofessional, foreign and domestic— crossroads that uniquely characterize Nollywood and its critics, even as they reflect broader developments in film production and film criticism.

AFRICAN BACKGROUNDS

Nollywood is now at a compelling stage of its development—one that offers considerable insight into the collision of old and new media (to borrow a phrase from Henry Jenkins) and the effects of that collision on film criticism.[9] Before I address these effects in greater detail, however, it is necessary to examine the relationship between Nollywood and African cinema—a relationship that has

always centralized the qualitative, affective, industrial, and economic differences between celluloid and video (in both its analog and digital formats). Having emerged, though under no agreed-upon name, with the advent of home-video devices (camcorders, VHS tapes, VCRs) in the 1970s and 1980s, the industry received its first shot in the arm around 1992, when Kenneth Nnebue produced the two-part Igbo melodrama *Living in Bondage*—a film whose release, as numerous Nollywood scholars have pointed out, broke ground not through any narrative, thematic, or stylistic interventions but instead through a series of extratextual promotional materials, such as standardized, shrink-wrapped cassette packaging and star-centered posters primed for dissemination in urban marketplaces.[10] With VHS distribution largely limited to these marketplaces, and with Nigeria's relatively high rates of illiteracy precipitating debates about how best to sell individual cassettes (whether by printing plot descriptions or simply by showcasing stars' familiar faces), local journalists mostly shied away from covering—let alone critiquing—Nigerian video films during the 1990s.[11]

For Françoise Balogun this critical reluctance had as much to do with the country's plummeting, post-oil-boom economy—one that directly and dramatically affected publishing—as with a certain intellectual snobbery, a sense that, because video production "was developed in its initial phase mainly by people who were not trained in filmmaking," it was by definition not deserving of film criticism.[12] This distinction—the alleged generic and qualitative contrast between celluloid film and "mere" video—has been upheld in other African contexts as well, reflecting Western critical concerns. Just as American video productions from the purely pornographic to the avant-garde were, throughout the 1980s and 1990s, explored almost exclusively in "underground" publications and in certain academic subfields, early Nollywood films could find only the occasional champion among writers, as Balogun pointed out. By the early 2000s, however, the situation seemed to be changing. In 2004 Balogun noted of video films that they had "gained recognition not only from audiences but also from critics."[13] In explaining this critical change of heart as a function of "the emergence of digital technologies," Balogun inscribed a dividing line between Nigerian videos shot using analog formats and those rendered digitally.

Such a dividing line could neither be neat (indeed, analog production has persisted in Nollywood well past the allegedly decisive digital turn) nor unique to Nigeria. Throughout the history of film criticism in and about sub-Saharan Africa, concerns about film technologies—particularly those that have obsolesced in the West—have only intensified the need to "prove" the legitimacy of African cinema as a subject of analysis. In some ways the reluctance of African publications to address video suggests a broader, transcultural resistance to critical coverage of the kinds of productions that, as James M. Moran argues, are often defined as "private documents" belonging to an exclusively "private

sphere."[14] Jonathan Haynes observes that the popular, persistent Nigerian designation of Nollywood films as "home videos" may seem confusing to Americans (calling up memories of home movies), but it may also have prevented sustained journalistic coverage.[15] Unlike American "home movies," Nollywood videos are public commodity products, but they are not, for the most part, viewed publicly; they share with their counterparts a consumption that is largely limited to private residences, thus appearing to preclude reportage. If journalistic film criticism, as traditionally defined, intends to approach film exhibition as an emphatically public event, then perhaps the resolutely "private" nature of the vast majority of Nollywood spectatorship—the dominance in southern Nigeria of the home-viewing model—has further obscured the need for Nollywood-focused reporting (at least as limited to information about when and where to watch films publicly). In a country where print film coverage stalled with the advent of structural adjustment programs and the associated shutdowns of movie houses, the link between criticism and the promotion of public film bookings has persisted; with very few daily showtimes to publicize, and with open-air video markets (especially in Idumota and Onitsha) responsible for their own modes of advertising, Nigerian print publications have tended to minimize accounts of local cinematic productions. Besides, as Nnaemeke Ijioma points out, publicity for Nollywood, to the extent that it infiltrates print venues, often focuses on the industry's biggest names and most beautiful faces—a further reflection, perhaps, of a star-conscious Western approach to "critical" reporting.[16]

In condemning the local, celebrity-centered coverage of Nigerian films, Ijioma makes an important point about the manner in which such coverage seems to mimic American modes of entertainment reporting, peddling an overpowering culture of uncritical consumption and seeing nothing of thematic or political value in "indigenous" African productions. Even with their focus on contemporary media forms, Ijioma's complaints recall several aspects of the seminal scholarship on African cinema that observed two modes of resistance to African film productions—one stemming from a local lack of critical knowledge, the other from an ethnocentric critical framework. In a groundbreaking 1988 article, Manthia Diawara assessed this situation, arguing in his opening paragraph that "there has been no African film criticism as enlightening and provocative as the criticism generated by the Brazilian Cinema Novo, the theories of Imperfect Cinema, and the recent debates around Third Cinema." He continued: "The lack of African critics who know African traditions is at fault, as well as the critical practice of the West, where the ethnocentrism of European and American film critics has limited them to evaluating African cinema through the prism of Western film language."[17] Having emerged as a discrete and definable film practice several years after Diawara wrote those words, Nollywood would seem to be at a double disadvantage, at least in relation to the dominant traditions of

film criticism. At once an example of African cultural production and a phenomenon solely reliant (at least in the beginning) on video technologies, Nollywood was largely ignored in the surveys of sub-Saharan African cinema that were published—many of them in response to Diawara's challenge—in the late 1990s and early 2000s.[18] Ousmane Sembène, to name just one widely celebrated West African auteur, continued to direct celluloid art films in the twenty-first century, although he made an unexpected foray into video production with 2000's *Faat Kiné*, which many critics read as a reflection of French soap operas, upholding video's long-standing association with television and thereby denying (or at least downplaying) the classically "cinematic" aspects of Sembène's film.[19]

Sembène might thus be seen as having symbolized, for a majority of anglophone and francophone critics, two of the chief justifications for avoiding southern Nigeria's video films during their first decade of dominating the commercial markets of West Africa. For starters, Sembène's storied success as a celluloid filmmaker, coupled with his sheer professional longevity, may well have militated against the study of early Nollywood. Indeed, the sheer number of print reviews of the films that Sembène made between 1988 (the year of release of *Camp de Thiaroye*) and 2004 (the year of release of *Moolaadé*) is staggering, far exceeding the number of print reviews devoted to the works of any other West African filmmaker operating during the very same period (with the possible exception of Idrissa Ouedraogo).[20] For those critics who, committed to examining African cinema without recourse to Western interpretive models, were increasingly situating Sembène's films in relation to the African oral tradition and to historiographic interventions of an emphatically African nature, there was simply too much to analyze within the boundaries of sub-Saharan art cinema—a corpus that included the works of Djibril Diop Mambéty (whose final feature, 1992's *Hyenas*, was screened in competition at the Cannes Film Festival) and Jean-Pierre Bekolo (whose 1996 film *Aristotle's Plot* galvanized academic film critics, as indicated by the sheer volume of conference presentations, articles, and book chapters devoted to it).[21] If the persistent critical privileging of a celluloid art cinema suggests a particularly Eurocentric pretension, then it is worth emphasizing France's pronounced role in postindependence financing structures for African films. Governing the use of celluloid from production to exhibition, French state agencies frequently upheld European conceptions of high culture, even as they conspired to exoticize African cinema as strictly ethnographic fare, compelling Sembène himself to complain that French aid was "tainted with paternalism and neocolonialism."[22]

Given this background, it has become increasingly difficult not to see a certain commitment to European critical traditions—especially a French-style celebration of "the art of cinema"—as having undergirded the loudly professed preference for celluloid over video in West Africa's contemporary mediascape. However, lest this preference—an obvious factor in the privileging of Sembène's

art cinema over Nollywood's popular products—seem rooted more in a preju-
dice against Nigerian cultural productions than in a strong, medium-specific
aversion to video, it is worth noting that Sembène's relatively low-fi *Faat Kiné*
received some of the least enthusiastic reviews of his career; in characterizing the
film in his 2006 survey of African cinema, Roy Armes highlights its "lively, well-
plotted" quality but also its relationship to "French-language television soap
opera."[23] If *Faat Kiné* failed to receive as much critical attention as, say, Sembène's
later film *Moolaadé*, then perhaps the culprit was video itself, a format whose
alleged limitations have long placed it at a distinct disadvantage, at least in rela-
tion to the "romance" of celluloid.[24]

VETTING VIDEO

A pronounced critical resistance to video is traceable to Jean Rouch's famous,
altogether offensive, complaint that the format represented "the AIDS of the
film industry"—a complaint that, for Rouch, centered on Africa and the vari-
ous VHS-based industries that were booming by the time of his death, in 2004.[25]
Rouch's impolitic remark is hardly unique to analyses of African cinema, how-
ever. Numerous scholars see it—or some more delicate variant thereof—as
having prevented both the academic and popular study of works produced with
the exclusive use of video technologies, such as Miranda July's *Joanie 4 Jackie*
video chain letter or, more broadly, pornography, workout, and self-help videos,
whose Western consumption was guided, as Lucas Hilderbrand suggests, more
by sheer market saturation than by careful critical appraisal.[26] Exceptions to the
lack of critical interest in video productions arrived in the early 1990s via queer
and feminist film critics operating, for the most part, in Britain and the United
States.[27] It arrived, as well, via such American print film critics as J. Hoberman,
Jonathan Rosenbaum, and Amy Taubin.[28] But as Nigerian scholar Ogu Enemaku
pointed out in 2003, the practice of a popular (i.e., nonscholarly, informational)
video criticism was almost nonexistent in West Africa in the 1990s—which is
not to say that there were no critics willing to assess the first decade of widely
profitable video production in Nigeria.[29] Instead of a Taubin tackling, on the
pages of *Artforum*, the latest avant-garde video, Nigeria had a preponderance of
what Foluke Ogunleye called "condescending cultural critics"—moralizing men
whose self-appointed task was to tease out the objectionably "titillating" aspects
of Nigerian video films or the allegedly "embarrassing" occult elements or the
regressive depictions of primitivism, of "savagery."[30]

Such figures failed to see much of value, either artistically or sociologi-
cally, in Nollywood films. In addressing this failure, Onookome Okome
describes, among predominantly Western-educated Nigerian "cultural media-
tors," an "unwillingness to see what Nollywood is all about, which is that it is

not consciously political and has so far stayed away from overt political topics."[31] Nollywood films contain, however, innumerable political dimensions, as Okome concedes—dimensions that may not shimmer as such but that nevertheless tend to structure Nollywood texts and to consistently suggest the need for critics to tease them out, to communicate their ostensible sources and potential effects to a wide readership. Nnaemeke Ijioma's call for the kind of critic who could determine, from a deluge of features, which film is worthy of seeing would appear to be far removed from Okome's position—from his envisioning of a politically mindful Nollywood criticism that would be unburdened by academic traditionalism and therefore unintimidated by the absence of "art," postcolonial theory, and Afro-optimism. However, it is a measure of the value of NollywoodCritics—as well as of blog-based film criticism more generally—that it can combine seemingly divergent critical approaches with relative impunity, avoiding cultural condescension while honoring artistic intentions, or directly addressing the observable needs of actual viewers while sidestepping the familiar publishing-industry fear of reaching too narrow a readership, all the while upholding Nollywood as a fount of discursive hybridity.

For Françoise Balogun southern Nigeria's (belated) digital turn inspired critics to finally take Nollywood seriously, but what have been the subsequent effects, in terms both of practice and of public perception, upon film criticism? An irony that Balogun does not address, and that seems especially pronounced in the context of Nollywood coverage, is that the digitization of criticism—its aggregation as a series of blog entries on a site such as NollywoodCritics—can seem a further challenge to traditional critical models. Nollywood itself, with its low-cost, high-speed ethos, has long been associated with the cheap, the indiscriminate, and the downright amateur. As a result the industry has often been charged with sullying the legacy of African cinema and preventing critical depth and excellence. In a strikingly similar vein, blogging has been popularly positioned as the opposite of "legitimate" film criticism—an amateur and ephemeral activity that travesties the practice of a slow, professionally sanctioned, editorially supervised form of textual analysis.[32] But if Nollywood has managed to shed some of the unflattering cultural trappings of "mere video," earning a reputation as a bona fide film industry whose constituent products contain considerable cinematic value, then perhaps blogging has traced a homologous trajectory, if only in the West. In African and diasporic contexts it continues to face challenges ranging from the practical to the prejudiced—from the infrastructural to the affective and theoretical. If Nollywood, which continues to connote a certain degree of amateurism in spite of its many demonstrable accomplishments, hinders the bloggers who cover it, then it may also help them.

For its part, NollywoodCritics understands that the industry, as a collection of "rebel" practices, overlaps with blogging in numerous ways: the

website proclaims, on its main page, that the qualities that make Nollywood so "dynamic"—its responsiveness to a dizzying diversity of themes, techniques, and technologies, as well as to cast and crew members from around the globe—are the very same qualities that make NollywoodCritics "the liveliest movie review destination on the web."[33] Just as Nollywood is hardly opposed to professionalized standard practice even as it embraces the contributions of "newbies," NollywoodCritics maintains that it democratizes the practice of film criticism, collecting and combining the writings of professional film critics and unsalaried "amateurs" worldwide. In revealing some of the kinships between blogging and Nollywood, the site demonstrates that to endorse one is to uphold the other.

"The African film industry's survival . . . depends on the quality, not the quantity, of movies it produces," reads the mission statement on NollywoodCritics.[34] Lest this statement seem a critique of Nollywood's famous (or infamous) annual output of more than a thousand films, the website goes on to position the prolific industry as part of the broader landscape of sub-Saharan African cinema and thus as deserving of "sharp and sustained" criticism—the same kind of criticism so passionately applied, beginning in the 1960s, to the films of Ousmane Sembène. That Sembène's name appears so prominently on a website created several years after his death is perhaps unsurprising; he remains, as Samba Gadjigo points out, "a towering figure of African literature and film"—the symbolic father of a postindependence African cinema committed as much to art as to social change.[35] When Sembène's name is evoked on NollywoodCritics, it is in an unmistakably defensive context—one that seeks to guard against the suspicion that Sembène's art films couldn't be more different from the videos produced in the Nollywood industry. Crucially, then, in aggregating print and online criticism from around the globe, NollywoodCritics also views Nollywood as belonging to the broader fabric of African cinema—a still-contentious move, as Onookome Okome makes clear, because Nollywood's medium specificity, its reliance on video technologies from VHS to VCD to (more recently) DVD and broadband, sets it apart from a cinema that is popularly seen as "classically" celluloid in spite of its now-inevitable digital trappings.[36] In other words what might be termed the stigma of video—and what ranges from the progressive degradation of analog technologies to the alleged inferiority of something shot (as most Nollywood films now are) on a consumer-grade digital device—has conspired to keep Nollywood from attracting evaluative coverage of a journalistic nature.

The absence of Nollywood in the interpretive columns of African, as well as of Western, print film critics can be traced, in part, to a global critical tradition that has long viewed videos (whether tape-based or streaming) as consumer items undeserving of sustained reflection or even of rudimentary evaluation. As Lucas Hilderbrand suggests, video—especially the VHS with which Nollywood first achieved liftoff—is associated, almost by definition, with "derogatory"

words and phrases and with "discourses of infringement, danger, degradation, distortion, degeneration, inferiority, and obsolescence."[37] This is no less true in contemporary West Africa than in the contexts of which Hilderbrand writes— the exclusively American circumstances of bootlegging, tape-sharing, and the avant-garde. Indeed, many of the low-grade technologies that have been so central to Nollywood production also readily lend themselves to bootlegging—to unauthorized reproduction and subsequent circulation. If, as Okome and Matthias Krings suggest, bootlegging is "at once Nollywood's boon and bane," then it is also possible to view the practice—and the fear and suspicion that, in Hilderbrand's telling, often surround it—as having further dissuaded critics from engaging in any serious way with Nollywood cinema.[38] If, as the axiom goes, to review a product is to honor it—to take seriously its aspirations to legitimacy, at the very least—then perhaps it is equally axiomatic to declare an illicit, seemingly boundless item to be beyond the scope of criticism. How to review a "rebel" product?

A form of bootlegging that differs somewhat from the ones that most interest Hilderbrand is that which depends on the practice of online file sharing—of illegal downloading within and across peer-to-peer networks. Since as early as 2002, when the term *Nollywood* was coined on the pages of the *New York Times*, individual Nollywood films have been uploaded illegally to a variety of websites.[39] On one level an inevitable reflection of the practices of piracy that had long dogged Nollywood prior to the digital turn, online bootlegging suggests, on another level entirely, a far more pressing problem, since it appears to promise the possibility of easier, more immediate, and even endless ways of making unlicensed products available to an ever-expanding base of consumers. In calling bootlegging both a boon and a bane, Krings and Okome mean to suggest the obvious—that bootlegging limits severely the profitability of Nollywood films, at least for their producers—but they also intend to describe a more elusive effect: with the unauthorized, unrestrained reproduction of films, Nollywood can—and does—reach a far wider audience than it would possibly reach within local Nigerian markets alone. Bootlegging, then, may serve the seemingly paradoxical purpose of simultaneously siphoning funds from their rightful recipients and ensuring that such figures continue to make films.

STREAMING FILMS, DIGITIZING CRITICISM

A form of stealing that is also, perhaps inevitably, a major mode of advertising, bootlegging has become a chief focus of reform for Nollywood producers worldwide. By 2008, just three years after YouTube was founded, Nigerian tech mogul Jason Njoku created Nollywood Love, a company devoted to obtaining official licenses for the uploading of thousands of Nollywood films to a

dedicated YouTube channel (also called Nollywood Love). Using his company's own capital—buoyed by extensive advertising support—Njoku established a legal model for making Nollywood films available online, combating piracy while ensuring free (and virtually unlimited) access. Within months of its You-Tube debut Nollywood Love was generating hundreds of thousands of views for individual Nollywood films, as well as obtaining hundreds of thousands of channel subscribers, boosting its profile and ensuring increased advertising revenue. Two years later, Njoku cofounded (with Bastian Gotter) iROKO Partners, an online media distribution company whose showpiece website, iROKOtv, started streaming thousands of Nollywood films in December 2011.

With iROKOtv now the dominant source of streaming Nollywood films—and with the website's advertising support guaranteeing free access—Njoku has largely succeeded in his goal of curtailing Internet piracy, but his company's success has brought unexpected challenges. With so many Nollywood films streaming through iROKOtv (well over five thousand as of August 2013), Nnaemeke Ijioma's question about how Nollywood fans might "sieve through" a vast cinematic corpus acquires a new urgency. While iROKOtv is often dubbed "the Netflix of Africa"—and, I would add, of the African diaspora, where broadband access tends to be more prevalent and more reliable than in Nigeria—the analogy can only go so far. It cannot, for instance, account for the dramatic discrepancy in the critical evaluation of the respective holdings of iROKOtv and Netflix. It is safe to assume that the overwhelming majority of the films available for streaming in the "instant-watch" section of Netflix have been "vetted" critically—have been "placed" in terms of genre, budget, and box office. Some of these films are bound to be "bad" according to conventional critical models, but those models are bound to have already been applied to them. Indeed, it is precisely this evaluative history that Netflix attempts to condense through its almost comically idiosyncratic system of classification, which offers taxonomic tags as diverse as "Dark Dramas with a Strong Female Lead," "Critically Acclaimed Thrillers," "Cult Films," and "Guilty Pleasures." Who, exactly, is qualified to similarly tag Nollywood films—who might be able to divide iROKOtv's holdings according to the Netflix style of categorization? Without a popular critical tradition to draw on—without the aid of a critical consensus on a particular film or set of films—iROKOtv has, since its inception, resorted to classifying its holdings according to some of the most recognizable contours of Nollywood's star system. One of iROKOtv's most notable features is its so-called Birthday section, in which it acknowledges and celebrates the birthday of a major Nollywood star by offering a string of links to streaming editions of several of his or her films. Other star-centered occasions arrive on a weekly basis. "Omotola Jalade-Ekeinde Week" will, for instance, highlight Jalade-Ekeinde's films, foregrounding them on the website's home page so that they may easily be watched in succession.

With the increasing—and increasingly licit—online availability of Nol-
lywood films comes an increasing number of calls to critically "cover" them
across the blogosphere, to finally situate and make better sense of this explosion
of streaming videos. If Netflix, similar to iROKOtv in so many ways, has not
inspired similar calls for critical coverage and classification, then that is arguably
a result of the website's unmistakable reliance on Western cinema—as well as
its astonishing paucity of African films both in its streaming and DVD-by-mail
services.[40] African cinema—like non-Western cinema more generally—is, of
course, still in need of pathbreaking criticism. By contrast, in covering contem-
porary Hollywood cinema, a blogger may only be able to join a cacophony of
voices—may only be able to contribute to a critical and promotional deluge. In
addressing the question of whether a film blog can truly be "useful" or "origi-
nal," David Bordwell and Kristin Thompson recognize the need for Hollywood-
focused bloggers to maintain vigilance in the hope of capturing an ephemeral
artistic or industrial development. "Keeping up a blog means seizing inspiration
where you find it," they write, "[whether] in a new film that sparks ideas, in a rash
prediction made by an industry insider, in a DVD release of a restored film that
deserves film lovers' attention."[41] When it comes to calling on Nollywood fans to
start writing about the industry, NollywoodCritics offers far fewer prescriptions
for success, invoking the "basic" need to promote a filmmaking practice that is
still unknown to most of the world beyond Nigeria and the African diaspora.

Because NollywoodCritics tends to offer an emphatically diasporic film
criticism—one practiced by writers of African descent who are living in Europe
and the United States—and because its reach is therefore wide, the website fre-
quently aggregates blog entries that identify the best places to find Nollywood
films in various parts of the world. For instance, a review of Desmond Elliot's
2013 film Weekend Getaway, which was written by a Nigerian-born research sci-
entist who now lives in North Carolina (Victor O. Olatoye), begins by address-
ing the career of one of the film's stars, the iconic Genevieve Nnaji. "It has been
a long while since I last saw Genevieve Nnaji in a Nollywood movie," writes
Olatoye. "Yes, I know there is Ijé"—Chineze Anyaene's phenomenally success-
ful, theatrically released, big-budget 2010 film—but "since I couldn't find it at
Walmart, it remains unseen by me."[42] In addressing the still-pressing matter of
availability, Olatoye highlights his diasporic identity, noting that no Walmart in
North Carolina actually stocks Nollywood films, despite the local presence of
Nigerian Americans, who are, in Olatoye's telling, demonstrably committed to
"consuming" Nollywood products, from DVDs to various commodity tie-ins,
such as T-shirts bearing the names and images of some of the industry's most
popular characters and stars.

In emphasizing the difficulty of locating licit, purchasable versions of Nol-
lywood films in North Carolina, Olatoye's review of Weekend Getaway serves

the perhaps inevitable purpose of promoting iROKOtv—although not, in this instance, the website's "free," strictly advertiser-supported, iteration. For such relatively big-budget, star-studded, high-profile Nollywood films as Elliot's *Weekend Getaway*, iROKOtv reserves a special pay-subscription setting, meaning that, for five dollars per month users have access to a wider range of titles that stream, in most cases, without commercial interruption. Called iROKOtv PLUS, this particular setting helps the website to shift even closer to a cinematic model of exhibition and spectatorship, as Olatoye points out: losing the ads that periodically interrupt "free" streaming films, iROKOtv PLUS also sheds the specter of broadcast television, an "old" medium that Bordwell and Thompson identify as one of the victims of the increased popularity of online videos.[43] But if streaming media manage to supplant television precisely by mimicking the older medium, then to what extent do the more "advanced," subscriber-based models mimic cinema? Because he identifies iROKOtv PLUS as the only source of *Weekend Getaway* available to him in North Carolina, Olatoye's praise for the film's "cinematic" qualities can seem an indication of the website's success in offering a "cinematic" experience.

While iROKOtv PLUS, in its capacity as a pay-subscription site that promises no commercial interruption, might seem an improvement on other, "lesser" ways of watching Nollywood films, it is important to stress that Nollywood has never relied exclusively on theatrical exhibition (although the New Nollywood Cinema is now pursuing multiplex bookings, particularly in London). Furthermore, the industry has always, as Don Pedro Obaseki argues, had a thematic, stylistic, and even infrastructural affinity with television; as Jonathan Haynes puts it, "Nigerian video films were born of television, not cinema."[44] If, as Haynes and many others argue, Nollywood films have become increasingly "cinematic" since the 1990s—more amenable to "a brisker, international professional style of shooting and editing"—then they still, on the whole, lack the sort of exhibition histories that centralize audiovisual "perfection" and big-screen spectatorship.[45] For Nollywood's current online critics the consequences of this lack can be located in yet another contrast between Netflix and iROKOtv. The blogs devoted to the former website have the luxury of detailing the relationship between streaming films as they appear on Netflix and those same films as they "should" appear on the big screen; by contrast, the blogs devoted to iROKOtv are often, through no fault of the bloggers, blind to "true" directorial intentions, especially in relation to framing.

Recently, a Tumblr blog titled "What Netflix Does" (www.whatnetflixdoes .tumblr.com) started archiving the numerous instances in which Netflix "crops" its films, offering visual, side-by-side evidence of how a film's framing can differ in its "original theatrical" and streaming versions. In denouncing Netflix's "pan-and-scan" style of streaming—which may in fact be attributable to the company's

unknowing acquisition of already-altered versions of films, as a spokesperson suggested—"What Netflix Does" offers a form of film criticism that is by now well-entrenched, especially in the blogosphere.[46] Characterized by communicating, in minute and even esoteric detail, the distortions that accrue across formats and playback platforms, this particular critical approach tends to uphold the primacy of a film's theatrical-release print and also, by extension, of its "original" critical reputation, to which the blogger adds his or her resistant or acquiescent voice. For example, "What Netflix Does" describes and confirms the critical significance of CinemaScope to Henry Koster's 1953 biblical epic *The Robe*, noting that Netflix, in cropping the film, did more than just eject its peripheral images; the website also obscured the critical standing of a project designed to publicize the widescreen process.[47] The sheer availability of such a historical narrative makes Netflix seem, in this instance, embarrassingly lowbrow—alarmingly willing to travesty an original visual field—but it also informs the website's acquisition of films, above and beyond the basic negotiations of licensing. Since the vast majority of titles in Netflix's catalog, which is derived largely from the libraries of Hollywood studios, have already been publicized and reviewed in "legitimate" print venues, and since, as Pauline Kael once pointed out, the post–*Star Wars* infrastructure of film advertising, with its promiscuous circulation of quotations from reviewers, has frequently succeeded in inspiring an extreme if often prosthetic familiarity with a film's critical "status," the blogs that address Netflix films tend to adopt a "supplementary" tone.[48] Take, for instance, a blog titled "Netflix Streaming" (www.netflixstreaming.blogspot.com), which situates films available on Netflix according to their popular and critical "reputations," offering original capsule reviews that either "confirm" those reputations or, in a section labeled "Netflix Surprises (Hidden Gems)," "correct" them. In all cases a perceived critical consensus is the starting point for the blog's own form of film criticism, marking it as alternately corrective and confirmatory.

The situation is dramatically different for bloggers whose film criticism focuses on Nollywood, as the case of Victor O. Olatoye suggests. Such bloggers can praise the way that a film appears on, say, iROKOtv PLUS—as Olatoye does in his review of *Weekend Getaway*—but they are not evaluating the relationship between a film's streaming version and a theatrical-release print. That is because Nollywood's technological contours have always been severely restricted, excluding celluloid (at least until the production of a few recent films) and occasioning a certain ephemerality, a sense of the transience of VHS tapes (particularly bootleg ones). As a consequence, bloggers are rarely able to judge a streaming film against its previous versions, or to position their reviews in relation to other, earlier critical models. In the Nollywood context such models are scarce—largely limited to the strictly dismissive generalizations that Onookome Okome and several other scholars have cited. As an ironic result of these

ostensible obstacles, Nollywood-focused bloggers can, in fact, appear to offer a more "traditional" film criticism, one that is committed almost entirely to textual analysis and that is not compelled to wrestle with a postmodern proliferation of "versions" of films. Indeed, one of the challenges unique to Nollywood criticism, as NollywoodCritics suggests, is "flying without a guide"—writing about a film without the aid of established theory or of recognized praxis, which is not a choice (as it might be within the boundaries of an iconoclastic Hollywood criticism) but a requirement.

Over the past two decades Nollywood has managed to transcend many of the problems of Nigeria's postindependence period to emerge as one of the world's leading producers of feature films, and its critics, writing online, themselves tend to suggest a conquering of certain limiting prescriptions. On NollywoodCritics there are no injunctions against analyzing old analog tapes, no dictums about the primacy of the traditional theatrical experience, and no apologies for blogging. As a rule the website rejects stale definitions of criticism in the way that the Nollywood industry, in its infancy, once roundly rejected Eurocentric notions of cinematic art. Nollywood was born, in part, of the repudiation of imposed cultural categories, and perhaps its committed critics, in carving out a space and developing a style for the examination of its films, will explicitly relinquish the Roger Ebert model of journalistic commentary, with its concise combination of plot summary, formalist analysis, biography, and autobiography. Ideological critique is quite at home on NollywoodCritics, but so are debates about whether Walmart, in recognizing the African diasporic consumer, can and should commit itself to retailing Nollywood films. If, in the digital age, film criticism is changing along with its object, then a considerable degree of synergy can be seen in the relationship between Nollywood and its emerging online advocates, making NollywoodCritics, in form as well as in content, a crucial barometer of its object of study.

NOTES

1. Nnaemeke Ijioma, "Roger That! Nollywood Needs Film Critics," *YNaija*, 11 April 2013, www.ynaija.com/opinion-roger-that-nollywood-needs-film-critics/.
2. For more on the Nigerian perspective see Lai Oso and Umaru Pate, eds., *Mass Media and Society in Nigeria* (Lagos: Malthouse Press, 2012).
3. See Mahir Saul and Ralph A. Austen, introduction to *Viewing African Cinema in the Twenty-First Century: Art Films and the Nollywood Video Revolution*, ed. Mahir Saul and Ralph A. Austen (Athens: Ohio University Press, 2010), 2.
4. Ijioma, "Roger That!"
5. Ibid.
6. Kael's complaint can be found in Susan Goodman, "She Lost It at the Movies," *Modern Maturity*, March-April 1998, 49.
7. See Santorri Chamley, "New Nollywood Cinema: From Home-Video Productions Back to the Big Screen," *Cineaste* 37.3 (2012): 21–23.

8. Jeffrey Geiger, "Nollywood Style: Nigerian Movies and 'Shifting Perceptions of Worth,'" *Film International* 10.6 (2012): 58–72.

9. Henry Jenkins, *Convergence Culture: Where Old and New Media Collide* (New York: New York University Press, 2006).

10. Jonathan Haynes, "Nollywood in Lagos, Lagos in Nollywood Films," *Africa Today* 54.2 (2007): 137.

11. Onookome Okome, "Nollywood and Its Critics," in *Viewing African Cinema in the Twenty-First Century*, ed. Mahir Saul and Ralph A. Austen (Athens: Ohio University Press, 2010), 26–41.

12. Françoise Balogun, "Booming Videoeconomy: The Case of Nigeria," in *Focus on African Films*, ed. Françoise Pfaff (Bloomington: Indiana University Press, 2004), 175.

13. Ibid., 173.

14. See James M. Moran, *There's No Place like Home Video* (Minneapolis: University of Minnesota Press, 2002).

15. Haynes, "Nollywood in Lagos," 136.

16. Ijioma, "Roger That!"

17. Manthia Diawara, "Popular Culture and Oral Traditions in African Film," in *African Experiences of Cinema*, ed. Imruh Bakari and Mbye Cham (London: British Film Institute, 1996), 209.

18. These include Roy Armes, *African Filmmaking North and South of the Sahara* (Bloomington: Indiana University Press, 2006); and Kenneth W. Harrow, *Postcolonial African Cinema: From Political Engagement to Postmodernism* (Bloomington: Indiana University Press, 2007). Harrow, however, does address Nollywood in *Trash: African Cinema from Below* (Bloomington: Indiana University Press, 2013).

19. See, e.g., Armes, *African Filmmaking*, 73; for a different view see Samba Gadjigo, "*Faat Kiné*, Ousmane Sembène," African Studies Review 44.1 (2001): 123–126.

20. See Samba Gadjigo, *Ousmane Sembène: The Making of a Militant Artist* (Bloomington: Indiana University Press, 2010).

21. See Lindiwe Dovey, *African Film and Literature: Adapting Violence to the Screen* (New York: Columbia University Press, 2009), 205–217.

22. See Manthia Diawara, *African Cinema: Politics and Culture* (Bloomington: Indiana University Press, 1992), 60.

23. Armes, *African Filmmaking*, 73.

24. For a different view see Jonathan Haynes, "African Cinema and Nollywood: Contradictions," *Situations: Project of the Radical Imagination* 4.1 (2011): 84.

25. See Pierre Barrot, "Video Is the AIDS of the Film Industry," in *Nollywood: The Video Phenomenon in Nigeria*, ed. Pierre Barrot (Bloomington: Indiana University Press, 2008), 3.

26. *Joanie 4 Jackie* is a video chain letter created by Miranda July in the 1990s. See Lucas Hilderbrand, *Inherent Vice: Bootleg Histories of Videotape and Copyright* (Durham, NC: Duke University Press, 2009), esp. 66.

27. See, e.g., Patricia White, *Uninvited: Classical Hollywood Cinema and Lesbian Representability* (Bloomington: Indiana University Press, 1999); and Chris Straayer, *Deviant Eyes, Deviant Bodies: Sexual Re-orientations in Film and Video* (New York: Columbia University Press, 1996).

28. For an overview see J. Hoberman, *Film After Film: Or, What Became of 21st Century Cinema?* (London: Verso, 2012).

29. Ogu S. Enemaku, "Ethical Foundations of the Nigerian Video Film: Towards a Reconstruction," in *African Video Film Today*, ed. Foluke Ogunleye (Matsapha: Academic Publishers, 2003), 69–80.

30. Foluke Ogunleye, preface to *African Video Film Today*, ed. Foluke Ogunleye (Matsapha: Academic Publishers, 2003), xi.

31. Okome, "Nollywood and Its Critics," 36.
32. See Jonathan Rosenbaum, *Goodbye Cinema, Hello Cinephilia: Film Culture in Transition* (Chicago: University of Chicago Press, 2010); Chuck Tryon, *Reinventing Cinema: Movies in the Age of Media Convergence* (New Brunswick, NJ: Rutgers University Press, 2009); and Christian Keathley, "La caméra-stylo: Notes on Video Criticism and Cinephilia," in *The Language and Style of Film Criticism*, ed. Alex Clayton and Andrew Klevan (New York: Routledge, 2011), 176–191.
33. Nollywood Film Critics, http://nollywoodcritics.com/home_page.aspx.
34. Ibid.
35. Gadjigo, *Ousmane Sembène*, 150.
36. Okome, "Nollywood and Its Critics," 26.
37. Hilderbrand, *Inherent Vice*, 5.
38. Matthias Krings and Onookome Okome, "Nollywood and Its Diaspora: An Introduction," in *Global Nollywood: The Transnational Dimensions of an African Video Film Industry*, ed. Matthias Krings and Onookome Okome (Bloomington: Indiana University Press, 2013), 1.
39. Ibid.
40. In November 2013 I counted only five African films in Netflix's catalog.
41. David Bordwell and Kristin Thompson, *Minding Movies: Observations on the Art, Craft, and Business of Filmmaking* (Chicago: University of Chicago Press, 2011), ix.
42. Victor O. Olatoye, review of *Weekend Getaway*, NollywoodCritics, July 2013, http://nollywoodcritics.com/Archives_Display.aspx?Videoid=479.
43. Bordwell and Thompson, *Minding Movies*, 110.
44. Haynes, "Nollywood in Lagos," 139.
45. Ibid.
46. See Drew Guarini, "Netflix Accused of Cropping Films, but Company Says It's All a Big Mistake," *Huffington Post*, 18 July 2013, www.huffingtonpost.com/2013/07/18/netflix-cropping-aspect-ratio_n_3616774.html.
47. "What Netflix Does," 26 August 2013, http://whatnetflixdoes.tumblr.com/post/59425138828/the-robe-1953.
48. Pauline Kael, "Whipped," in *Taking It All In* (New York: Holt, Rinehart, and Winston, 1984), 207.

PART III INSTITUTIONS AND THE PROFESSION

8 ★ AMERICAN NATIONWIDE ASSOCIATIONS OF FILM CRITICS IN THE INTERNET ERA

ANNE HURAULT-PAUPE

Regional and national associations of film critics in the United States are numerous and vocal. Although the members of these associations are specialized in writing reviews and essays on film, many of them write on other areas of culture as well. Associations of film critics belong to what James F. English has called the "economy of prestige."[1] As English has shown, a global cultural and economic phenomenon developed during the twentieth century and continues today, whereby all cultural productions in the world are received in a highly ritualized and competitive manner. American associations of film critics compete with each other, as well as with film festivals, academics, bloggers, and the Academy of Motion Picture Arts and Sciences in delivering various awards.[2] But professional film reviewing has been in a crisis since the mid-1990s, when it started to become relatively easy to post and consult files on the Internet using the HTTP protocol. Examining American film critics associations' evolving web presence helps us to understand how institutional film reviewing has changed in the digital age and allows us insight into how film critics position their professional identity in the face of challenges by bloggers and the presumed "democracy" of criticism. Whereas in general the websites have consolidated and converged around discourses of professionalism, canon building, and prestige, we will see how the visual forms and structure of these sites have served to form distinctions that can be explained in part by these associations' platforms and purposes.

This chapter explores how three nationwide American associations of film critics—the New York Film Critics' Circle (NYFCC), the National Society of Film Critics (NSFC), and the Online Film Critics Society (OFCS)—have adapted to the Internet. Historically speaking, these associations are very dissimilar. The NYFCC, created in 1935, is the oldest association of film critics in the United States. Most of the leading newspaper film critics traditionally belong to it because many of the country's leading newspapers are based in New York. Membership is limited—thirty-five members in 2013—and works by application or invitation only. It started to include magazine reviewers in 1962 and only recently broadened to include a few critics whose work is published in online newspapers or magazines. The NSFC was created in 1966 and includes reviewers from all the major publications in the country. To become a member, one must be elected by current NSFC critics. The society's members—sixty-one in 2013—may write in newspapers or magazines, in print or online. Finally, the OFCS was founded in 1997, and its members—271 in 2013, chosen by application—write online reviews for "professionally maintained" websites and come from various countries, although they mostly write in English.

THEORETICAL FRAMEWORK

Reviewing, like all forms of writing, has been affected by the ongoing revolution in conceptions of textuality brought about by the Internet. Nowadays, many published film reviews are made of electronic hypertext, which is defined by George Landow as "text composed of blocks of text . . . and the electronic links that join them." Electronically linking texts "simultaneously blurs borders, bridges gaps, and yet draws attention to them." As a consequence, readers have become empowered and active; they are now consumers of what Roland Barthes once called "writerly texts" (*textes scriptibles*), which blur the boundaries between readers and writers.[3]

As film reviews are posted online more and more frequently, and very often written solely for such a purpose, the boundaries between professional reviews and nonprofessional appreciation have become increasingly hard to define. Moreover, it has become possible to publish multimedia film analyses online (as discussed in this volume's chapter 2), and it is now much easier for spectators to turn into commentators. Simultaneously, the work of film reviewers has become much more accessible and searchable, as it can be consulted from anywhere in the world, be archived and easily retrieved, and coexist on the web with other texts whose authors may be unknown. Additionally, the form of film reviews has become mutable because user interfaces change over time.[4] More specifically, the digital era has led associations of film reviewers to modify their communication strategies, relying not just on press releases and awards ceremonies but also

on a permanent, though evolving, Internet presence. As web-based communication is both textual and graphic/visual, it has become more complex for these associations to control their public image.

This chapter focuses on *discourses*, that is, on linguistic productions considered along with their contexts of production and reception. Hence, it does not only study these utterances, or *texts*, but also takes into account the social and cultural conventions that govern them.[5] I draw from the theoretical framework of enunciative discourse analysis and especially the concepts and methodology created by Dominique Maingueneau,[6] who defines discourse as both a linguistic and a social phenomenon shaping our perception of reality. Discourse is produced by an enunciator with a specific purpose; it implicitly involves a coenunciator, whom it prompts to act by using, for instance, verbs such as "to suggest," "to ask," or "to claim."

But discourse is also governed by social rules,[7] and Maingueneau's main focus has been on creating a typology of forms of discourse. To him discourse exists within an "enunciative scene," which consists of three main components. First, all discourses are part of a wider, more encompassing "type of discourse," characterized by the social sphere in which it is used. During an electoral campaign, for example, political discourse may take the form of party platforms, leaflets, and orators' speeches.[8] To Maingueneau political discourse constitutes these utterances' "encompassing scene" (*scène englobante*).

Second, most discourses produced by institutions contain obligatory components that qualify them as "instituted genres."[9] As Maingueneau observes, the roles played by the participants of instituted genres are set a priori and, as a rule, remain stable during the process of communication. The coenunciators enter a preestablished frame that they generally do not modify: their roles are set, the objective of the discourse is defined, and the legitimate circumstances for the exchange of discourse (i.e., its time, place, length, and medium) are defined by social conventions that have evolved through history. These speech constraints form what Maingueneau calls a "generic scene."[10]

Third, scenography—the way in which a discourse is presented to its readers—can reinforce the message expressed by this discourse or, conversely, undermine it. To explain the notion of scenography, Maingueneau uses the example of Blaise Pascal's first ten *Provinciales*: while they were religious texts (that was their encompassing scene), they were also lampoons (that was their generic scene) and presented as letters to a friend living in the provinces (that was their scenography). Maingueneau considers that digital scenography has three components: it is made up of icono-textual scenography (the texts and their layout on the page), architectural scenography (the organization of the information into modules on the page, the architecture of the website, and the links that are provided to other sites), and procedural scenography (the instructions given to the website's users).[11]

Following Maingueneau's methodology, the first part of this chapter asks two questions: What is the film critics associations websites' encompassing scene? And how can we characterize the type of discourse that these associations produce in their websites? The second part links the web discourses produced by film critics associations with instituted genres framed by speech constraints. This chapter's last segment identifies the components of the digital scenography used in each site.

To analyze the evolution of the three elements of the enunciative scene in each case study, I have retrieved archived versions of each website using the Wayback Machine service provided on the Internet Archive.[12] The first record of a website for the New York Film Critics Circle available on the Wayback Machine appeared in 2001.[13] Given that the home page features the 2000 NYFCC Awards, the website was probably launched at the end of 2000. Except for a few changes, the site kept its 2001 architecture and design until 2010. During that period it seems to have been updated at least once a year to add the yearly list of awards. It also incorporated a regularly maintained membership page. In 2011 a new website for the NYFCC was launched, still at the same address, with a modified blog-like structure in the home page and a modernized look.[14]

The history of the NSFC website is much shorter, as the first recording on the Wayback Archive is dated 10 October 2010, and consists of only two pages. Since then, the society's website has been enriched with a third page, a Meta section, a Posts feed, and a Comments feed, while keeping the same type of structure until October 2013, when this chapter was completed. The history of the OFCS website, in turn, is long: the society has had an Internet presence since its inception, changing hosts several times. The first recording by the Wayback Archive is dated 8 May 1999 and lasted until February 2001. The society's site was then hosted by the film-review aggregator Rotten Tomatoes from March 2001 to October 2009, until it moved to Blogspot/Blogger, where it was freely hosted from February 2011 to June 2012. Finally, in June 2012 the OFCS created its own site and established membership dues to help cover the costs.[15]

ENCOMPASSING SCENE

The websites of both the NYFCC and the NSFC have consistently been fraught with canonizing discourse. Indeed, the 1 March 2001 NYFCC home page opened with the following statements:

> Welcome to the web site of the New York Film Critics Circle, an organization of film reviewers from New York–based publications that exists to honor excellence in U.S. and world cinema.

Founded in 1935, the Circle's membership includes critics from daily newspapers, weekly newspapers and magazines. Every year in December the organization meets in New York to vote on awards for the previous calendar year's films.[16]

The claim "to honor excellence" underlines the prestige the Circle attached to itself and to the awarded films and people. Further down the home page, the same text mentioned that "special . . . awards [were] also given to individuals and organizations that have made substantial contributions to the art of cinema," thus specifying that the Circle's canonizing discourse was based on a consideration of film as art, not as entertainment.[17]

The Circle also defined itself in oppositional terms. The home page concluded by emphasizing that "the Circle's awards are often viewed as harbingers of the Oscar nominations, which are announced each February. The Circle's awards are also viewed—perhaps more accurately—as a principled alternative to the Oscars, honoring esthetic merit in a forum that is immune to commercial and political pressures."[18] The use of the passive form ("are . . . viewed") left ambiguous the website's potential audience and indeed implied a wide breadth of observers who followed the NYFCC, thereby asserting its importance. The Circle further established its own legitimacy by correcting the commonplace representation of its function and suggesting how it wanted its awards to be considered. The words "a principled alternative to the Oscars" implied that the association's adversaries— essentially the Academy of Motion Picture Arts and Sciences, or the Hollywood film industry—had no such principles. The NYFCC promoted the professional status and image of its members by presenting them as defenders of high culture impervious to commercial and political pressures.

When the NYFCC website was redesigned in 2011, some of the original content was kept, and the architecture remained quite similar. The three key sections of the site—About, History, and Membership—hardly changed at all. Yet the top of the home page was entitled "Recent Releases—Read Current Reviews from NYFCC Members."[19] The adjectives *recent* and *current* insisted on the immediacy of the content to be found on the site, while the word *reviews* highlighted the fact that this content consisted in journalistic evaluations. As a consequence the page gave the impression that the site belonged to the encompassing scene of journalistic and evaluative discourse.

But other content posted on the site belied this impression. For instance, scrolling down the home page on the same date, one discovers a text authored by Armond White, who had chaired the NYFCC in 1994 and between 2009 and 2010. The opening paragraph reads:

We are film critics. We are an ever expanding-yet-diminishing breed. Gossip columnists, bloggers and Oscar-touts continuously try to usurp our influence but

the New York Film Critics Circle has one important advantage over the season's many undistinguished award-giving organizations: We lay claim to a 76-year-old tradition that annually honors the best in film. We do it without the movie-industry's box office preoccupation and without other awards groups' obsession with fads and pathetic hunger for recognition. The New York Film Critics Circle stands apart as the oldest, most prestigious critics organization in the world. Our prizes are voted through the assembly of professionals concerned with quality and discernment.[20]

Consistent with what we have seen in the introduction to this volume and in Daniel McNeil's chapter, White's rhetoric agitates for a "professional" criticism and against a "dumbed-down" reviewing. This paragraph associates the NYFCC with the image of a monarchy under siege, with unfit pretenders to the throne constantly threatening its power. Somewhat ironically, however, White included "bloggers" among those pretenders; there is a tension between his statement and the format of the new NYFCC website, which was itself organized like a blog. This aggressively elitist discourse—with the words "obsession for fads" or "pathetic," for instance—placed the bottom of the 4 February 2011 page in sharp opposition to the tone used at the top of the page. Terms such as "honors" or "quality and discernment," as well as the use of the superlative— "the oldest, most prestigious critics organization in the world"—placed White's discourse on the encompassing scene of high culture, just like the former version of the website.

Similar discourse appeared in the About and History pages. The first contained a close copy of the welcoming text that used to appear on the home page of the site's former version. The only addition related to membership: "Founded in 1935, the Circle's membership includes critics from daily newspapers, weekly newspapers, magazines, *and qualifying on-line general-interest publications*."[21] It follows that the Circle's extension of membership to some online reviewers did not change the site's encompassing scene, which remained dominated by canon building and gatekeeping.

The NSFC website is similarly set in the encompassing scene of canonizing discourse. Its first entry in October 2010 (yet dated 3 January 2010) was entitled "*Hurt Locker* Leads 2009 Awards,"[22] with a header reading "National Society of Film Critics" and, to the right of the header, a link to the only other page in the website, entitled Past Awards. The site's only concern, therefore, appeared to be the awards season. The same encompassing scene was also used in the updated 10 January 2011 web page.[23] Indeed, under the society's name and logo a motto appeared: "The Truth, Once Every 12 Months"—a reference to the society's list of awards, published once a year. Below, the headline for the first entry read: "*Social Network* dominates 2010 NSFC awards." Again, the site presented the

NSFC as solely interested in the "economy of prestige" described by English, as it subscribed to the competitive spirit of the awards season instead of focusing on film as art.

In contrast, the encompassing scene of the OFCS website has changed over its long history. The first home page was vertically divided in two sections, which used two different types of discourse.[24] The upper-right section contained links to "Featured Articles, including our comments on the 1998 Academy Awards" and to "various Film Festivals around the world," while the bottom of the page contained a reverse-ordered list of links to reviews, placing this section in the encompassing scene of evaluative journalistic discourse. However, the upper-left section was characterized by promotional discourse. Indeed, it included a link to the "Featured Member of the Month," as well as incitements for members to submit their "Summer Preview articles" and a link to an "Internal-Only Forum," whose current issues concerned the "Voting Booth." This transparency promoted the image of the OFCS as a welcoming and democratic institution.

When the website was hosted by the review aggregator Rotten Tomatoes, it was redesigned, and the encompassing scene shifted to canonizing discourse. The top of the 31 March 2001 home page was dominated by a section that read: "Announcing the 2000 OFCS Year End Awards."[25] Below, to the left, there was a list of the awards with links to OFCS members' reviews of the films in question, and to the right was a section typical of the awards season: "The Online Film Critics Society's Top Ten Films of 2000." At other times, however, the society's discourse was characterized by gatekeeping. The 10 February 2002 About page, for instance, presented the OFCS as "the premiere international organization of film critics who post their printed movie reviews exclusively or primarily online" and contained indications on how to join the OFCS that repeatedly used the modals "must" and "should," thus presenting the society as synonymous with excellence and selection.[26] As with the NYFCC, canonizing and gatekeeping discourses went hand in hand.

When the society's website moved to Blogger in 2011, its encompassing scene became ambiguous. The home page was divided into two modules: the left and center part of the screen consisted in a weblog of reviews by OFCS members (in keeping with the previous versions of the site), while the right-hand section contained seven modules: OFCS Awards, Search, About the OFCS, Twitter, OFCS Fans, Categories, and Previous Posts.[27] Users were faced with the promise of so many different types of discourse that it is impossible to ascribe a specific encompassing scene to this page.

When the society launched its own website in June 2012, the purpose of each module became clearer. The left-hand section of the home page remained a weblog of member reviews, now structured as subcategories.[28] The right-hand section still contained a variety of links, which principally presented the society

("About the OFCS") and addressed prospective and existing members (through a "Further information" module containing such links as "Our Bylaws," or "Want to Become a Member?"). It was then possible to understand that the site was organized by the encompassing scene of promotional discourse—the reviews promoted the work of the society's members, while other features of the site aimed to attract new members. In brief, the websites of the NYFCC and the NSFC have been dominated by canonizing discourse, while that of the OFCS has been set in more variegated encompassing scenes, thereby hindering its communicative efficiency.

GENERIC SCENE

All three websites currently display some institutional discourses, but only the NYFCC has consistently done so. Indeed, the 2001 NYFCC website prominently featured information about the Circle (in the Home and History pages, which users reading the horizontal navigation bar from left to right would have noticed first), about NYFCC members (in the Membership page, which was third in the navigation bar), and about the Circle's awards (in the Awards page, which was fourth in the navigation bar).

However, most institutional sites require regular updating in order to persuade their users that the institution or corporation that commissions them is reliable. But the Articles page, fifth and last in the navigation bar, on the contrary, remained mostly incomplete or out-of-date from 2001 to 2007. From 2001 to the end of 2003 it only included the sentence "Please visit us again in the future as we furnish this area with articles by New York Film Critics Society members."[29] Some users might have inferred from the absence of articles that the association did not want to establish itself on the generic scene of evaluative discourse and was instead focused on canonizing discourse.

In early 2004 a minor structural change took place when the Articles page was replaced with a Photos page featuring images of celebrities attending the 2003 NYFCC awards ceremony.[30] The page was therefore up-to-date for the year 2004. But the 2003 photographs stayed on the page through 2005, and then sometime between 2005 and 2006 they were replaced by the line "Photos from the 2003 awards ceremony will be posted back online shortly," which was left untouched until the end of 2007.[31] Users consulting the Photos page from 2004 to 2007 would therefore have been disappointed. The Photos section was eventually removed sometime between 17 October and 17 December 2007.[32] This might be seen as a sign that the NYFCC hesitated but ended up renouncing celebrity-driven discourses.

Another negative impression would have been conveyed by the lack of regular updates on the website's header, whose featured date would not match the date of access. Users of the March 2001 version would have seen the date 2002

already displayed on the header, and users of the 2005 version would have seen the year 2004 until at least 12 November 2005. The probable reason for these discrepancies was that the site was programmed in the HTML language and commissioned to a web development firm, Atomic Fridge (credited on the home page). This situation is frequent when an institution has neither the means nor the expertise to design and develop its own website. While the resulting sites are generally well-structured and well-designed, the drawback is that new content needs to be sent to the web development firm to be updated, because all content has to be programmed in HTML. This takes longer than if the commissioning institution has its own web-design team and introduces the risk that updates are not consistently implemented, because quite frequently the role of web editor does not exist in the institution.

The new website, launched in January 2011, has been updated regularly. It originally contained six pages, as indicated from left to right on the navigation bar: Home, About, History, Membership, Awards, and Recent News (which was renamed "Blog" a few months later).[33] The titles of the first five sections squarely place this site in the genre of institutional sites, as described above. Therefore, the generic scene has not been affected by the new design.

In contrast, the NSFC's site primarily belongs to the generic scene of news dispatches, because its home page is structured like a weblog, with each article beginning with a date followed by a headline. By definition, each new entry has a title and a date, which follows the logic of newspapers. Furthermore, the brevity of the titles and the predominance of active verbs attract the readers' attention in the manner of newspaper headlines—"*Hurt Locker* Leads 2009 Awards" is a case in point.[34]

But the NSFC website also belongs to the generic scene of institutional discourse, albeit in a more discreet way. Indeed, since 2011 the site has included a third page, entitled Who We Are, which presents the society's purpose and action in a way typical of institutional sites:

The National Society of Film Critics counts among its members many of the country's leading film critics. Its purpose is to promote the mutual interests of film criticism and filmmaking.

Founded in 1966, the Society differs from other critical associations in a number of significant ways. In the first place, it is truly national. Its 61 members include critics from major papers in Los Angeles, Boston, New York, Philadelphia, and Chicago. Its members also include the critics not just of *Time*, *Newsweek*, and *The New Yorker*, but also of *The Village Voice*, *The Boston Phoenix*, and *Salon*. Second, membership is by election.

The Society represents movie criticism in the United States by supplying the official critic delegate to the National Film Registration Board of the Library of

Congress and abroad as the official American representative to FIPRESCI, the international federation of members of the film press.

Besides responding to specific issues, such as colorization, film preservation, or the ratings system, the Society regularly meets early in January to vote on the Society's awards for the finest film achievements of the year.[35]

The mention of the society's role in the National Film Registration Board and FIPRESCI (International Federation of Film Critics), as well as to its involvement in technical or censorship issues, grounds this page in the generic scene of institutional discourse.

The OFCS web page, in turn, has only recently moved toward institutional discourse. The first OFCS site actually followed the generic logic of a user forum, while also being organized as a weblog of news. On one hand it addressed members and prospective members, encouraging them to submit articles, voice their opinions, and vote; on the other hand it addressed readers by both referring them to the society's awards and festival reports and providing links to reviews written by OFCS members. A subsection entitled "The OFCS Journal" belonged to the genre of webzines—the second issue, saved by the Web Archive on 12 October 1999, was entitled "Mischief. Mayhem. Reviews," a provocative slogan playfully reminiscent of exploitation films' taglines.[36] Whether in its forum or in its news pages, the site maintained a tone of friendliness and humor that was far removed from institutional websites.

This changed with the 2001–2009 version: the website's five-page navigation bar contained such sections as "About OFCS," "Member Profiles," and "Schedule," which located it in the generic scene of institutional discourse.[37] Although the home page still displayed links to film reviews, its content was clearly presented as a showcase of the society's talents, not as a democratic webzine. In particular, it featured a regularly updated header that either presented the society's awards of the ongoing year or contained a brief welcoming message typical of institutional sites. Similarly, the OFCS website at Blogger was organized as an institutional site, with a module entitled "About the OFCS" situated on the right of the screen.[38] The largest module of the home page, however, which occupied the whole of its left side, consisted in a weblog of reviews, interviews, and articles. Therefore, while it remained clear that this was an institutional site, it could also be construed as a sort of webzine.

The OFCS private website once again stressed its institutional quality. On the home page, below a header with the society's name, the navigation bar linked to six pages, two of them dealing with members and their reviews, and the remaining four pages presenting the society's awards, its bylaws, awards rules, and the conditions for membership application.[39] While links to reviews occupied the central module on the home page, they could not but be understood as institutionally approved selections.

In sum, the three websites' generic scenes have converged over time, at least in part because of the conventions that have emerged concerning how an association's website should be structured.[40]

SCENOGRAPHY

It is mostly around scenography that these associations' sites have differed. The NYFCC has chosen to present its successive websites (2001–2013) with a scenography consistent with its encompassing and generic scenes. Visually, the early version conveyed an impression of formality and classicism. The whole site was set against a black background.[41] The home page featured a header in the form of a grainy sepia film reel whose frames zoomed closer and closer to the Statue of Liberty, with the words "New York Film Critics Circle" superimposed on it. Confirming the close ties between the NYFCC and New York City, this header also linked the Circle with celluloid film reels, thereby implying that the association stood for a passion for film history. This header might also have been used to underline the fact that the NYFCC had a long history. The same reference to old black-and-white films was taken up in the illustration that appeared in the upper left-hand side of the home page, below the header: a grainy sepia photograph of an unspooling film reel. Again, this illustration may have been chosen purely for its metonymic ability to refer to the cinema—and, in this case, some users might have found it unsophisticated. At the same time, the grainy sepia photograph also suggests a preference for early cinema. The same scenography, with the same header, was used for all web pages. The reference to early cinema was taken up again in the biographies accessible from the Membership page: each member's biography was illustrated by a sepia photo of that member, with an animation that superimposed flickering grains so as to mimic analog film projection.[42] As it was obvious that the animation was an effect added to a recent photograph, which had been intentionally changed to a sepia tone, the result was that NYFCC members seemed to greet the site's users from the past.

The architectural scenography of the website reinforced this classic tone. Indeed, as was common in the early 2000s, this was a static site—it featured prebuilt content, as opposed to the user-tailored content that dominates today's most dynamic websites. The layout of most pages contained three main elements: a header, with an image to the left just below it, and the main content in the middle of the page. Very few links were included in the website: some led to other pages (the home page linked to the Awards page, for instance) and some to external institutions (like the employers of the NYFCC members) or the People's section on the Internet Movie Database. All in all, this sort of architecture did not generate any sense of a personal contact with the institution.

The procedural scenography of the website was consistent with the generic scene of corporate or institutional sites: it made clear that users were expected to

consult the site primarily for information on the NYFCC's main public activity: its awards. Right from the top of the home page, users' roles were prompted by an invitation to "View the winners!" by clicking on a link. The imperative tone was taken up again at the bottom of the welcoming text ("For a complete list of winners, click here") and on the Awards page, which linked to "Award listings for other years." As the association's prizes are published every year in December, one may suppose that the NYFCC expected Internet users to consult its website mostly at the beginning of each year. The site provided neither contact information for the NYFCC nor features for user feedback, which reinforced the impression that its scenography aimed at presenting it as inaccessible.[43] Clearly, the scenography of the former NYFCC website was designed primarily to publicize the association's canonizing discourse.

The design of the new NYFCC site has been radically altered.[44] Most important, the home page is now presented like a weblog.[45] The central module of the page contains a reverse-ordered list of links to reviews, which seems to be updated once a week. To the right of the central module, the new home page also highlights links to the RSS feed, the Twitter account, and the Facebook page of the NYFCC. The Recent News page, which was the fifth and last section featured on the navigation bar, has also been structured like a weblog.[46] Such emphasis on modernity in the scenography suggests that the Circle now intends to reach audiences through both the site and social media applications.

However, the icono-textual scenography of the Circle's new site maintains the general impression of classicism generated by the former version. All the linguistic content is set in the Georgia typeface, a serif font that connotes elegance and formality. The black header is reminiscent of the dark tones of the former site. Yet page headers no longer include a logo or the Circle's name or acronym. It is difficult to identify an author, as the site does not follow the well-established convention of placing the logo of the authoring institution at the upper left corner of each page. The navigation bar also does not use the acronym "NYFCC," so that it is only by reading headlines or noticing the link to the Circle's Facebook page that users can identify the site's author and understand that its activity involves film reviewing. Consequently, despite some modern features, the site's scenography remains formal and remote.

Conversely, the icono-textual scenography of the NSFC website conveys simplicity. First of all, the home page of the 2010 version did not include a logo, and the society's name was presented in white characters against a soft gray background.[47] The main text was set in the Lucinda Sans font quite frequently used on the Internet. This uncluttered scenography highlighted the filmic image that the website's authors inserted in each new entry. For instance, the 10 October 2010 entry featured a striking picture from *The Hurt Locker* (Kathryn Bigelow, 2008), with a bomb-disposal expert walking straight toward the camera in his

protective gear. Such an image, with its centered composition, symmetrical framing, and spectacular subject, directed readers' attention more to the prize-winning film than to the society itself. The very first entry in the website, dated 3 January 2010, acknowledged the fact that the site was quite basic:

> Welcome to the brand-new, fresh-out-of-the-box, barely functioning website of the National Society of Film Critics, a professional organization formed in 1966 to promote the art and science of reviewing motion pictures for general interest publications. We have approximately 60 members whose work appears in a variety of formats, including daily newspapers, weekly and monthly magazines, alternative weeklies and on the internet. We've published a number of anthologies of distinguished writing on the movies, and each January we meet to vote awards for the year's achievements.[48]

Because of the reverse-ordered presentation of the site, this entry was rapidly replaced by others; less conscientious readers of the site's updated versions were not likely to have read it. The passage transformed the simplicity and lack of frequent updating of the site into advantages by openly acknowledging them. Consequently, the information about the nature and purpose of the NSFC as "a professional organization" was colored by proximity with such terms as "barely functioning," used just before. A parallel was established in the syntax between the NSFC, "formed . . . to promote the art and science of reviewing motion pictures," and the Academy of Motion Picture Arts and Sciences. Contrary to the NYFCC, the NSFC at once implicitly admitted that its role was linked with the Oscars ceremony and remained neutral about the potential competition between the two sets of prizes.

This scenography established some proximity with readers. However, the society's legitimacy was indirectly maintained by purely visual means; for instance, the header of the 2010 home page was set in a classical serif typeface (Times New Roman), with italics, which is connoted as formal and slightly elitist. Starting in January 2011, the Tahoma font was chosen for the whole home page, eliminating this classical touch.[49] Instead, the NSFC began to use its logo, a green, stylized round flower. Choosing such a logo was a risk, as the society might not be visually associated with film. But the very existence of a logo, by definition, signaled the existence of a distinct institution and made it easier for readers to recognize and remember the society in other settings. The high quality of the photographs illustrating each new entry on the home page also enhanced the overall impression of accessible formality.

The architectural scenography of the website, with its restricted number of pages, reinforced the impression of simplicity generated by the icono-textual scenography. The procedural scenography made it clear that the site addressed

two types of users. On the one hand people curious about the society's awards were given the possibility to read the content of the home page, with a "search" button indicating they could refer to the list of past awards; besides, they could also learn about the society's purpose and action. On the other hand, since the end of 2011 the site has also targeted the society's members through the addition of a "Meta" section, accessible with a username and password. Yet, according to 2013 chairman David Sterritt, this section contains "pretty much the same material that everyone sees."[50]

In turn, the scenography of the OFCS has been completely altered over time. The first OFCS site had the playful icono-textual scenography of an online fanzine. In August 1999 the home page was dominated by a logo presenting seven walking figures and reading "Mystery Critics."[51] Below this logo, also centered on the page, a catchphrase read, "Who are they? Find out at the Online Film Critics Society!" While generating suspense about the society, this layout attracted attention to the fact that the OFCS was little known and amateurish. This impression was reinforced by the lurid colors in the layout of the society's "Journal." That first site's lack of a visible architecture also suggested amateurism.

In 2001 the site's scenography was entirely redesigned, foregrounding the institutional nature of the society by displaying its official logo in the upper-left corner.[52] This logo had already featured on the former OFCS site, but it had not been placed in this position, which is the traditional place for institutional logos. A first version of the logo (ca. 1999–ca. 2005) highlighted the importance of celluloid film to the society, as it represented a segment of celluloid film, with vertical holes on each side, and a film reel. A second, more stylized version of the logo (ca. 2006–ca. 2011) still referred to celluloid film.[53] With both logos the society proclaimed that "traditional"—not digital—film was an essential part of its identity. Additionally, the new site's wallpaper displayed a pattern formed by repeating the letters "OFCS," which further underlined its institutional quality. This official-looking scenography was reinforced by the existence of such functionalities as a search engine and a members-only page (accessible by logging in). Similarly, the site's procedural scenography made the users' roles clear: nonmembers were expected to click on links in order to read reviews and learn about the OFCS and its awards, while OFCS members were supposed to participate in the society's forums and, of course, post reviews.

When the OFCS site was moved to the hosting site Blogger, its scenography briefly included the new logo along with color images from films in the header, thus engaging readers to relate to the represented filmic characters.[54] However, the logo and images disappeared from page headers a few months later.[55] Instead, the scenography of the Blogger OFCS site consisted in white modules set against a light-gray background. The blog-like architecture imposed by the site's host made the scenography look impersonal.

This relatively impersonal scenography was also used in the latest version of the OFCS site: there is no logo, so users have to read the header, which displays the society's name, in order to identify the nature of the OFCS's activities.[56] Each module is presented in muted shades of gray. Headlines, in orange characters, are visible but discreet. Throughout, the text is set in Arial fonts, as in countless other sites. In the most recent version of this site the header features the black outline of a tree, thus conveying a sense of stability and dependability. The overall impression given by this scenography is that of an official weblog.

To conclude, being the oldest association of film reviewers, the NYFCC has used the Internet to stay true to its elitist aspirations, thanks to a formal and remote scenography. Its direct competitor, the NSFC, has chosen to enter the Worldwide Web very late and to project an image of simple, accessible formality. The OFCS, in turn, has suffered from the hazards of multiple online relocations, so its site's scenography has evolved from looking like a fanzine to the current impersonal and formal design.

CONCLUSION

Over the past decade, associations of film reviewers have gradually created durable and mutable online personalities for themselves. They have progressively established their own legitimacy on the Internet by demonstrating their ability to attract readers' attention and to contend with their competitors in the awards season. Indeed, in the course of this analysis it becomes clear that one major function of the associations' sites is to create an aura of professionalism in the face of both celebrity and industry discourses on the one hand and the reviewing of bloggers and "moonlighters" on the other. The implied audiences of these sites are probably casual filmgoers who might be tempted to take celebrity and industry discourses for granted or to follow the advice of the "ten-best" type of bloggers. Nevertheless, it is clear that the emphasis on canon building and prestige does not foreclose a relationship to red-carpet culture and popular forms of film appreciation. To wit, the very fact that these associations explicitly present their awards as "competitors" to the Academy Awards implies that they intend their prizes to have a function similar to that of the Oscars, even while their plaudits are to be understood as emanating from a more refined cultural sphere.

Furthermore, the three associations studied here have all had trouble controlling the proliferation of discourses imposed by the Internet. Only the NSFC may be considered to have successfully adapted, but this is only due to the short lifespan and spartan character of its website: its designers have accomplished a tour de force by managing to present the association as simple and accessible through the site's scenography, despite its clearly institutional quality. Contrary to the NSFC, the NYFCC went online quite early. But the Circle's communication

plans do not seem to have been changed by the digital age: they have used the Internet as a tool to maintain the Circle's elitist image, and its recent inclusion of a blog-like scenography looks more like a technological affectation than a genuine attempt at proximity with readers. Finally, the OFCS might have been expected to perfectly master the hypertext medium, as it was created by and for online reviewers. Its online personality, however, has evolved from an initial lack of credibility (which was reinforced by the mischievous scenography of its website) to the bland and impersonal online image it now projects.

This case study into the discursive evolutions (or lack thereof) of institutional film criticism shows a remarkable resilience of "authority" in the digital age. If the NYFCC and NSFC have used the web to further their traditional concerns to be seen to represent the *crème de la crème* of critical opinion, the OFCS has used the Internet to *establish* that very authority. In the end the institutional agitations of professional critics associations revolve around legitimacy and inclusion: Who can be a critic, and why should he or she be read and respected?

NOTES

I would like to thank Cecilia Sayad and Mattias Frey for their careful proofreading and their valuable input into this article. I am also very grateful to David Sterritt and to the OFCS Governing Committee for answering my questions.

1. James F. English, *The Economy of Prestige: Prizes, Awards, and the Circulation of Cultural Value* (Cambridge, MA: Harvard University Press, 2008).
2. Following James English, one could even argue that film-evaluative discourses also compete on a global scale with other categories of cultural and entertainment evaluation.
3. George P. Landow, *Hypertext 3.0: Critical Theory and New Media in an Era of Globalization* (Baltimore: Johns Hopkins University Press, 2006), 3, 22, 4. Landow is referring to Roland Barthes, *S/Z* (Paris: Seuil, 1970), 10. The reference for the English version of Barthes's work is Roland Barthes, *S/Z: An Essay*, trans. Richard Miller (New York: Farrar, Straus and Giroux, 1974), 4.
4. Guillaume Latzko-Toth and Serge Proulx define five main characteristics of web-based information: it is searchable, ubiquitous, persistent, mutable, and unverifiable. See Guillaume Latzko-Toth and Serge Proulx, "Enjeux éthiques de la recherche sur le web," in *Manuel d'analyse du web*, ed. Christine Barats (Paris: Armand Colin, 2013), 37–39.
5. The basic opposition in discourse analysis is not that between text and language, as in Saussurean linguistics, but between text and discourse. See Deborah Schiffrin, *Approaches to Discourse: Language as Social Interaction* (Malden, MA: Blackwell, 1994), 363.
6. As Marie-Anne Paveau and Laurence Rosier have shown, there are six main approaches within the wide and varied field of discourse analysis: discursive semantics (Michel Pêcheux), traditional discourse analysis (Zellig Harris), interactive discourse analysis (Catherine Kerbrat-Orecchioni), critical discourse analysis (Teun Van Dijk and Norman Fairclough), enunciative discourse analysis (Dominique Maingueneau), and communicational discourse analysis (Patrick Charaudeau). See Michel Pêcheux, *Analyse automatique du discours* (Paris: Dunod, 1969); Zellig Harris, *A Theory of Language and Information: A Mathematical Approach* (Oxford: Clarendon, 1991); Catherine Kerbrat-Orecchioni, *Le discours en interaction* (Paris: Armand Colin,

2005); Teun Van Dijk, *Discourse Studies* (London: Sage, 2007); Norman Fairclough, *Critical Discourse Analysis: The Critical Study of Language* (London: Longman, 1995); Dominique Maingueneau, *Les termes clés de l'analyse du discours* (Paris: Seuil, 1996); and Patrick Charaudeau, *Les médias et l'information: L'impossible transparence du discours* (Brussels: De Boeck-Ina, 2011).

7. Dominique Maingueneau, "Discours," in *Dictionnaire d'analyse du discours* (Paris: Seuil, 2002), 187–190.

8. See Dominique Maingueneau, *Analyser les textes de communication* (Paris: Dunod, 1998), 74.

9. See Dominique Maingueneau, "Analysis of an Academic Genre," *Discourse Studies* 4.3 (2002): 319–342; and Dominique Maingueneau, "Retour sur une catégorie: Le genre," in *Texte et discours: Catégories pour l'analyse,* ed. Jean-Michel Adam, Jean-Blaise Grize, and Magid Ali Bouacha (Dijon: Editions Universitaires de Dijon, 2004), 107–118.

10. Maingueneau, *Analyser les textes de communication,* 74.

11. Dominique Maingueneau, "Genres de discours et web: Existe-t-il des genres web?" in *Manuel d'analyse du web en sciences humaines et sociales,* ed. Christine Barats (Paris: Armand Colin, 2013), 80–84.

12. Internet Archive, Wayback Machine, http://archive.org/web/web.php. The Wayback Archive randomly records the websites that have been brought to its attention. It is possible for a new website not to be archived for some time when it is first launched. The links to the Wayback Machine correspond to the URL of the pages in question as they appear in the archive; the referenced article may only be viewable in this original form through a search using the Wayback Machine.

13. NYFCC website, http://web.archive.org/web/20010301235824/http://www.nyfcc.com/.

14. The first recording of the new version appeared on the Wayback Machine in January 2011. NYFCC website, "The Lost Year," http://web.archive.org/web/20110113115538/http://www .nyfcc.com/2011/01/the-lost-year/.

15. Author email interview with the OFCS Governing Committee, 31 August 2013.

16. NYFCC, "Welcome," NYFCC website, http://web.archive.org/web/20010301235824/ http://www.nyfcc.com/.

17. The recipients of these special awards included many professions in the film industry ("producers, directors, actors, writers"), as well as in the media ("critics"), academia, and film-preservation institutions ("historians, film restorers and service organizations"). The NYFCC's listing of all these professions as possible recipients of its special awards constructed a wide social scene for its discourses, while also conveying the idea that it deemed itself legitimate in canonizing members of these areas of activity.

18. NYFCC website, http://web.archive.org/web/20010301235824/http://www.nyfcc.com/.

19. NYFCC website, http://web.archive.org/web/20110204074213/http://www.nyfcc.com/?.

20. Armond White, "Message from the Chairman," NYFCC website, http://web.archive .org/web/20110204074213/http://www.nyfcc.com/?.

21. NYFCC website, http://web.archive.org/web/20110118072726/http://www.nyfcc.com/ about/ (emphasis mine).

22. NSFC website, http://web.archive.org/web/20101010004050/http://www.nationalsociety offilmcritics.com/.

23. NSFC website, http://web.archive.org/web/20110110234226/http://www.nationalsociety offilmcritics.com/?.

24. OFCS website, http://web.archive.org/web/19990125091233/http://ofcs.org/.

25. OFCS website, http://web.archive.org/web/20010331225508/http://ofcs.rottentomatoes .com/.

26. OFCS website, http://web.archive.org/web/20020210153114/http://ofcs.rottentomatoes .com/pages/about.

27. OFCS website, http://web.archive.org/web/20110209171357/http://www.ofcs.org/.

28. OFCS website, http://web.archive.org/web/20120601101742/http://www.ofcs.org/.

29. NYFCC website, http://web.archive.org/web/20010405144924/http://www.nyfcc.com/articles.html.

30. NYFCC website, http://web.archive.org/web/20040402032834/http://www.nyfcc.com/photos.html.

31. NYFCC website, http://web.archive.org/web/20070426162644/http://www.nyfcc.com/photos.php.

32. NYFCC website, http://web.archive.org/web/20071217182216/http://www.nyfcc.com/awards.html.

33. The change occurred between the 4 February and 26 May crawls of the site.

34. Journalism textbooks encourage students to seek conciseness. See Joan Clayton, *Journalism for Beginners* (London: Piatkus, 1992), 99; and Richard Keeble, *The Journalism Handbook* (London: Routledge, 1994), 88.

35. NSFC website, http://web.archive.org/web/20110111174915/http://www.nationalsocietyoffilmcritics.com/?page_id=28.

36. OFCS website, http://web.archive.org/web/19991012023238/http://ofcs.org/journal/index.html. Compare with the tagline for Roger Corman's 1966 *The Wild Angels*: "Their credo is violence . . . Their God is hate . . . The most terrifying film of our time!"

37. OFCS website, http://web.archive.org/web/20010331225508/http://ofcs.rottentomatoes.com/.

38. OFCS website, http://web.archive.org/web/20110209171357/http://www.ofcs.org/.

39. OFCS website, http://web.archive.org/web/20120601101742/http://www.ofcs.org/.

40. These conventions dictate that the website should provide an introduction to and a positive image of the institution. See Marià José Luzón Marco, "A Genre Analysis of Corporate Home Pages," *LSP and Professional Communication* 2.1 (2002): 41–56.

41. NYFCC, "Welcome," NYFCC website, http://web.archive.org/web/20010301235824/http://www.nyfcc.com/.

42. See, e.g., the biography of Thelma Adams, NYFCC website, http://web.archive.org/web/20010306105825/http://www.nyfcc.com/bioTA.html.

43. Web conventions have it that such information generally appears in a footer, but none of the pages of the first version of the site had one.

44. NYFCC website, http://web.archive.org/web/20110204074213/http://www.nyfcc.com/?.

45. Susan C. Herring, Lois Ann Scheidt, Elijah Wright, and Sabrina Bonus define weblogs as "frequently modified web pages in which dated entries are listed in reverse chronological sequence." See their "Weblogs as a Bridging Genre," *Information, Technology and People* 18.2 (2005): 142.

46. NYFCC website, http://web.archive.org/web/20110118082934/http://www.nyfcc.com/category/news/.

47. NSFC website, http://web.archive.org/web/20101010004050/http://www.nationalsocietyoffilmcritics.com/.

48. Ibid. (see bottom of the page).

49. NSFC website, http://web.archive.org/web/20110110234226/http://www.nationalsocietyoffilmcritics.com/?.

50. Author email interview with David Sterritt, 18 August 2013.

51. OFCS website, http://web.archive.org/web/19991008222627/http://www.ofcs.org/content.html.

52. OFCS website, http://web.archive.org/web/20010331225508/http://ofcs.rottentomatoes.com/.

53. OFCS website, http://web.archive.org/web/20060118050018/http://ofcs.rottentomatoes.com/.

54. OFCS website, http://web.archive.org/web/20110209171357/http://www.ofcs.org/.

55. OFCS website, http://web.archive.org/web/20110722174355/http://www.ofcs.org/.

56. OFCS website, http://web.archive.org/web/20120601101742/http://www.ofcs.org/.

9 ★ FINNISH FILM CRITICS AND THE UNCERTAINTIES OF THE PROFESSION IN THE DIGITAL AGE

OUTI HAKOLA

The status of critics has always been in flux, but since the advent of the Internet in the early 1990s and the spread of digital culture, significant and singular changes have severely tested long-standing media truths. Formats and contents of criticism and its platforms, audiences, and expectations have had to adjust. The very idea of the critic's profession has been placed under scrutiny and subjected to existential doubts.

In Finland, online film criticism took off in the late 1990s. *Film-O-Holic* started in 1998 and was one of the first online magazines to publish edited and professional film criticism written mainly by film scholars and students; *Filmgoer*, an edited site for film and television criticism, opened in 1999. *Leffatykki*, to name another example, welcomes all interested writers to upload their texts; it was launched in 2001. Even today, these three online magazines are among the most popular sites that deliver their articles only on the Internet (in addition, most newspapers publish online reviews). Thus, by the beginning of the twenty-first century, online film criticism was a prevalent and growing part of the Finnish film scene.

This timing ran parallel to an increasing interest in cinema. Whereas 1995 had seen an all-time low in cinema visits in Finland (5.3 million admissions), by 1998 the number had climbed to more than six million viewers. In the twenty-first century the annual number has stayed close to seven million viewers, and in 2012 the number of viewers crossed the threshold of eight million.[1] Already

these figures show that film attendance has increased. The success is partly due to international supply and local ease of access since the first multiplex theaters opened in 1998; it is also attributable to the increasing production of and demand for the domestic cinema. Film enthusiasm fueled a growth in film journalism in traditional media, online, and the appearance of new, specialized film magazines, including *Hohto* (2001–2007), *Elokuva* (2002–2003), and *Episodi* (2003–).

Despite the renewed interest, new platforms, and increasing quantity of film journalism and reviewing, Finnish critics of film and other subjects feared a "crisis of criticism." The climax of the crisis occurred when literary critic and researcher Martti-Tapio Kuuskoski claimed publicly that Finnish film criticism does not exist; domestic texts, according to Kuuskoski, are superficial plot descriptions, and the writers lack professionalism and any sense of film theory or history.[2] This claim was made in the context of increasing online content, the encroachment of "journalistic" values (superseding aesthetic evaluations), and changing professional practices accompanying worsening contractual conditions and the influx of new (often amateur) writers.

Indeed, during the twenty-first century, professional critics have expressed serious uncertainty about their future. This chapter examines how Finnish critics have assessed their own status before and after the digital turn in criticism. Data generated by surveys of the Finnish Critics' Association members and an analysis of self-reflexive statements in their most important professional organ reveal how they perceive the possibilities and threats of film criticism in the digital age. The chapter proceeds in two parts. The first outlines the historical background of film criticism as a profession in Finland. It argues that rather than the digital age representing an unprecedented caesura, the nation's film criticism has repeatedly been subject to shocks and changes, the most consistent of which have been generational shifts and renewals. The second part details the results of the critics' surveys and statements. Although Finnish film critics register a diminished sense of their status and gatekeeping role, this does not constitute a radical change in self-perception. Instead, the data reveal a significant transformation in perceptions of critics' working conditions and an ambivalent relationship to new media criticism—a result that I argue is ultimately related to the generational mode of criticism in the country.

THE GENERATIONAL SHIFTS OF FINNISH FILM CRITICS

To comprehend certain arguments in the discussions of the crisis of film criticism and critics' working conditions, it is necessary to understand the national context. The history of the profession reveals that at least in Finland there has never been stability in film criticism: every new generation has created its own

specific approaches. Thus, the only constants have been change, generational conflicts, and debates over the modes and aims of criticism.

Early Finnish film criticism witnessed discourses and themes similar to those of other national traditions. Newspapers reported the first film screening that took place on 28 June 1896; the curious focus was either on technology or audience reactions. This ushered in film journalism, but the tradition of criticism first started to take shape during the 1920s.[3] The models for film reviewing were borrowed from other fields of criticism, especially theater and literature, which had been established in Finnish newspapers during the early nineteenth century.[4] As a newcomer both in the field of art and arts criticism, film criticism entertained little regard and even less appreciation for newspaper editors. Whereas reviews from other fields were written by experts (often by other artists or researchers), film notices were composed anonymously by occasional and subjective writers, including freelancers and assistants. Often the reviews represented hasty rewrites of marketing materials. These practices earned censure as "gofer criticism"; this reproach would haunt domestic notices as late as the 1950s.[5]

The first generation of Finnish professionals emerged in the late 1930s, when newspapers started to hire writers who concentrated on cinema and published write-ups with bylines. But most of the notices were actually interviews, production reports, or gossip about film stars rather than independent reviews. At first the critics were caught between the tradition of comparing films to theater and developing new vernaculars to describe film's unique mode of expression. There were growing demands for the independent understanding of film approaching and during the 1940s, however, when, for example, Helge Miettunen demanded that each art form should be evaluated in relation to its own theory.[6] In addition, film criticism's lack of independence was visible in its relations to the industry. Indeed, the era's reviewing has been dubbed "cognac criticism." At press screenings (especially of domestic fare) producers made sure that critics were spared no enjoyment; the latter duly repaid the hospitality with favorable appraisals. Symptomatic of the cozy and often blurry relationship between critics and industry, newspapers' financial model typically depended on advertisements from the production companies.[7]

The first major generational conflict in Finnish film criticism arose in the early 1950s, when a new cohort of "angry" young (male) film critics emerged on the scene. They had theoretical understanding and a critical view of cinema, and they argued that the medium should be approached as its own autonomous art form. They sought to replace plot protocols with sophisticated criticism attuned to categories of aesthetic evaluation, important social themes, and personal creativity. They also demanded independence from the film industry and other forms of external influence. Their activism was related to the birth of "intellectual film culture" in Finland, including a new cinephilia, the proliferation of film

societies, and the founding of the National Film Archives in 1957. As a conse-
quence they professionalized and stabilized film criticism in the eyes of readers.[8]
The film critic became an identifiable constitutive element of cultural journalism
as new editorial processes stabilized reviewing via the role of freelancers, who
wrote most of the cultural pages' external content.[9] Thus, the identity of a critic
was clarified. The founding of the Finnish Critics' Association in 1950 formalized
this development.

Nevertheless, the young generation of film critics wanted to do more than
professionalize their field of writing. They also wanted to actively engage with
the policies and politics of film production, distribution, and reception. As
their approach highlighted film as an art form (rather than entertainment), they
contrasted (American) mass-market films with (European) art films. As Mervi
Pantti argues, high culture preferences legitimize film (and by extension the
film critic), and in this process the tastes of the masses become automatically
defined as "other."[10] Although the new generation's tastes rarely correlated with
the audiences' preferences, film critics' advocacy for challenging material led to
the inclusion of some such films (including Italian neorealism) in domestic pro-
grams. Furthermore, critical emphasis on aesthetic values and societal themes
influenced the selection criteria of the emerging national film prize system and
production subsidies.[11] In other words they managed to influence the underlying
practices and values of the Finnish national cinema for years to come.

Their activism was not uniformly greeted, however. Finnish film producers
and distributors chafed at the overtly critical attitude; the older generation of
critics, still writing at some organs, emphasized the importance of film jour-
nalism and the understanding of popular film. These conflicts culminated in
the 1960s and resulted in the disintegration of the film journalists' association
(Suomen elokuvajournalistit ry) and the slow displacement of many older crit-
ics.[12] The emergence of new wave films fueled hopes of a politicization of film
and film criticism;[13] these aspirations, however, were short-lived. After the politi-
cal climax of film criticism in the 1970s, editors urged for more calm in debates
and requested a more audience-friendly approach. In domestic production aes-
thetic experimentation and radical social themes yielded to a nostalgic approach
that aimed to lure the public back into theaters. Furthermore, the government's
new welfare state values emphasized culture over art and films that potentially
addressed all citizens rather than an educated elite. The cinema was again seen as
a cultural industry, not only as an art form.[14]

Although the ideas about intellectual film criticism of the 1950s would still
influence debates in the twenty-first century, values such as topicality, speed,
and diversity became increasingly important during the 1980s; the new liber-
alism and financial values that emerged in the 1990s emphasized questions of
content production and selling cultural events to audiences.[15] Heikki Hellman

and Maarit Jaakkola, who have researched the status of cultural journalism in the biggest Finnish newspaper, *Helsingin Sanomat*, argue that journalistic values have slowly overtaken arts pages. Since the 1990s, critics have been given additional tasks, and new writers sometimes lack expert knowledge in a certain arts field or article format. This tendency to use general journalists has decreased the use of specialist freelancers. Criticism still has maintained its status; nevertheless, it rarely heads the cultural section anymore. Instead, the role of interviews and news on films has increased. In addition, popular topics supersede artistic values. Critics' former gatekeeping function has also been eclipsed: rather than educating, forming taste, or leading opinion, the emphasis is now on reflexivity and dialogue.[16]

Although some critics have called for an end of the new "journalistic" film reporting and "thumbs-up, thumbs-down" evaluation and a renewed focus on specialist, professional criticism, it is important to note that during the 1990s dissenting voices grew louder. Artists begrudged attempts to manipulate or even censor cultural possibilities; audiences resented critics' pretensions to monopolize meanings.[17] Precisely at this juncture Internet criticism materialized. On the one hand it increased the volume of film criticism with new publications and participation channels. On the other hand it elicited a debate about standards of film criticism, both of reviewing uploaded on the Internet and of that appearing in traditional newspapers' "dumbed-down" entertainment pages. Mervi Pantti argues that the Internet has affected criticism more strongly than the other areas of journalism; unlike, for example, the crime beat, criticism is open—and potentially appeals—to all writers. This democratization, Pantti argues, has not only expanded the range of reviews but has also altered the balance of power. In her study film viewers, who saw professional critics as out of touch, arrogant elitists and abusers of their gatekeeper's role, welcomed the Internet and the opinions and reviews of other lay viewers.[18] Thus, there exists a significant divergence of opinion about film criticism in the digital age: although many critics have not welcomed the new journalistic practices, many readers have found them desirable or necessary.

In one way late twentieth-century film criticism returned to its origins: it revived audience-friendly reviews alongside popular stories about productions and stars. However, two main differences remain. First, by the end of the century film journalism was more popular than ever, and its role both in traditional and new media was increasing. Second, although newspapers are still often seen as the main medium and format for criticism, the Internet started to provide different options for diverse audiences. In the next section of this chapter I will discuss in more depth how the online era and changing digitalized media realities have influenced the profession and how the question of *who* is publishing criticism is becoming more differentiated.

MATERIAL OF THE STUDY

This study is based on two types of materials: a survey of Finnish critics in 2012 and the discussions from the critics' professional magazine *Kritiikin uutiset* (Criticism news) from 2000 to 2012. Although the material includes some notes on arts criticism in general, I will concentrate on the status of film critics and film criticism. Both the survey and the professional discussion reveal how film criticism and the critic's profession have changed in the digital age. The importance of traditional media has decreased while the Internet has opened up new possibilities to publish criticism and debate with readers. The reactions to these changes have been both positive and negative. Whereas critics see the Internet as a new medium for film culture to flourish, anxiety over the future of the (paid) profession prevails.

Kimmo Jokinen surveyed the members of the Finnish Critics' Association (SARV) in 1987. In this survey Jokinen sought to understand the identity of Finnish critics—who they are, what their profession is about, and how they understand the role of criticism.[19] In 2012 I carried out a similar survey—the original questions remained essentially the same, but, in addition, the digital and online dimensions of the contemporary media environment were included in the questions and possible answers. The purpose of the new survey was to determine to what extent and how critics' professional self-regard has changed in the last twenty-five years.

The survey was sent, again, to the members of the Finnish Critics' Association. However, whereas Jokinen received 438 answers to his survey, only fifty-six critics answered the questionnaire in 2012. There are several possible reasons for this outcome. One of these is the method of dissemination. Jokinen sent his survey through mail to make sure that every member of the union received a copy. I chose to e-mail the link of the questionnaire to the association e-mail list; however, it is not obligatory to belong to the e-mail list, nor do all the members necessarily follow it. Because the number of responses in 2012 was significantly low, the results of that survey and the comparisons with the 1987 version need to be considered with some caution. Nevertheless, I introduce the main results here in order to outline the possible changes in critics' identity. In addition, whenever possible, I also use the results of the association's own partial survey, conducted in 2001,[20] to provide a more comprehensive reference point to track down the possible changes (the association asked only background questions and questions related to salaries and fees, receiving 262 answers).

As the survey results cannot furnish a representative, comprehensive image of the reviewer's role in the digital era, material from *Kritiikin uutiset* is also analyzed in this study. *Kritiikin uutiset* is a membership quarterly published by the Finnish Critics' Association; each issue contains professional news, thematic articles, reviews, forums for debate, and comments on different fields of art. I have systematically analyzed each of the forty-seven issues from 2000 to 2012. In

my analysis I concentrate on discussions about the role of criticism as a profession and polemical debates over film criticism.

Before proceeding with the analysis of the material, I want to provide a brief description of the Finnish Critics' Association since it plays a specific role in both sets of data. The association is a national institution with nearly one thousand members. It aims, according to its website, "to promote arts critics' professional activity and expertise" and "to improve its members' economic, social and judicial status."[21] To become members, applicants must prove that they have been writing reviews professionally and that they are published in Finnish media platforms with established editorial practices; amateurs or occasional writers cannot become members of the union. Thus, both the survey answers and the discussions found in *Kritiikin uutiset* should reflect the attitudes of more or less "professional critics," as defined in this way.

EDUCATION AND MOTIVATIONS OF FINNISH CRITICS

In Finland "professional critics" are highly educated, and most have several professional roles within film culture. These writers see criticism as a way to further improve and demonstrate their professionalism in general, instead of spreading their tastes or opinions about films as such. In the context of a discussion of "professional critics" it is important to notice that the concept of professionalism refers to critics' expertise and education, not to the status of their employment. Most Finnish critics write reviews on a part-time basis. This has remained a consistent feature throughout the years: most critics either are full-time freelancers writing for several publications or are part-time freelancers.

Typically, Finnish critics write criticism *alongside* (rather than *as*) their main profession. Almost 70 percent of critics have another full-time job or another main source of income. The most typical "other professions" have remained consistent

TABLE 9.1. Type of Employment of Finnish Critics

	Survey 2012 (56 answers)	Survey 2001 (262 answers)	Survey 1987 (438 answers)
Full-time salaried journalists/critics	5%	2%	9%
Full-time freelancers	25%	14%	13%
Part-time freelancers	32%	44%	44%
Occasional writers	38%	37%	34%

SOURCES: 2012: Author's survey; 2001: Jokinen, "Arvostelijoiden palkkiot," 4–5; 1987: Jokinen, *Arvostelijat*, 19.

since at least 1987. The critics are often journalists (either full-time or freelancers), researchers, teachers, librarians, students, artists, or employees for cultural organizations in the public sector.[22] In other words critics characteristically work professionally in another role within the same field about which they write criticism.

In addition to the critics' frequent (but not always) expertise in their own field, they are also highly educated. Most of them have a university degree (85 percent in 2012, and 77 percent in 1987).[23] Two-thirds have also received some training or education in criticism. They have taken courses as part of their university studies, have participated in writing courses, or have taken courses provided by the Finnish Critics' Association or other cultural institutions. The critics tend to take pride in their expertise—both in their knowledge of the field and in their writing skills. Here the situation differs slightly from that of the 1980s, when, in addition to their studies in their field, they rarely participated in other courses on writing or criticism. The changed attitude is reflected in their opinions: whereas one-third of critics in 2012 saw practice as the most convenient way to learn to write criticism, almost half of them preferred practice to be combined with education.

The critics value their work. Most of them answered that they enjoy writing reviews and believe that their activity is important. Also, they emphasized that money is not their primary motivation. In 1987 the critics reported they wrote reviews because of their love for their art field.[24] The reason obtains as an explanation even in the twenty-first century, although the critics emphasized their need to remain aware of new works, events, and trends in their field. They considered criticism an ideal way to update their expertise, to remain alert to new trends,

TABLE 9.2. Most Rewarding Elements of the Profession According to Finnish Critics

	2012	1987
Opportunity to know the field widely, to concentrate on artworks, and remain alert to new trends in the subject	48%	34%
Writing, creativity, expressing oneself	18%	29%
Freedom of the profession	14%	19%
Possibility for power, to share information, create dialogue with the audience, and receive feedback	16%	8%
To meet other people from the field	2%	4%
Financial reasons, free tickets	0%	4%
Other reasons	2%	2%

SOURCES: 2012: Author's survey; 1987: Jokinen, *Arvostelijat*, 32.

NOTE: Percentages are calculated from the number of the mentions; there were no limitations for the answers.

and to acquire deeper knowledge of their subject. Furthermore, the importance of dialogue with readers was provided as a rewarding element of criticism in the twenty-first century. This is an important indicator: it tends to correlate with the demands of the online era and its journalistic values. Furthermore, it contradicts the impression (as articulated by some audiences and discussed above) that critics are aloof elitists.

Interestingly, in 2012 none of the critics (although the sample size is too small to make generalizations as such) mentioned financial reasons as a motivator for their writing. The reason for this might be explained by looking at what the critics considered the worst parts of their profession. Dissatisfaction with pay, contracts, and the social status of the profession have grown. Still, almost all survey participants concluded that the positive aspects of their work exceeded the negative; the profession of criticism, they concluded, is personally rewarding.

NEW CHALLENGES TO THE PROFESSION

Although critics have always complained about low wages, dissatisfaction with the practicalities of the profession has increased in the twenty-first century. The reasons can be gleaned from the changing media landscape. In their research into arts pages Hellman and Jaakkola note that until the early 2000s,

TABLE 9.3. Most Challenging Elements of the Profession According to Finnish Critics

	Survey 2012	Survey 1987
Low pay	34%	28%
Time pressures, pressure for quality	17%	19%
Lack of good artworks	13%	8%
The necessity to write about everything, tired of writing	2%	12%
Lack of respect for the profession, including lack of respect from employers in the form of unflattering contracts and problems with copyright issues	16%	11%
Need to give negative feedback on artworks	2%	11%
Negative feedback and negative attitudes	5%	6%
Outside pressures on work: editorial interference, increasing demands to entertain and to write about entertainment	9%	0%
Other reasons (including loneliness, lack of work)	2%	5%

SOURCES: 2012: Author's survey; 1987: Jokinen, *Arvostelijat*, 33.

culture sections and the number of culture notices consistently expanded and increased, respectively. Since 2003, however, the size of the culture section has been decreasing. At the same time, article lengths have shortened.[25] Also, because of economic reasons, the traditional media have used fewer external, specialized writers. Consequently, the profession has become marked with uncertainties. This trend has resulted in increasing feelings of inferiority: critics fear that they are appreciated not for their highly self-valued professionalism but for their capacity to entertain readers.

For most critics the profession is not their main source of income. This is visible in earnings. Only a small percentage of critics earn enough money to live on by writing criticism alone. Most critics receive modest wages, but an increasing number of critics receive no pay at all; clearly, their motivations to write are not related to money. Already in 1987 critics' income was low; only about every tenth critic earned enough from the profession to survive on that income alone. In addition, in 1987 work-related expenses were fully reimbursed to 20 percent of critics and only every third had to pay all expenses themselves.[26] In 2001 the proportion of critics living on their criticism earnings had decreased to a few percent, and about 60 percent received occasional fees for their work. Now, however, more than half of employers fail to pay for any expenses; only every tenth critic has all expenses covered. The main issue has been that freelancers are rarely paid for their expenses; they are cheap labor for cultural media. Already in 2001 survey participants wrote criticism without pay in some specialized magazines such as scholarly journals.[27] In 2012, however, 15 percent of the critics answering the survey received no fees at all for their writing, and more than half had no expenses covered. The use of free labor has therefore increased in the field—in specialist magazines but also in Internet publications. The issue of free labor has been debated in *Kritiikin uutiset* as well. For example, already in 2002 the chairman of the Finnish Critics' Association, Siskotuulikki Toijonen, argued that writing criticism without pay shows a lack of solidarity with colleagues in a context where traditional media devalue the work of critics.[28]

The low pay in the profession means that critics are often forced to write for multiple publications. The numbers of publications have remained quite stable since 1987. Full-time critics and occasional writers tended to write for only one publication. Freelancers had the most engagements: most of them wrote for at least three different media.[29] Recently there have been complaints about the reprinting of published reviews in other outlets (other newspapers within the same corporation or on the web pages) without any extra remuneration. Such complaints have increased since 2008, when the first signs of degenerating freelance contracts surfaced. The debate expanded in 2009 when the biggest media house, Sanoma News, one-sidedly altered its freelance contracts so that the publisher would automatically own the copyrights to all texts, which the corporation

could subsequently republish wherever, whenever, and how often it desired. The move aroused extreme passions, and although the critics lost their lawsuit in court as the new contract format was seen as legal, the discussion has continued, with claims of unethical practices and lack of respect toward critics.[30]

For several decades critics usually stayed outside newsrooms. This was seen as a symbol of criticism's independence, but it can also detach critics from editorial decision-making processes. Especially in the past ten years, the outsider role has harmed the critics' opportunity to codetermine their profession and activity. In a similar way Hellman and Jaakkola argue that publishers have become the dominating voice in cultural journalism.[31]

Certainly, in the debates among critics in *Kritiikin uutiset* publishers' interventions have been perceived to influence independence and freedom of expression. Demands for more "journalistic" stories have often been understood to mean priority for more entertaining, superficial, and commercialized reviews. Such demands are also connected to the receding length (and quantity) of the reviews in the newspapers. Critics perceive the shorter format to result in mere plot descriptions without room for proper intellectual analysis or negative criticism.[32] Dissenting voices have argued that shorter formats do not preclude intellectuality and that quality criticism that responds to audiences' needs can be considered as a possibility amid the changing material conditions of journalism.[33]

In addition, "journalistic" values were seen to diminish the "traditional" values of criticism, such as the importance of art and aesthetic forms; according to commentators in the debate, articles in this vein merely duplicate the news pages.[34] As a counterbalance to this development, a number of writers have demanded more "professional" criticism. By this they refer to one or all of the following claims: reviews should concentrate on the artwork (instead of the artist); reviews should look past personal whims; contextualization and understanding of different genres are necessities; aesthetic issues need to be considered; reviews should be based on extensive consideration of the work; critics must have and display deep understanding of their subject.[35] Furthermore, the conceptual separation between review and commentary or report is seen as a solution to highlight professionalism.[36] Despite their wide disapproval among most critics, "journalistic" values found some support. Criticism was argued to be a subset of journalism; a journalistic approach could be more palatable to wider audiences. Other article formats such as interviews were seen, according to some interlocutors, to enrich—rather than diminish—the dissemination of cultural information.[37]

The discussion of professionalism is closely related to issues of status and power. The increasing conflicts with employers engendered a sense of a lack of respect. In the 1987 survey critics placed themselves in third place, after artists and producers, when answering the question about who has the most

influence on the appreciation of an artwork.[38] In 2012 critics ranked themselves fifth after artists, producers, audiences, and teachers. In other words critics disregard their gatekeeping power and deem the concept of cultural arbiter to be outdated, although some writers were nostalgic about the era when the critic maintained a more important role in shaping tastes and canons.[39] In 2009 Niklas Herlin publically claimed that there was no longer a need for elitist criticism, because consumers' opinions were filling in the void on the Internet. Passionate debate ensued; critics were still tasked with discussing aesthetic values, both good and bad.[40] As Otso Kantokorpi argued in 2007, critics crave distinction: they often desire the old top-down model of evaluation and taste-making and tend to play the outsider role.[41] However, many critics welcome their new role as participants in—rather than leaders of—cultural discourse, and in the survey some critics greeted the fact that the "godlike" positions of some critics have been shaken.[42]

Although *Kritiikin uutiset* published an impressive article on the "destruction of criticism" in 2009 where Ville Hänninen argued that free online content, journalistic stories and values, and the loss of mass audiences would destroy criticism as it has been known, the mainstream discussion started to feature more nuanced arguments.[43] The ongoing changes were positioned within larger media developments; specifically, the role of newspapers, the (former) cornerstones of criticism, was in transition. Thus, there were ever fewer claims of a "crisis of criticism"; rather, the discourse honed in on a crisis of the profession as it had been known hitherto. Even in the destruction narrative the Internet was seen as an option for a diverse and professional mode of criticism, if one addressed to more fragmented audiences. The theses of crisis connected to changing practices of cultural journalism, lowered wages, and worsening copyright issues were redirected toward traditional newspapers and big media houses; other platforms, such as specialized publications and online publications were increasingly deemed worthy alternatives.[44]

THREATS AND POSSIBILITIES OF THE INTERNET

In 1987 most critics wrote for local newspapers, national newspapers, or magazines. These forums encompassed nearly two-thirds of all published reviews.[45] In 2001 the situation had remained the same,[46] and by 2012, well into the age of digital culture, newspapers and magazines still claimed more than 60 percent of published reviews. In 2012, however, more than half of critics wrote for websites, or their notices were also published online. Moreover, there were critics who wrote only online criticism and who considered the Internet the most powerful channel of dissemination. Most critics, however, considered the printed newspaper or magazine more important than the Internet. This fact makes the fears about

media changes quite understandable, yet the new generation of critics who are more accustomed to Internet publishing do not share these anxieties.

As of the year 2000, newspapers were still seen as a proper forum for criticism, and the Internet was seen as an underdeveloped arena for nonprofessionals "pretending" to be critics.[47] In Finland, film criticism was one of the first arts criticisms to be featured predominantly online. For this reason it also engendered heated metadiscussion in the early years of online criticism. Reproducing familiar "dumbing-down" discourses, some saw quantity replacing quality; contemporary writers, so this argument went, lacked the criteria on which to base their criticism. There was also nostalgia for the era of aesthetic film criticism. Furthermore, the influence of film criticism was deemed to be on the wane, usurped by online and social media, as well as the journalistic practices of newspapers to provide films with unconsidered publicity. In this way the critic's power was seen as limited to smaller films, whereas big-budget blockbusters were now immune to the pronouncements of reviewers.[48] Nevertheless, online content had defenders from the beginning. For example, Juha Rosenqvist, a leading editor of the online film magazine *Film-O-Holic*, argued that film criticism has not necessarily degenerated; instead, supply has increased in accordance with the new interest in film by online writers and journalists from traditional media. Rather than a threat, Rosenqvist maintained, this development should be treated as an opportunity; now there are multiple options available to all kinds of readers. Arguing for an inclusive, pluralistic field, he claimed that there is no reason to look down on the Internet and the coexistence of more and less professional reviewing.[49]

The status of online criticism has slowly increased. Despite fears that it would replace professionals with amateurs, the Internet also provided new publicity for established critics, voices for up-and-comers, and a conversationalist venue for experimenting with new forms of criticism.[50] In addition, the discussion of professionalism has shifted from simplistic doomsday assessments to reckonings with promising alternatives and solutions. Despite its challenges to pay rates and some other professional problems, online criticism was widely seen as an antidote to the decreasing criticism of daily newspapers; it allowed for an option to practice professional, aesthetic, and sociological criticism in the vein of the 1950s.[51]

The 2012 survey also included one additional question about how online reviewing has affected the respect and importance of criticism. The question provoked equally negative and positive comments. On the one hand the Internet was seen to blur the distinction between amateurs and professionals, a fact that has obscured the functions of criticism, complicated the understanding of professionalism, and devalued the respect for the profession. Critics were especially worried about how these developments might influence their pay rates in the traditional media and their roles as gatekeepers. Nevertheless, although many

critics acknowledged the changes to traditions, they also saw online options as a renewal of their profession. Respondents argued that more diverse criticism attracts more audiences. They also believed that criticism has gained more popularity and visibility, has allowed for specialist writing and niche audiences, and has become easier to access (especially reviews of older works of art and those from different parts of Finland and the world). These new publications enable more freedom and more room for creativity—and even, in some cases, higher professional standards—when compared to the journalistic criteria of newspapers. Digital-age criticism has also increased the potential of dialogue and the amount of feedback. For these optimistic critics, in fact, the diminished role of gatekeeping was seen as a positive effect.[52]

Whereas criticism has always been subject to revision and renewal, it is interesting to note how critics see their own future. In 1987 one-third of the surveyed critics answered that the importance of criticism is increasing as a result of increasing leisure time. In other words when people have more time to consume culture, more reviews are needed. More than 40 percent of critics also believed that the importance of criticism would continue to grow in the future. Their understanding correlates with the widening of cultural journalism at that time. Nevertheless, even back then every fifth critic argued that criticism had suffered as a result of superficiality and the "entertainment" approach; 28 percent believed that criticism would deteriorate in the future because of commercialization.[53]

In 2012 the views were somewhat more pessimistic. Only 12 percent believed that the importance of criticism has increased, whereas 61 percent believed that it has decreased. Respondents argued that the media no longer maintained (or sustained) interest in criticism; editorial practices and interventions marginalized critics. Dwindling numbers and lengths of published reviews in traditional media, as well as competing online material, were deemed to have undermined and "dumbed-down" professional criticism. Some critics, however, still recognized the public need for their field. They argued that as long as there are cultural products and artworks, some respect will exist. In addition, those who believed that their status would stay either the same or increase tended to see the Internet as a possibility rather than as a threat. They claimed that the options to publish without the limitations of traditional editorial processes have brought new opportunities, widened perspectives, and provided new forms of expression, quality, and lengthier texts. In this way the Internet has invigorated critical form.

Like the academic discourses outlined in the introduction to this volume, Finnish critics' prognostications about the future of criticism in 2012 were decidedly divided. Some thought that the standard and status of criticism will decrease and professionalism would be overtaken by entertainment and free, superficial, and commercialized online content. Others saw the future of criticism in itself as secured but dwelt on the problems of pay scales and business models. Indeed,

criticism was considered to have a future on the Internet, with social media, and in specialized publications. The optimistic views related to digital write-ups were also visible in 2013's first issue of *Kritiikin uutiset*. Online criticism received much attention and was seen to play an important role in a changed media world, where it could offer new possibilities for debating culture.[54]

CONCLUSIONS

A quarter-century ago Finnish critics believed in the importance of reviewing and trusted the audience to respect their perspectives on films. In 2012 the belief in both their importance and status was diminished. The most drastic difference, however, lies in assessments of working conditions, as the amount and length of criticism is decreasing in the newspapers and new freelance contracts force writers into an unfavorable, uninfluential position vis-à-vis editors. Audiences have more information than ever about a flourishing film culture; this gain comes at the expense of professional critics' former perception of their gatekeeping position. But not all critics bemoan the changes: online options also represent a way out from the dead-end traditional media. In sum, whereas the critic's profession is uncertain, the love for film and writing—by far the motivation for most critics in the surveys—has also found new platforms and outlets.

The ambivalent picture of threats and possibilities revealed in the internal debates of Finnish critics reveals an ongoing generational shift, a typical feature of the national film culture. Critics used to the importance of newspapers, printed reviews, and gatekeeping positions are struggling to keep up or are resigned to nostalgia, whereas younger critics more accustomed to the digital media environment adjust and enjoy the new possibilities—at least as an experience, if not paid employment.

The Finnish situation, despite its specificities, cannot be divorced from the global debates on film criticism. Online options have challenged the gatekeeping positions of the critics in many other Western countries; Finnish formats for the online film magazines and sites have had international models, and Finnish audiences follow both national and international online media. Indeed, online options have opened up national film debates, and, for example, IMDb provides an easy access format to share cinematic experiences globally.

The Finnish case study reveals that the anxiety related to the so-called crisis of criticism is a question of perspective, not only in Finland but internationally as well. From the perspective of critics used to the gatekeeping power of the traditional media, the future of criticism and the profession are endangered. When the same situation is considered from the perspective of the reader and film enthusiast, however, the state of film criticism looks much different. Regarded in this way, lay reviews, YouTube film interpretations, IMDb ratings, and professional

articles serve their own audiences at the same time that accessible film culture has increased. The generation of online critics values the possibilities in choosing among various styles and evolving audiences, without needing to abide by the preconditions of traditional media. From this perspective there is no crisis of criticism but rather a bright future with imaginative prospects.

NOTES

1. Reetta Hautamäki, *Tilastoja / Facts & Figures 2004* (Helsinki: Suomen Elokuvasäätiö / Finnish Film Foundation, 2005), 2; Reetta Hautamäki and Petri Kemppinen, *Elokuvavuosi 2012 Facts & Figures* (Helsinki: Suomen Elokuvasäätiö / Finnish Film Foundation, 2013), 17.

2. Martti-Tapio Kuuskoski, "Arvostelukyvyttömyyden kritiikki," *Yliopisto* 49 (2001): 4.

3. Ari Kivimäki, "Elokuvakritiikki kulttuurihistorian lähteenä," in *Kulttuurihistoria—Johdatus tutkimukseen*, ed. Kari Immonen and Maarit Leskelä (Helsinki: Suomalaisen kirjallisuuden seura, 2001), 296–297.

4. Merja Hurri, *Kulttuuriosasto: Symboliset taistelut, sukupuolikonfliktit ja sananvapaus viiden pääkaupunkilehden kulttuuritoimituksissa, 1946–80* (Tampere: Tampereen yliopisto, 1993), 12–14.

5. Kivimäki, "Elokuvakritiikki," 297; Hurri, *Kulttuuriosasto*, 14; Ari Kivimäki," Elokuvan selostajista tuomareiksi: suomalainen elokuvajournalismi, 1950-luvulla," in *Kriisi, kritiikki, konsensus: Elokuva ja suomalainen yhteiskunta*, ed. Hannu Salmi (Turku: Turun yliopisto, 1999), 79.

6. Helge Miettunen, *Elokuva itsenäisenä taidelajina* (Helsinki: Helsinginyliopisto, 1950).

7. Kivimäki, "Elokuvakritiikki," 298–299; Kivimäki, "Elokuvan selostajista tuomareiksi," 81.

8. Kivimäki, "Elokuvan selostajista tuomareiksi," 79–81; Kivimäki, "Elokuvakritiikki," 296–301; Ari Kivimäki, "Elokuvajournalismin julkisuuspelit: Ideologiaa, odotuksia ja valtaa," *Lähikuva* 3–4 (1993): 64–65; Mervi Pantti, *Kaikki muuttuu . . . elokuvakulttuurin jälleenrakentaminen Suomessa 1950-luvulta 1970-luvulle* (Jyväskylä: Suomen Elokuvatutkimuksen Seura, 1998), 33–37.

9. Hurri, *Kulttuuriosasto*, 14.

10. Pantti, *Kaikki muuttuu*, 44–48.

11. Kivimäki, "Elokuvan selostajista tuomareiksi," 80, 87; Kivimäki, "Elokuvajournalismin julkisuuspelit," 66; Pantti, *Kaikki muuttuu*, 33.

12. Pantti, *Kaikki muuttuu*, 41–44.

13. Kivimäki, "Elokuvan selostajista tuomareiksi," 89–94; Hurri, *Kulttuuriosasto*, 116; Mervi Pantti, "Tehtävänä todellisuuden tutkiminen," in *Kriisi, kritiikki, konsensus: Elokuva ja suomalainen yhteiskunta*, ed. Hannu Salmi (Turku: Turun yliopisto, 1999), 120–132.

14. Pantti, *Kaikki muuttuu*, 186–190; Hurri, *Kulttuuriosasto*, 182–224.

15. Hurri, *Kulttuuriosasto*, 232–260; Katri Halonen, *Kulttuurintuottajat taiteen ja talouden risteyskohdassa* (Jyväskylä: University of Jyväskylä, 2011).

16. Heikki Hellman and Maarit Jaakkola, "Kulttuuritoimitus uutisopissa—Kulttuurijournalismin muutos Helsingin Sanomissa 1978–2008," *Media & Viestintä* 4–5 (2009): 24–40.

17. Hurri, *Kulttuuriosasto*, 296–297, 300.

18. Mervi Pantti, "Elokuvakritiikki verkkojournalismin aikakaudella," *Lähikuva* 1 (2002): 85–105.

19. Kimmo Jokinen, *Arvostelijat—Suomalaiset kriitikot ja heidän työnsä* (Jyväskylä: Jyväskylän yliopisto, 1988).

20. Heikki Jokinen, "Arvostelijoiden palkkiot ja olosuhteet vaihtelevat rajusti," *Kritiikin uutiset*, no. 2 (2001): 4–6.

21. SARV, www.sarv.fi/2010/index.php?p=sarveng.
22. Jokinen, *Arvostelijat*, 18.
23. Ibid., 20–21.
24. Ibid., 27.
25. Hellman and Jaakkola, "Kulttuuritoimitus uutisopissa," 31–32.
26. Jokinen, *Arvostelijat*, 34–35.
27. Jokinen, "Arvostelijoiden palkkiot," 4–5.
28. Siskotuulikki Toijonen, "Ilmaiskritiikki—harmaata taloutta?" *Kritiikin uutiset*, no. 3 (2002): 31.
29. Jokinen, *Arvostelijat*, 21.
30. For example, Heikki Jokinen, "Sanoma Newsin tapaus: Mitä tapahtuu todella?" *Kritiikin uutiset*, no. 2 (2009): 3–5; Siskotuulikki Toijonen, "Lausunto työryhmän esityksestä tekijänoikeuslain muuttamiseksi," *Kritiikin uutiset*, no. 4 (2009): 8–9; Heikki Jokinen, "Free?" *Kritiikin uutiset*, no. 4 (2010): 5; Heikki Jokinen, "Viimeinen väsytystaistelu?" *Kritiikin uutiset*, no. 2 (2012): 3.
31. Hellman and Jaakkola, "Kulttuuritoimitus uutisopissa," 39.
32. See, e.g., Ritva Kolehmainen, "Onko kulttuuri kriisissä?" *Kritiikin uutiset*, no. 1 (2005): 24–25; Ritva Kolehmainen, "Merkkipuhetta," *Kritiikin uutiset*, no. 4 (2006): 3; Matti Linnavuori, "Moite katosi arvosteluista," *Kritiikin uutiset*, no. 4 (2008): 9.
33. See, e.g., Antti Selkokari, "Voiko vain pitkä kritiikki olla kritiikki?" *Kritiikin uutiset*, no. 4 (2003): 13; Juha Drufva, "Taide on kulttuurin hiiva," *Kritiikin uutiset*, no. 2 (2010): 12–13.
34. Kari Salminen, "Kriitikon täytyy myydä tyhjänpäiväisyyksiä," *Kritiikin uutiset*, no. 3 (2010): 22–23.
35. See, e.g., Reijo Virtanen, "Keskustelua kritiikistä," *Kritiikin uutiset*, no. 1 (2000): 23; Pekka Helin, "Freelance-kriitikko," *Kritiikin uutiset*, no. 2 (2000): 22; Rainer Palas, "Mietteitä kritiikistä," *Kritiikin uutiset*, no. 4 (2004): 8–9; Maila-Katriina Tuominen, "Mikä merkitys on ammattikriitikon teoreettisella taustalla," *Kritiikin uutiset*, no. 1 (2005): 22; and Otso Kantokorpi, "Kritiikki on kulttuurilinnakkeen puolustamista," *Kritiikin uutiset*, no. 1 (2006): 5–7.
36. See, e.g., Veijo Hietala, "Kritiikki—katoava luonnonvara," *Kritiikin uutiset*, no. 4 (2003): 6; Juha Drufva, "Miten arvioida taiteen pirullisen ihanaa valtakuntaa?" *Kritiikin uutiset*, no. 3 (2004): 28.
37. See, e.g., Siskotuulikki Toijonen, "Rehellisyys objektiivisuuden edelle," *Kritiikin uutiset*, no. 3 (2010): 12–16; Harri Römpötti, "Mekö muka journalisteja?" *Kritiikin uutiset*, no. 1 (2009): 5–6.
38. Jokinen, *Arvostelijat*, 48.
39. Timo Hännikäinen, "Kritiikon on pudottava kärryiltä," *Kritiikin uutiset*, no. 2 (2003): 12–13.
40. See, e.g., Antti Selkokari, "Murinaa mediapäivillä," *Kritiikin uutiset*, no. 2 (2009): 6–7; Otso Kantokorpi, "Kenen joukoissa seisot?" *Kritiikin uutiset*, no. 2 (2009): 1.
41. Otso Kantokorpi, "Kritiikkiä voisi luonnehtia journalismin äpärälapseksi," *Kritiikin uutiset*, no. 1 (2007): 18–19.
42. See, e.g., Matti Saurama, "Kohti keskustelua," *Kritiikin uutiset*, no. 2 (2003): 3; Römpötti, "Mekö muka journalisteja?" 5–6; Drufva, "Taide on kulttuurin hiiva," 12–13; Toijonen, "Rehellisyys objektiivisuuden edelle," 12–16.
43. Ville Hänninen, "Kritiikin tuho! Katso kuvat!" *Kritiikin uutiset*, no. 2 (2009): 8–9.
44. Drufva, "Taide on kulttuurin hiiva," 12–13; Kolehmainen, "Merkkipuhetta," 3.
45. Jokinen, *Arvostelijat*, 26.
46. Jokinen, "Arvostelijoiden palkkiot," 4–5.
47. Suna Vuori, "Nuori kriitikko," *Kritiikin uutiset*, no. 2 (2000): 23–25.

48. See, e.g., Hietala, "Kritiikki—katoava luonnonvara," 6; Taneli Topelius, "Kuka kaappasi elokuvajournalismin vallan?" *Kritiikin uutiset*, no. 4 (2003): 7–8.

49. Juha Rosenqvist, "Elokuvakritiikin nykytilasta," *Kritiikin uutiset*, no. 1 (2001): 5–6.

50. See, e.g., Markku Soikkeli, "Nettikritiikin toinen sukupolvi," *Kritiikin uutiset*, no. 4 (2005): 7; Heikki Kastemaa, "Vain muutos pysyy, vai pysyykö sekään," *Kritiikin uutiset*, no. 4 (2009): 8–9.

51. Jouni Huhtanen, "Kritiikin arvoista ja arvojen kritiikistä," *Kritiikin uutiset*, no. 4 (2009): 10–12.

52. See also Tommi Melander, "Kritiikki vaatii ravistelu," *Kritiikin uutiset*, no. 4 (2010): 24; Tere Vadén, "Missä on kritiikin tulevaisuus?" *Kritiikin uutiset*, no. 4 (2010): 25; Matti Linnavuori, "Mihin kritiikki joutuu, kun se häviää lehdestä?" *Kritiikin uutiset*, no. 1 (2011): 9–10.

53. Jokinen, *Arvostelijat*, 49–50, 77–81.

54. "Verkkokritiikin kova ydin," *Kritiikin uutiset*, no. 1 (2013): 2–3.

10 ★ THE SOCIAL FUNCTION OF CRITICISM; OR, WHY DOES THE CINEMA HAVE (TO HAVE) A SOUL?

THOMAS ELSAESSER

As film critics argue over the merits of the web as a forum for informed debate about the movies,[1] with some welcoming the diversity of views and the nerdy expertise on display,[2] while others regret the decline in professional standards and expectations due to the blogs,[3] or mourn the death of the last authoritative film critic with worldwide appeal,[4] it is instructive to return to the writings of critics-cum theorists like Béla Balázs, Siegfried Kracauer, Parker Tyler, and Edgar Morin. Each was a distinctive critical voice in his time and for his age, and each reflected, implicitly and often enough explicitly as well, on the task at hand: to put into words the kind of knowledge the cinema embodies, engenders, and transmits. In what follows, I touch on several aspects of the relationship between film criticism and the very idea of a social function, giving my remarks, across the names just cited, a personal inflection. In passing I also wonder whether the cinema is ever likely to attract another critical and intellectual enterprise that tries to grasp its history and existence within an anthropological horizon, such as I see it manifest in the works of these critics.

Balázs's *Visible Man* and *The Spirit of Film* register a profound culture shock that transmits itself as a discovery and disclosure, while the reason a project such as Kracauer's *From Caligari to Hitler* is still read is that one senses the urgency of someone bearing witness and rendering account, and at what cost. It is this burden of proof of a momentous social fact that sometimes establishes

for the cinema the claim to a profoundly impersonal kind of knowledge, one that does not preclude one's pleasure in pure spectacle (at times in spite of oneself). The best critics have always been able to convey this conflicted knowledge both in their more self-reflexive moments and in their day-to-day reviewing. On one hand it makes the productive ambivalences surrounding the cinema as a window on the world *and* a mirror to the self still one of the best reasons for not dismissing psychoanalytic criticism, whatever one's methodological misgivings. On the other hand is it not the case that Gilles Deleuze, though hardly a film critic as we usually understand the term, has given us with his *Cinema* books the last of such overarching *critical* projects by a dedicated cinephile?[5] And is not the broad-fronted recovery and rediscovery currently under way of André Bazin's voluminous writings meant to establish him not just as the influential and charismatic critic that he was but precisely as such a thinker capable of conveying the cinema's epochal and, in this sense, social and anthropological significance?[6]

FILM CRITICISM AND THE NATURE OF KNOWLEDGE

Commenting retrospectively on cinema and its conversion to sound in a number of subtly reworded and reflective pieces, Béla Balázs, who much regretted these changes, bid farewell to silent pictures. He noted that thanks to the new medium, in "the epoch of word culture the soul learnt to speak but had grown almost invisible," and that the photoplay's emerging speechless art of movement, gesture, and physiognomy "revealed new worlds until then concealed from us: such as the soul of objects"; this process communicated neither "rational, conceptual contents" nor simply translated irrational sensations.[7] This paradoxical observation about the nature of knowledge and disclosure, of concepts and sensations, occasioned by the sudden shock that the movies were no longer eloquent in their silence, has today a familiar ring. It reminds us why Deleuze found in Balázs a kindred spirit and a vital inspiration, and it suggests that for all the disruptive energies the digital age continues to deploy, it may not have brought about the kind of ontological shift that Balázs detected between the world of the printed book and the world of the moving image. This is not to deny that the web has radically redefined the scope of criticism and the parameters of its social relevance, and not only because it turns critical discourse into mere opinion and commentary (which, as the saying goes, "is free"). The legacy of Kracauer, for instance, is today more alive and visible in the blogs and columns on TV series like *The Wire* or *Breaking Bad* than in the reviews of Hollywood blockbusters, but not only do accredited critics (like J. Hoberman and A. O. Scott) and theorists (like Fredric Jameson and Slavoj Žižek) join the fray of bloggers and online pundits at large; the makers themselves go on record and share with their viewers the

kind of critical intervention their work is making. They put themselves forward not so much as authors and authorities but more as audiences and critics, trying to understand their characters and, with or through them, the society we live in.

Behind this, too, stands the question already alluded to: what kind of knowledge is it that we (hope to) get from films or high-end television, and by extension, how has the existence of the cinema altered our very conception of what knowledge is? Bazin's famous *What Is Cinema?* has always had an epistemological as well as an ontological dimension, and insofar as perceptions, sensations, and actions have, in the cinema, a cognitive-conceptual function, Morin's *The Cinema, or the Imaginary Man* acknowledges this phenomenological aspect along with the anthropological one. In turn, Parker Tyler's *The Hollywood Hallucination* recognizes that in the cinema at least, the soul stirs most palpably on the surface of things, allowing the most furtive and fugitive of desires to body forth shapes more real than reality and triggering memories that can linger for an entire lifetime.

SOULS OF CINEMA: PARKER TYLER AND SIEGFRIED KRACAUER

My own first contact with the cinema was across several hurdles of shyness and reticence. And because of the nature of that initial encounter, my own ideas about why one might be captivated by the cinema have remained more hesitant than militant, more ruminating than combative, more mediating than polemical. But even before becoming a student of cinema, I was greatly enthralled by Parker Tyler, a lover of cinema who was both combative and polemical—flamboyant even—in his tastes, his likes, and his dislikes and who knew exactly what cinema was. Tyler had great appeal to me because besides the certainty, it was the encompassing scope of his judgment that impressed. For instance, in the course of his essay "The Costume Romance," which takes in, in one sweep of his cape, *La belle et la bête* (*Beauty and the Beast*, Jean Cocteau, 1946), *Ivan Groznyy* (*Ivan the Terrible*, Sergei Eisenstein, 1944), *Great Expectations* (David Lean, 1946), and *Les enfants du paradis* (*Children of Paradise*, Marcel Carné, 1945), Tyler remarks, quite casually:

> I think that film critics would profit by investigating the field in which certain moral ideas seem to survive in life *only* through the media of the arts, of which film is one. . . . My own, more partisan, question would be: what practical validity has the movie myth?—and as corollary: is psychopathic murder the new *practical*, neo-nineteenth-century form of romantic love in America? In Joan Crawford's movie *Possessed* [Curtis Bernhard, 1947], the heroine, whose tragic obsession with a faithless lover leads to her murdering him, would have been romanticized up to the second quarter of this century; now she is a psychopath with hallucinations. *Les Enfants du Paradis* would push the practical consequences of romantic love as absolute moral commitment no further than 1850. From then on, the

tendency was toward the strange prophylaxis of a Stendhalian hero or the death-and-disease love-symbolism of a Baudelaire.[8]

Here one has, with a well-read connoisseur's flourish, not only the cinema integrated with literature, poetry, and painting around one of Western art's most enduring tropes, but Tyler also makes the proposition that a Hollywood melodrama can embody a very specific addition to the myth of romantic love, where the American cinema tests the limits of this ideal by revealing about it a truth that the European cinema might blush over. In a similar vein Tyler had no compunctions about denouncing the *nouvelle vague*, in the shape of *Les cousins* (1959), the then much-praised second film of Claude Chabrol:

> In *La Dolce Vita* [Federico Fellini, 1960], [the function of the wild party] becomes archetypal; in *Les Cousins*, it is merely a sex get-together with liquor. . . . There is no try for subtlety . . . and the film's main shindig could not be more orthodox if it were meant to portray the eternal Greenwich Village orgy. Broadly speaking, a wild party is where the several sexes let down everything, where "heteros" may become "homos" and "homos" become brazen. . . . *Les Cousins* tells us, though not consciously, that the enthusiasm of a Baudelaire for Wagnerian heroism in the sphere of love is not just sick, it's *dead*. What remains . . . is only a vulgar dandy's fetishism for party stunts.[9]

The malicious irony of such a passage has an echo to this day, as a riposte to some of the anti-Americanism once more rampant in Europe. Here is a New York film critic, with an insider's self-assurance, insinuating to a French film director that Greenwich Village and an Ivy League education could teach him a thing or two about fin-de-siècle culture, about sexuality and decadence, and yes, even about social class, all of which would probably improve the quality of his film. But Tyler comes fully into his own when taking on the mythic "work" (in the Freudian sense) of Hollywood genre films. In his still eminently readable essay "The Horse: Totem Animal of Male Power," Tyler writes about the western:

> As England and Europe are more thoughtfully aware than we ourselves, America is the land of, among other things, "the open prairie" and the "lone cowboy": alone, save for his eternal partner: the horse. This coupling is a paradigm for the pagan myth-creature, the Centaur. The man-horse becomes a pseudo-organism; a cowboy has a grandeur and a sense of power, with his horse under him, which he could not possibly have afoot. Totemically speaking, this is a merging between the religious-magical image, the clan emblem, and the work animal. But the *personal* relation, with its imaginative reverberation, makes the mythical importance of the American man-horse. The horse is not only a power-symbol as a fleshly

engine but as an extension of the man's personal power and, more specifically, his sexual power. . . . "The lone cowboy," in this perspective, is the initiated youth joined to the totemistic father-animal, which, as the horse's rider, he has symbolically vanquished.[10]

However mannered or mannerist this form of movie criticism might appear today, it did stay close to the physicality and *élan vital* of the American cinema when it touches the many, often contradictory, layers of its collective soul-searching. In France at the time, only the macho and *fascisant* discourse of a Michel Mourlet came close to the quality of these insights, locating style as bodily gesture and a way of being in the world rather than as an ideology, which had to be pinned down, critically exposed, or politically denounced.[11] If anything, this bodily envelope and motor-sensory articulation of the American cinema appeared more like thought in motion, a modus of cogitation clothed in body, especially when it concerned the often contradictory layers of collective thought and aspiration, as in the melodrama, for instance. What Tyler in the 1950s very clearly reflected, and presumably also respected, were the values that Hollywood cinema could project, not in spite of the moneymaking but because of the huge financial investments, the risks, and the profits. It was a restlessly seeking, forward calculating, and thus quite literally avant-garde art, in a constant dialogue with the myths and the money, which is to say, with some of the ultimate reasons and "last things" of our Western culture.

For me Tyler opened a new way of reading the book that he himself called "an over-written psychological case-history," Siegfried Kracauer's *From Caligari to Hitler*. I had read it briefly in the early 1960s and had put it aside, because for the first fifteen years of my obsession with cinema, I was mostly interested in Hollywood and, in fact, was somehow put off by Kracauer's preposterous title, which promised what I knew it could not deliver: that a line can be drawn between a movie monster and a political monster. But what did eventually intrigue me was the suggestion that the link between a series of films and a given *society*, however ideologically or politically argued, must go via making contact with a *soul*: a notion that made sense to me, not so much in a religious context but as the name for the intangible emanation that was the "perfume" (Mallarmé may forgive me) of cinema. Kracauer puts it in his preface in more sociological and psychological terms: "The films of a nation reflect its mentality . . . not so much explicit credos as psychological dispositions—those deep layers of collective mentality which extend more or less below the dimension of consciousness."[12]

Moreover, Kracauer gave me the idea that the advent of the cinema had brought about a massive transfer: the cinema had deindividualized the soul and depersonalized the unconscious, gathering up the meaning and function of both with the capacity of either giving it back in the act of spectatorship, and

thus preserving it, or purloining it, making us spiritually poorer and feeling more bereft. Precisely this process is enacted and at work in so many of the films that he discusses: the doubles, the lost shadows, the phantoms that greet you when you cross that bridge ("Passé le pont, les fantômes vinrent à sa rencontre" was the French intertitle in *Nosferatu* [F. W. Murnau, 1922] that haunted André Breton).

From Caligari to Hitler is the most thorough attempt at outlining the determinants of a body of films whose common denominator is neither author nor genre but a historical period, itself defined by what was terminated: a political dictatorship. Kracauer supports his arguments primarily with plot synopses and the striking evidence of repeated motifs across seemingly distinct generic or authorial codes. This makes him posit a structural convergence between story and history, dramatic conflict and social conflict. He sees a force working above or outside the individual texts, whose emergence can only be understood in the light of these extracinematic factors. The cinema appears to him to be just such a field of fluid contours, and seemingly indeterminate epiphenomena, from which he can nonetheless extract specifically new knowledge about social life.[13] What ensures the coherence and power of conviction in Kracauer's various moments of political and historical construction is a level of psychological truth and consistency, the psychocritical analysis of recognizable dispositions or character typologies. Despite manifest flaws in arguing from individual to collective, or from fictional characters to national stereotypes, indeed almost anyone who either as a film historian or as a critic has tried to deal with a group of films belonging to a period or a national cinema, finds him- or herself operating on assumptions not that different from those of Kracauer. For although most film critics studiously avoid arguing such one-to-one psychosocial constructions of specific films, we still tend to hold to various forms of determinism when it comes to the cinema's relation to social and political life. As indicated, the reason why projects such as Kracauer's are still read, both by critics and ordinary readers, is that the desire to have demonstrated some sort of "fit" between film (narratives) and the social (narratives) always exceeds the proof that can be offered in support of it. It is this excess that justifies (and solicits) criticism in the first place, and not just in order to lay one's credibility on the line and bridge this gap. On the other hand the search for analogies between, say, films and the zeitgeist is itself grounded in a desire to establish for cinema a specific kind of knowledge or a particular kind of purpose that goes beyond either mere distraction or mere authorial-artistic self-expression.

Here one can sense most keenly the dilemma of the film critic, about the kind of hidden or disavowed bond she or he has not only with the reader. For film criticism, whatever else it does or thinks it is doing, must address an audience. This is in contrast to film theory and film history, which are both essentially self-reflexive (and, often enough, self-referential) activities. Film theory in particular may have some pedagogical uses within educational institutions, but it is

otherwise—depending on one's vantage point—the disinterested pursuit of the ground of one's thinking or a socially useless, self-indulgent activity.[14] Film criticism, in contrast, remains a service industry: the other side of the dilemma is that it is situated between being a service to the public and a service to the producer. This is not quite as cynical as it may sound: the producer is, after all, also the filmmaker and author, and providing a service to the latter may well be that time-honored if often deconstructed task of explaining the maker's intentions. These intentions are either overt and explicit, in which case the critic may well be an extension of the press release, or more unconscious and implicit, in which case the critic is offering what is called a "symptomatic reading," precisely the kind of activity that Tyler and Kracauer thought they owed not only to the movies they discussed but also to the society of which they considered themselves responsible members, speaking in the language of reason and enlightenment about the excessive, the expressive, and the enigmatic within the knowledge the cinema may give us. To that extent Tyler and Kracauer provided a service to the public, though not altogether in the sense we understand this today, as a consumer's guide, in which the critic has a choice of either being as personal as possible, his or her eccentricity functioning as the mark of independence (one thinks of Andrew Sarris), or he or she miraculously reproduces the cultural values, if not the tastes of his or her readership (one thinks of Pauline Kael). The latter is the mark of credibility. It can be the source of authenticity, but it can also be the basis on which the critic sells readers to advertisers and their clients, the corporations, which is why we fear that the critic of the mainstream press might become someone who services the producer, delivering free advertisement to the production company or distributors. By contrast, eccentricity and "credibility" might make the critic a prisoner of his or her own personality, but it has the advantage of liberating him or her from the stigma of being a mere mouthpiece of the industry. The dialectics of freedom, in this case, work most efficiently when the critic—as used to happen with the syndicated stars of the reviewing circuit in the United States—already writes reviews with these mechanisms in mind so that the quotable sound bites take the shortest route from the article back into the press releases, generating a form of product endorsement that upgrades the status of the critics, by making them an authority not so much worth quoting as worth inviting to write advertising slogans for themselves. Those who welcome the demotion of the critic as pundit in the age of the Internet may have these abuses in mind and consequently see in the blogger-as-critic a much needed lateral distribution of authority and voice.

Yet when one looks at the criticism from the 1950s and 1960s, a quite different self-understanding and thus more socially alert, as well as aesthetically combatant, discourse prevailed: for the decades between the World Wars and for some time after, "serious" film criticism had been fueled by the nagging question of whether film was an art form, and if it was, on what grounds, seeing that many

of the cinema's effects were mechanically produced and its raison d'être was making money. In Parker Tyler the obligation to declare his hand on this issue is still very evident, except that he everywhere sidesteps it by displaying his familiarity with both the classical arts, with romantic aesthetics and modernism, and by so painstakingly exploring the mythical roots, but also the wit and irony, of the popular arts, in what he himself called "mass film criticism."

At the same time, his criticism was also quite aware of its qualities as "writing," which meant that its degree of autonomy derived from literary examples— the essay, the aphorism—and therefore was addressing a community that he as critic needed as much as it needed him: that of the aesthetically literate, sensible, educated public, with whom he occasionally shared not only whether this film or that film was any good and why but also his enthusiasm when he thought he had discovered a masterpiece among the commercial dross. It is a community that Tyler's essays both address and construct for themselves, precisely by making sure that a piece on Joan Crawford can mention Baudelaire or that a quotation from Ezra Pound's *Pisan Cantos* is not out of place in a discussion of *Gone with the Wind* (Victor Fleming, 1939) and of Cecil Beaton.

In this respect Tyler's balancing act between romanticism and modernism, between Greek myth and the archaic totem, between erudite literary reference and pop-art irreverence, between Freudian symbolism and camp sexuality outlines a field of force for the cinema's effervescent soul with which a viewer may well feel more comfortable than with either the academic discourse or the sociological approach. Although they may seem polar opposites, Tyler and Kracauer are more each others' mirror image: reflected across the same psychogrammatic axis, which in Kracauer bears the traits of an authoritarian personality, sexual repression, and petit-bourgeois resentment compared to Tyler's hedonism, polymorphous perversity, and dandy disdain. Neither would have recognized himself nor the films he wrote about in the linguistic-psychoanalytic-philosophical metadiscourse that, in the wake of Roland Barthes, Jacques Lacan, and Louis Althusser, made for the success of academic film studies in the 1970s.

IMAGINARY MEN

What this schematic sketch circles around is the ambiguous status of psychoanalysis both in Hollywood movies themselves and in the consumer culture they fostered and fed off of especially since the 1940s: it is almost as if with the first psychoanalysts appearing in a Hollywood film—in Jacques Tourneur's *Experiment Perilous* (1944), Hitchcock's *Spellbound* (1945), Fritz Lang's *Secret Beyond the Door* (1947)—psychoanalysis became impossible as a "critical" (di)stance, as that which could reveal something the text did not itself know. Instead, it became a kind of hide-and-seek game—rather like the one Hollywood engages in when

it speaks about art and the artist: paying both the most double-edged kind of homage by offering the viewer its most perfect simulacrum. There the question always remains: what kind of game with knowing and not-knowing, revealing and repressing is being played? Is Hollywood second-guessing what we, as audiences and critics, want to see (in a film): in which case, it is no longer the soul we thought we were tracking but the mirage of hidden depths, merely reflecting my own desire to be duped, in order then to triumphantly prove that we have not been taken in?

With this thought I have come to the crossroad where, Sphinxlike, a concept is beckoning, which is forever linked for me with the work of Edgar Morin, that of the imaginary, as he developed this notion in *Le cinéma ou l'homme imaginaire*.[15] Morin, writing as a social anthropologist, did confirm the idea that it might indeed be possible to specify for the cinema a relation between the overt and the covert, the manifest and the hidden, between the self and the other that has echoed through the different paranormal, pseudo-religious, mythic, and psychoanalytic accounts that have been offered about the cinema's essence or soul. Morin seemed to promise that one could also advance a little further in specifying the kind of knowledge the cinema, as a unique and yet exemplary historical phenomenon, might contain and convey.

For me the crucial aspect of the notion of the imaginary in Morin was the distinction he makes—more implicitly than explicitly—between the imaginary as a product of an imagination (either individual or collective), whose basis might be a wish-fulfilling fantasy (as in Freud's notion of the artist as daydreamer) or a collective anxiety (as in Kracauer's notion of the Weimar cinema's soul, tossing and turning in fearful anticipation). He contrasts this with another notion of the imaginary, one that resides in the filmic process itself, creating particular kinds of relationships that are as irreducible to the sociology or pathology of the spectator as they are to the ideological message of the filmmaker-producer-cinema institution. It is the latter I found most helpful when, with the concept of the "historical imaginary," I tried to recast the relation of Weimar films to the society from which they emerged, a society that also refused to recognize itself in many of what we now consider its masterpieces.[16]

Morin's approach was, as he himself pointed out, that of a sociologist, but not in the sense of trying to establish for the cinema a typology of social agents or social systems, and even less to treat cinema as a direct reflection of social reality. His is a quasi-ethnographic inquiry into the reasons for and consequences of the historical fact that cinema should have emerged at about the same time as psychoanalysis and the airplane, asking himself whether cinema's effects on our relation to time are as profound as the airplane's effects were on our relation to space. *Le cinéma ou l'homme imaginaire* has to be seen in context, one within which Morin worked and one he wanted to set himself off from. The

one he worked within is of some significance for the development of academic film studies, because it situates him in the intellectual framework that is properly the province of the "linguistic" turn. Theoretical writings about cinema during the 1920s and 1930s in Europe—from the filmmaking avant-garde to the writings of Balázs, Kracauer, Rudolf Arnheim, and including the Russian formalists— were, as indicated, across their differences such as "formalists" versus "realists," nonetheless united in their need to legitimate cinema as an important cultural fact and *the* art form of the twentieth century. This newly secured status emerged most clearly after the Second World War in France thanks to the Institute of Filmology, founded in Paris in 1946.[17] Associated primarily with Gilbert Cohen-Séat, Étienne Souriau, and Jean Mitry, filmology was instrumental in laying the ground for a systematic and institutionally based theory of the cinema, leading to a concern with method, which was to have major consequences for the relationship between, among others, linguistics and film, but also between narratology and film.[18] From pleading and proselytizing for the new art and thus directly engaged on a cultural front, film criticism in France bifurcated in the 1950s: becoming militant and arguing on behalf of future filmmakers in *Cahiers du cinéma* and its *politique des auteurs* on one side, and on the other, shedding topical concerns and giving it a philosophical grounding in order to turn film into an academic subject that could take root in university departments as a recognized discipline in France's exclusive institutions of higher learning, which it did with figures like Jean Mitry, Roland Barthes, and Christian Metz.

The filmologists' main purpose, however, did not differ radically from earlier approaches of the critics-turned-theorists: the overall objective remained the study of cinema's "specificity" as it can be located in its techniques, such as montage; its materiality, such as the photographic image; and its technology, such as the automatic recording of phenomenal reality. The exception was in fact Morin, who worked outside the filmological agenda but within the university protocols by pioneering in both of his pathbreaking studies of the cinema—the one on the star phenomenon and *Le cinéma ou l'homme imaginaire*—an anthropological perspective, which focused neither on the psychology of cinema (as had Jean Mitry) nor on the aesthetic object of film, neither on a film's textual (linguistic-rhetorical) organization nor on film narrative (and its corollary, narration, point of view); rather Morin put at the center of his considerations the emerging species of "man" as spectator of the world and of himself (not unlike Stanley Cavell's *World Viewed* of two decades later).

Morin's main point is that the cinema must be seen within an evolutionary perspective that reevaluates the meaning and function of "magical" forms of agency and knowledge. The magical is a sphere that is needed, according to Morin, to account for the many ways humans understand their ways of being in the world and of being part of it, but also outside of it, and in a reflexive as well as

instrumental relation to it. It is in that intermediary zone where causal chains are renegotiated and objects have transformative powers. As a successor of this zone or sphere—the space where, earlier on, I located the "soul" of cinema, as envisaged by Kracauer and Tyler—the cinema humanizes the world of things (the inherent anthropomorphism of all "animation"), but it also depersonalizes the human, a phenomenon we often designate by the Freudian concept of the uncanny: the familiar made strange, but even more so, the strange made familiar. More specifically, the apparent objectivity (at the center of "realist" aesthetics) contains within it a subject-effect: that of a "mana" (or soul-spirit) emanating from an "other"— that is, the object world is looking at us, knowing us, and speaking to us (this time, Balázs's "soul"). What is both magical and uncanny about the cinema is that it produces a subjectivity that does not belong to us but to the world. Morin named this doubling of self and world in a mutual process of illumination and estrangement "imaginary."[19] This is a somewhat different imaginary from the "historical imaginary" I identified in Kracauer's retroactive diagnostics-prognostics of Weimar cinema when revisiting the films he had written about in the 1920s in Berlin during his exile in New York in the late 1940s, and finding them anticipating a future they could not have known about. Nevertheless, it is remarkable that Morin, too, locates the historical value of cinema not in any direct "reflection" of society but in the complex relations of mutually sustaining projections.

What makes these writers and critics of the 1940s and 1950s relevant today and signposts for the challenges film criticism faces in the digital age? At first sight, not much. To return to one of my initial propositions: A critic's inner hesitancy—about what exactly he or she is doing, what kind of knowledge the cinema puts us in touch with, whom the critic represents, and on whose behalf he or she speaks—confirms a constitutively precarious position of the critic as interface, as well as stand-in for the spectator. Vanguard of our judgment, the critic helps us find the way to the movies whose memory we want to own. But as Mark Kermode has ruefully remarked, it is often the films he vituperatively disliked that his readers remember. At the same time, his verbal bile also confirms his status as a critic with authoritative judgment, rather than consigning him to the role of spectator with an opinion. But the Internet tends to level such distinctions: movie sites like Rotten Tomatoes or Metacritic come to resemble Trip Advisor on hotels and customer reviews on restaurants. We all like a (second) opinion.

Yet in critics' hesitancy there should echo the knowledge that films are also symptomatic: the "imaginary" of Kracauer and Morin, of Balázs and Tyler being the fever chart of the body politic. What makes them different from opinionators is that critics can take the temperature of the various kinds of affects, agitations, and accelerations stirring in society, for which the movies provide the microscope or the magnifying glass. In turn, this fact begs counterfactual questions about our canonized film critics and theorists. If Balázs were alive today, would

he have a Twitter account to comment on today's universal languages and new media? It is tempting to believe that Austria's first film columnist, who marveled at the sheer numbers of Viennese attending screenings across the city, would indeed have wanted to communicate his utopian enthusiasm for novel developments via the latest channels. Would Kracauer be bearing witness to contemporary cinema, sensitive to historical transformations in Berlin, with a blog? Here, too, one can imagine a writer so perceptive of contemporary trends to want to measure their pulse with the most direct means. Would the exposure that such tweets and blogs provide have diluted Balázs's and Kracauer's long-term value to future film historians? In other words, in a fully documented documentary era is it possible to retain the rarefied mystique that has surely contributed to the authority that such critics posthumously enjoy in university lecture halls and learned journals? It is perhaps too early to tell what will be forgotten about an age in which everything is recorded and potentially remembered.

Even if such subjunctive moods elide integral historicities, they nonetheless help us grapple with the fundamental issues at stake here. Examining the social tradition of film criticism means evaluating the sociality of criticism: its dialogism, its modes of address, and its audiences, real and imaginary. Speaking of the people entails speaking *to* the people. Such matters—now reemerging in the digital era's claims to democracy and universalism—were always at the heart of the social tradition.

Two other considerations, however, are perhaps even more decisive for reviving the idea of a soul of cinema and align it with the social function of the critic. One is the fact that the "digital age" not only stands for the Internet. As the very meaning of the word *social* has narrowed to designate merely the networked connectivity of our online lives, the past two decades have also seen an even more momentous shift: "biology dethrones physics, the environment displaces society, and 'bio-power' attempts to elbow out more traditional conceptions of the political in the public sphere."[20] The evacuation of the social, when it does not reference social networks, opens it up to the anthropological perspective I have been referring to, but it also leaves it open to other determinations—for instance, to the amplified political power of narrative:

Something happened a decade ago, perhaps in parallel with the internet becoming a major actor in the transmission of geopolitical events across vast distances at incredible speeds. Narration emerged as the primary means of explaining events or justifying political acts. [The Iraq war's Hitchcockian McGuffin, i.e., the "weapons of mass destruction" revealed] something else that was always hidden behind the need for political will to control the narrative. It recognized and released an enormous space within the political field where legitimacy is produced by means of narration rather than evidence or a court order. While artists were struggling

to locate political agency in works of art, the actual political sphere had already gone fully cinematic in its approach.[21]

In other words, as politics goes "fully cinematic," and society reverts to nature, we need to find a new word for the cinema's social function, and this word, I have been suggesting, is *soul*: understood as the animating breath infusing the world but also the departing breath emanating from the world. The magic that Edgar Morin associates with the cinema as the zone or mode of being that both hides and discloses the nonhuman kinds of agency at work in the world receives in Béla Balázs a different gloss, when he states that "the cinema is the only art that owes its existence entirely to capitalism."[22] What, then, could be more urgent, as a social task, than to learn in and through the cinema and the critics who are its guardians, as well as its gatekeepers, about the soul of capitalism, for are we not committed to believing that it, too, must have a soul: otherwise, would we not have lost ours?

NOTES

1. See, e.g., "Film Criticism in the Age of the Internet: A Critical Symposium," *Cineaste* 33.4 (2008): 30–46.

2. Roger Ebert, "Film Criticism Is Dying? Not Online," *Wall Street Journal*, 22 January 2011. Ebert wrote for the *Chicago Sun-Times*, but he was one of the first to put all his reviews online, generating a worldwide following.

3. See, e.g., Armond White, "Do Movie Critics Matter?" *First Things*, April 2010, www .firstthings.com/article/2010/03/do-movie-critics-matter.

4. I am thinking of the same Roger Ebert who praised bloggers and whom President Obama eulogized with the words: "For a generation of Americans . . . Roger was the movies. When he didn't like a film, he was honest; when he did, he was effusive—capturing the unique power of the movies to take us somewhere magical" (cited in the *New York Times*, 4 April 2013).

5. See Gilles Deleuze, *Cinema 1: The Movement-Image*, trans. Hugh Tomlinson and Barbara Habberjam (Minneapolis: University of Minnesota Press, 1986); and Gilles Deleuze, *Cinema 2: The Time-Image*, trans. Hugh Tomlinson and Robert Galeta (Minneapolis: University of Minnesota Press, 1989).

6. Among the many signs of the revival of Bazin, I mention only three: Dudley Andrew and Hervé Joubert-Laurencin, eds., *Opening Bazin* (New York: Oxford University Press, 2012); the new translation of André Bazin, *What Is Cinema?* trans. Timothy Barnard (Montreal: Caboose, 2009); and "Revisiting Bazin," a special issue of *Paragraph* 36.1 (2013).

7. Béla Balázs, *Theory of the Film: Character and Growth of a New Art*, trans. Edith Bone (London: Dennis Dobson, 1952), 41, 47, 42, 124.

8. Parker Tyler, *Sex Psyche Etcetera in the Film* (Harmondsworth: Penguin, 1969), 45.

9. Ibid., 110–111.

10. Ibid., 30–31.

11. Michel Mourlet, *Sur un art ignoré* (Paris: La table ronde, 1965).

12. Siegfried Kracauer, *From Caligari to Hitler* (Princeton, NJ: Princeton University Press, 1947), 5, 6.

13. Ibid.

14. Professional film critics tend to be especially dismissive of film theory. In another contribution to the debate about film criticism in the age of the Internet, Mark Kermode opined that "seeing *Forrest Gump* [Robert Zemeckis, 1994] as some kind of neoconservative tract is a perfect example of what happens when film theory gets in the way of film-viewing; when people start reading movies rather than watching them." See Mark Kermode, "Hatchet Jobs, Anonymity, and the Internet: Being a Film Critic in the 21st Century," *Observer*, 29 September 2013.

15. Edgar Morin, *Le cinéma ou l'homme imaginaire* (Paris: Gallimard, 1956). See also the English translation: Edgar Morin, *The Cinema, or the Imaginary Man*, trans. Lorraine Mortimer (Minneapolis: University of Minnesota Press, 2005).

16. "[A historical imaginary] names the kinds of slippage between cinematic representation and a nation's history. Starting with *The Cabinet of Dr. Caligari*, the films usually indexed as Weimar cinema have one thing in common: they are invariably constructed as picture puzzles. Consistently if not systematically, they refuse to be 'tied down' to a single meaning [and] thanks to a film language that resists reference, Weimar cinema has allowed all kinds of 'realities' (including an all too real social reality) to shape a special semblance of sense." See Thomas Elsaesser, *Weimar Cinema and After: Germany's Historical Imaginary* (London: Routledge, 2000), 4.

17. In September 1946 Gilbert Cohen-Séat founded the Association française pour la recherche filmologique, which in July 1947 published the first number of the *Revue internationale de filmologie* and in September 1947 held its First International Congress of Filmology. A year later, in September 1948, the Institut de filmologie officially became part of the Sorbonne. It dissolved itself in 1963. For more see the special issue of *montage a/v* 6.2 (1997).

18. Gilbert Cohen-Séat's book was called *Essai sur les principes d'une philosophie du cinéma* (Paris: Presses universitaires de France, 1946), which was followed by Étienne Souriau's edited volume, *L'univers filmique* (Paris: Flammarion, 1953).

19. "The world is humanized before our eyes. This humanization illuminates the cinema, but it is also man himself, in his semi-imaginary nature, that the cinema illuminates." Morin, *The Cinema, or the Imaginary Man*, 215.

20. See Poulod Borojerdi's review of Fredric Jameson's *Archaeologies of the Future*: Poulod Borojerdi, "Rattling the Bars," *New Left Review* 48 (2007), http://newleftreview.org/II/48/poulod-borojerdi-rattling-the-bars.

21. Julieta Aranda, Brian Kuan Wood, and Anton Vidokle, "Editorial—'Pieces of the Planet' Issue Two," *e-flux* 49 (2013): www.e-flux.com/journal/editorial—pieces-of-the-planet-2/.

22. Quoted in Karsten Witte, ed., *Theorie des Kinos: Ideologiekritik der Traumfabrik* (Frankfurt: Suhrkamp, 1972), 153.

PART IV CRITICS SPEAK

11 ★ THE CRITIC IS DEAD . . .

JASMINA KALLAY

The recent *Guardian* list of the top one thousand films, serialized in daily supplements, roughly coincided with *Sight and Sound*'s special seventy-fifth anniversary edition featuring seventy-five obscure films, or "hidden gems," as they were called. The usual response to these lists is to see how many inclusions you agree with, but also to nitpick and find the one film that didn't make it onto the list (my gripe with the *Guardian*'s list was the omission of Palme d'Or winner Theo Angelopoulos), thus giving you a reason to argue about the arbitrariness of selecting films that have shared cultural meaning. What was especially interesting, however, was the disparity between the two mentioned lists, both of which were compiled by film critics and not the public. For starters, only four film titles were shared by both lists.[1] This brought into relief some pertinent questions in regard to film criticism, namely what its current role and relevance is within the changing landscape of new digital media. While it's beyond a doubt that the era of influential film critics of Pauline Kael's ilk is well over, her assessment of film criticism in 1963 still holds: "Film criticism is exciting just because there is no formula to apply, just because you must use everything you are and everything you know." So the question is, how does what we are and what we know in this digital media age affect film criticism, and in turn, what is to be expected of the film critic?

THUS SPAKE ZARATHUSTRA'S KEYBOARD

If we go by Nietzsche's remark that "our writing materials contribute their part to our thinking," then we must turn to the Internet and digital media theory for answers. The greatest and most obvious consequence of the Internet is that printed opinion has lost its hold, and the plethora of individuals proffering their

twopence worth in blogs means we are no longer governed by a hierarchy within which a select few opinion-makers shape views and attitudes. This is what Mark Dery calls a "world unmediated by authorities and experts"; he goes on to deem that "the roles of reader, writer, and critic are so quickly interchangeable that they become increasingly irrelevant in a community of co-creation." In this climate of co-creation, the average Internet user is more likely to post his/her opinion before seeking out a more qualified criticism. Likewise, this same user will probably seek the opinions of like-minded souls among subjective and personable bloggers, and have greater trust in their judgment than in that of an impersonal, arch film critic. With the blurring of the lines between critic, reader, and writer, we are relinquishing the one-way form of criticism and entering a multilane highway of dialogue and debate, which alone could transform the concept of film criticism. Further erosion of the authority of printed media voices comes from the decamping of advertising revenue to online ventures, which means newspapers are frequently under pressure to placate their advertisers, a practice that at times involves editorial intervention in the critics' assessments. *Sight and Sound* has sporadically commented on this market-fuelled and deplorable collusion of the editors who inflate a film's rating with complete disregard for the critic's article, thus creating a strange dichotomy of a fairly damning review finding itself in receipt of an unusually high number of stars (which also reveals the editor's lack of faith in the average reader's willingness to read beyond the star rating)!

While it would be naive to ignore this same commercial impetus behind the *Guardian*'s serialized one thousand films of all time (after all, these kinds of supplements raise sales, and are a way of attracting new readership), it's the basic idea of collecting a list of film titles that seems dated. This system suggests hierarchy and in its essence is contradictory to the fluid, orderless digital world. Fredric Jameson, one of the most influential commentators of postmodernism, has identified the emergence of "cultural depthlessness in the form of historical amnesia" as one of the overarching principles of our age, in which "history has been reduced to a perpetual present." From this angle, then, it seems especially irrelevant to compile a film list that reads as a history of narrative film, when some of the titles, while originally influential and mold-breaking, have now lost that meaning and can't be grasped within the same context. The inclusion of works from film pioneers such as D. W. Griffith (that bane of a film student's life) or Sergei Eisenstein reflects the chasm between today's average film buff and the relevance of constantly invoking old classics. In these instances there is a clear whiff of an enforced attempt to canonize, lest historically relevant work be forgotten. In our global amnesia, the overload of constant information limits capacity for remembering, and what's relevant is what's most recent, not what's most ancient. And yet, paradoxically enough, the one-thousand list also bears proof of this favoring of the most recent, as the statistics show that roughly a third of the

films date from the nineties and noughties (308 to be exact). The average reader is unlikely to seek educational tips from such lists, while, for film aficionados, the list merely becomes a test of their film acumen. So for whom and for what purpose is this list compiled?

EDITING EISENSTEIN OUT

Let's take a look at a concrete example—how to justify and interpret the inclusion of Eisenstein's *Battleship Potemkin*. Eisenstein's revolutionary use of montage is familiar to every film student; were it not for the bravura editing of the famous Odessa steps sequence, narrative filmmaking might have followed a slightly different evolutionary orbit. But it is difficult to appreciate just how revolutionary a development this was, and it is even more challenging actually to sit all the way through an Eisenstein film and enjoy it. If we acknowledge that we are living in a depthless world, in which "radical presentism" is the modus operandi, then surely we have to let go of the structured modernist way of thinking. *Battleship Potemkin* thus perfectly encapsulates the theory that "we live surrounded by artifacts salvaged from the past that have been commodified for our consumption but have lost the meanings provided by their original contexts"; in our celebration of a perpetual present there seems to be either little room for dinosaurs or, if they're invoked, they no longer take the shape they originally had and therefore appear pointless.

So, following Friedrich Nietzsche's astute links between the mode of writing and the act of thinking, we should look at the structures emerging from the digital media to discover the new criticism forum. The old-fashioned top ten or one thousand system looks positively simplistic when compared to the multistranded, hyperlink, and rhizome structures that govern the mode of surfing. While a quick search on the net for a film might include going from the film's official website to IMDb via Rotten Tomatoes for sound-bite reviews, a more discerning user will have identified a chain of interconnected sites and blogs that reflect and cater to his/her personal taste, no matter how eclectic it may be. And this is what the www entails—worldwide access combined with niche interests. The closest you'll come to this kind of identification in print media is happening to come across a film critic whose opinions match yours. For instance, reading through the *Sight and Sound* issue featuring their critics' top films of the year, I discovered that my tastes came closer to Kim Newman's and Philip Kemp's, and so as a result from then onward I paid closer attention to their film analyses. But this point of relation pales in comparison with the identification that takes place when you get hooked on a blog. The fact that there is a growing trend of press screenings organized for bloggers shows that the film industry is taking blogging seriously, and not dismissing it as a passing fad.

Given that in the global digital community the water cooler syndrome is no longer limited to last night's TV, and stretches to talking about the latest popular YouTube clip with a Facebook friend who could be anywhere in the world, one would expect a comprehensive film list to be slightly more culturally diversified. And yet of the *Guardian's* one thousand films, only 263 are non-English language. *Sight and Sound's* seventy-five "hidden gems," on the other hand, feature forty-four non-English language films, which is not necessarily commendable as on some level it equates obscure with foreign. The other issue at hand is the question of distribution and access, which again is being hugely improved upon by many online DVD rental companies specializing in world cinema. But because this type of access isn't the same as cinema distribution, for the time being these "obscure" films will rarely feature on any major polls, and in most cases critics cannot appear elitist by discussing films that the majority will not have seen. Here, again, is where the blogger has the unrestrained freedom to discuss any film under the sun. What *Sight and Sound's* seventy-five films prove, though, is the relativity of any definitive list such as the one the *Guardian's* critics attempted.

DEATH LISTS

In view of the crumbling ground beneath the "traditional" film critic, fast losing his stature and influence, perhaps these lists can be seen as a last-ditch attempt to exert some ever-diminishing authority. And nothing seems to illustrate this occurrence better than the positively morbid exhortation of Film4's series of late-night Friday films—"Films to see before you die." While I'm sure the decision to brand these films in such a melodramatic manner came from the need to market them more forcibly than simply labeling them with the tired tag of "classic," or "cult classic," in my mind I see a room full of jaded, disillusioned film critics, trying to find a way to bully people into seeing a film. If seeing a review won't do it, then tell them it's a life-or-death situation. Considering the fact that I seem to have seen the majority of these films, I wonder whether the upshot of this twisted logic is that I can now die peacefully?

Further crushing the critic's power is the juggernaut of publicity following blockbuster releases, which raze to oblivion any voice of dissent, even when numerous. To put it bluntly, it doesn't matter whether nine out of ten critics pan the latest installments in the *Shrek* or *Pirates of the Caribbean* franchises, the films are still going to be seen en masse and make money. From this perspective, anecdotes of the legendary Pauline Kael being courted by the studios in an attempt to win her over, as her pronouncement could make or break a film, must seem like the promised land to today's disgruntled film critic.

Just as film theory emerged partially in order to challenge "the dominant notions of cinema installed and defended on the basis of the assumed excellence of the 'taste' of a few journalists and reviewers, appealing to the 'age-old canons and principles' of Art in general," now a less canonical and more haphazard mode of film commentary is taking root on the web. This time around, though, it's far from being anything as aggressive as a challenge to the dominant school of criticism, but rather it's a result of boredom with the stale and commerce-driven format of reviewing in most print publications. The main note of caution— aside from the obvious inherent narcissism involved—that has to be sounded in regard to film bloggers is in the case of influential bloggers. Anyone attracting masses of clicks will immediately be solicited by the studios for namechecks, and handsomely paid in exchange—this type of surreptitious advertising has already taken root among the more famous bloggers, and involves all manner of products and cultural events.

Proof that all of this is not just simple ranting of a frustrated film critic is the recent case of *Once*. This magical, inspiring homegrown film garnered excellent reviews, and yet here in Ireland the box office was disappointing. Once it was given the US studio heave of promotion and distribution, however, it received the deserved attention and accompanying financial rewards. The simple lesson to be gleaned from this case in point is that the film reviewer's influence is firmly on the wane and powerless before the promotional media assault of the big studios. But every mythological giant has a blind spot, and here the new media offer the way forward. What better medium in which to express everything you are and everything you know, as Pauline Kael urged, than to blog. If she were alive today, I have no doubt that the maverick Kael would have had her own blog. Perhaps I ought to start a film blog. . . .

NOTE

1. Abraham Polonsky's *Force of Evil* (1948), Ladislaw Starewicz's *Le roman de Renard* (1931), Douglas Trumbull's *Silent Running* (1972), and Steve Roberts's *Sir Henry at Rawlinson End* (1980).

12 ★ WHAT WE DON'T TALK ABOUT WHEN WE TALK ABOUT MOVIES

ARMOND WHITE

There's more writing about movies these days than ever before. In print and online, it's never been worse—especially on the Internet where film buffs emulating the Vachel Lindsay–Manny Farber tradition are no longer isolated nerds but an opinionated throng, united in their sarcasm and intense pretense at intellectualizing what is basically a hobby.

Although criticism is everywhere, and some online reviewers prove themselves honest and less beholden to the power elite than print critics, the problem is this: so many Internetters get to express their "expertise," which essentially is either their contempt or idiocy about films, filmmakers, or professional critics. The joke inherent in the Internet hordes (spiritedly represented by the new REELZ-TV program *The Movie Mob*) is that they chip away at the professionalism they envy, all the time diminishing cultural discourse—perhaps as irreversibly as professional critics have already diminished it themselves.

Recently, professional critics have felt a backlash from this Internet frenzy. Print publications restructuring to keep up with the web have dismissed or offered buyouts to noticeable numbers of employees, including critics. Trimming these fatted ranks is a result of basic disrespect for criticism as both a true journalistic profession and a necessary intellectual practice.

This backlash follows a perfect storm of anti-intellectual prejudice: movies are considered fun that needn't be taken seriously. Movies contain ideas better left unexamined. Movies generate capital in all directions.

The latter ethic was overwhelmingly embraced by media outlets during the Reagan era, exemplified by the sly shift from reporting on movies to featuring inside-industry coverage. Focusing on weekend box-office totals—now a post-Sabbath religious habit—first legitimized movie-talk for that era enthralled with tax shelters, bond-trading, and protrust legislation (peaking with Reagan's regressive repeal of the landmark 1949 Paramount Decree, giving back monopolies to the studios). This sea change in media attitude was typified by the American launch of *Premiere* magazine (finally trimmed away two years ago), which perverted movie journalism from criticism to production news. It familiarized the production of movies, not like the trade publications *Variety* and *Hollywood Reporter* do for industry participants, but by simply jettisoning exegesis and replacing interest in content with production stills, personality profiles, and a humor column that witheringly trivialized the critic's pursuit.

This disrespect for thinking—where film criticism blurred with celebrity gossip—has resulted in today's cultural calamity. Buyouts and dismissals are, of course, unfortunate personal setbacks, but the crisis of contemporary film criticism is that critics don't discuss movies in ways that matter. Reviewers no longer bother connecting movies to political or moral ideas (that's what made James Agee's review of *The Human Comedy* and Bosley Crowther's review of *Rocco and His Brothers* memorable). Nowadays, reviewers almost never draw continuity between new films and movie history—except to get it wrong, as in the idiotic reviews that belittled Neil Jordan's sensitive, imaginative *The Brave One* (a movie that brilliantly contrasts vengeful guilt to 9/11 aftershock) as merely a rip-off of the 1970s exploitation feature *Death Wish.*

If the current indifference to critical thought is a tragedy, it's not just for the journalism profession betraying its promise of news and ideas but also for those bloggers. The love of movies that inspires their gigabytes of hyperbole has been traduced to nonsense language and nonthinking. It breeds a new pinhead version of fan-clubism.

What we don't talk about when we talk about movies these days reveals that we have not moved past the crippling social tendency that 1990s sociologists called "denial." The most powerful, politically and morally engaged recent films (*The Darjeeling Limited, Private Fears in Public Places, World Trade Center, The Promise, Shortbus, Ask the Dust, Akeelah and the Bee, Bobby, Running Scared, Munich, War of the Worlds, Vera Drake*) were all ignored by journalists whose jobs are to bring the (cultural) news to the public. Instead, only movies that are mendacious, pseudo-serious, sometimes immoral or socially retrograde and irresponsible (*4 Months, 3 Weeks, and 2 Days, Army of Shadows, United 93, Marie Antoinette, Zodiac, Last Days, There Will Be Blood, American Gangster, Gone Baby Gone, Letters from Iwo Jima, A History of Violence, Tarnation, Elephant*) have received critics' imprimatur.

That there isn't a popular hit among any of these films proves how critics have failed to rouse the moviegoing public in any direction.

Critics customarily show their allegiance to Hollywood blockbusters, granting them inordinate attention in the entertainment pages, but that's not the way to build an enlightened public or a healthy culture. You can't praise the *Pirates of the Caribbean* movies or the *Bourne* movies and then expect benumbed thrill-riders to sit still for *A Prairie Home Companion, Neil Young: Heart of Gold*, or *Munich*. The critical consensus toward denial forsakes what really inspires passion in moviegoers—those priceless moments when a movie addresses personal emotion (Dakota Fanning asking "Are we still alive?" in *War of the Worlds*) or informs some confounding social experience (*Broken Sky's* young lovers alienated by soulless disco beats).

Jeff Nichols's *Shotgun Stories* is a perfect example of what critics don't talk about. *Shotgun Stories* should have rocked film culture. Ideally complementing the Coen brothers' *No Country for Old Men*, it questions the temperamental and social sources for modern behavior. Nichols tells a Faulknerian, Snopes-like story of male fecklessness and the reality of frustration in the American working class. We are introduced to three Hayes brothers in Arkansas: Son (Michael Shannon), Boy (Douglas Ligon), and Kid (Barlow Jacobs) are totally rudderless—gambling, coaching basketball, womanizing—yet succumbing to the instinct for vengeance passed on to them by their bitter, resentful mother. This recognizable sense of family isolation (the flip side of *The Darjeeling Limited*) reveals a warped masculinity that goes to the heart of American experience. *Shotgun Stories* is set in a red-state community, but the truth of its ineffectual, slatternly men can be seen across the country, even in blue-state parochialism.

Its story of warring clans (sympathetic reprobates mirroring sympathetic churchgoers) confirms a concept of brotherhood that has wide-ranging application, but it is primarily, stunningly empathetic. Like last year's family drama *Black Irish* (another good, modest film that critics lost), *Shotgun Stories* deals with fundamental experiences that media consensus ignores. When Son and his siblings crash the funeral for their father (who left them behind when he remarried to begin a second family), it starts a stupid, unstoppable feud. Things get nasty and then work out tragically: It's the opposite of *There Will Be Blood*, where things begin tragically then work out nastily—a trajectory that slakes the dissatisfaction and lack of control that spooks our everyday lives. Yet *Shotgun Stories* dramatizes human compulsion.

P. T. Anderson creates aestheticized tension and a floridly melodramatic, false sense of history that's easy for critics to endorse. *Blood* is meant to impress, while *Shotgun Stories* is meant to be felt. Director-writer Nichols shows a weird yet authentic sense of classical style. This doesn't feel like a regional work, nor is it a movie-soaked movie like *The Darjeeling Limited*. It's between the two.

Nichols understands countrified living and American habit that may repel urban reviewers, but it allows him to jump off from Hatfields-McCoys legend into an uncondescending vision of how slackerdom really manifests itself. He counters the meretricious tendency of Richard Linklater, Gus Van Sant, and Judd Apatow films whose celebrations of American sloth have blunted the sensibilities of critics trying to keep up with industry fads.

There's hardly language or space in our class-based, Hollywood-pledged film journalism to deal with the way *Shotgun Stories* keeps its Faulknerian roots while branching out to a new sense of American behavior. (When Boy's car radio blasts a Ronnie Montrose song, suddenly reminding him of Kid, it's the kind of richly authentic moment we used to only get in documentaries like Joel DeMott's *Seventeen*.) Nichols's lyric sense of location—of men and women keeping their own balance as they walk, argue, and clash—conveys a complicated spiritual agony. Being a nonhipster film meant that *Shotgun Stories* was off established critics' radar screens. Even I, shamefacedly, only caught up after it had opened, but it's been the most resonant American movie so far this year [2008—Eds.].

Son, Boy, and Kid's actions (you have to be in touch with your own American roots to feel the humor in those names; the only thing left out is Phil Morrison's *Junebug*) point toward a common, unknowable future. Nichols uncannily combines hope and despair. On appearance, *Shotgun Stories* is a world away from the attention-grabbing topicality of critics' faves *There Will Be Blood, In the Valley of Elah, Redacted, Rendition*, and *The Kingdom*; it's quiet, almost elliptical like *George Washington* (David Gordon Green is the producer). Yet this terse family epic may be the Iraq War movie we've waited for without being able to articulate exactly what we wanted. Nichols's complex mix of native resentment and culturally bred fury also contains knotted-up affection and pride. *Shotgun Stories* is genuine. When it ends, it isn't over. It's something to talk about.

To discuss movies as if they were irrelevant to individual experience—just bread-and-circus rabble-rousers—breeds indifference. And that's only one of the two worst tendencies of contemporary criticism. The other is elitism.

This schism had an ironic origin—the popularization of film criticism as a consumer's method. A generation of readers and filmgoers were once sparked by the discourse created by Pauline Kael and Andrew Sarris during the period that essayist Phillip Lopate described as "the 'heroic' age of moviegoing." The desire to be a critic fulfilled the urge to respond to what was exciting in the culture. Movie commentary was a media rarity in those days and relatively principled (even the *Times'* Arts & Leisure section used to present a forum for contrary opinions). And then the television series *At the Movies* happened. Its success, moving from public to commercial broadcast (who can tell the difference anymore?), resulted in an institution. Permit an insider's story: it is said that *At the*

Movies host Roger Ebert boasted to Kael about his new TV show, repeatedly asking whether she'd seen it. Kael reportedly answered, "If I want a layman's opinion on movies, I don't have to watch TV."

Kael's cutting remark cuts to the root of criticism's problem today. Ebert's way of talking about movies as disconnected from social and moral issues, simply as entertainment, seemed to normalize film discourse—you didn't have to strive toward it, any Average Joe American could do it. But criticism actually dumbed down. Ebert also made his method a road to celebrity—which destroyed any possibility for a heroic era of film criticism.

At the Movies helped criticism become a way to be famous in the age of TV and exploding media, a dilemma that writer George W. S. Trow distilled in his aperçu "The Aesthetic of the Hit": "To a person growing up in the power of demography, it was clear that history had to do not with the powerful actions of certain men but with the processes of choice and preference." It was Ebert's career choice and preference to reduce film discussion to the fumbling of thumbs, pointing out gaffes or withholding "spoilers"—as if a viewer needed only to like or dislike a movie, according to an arbitrary set of specious rules, trends, and habits. Not thought. Not feeling. Not experience. Not education. Just reviewing movies the way boys argued about a baseball game.

Don't misconstrue this as an attack on the still-convalescent Ebert. I wish him nothing but health. But I am trying to clarify where film criticism went bad. Despite Ebert's recent celebration in both *Time* magazine and the *New York Times* as "a great critic," neither encomium could credit him with a single critical idea, notable literary style, or cultural contribution. Each paean resorted to personal, logrolling appreciations. A. O. Scott hit bottom when he corroborated Ebert's advice, "When writing you should avoid cliché, but on television you should embrace it." That kind of thinking made Scott's TV appearances a zero.

Unfortunately, it is this very process of affirming the Ebert institution that contributes to confusion about what film criticism has lost. *Time* marvels that Ebert "typically would give thumbs up to two or three" of the "four or five films up for review on his weekly TV show" without asking if it's credible or disingenuous. (It will take a separate article to expose the absurdity of a TV show bearing Ebert's name without his presence, whose interchangeable roster of ineffectual reviewers loyally prevaricate in Ebert's manner—a "criticism" show owned and sponsored by the Disney conglomerate!)

In the Ebert age of criticism, the Aesthetic of the Hit dominates everything. Behind those panicky articles about critics losing their jobs (what about autoworkers and schoolteachers?), lurks the writers' own fear of falling victim to the same draconian industry rule: most publishers and editors are only interested in supporting hits in order to reach Hollywood's deep-pocket advertisers. This

is what makes traditional criticism seem indefinable and obsolete, leaving web criticism as a ready (but dubious) alternative.

The Internetters who stepped in to fill print publications' void seize a technological opportunity and then confuse it with "democratization"—almost fascistically turning discourse into babble. They don't necessarily bother to learn or think—that's the privilege of graffito-critique. Their proud unprofessionalism presumes that other moviegoers want to—or need to—match opinions with other amateurs. That's Kael's "layman" retort made viral. The journalistic buzzword for this water-cooler discourse is "conversation" (as when the *Times* saluted Ebert's return to newspaper writing as "a chance to pick up on an interrupted conversation"). But today's criticism isn't real conversation; on the Internet it's too solipsistic and autodidactic to be called a heart-to-heart. (Viral criticism isn't real; it's mostly half-baked, overlong term-paper essays by fans who like to think they think.)

And in print, "conversation" is regrettably one-sided. Power-sided. This is where the elitist tendency sours everything. The social fragmentation that fed the 1980s indie movement, decentralizing film production away from Los Angeles, had its correlative in film journalism. Critics everywhere flailed about for a center, for authority, for knowledge; they championed all sorts of unworked-out, poorly made films (*The Blair Witch Project*, *Gummo*, *Dogville*, *Southland Tales*) proposing an indie-is-better / indie-is-new aesthetic. The sophomoric urge to oppose Hollywood fell into the clutches of Hollywood (i.e., Sundance). Similarly, the decentralized practice of criticism now scoffs at former *New York Times* potentate Bosley Crowther, while crowning a network of bizarro authorities—pompous critics who replace Crowther's classical-humanist canon with a hipster/avant-garde pack mentality (from *The Village Voice* to *Time Out New York* to Indiewire).

The new inclination is to write esoteric criticism. Post-Tarantino cinema has wrung the pop aesthetic dry, so the new gods of criticism have made totems of movies so unwatchable and so unappealing that they prohibit the basic pleasure and amazement of moviegoing. Critical babble doesn't talk about what matters, but it sustains Ten Current Film Culture Fallacies: (1) "The Three Amigos" Iñárritu, Cuarón, and del Toro are Mexico's greatest filmmakers while Julián Hernández is ignored. (2) Gus Van Sant is the new Visconti when he's really the new Fagin, a jailbait artful dodger. (3) Documentaries ought to be partisan rather than reportorial or observational. (4) *Chicago*, *Moulin Rouge*, and *Dreamgirls* equal the great MGM musicals. (5) Paul Verhoeven's social satire *Showgirls* was camp while Cronenberg's campy melodramas are profound. (6) *Brokeback Mountain* was a breakthrough while all other gay-themed movies were ignored. (7) Todd Haynes's academic dullness is anything but. (8) Dogma was a legitimate film movement. (9) Only nonpop Asian cinema from J-horror to Hou

Hsiao-Hsien counts, while Chen Kaige, Zhang Yimou, and Stephen Chow are rejected. (10) Mumblecore matters.

These delusions derive from an elitist, art-for-art's-sake notion. It's the "Smart About Movies" syndrome allowing bloggers and critics to feel superior for having suffered through *Dead Man, Ye-Ye, Gerry, Inland Empire*—movies that ordinary moviegoers want no part of and that hardly reflect a community of citizens or the New Millennium's political stress. It may be a coincidence of social class that most movies are made by people espousing a liberal bent, but it is the shame of middle-class and middlebrow conformity that critics follow each other when praising movies that disrespect religion, rail about the current administration, or feed into a sense of nihilism that only people privileged with condos and professional tenure can afford.

Routine reporting from Cannes and Sundance is another expression of journalists' perks that encourage a sense of elitism. Fact is, those fests are remote from how most people experience or relate to film culture. Like the weekend grosses list, it promotes a false sense of being informed—not art interpretation or feeling. And festival favorites aren't discussed in fundamental terms. Critics talk around what's happening inside Pedro Costa or Apichatpong Weerasethakul movies. Instead, they call the latter "Joe"—proof of their in-group shamelessness. They'd rather make xenophobic jokes about Weerasethakul's exotic name than actually deal with the facts of his Asianness, his sexual outlawry, and his retreat into artistic and intellectual arrogance that evades social categorization. Such hipoisie canonizing is as unhelpful as TV's pop reviewers who only respect banal Hollywood blockbusters. They also, consequently, discuss the Oscars as a plebiscite that readers must dutifully and mindlessly observe. It's entertainment—weakly.

Avoiding the substance of movies in film discussion has worsened beyond Ebert's TV glibness. Recall how few critics were able to apply standard Judeo-Christian readings to *No Country for Old Men* (let alone *The Passion of the Christ*) but remained perplexed or aggrieved. Contemporary criticism doesn't deal with politics, morality, or history. That's why critics wrote head-in-the-sand responses to the obvious Clinton censure in David Mamet's *The Winslow Boy* and praised socialist Mike Leigh's *Topsy-Turvy* as if it were an Anglophile's Merchant-Ivory pageant. They even let pass the *Paranoid Park* scene of a security guard's vivisected torso crawling across railroad tracks—surely the most egregious movie moment of the decade. Critics say nothing about movies that open up complex meaning or richer enjoyment. That's why they disdained the beauty of *The Darjeeling Limited*: Wes Anderson's confrontation with selfishness, hurt, and love were too powerful, too humbling. It's no wonder that the audience for movies shrinks into home-viewership; they also shrink away from movies as a great popular art form.

These desperate stakes became even more alarming with the recent announcement of the Museum of the Moving Image's Second Annual Institute on Criticism and Feature Writing—a project seemingly designed to further confuse the profession. Offering a session on marketing and publicity, the MMI's Institute implies that flackery is part of critical journalism, and that's really the root of the problem—sanctioning the way in which critical journalism has blurred its mandate into promoting the industry, not the art form. It overlooks any chance for criticism to unite while enlightening the audience, keeping it divided. There is no "conversation" when what we say when we talk about movies is driven by elitism or commerce, both now horribly combined in Queens. Hollywood's emphasis on impersonal product then holds sway over art. Ideas get smothered in formula, and hype becomes the language of so-called discourse.

Does the training of movie critics matter if they aren't taught to preserve the idea that movies must affirm our humanity? The public deserves critics who appreciate when an audience wants to be moved, encouraging them to experience catharsis at *World Trade Center* or *War of the Worlds*. But when people walk out of *Paranoid Park* feeling bewildered and unedified, where do they turn? What do they talk about?

13 ★ WHO NEEDS CRITICS?

NICK JAMES

What use are film critics? It might seem an obvious point in *Sight and Sound*, but ever since the second phase of the Internet (web 2.0) began to undermine the print industry's economic base, the question keeps coming up. By film critics I mean what most people mean: writers who review films for a living. The reviewer's trade has always enjoyed its teeth-baring and wound-licking moments of "crisis," but this time there is real pain. The recent US cull of print film reviewers proves that their market value has declined. Over the last couple of years, a lot of people with that title have been removed from their job (thirty-one at time of writing). They have not been replaced, but their function is performed remotely, by more illustrious colleagues, and by unpaid enthusiasts.

The Internet gives users free access to film reviews from a large number of recognized or established sources (from the *New York Times* to *Salon*), as well as to an army of opinionated bloggers, many of whom write for free. So why pay to read a newspaper or magazine critic? If a critic is surpassingly insightful and entertaining, you'd hope a publisher would still want to keep her, but that would be reckoning without the web's success in attracting advertising. US regional newspapers are suffering from catastrophic falls in ad revenue as advertisers migrate to the web. Publishers see sacking the film critic as an easy economy, as they try to cut staff costs to an absolute minimum.

Meanwhile print film critics in the United Kingdom—not such a numerous bunch—are feeling nervous because their publications are seeing similar revenue drops. So far, the negative impact on them is that they must write extra copy for their employers' websites with no increase in pay. But another indicator of their loss of status is the way some film distributors now think it is OK to bypass many, if not all, UK reviewers. They do it either because the film is a

"critic proof" blockbuster, or it's a dog's breakfast they're trying to smuggle out to fool the public.

The dilemma is clear. There's a welcome increase in free access to writing about film, but the consequence has been a drop in the status of the professional film reviewer (which may, in turn, be a symptom of a general decline in the status of journalism). No one therefore seems to find the critic-dodging of distributors unusual. But the web is not the only culprit undermining the professional reviewer; the other is marketing. Today the language of marketing is a culture all its own, one currently more powerful and influential than criticism. Not only has it become, under New Labour, the language of government but also, if we can believe Nick Davies's recent book *Flat Earth News*, it makes up much of the news content in quality newspapers. According to Davies, researchers at Cardiff University found that "a massive 60 per cent of these quality print stories consisted wholly or mainly of wire copy and/or PR material and a further 20 per cent contained clear elements of wire copy and/or PR material."

We live in a culture that is either afraid or disdainful of unvarnished truth and of skeptical analysis. The culture prefers, it seems, the sponsored slogan to judicious assessment. Given that the newspapers are so in thrall to marketing, you might think that they would feel responsible for their own decline. But plenty of veteran hacks claim it was always like this.

So pity the poor professional critic, but of course hardly anyone does. Critics have long been the villains of the arts, loathed (usually) by the talent, and mistrusted by the public. Think of their depictions in cinema; the urbane schemer Addison DeWitt in *All About Eve*, or cold Waldo Lydecker in Otto Preminger's *Laura*. Prissy droppers of vitriol they may be, but at least they loom large. Who now makes films featuring critics—and why should they? Never mind that it was a bunch of critics that transformed cinema in the 1950s to create the *nouvelle vague*, or that another bunch paved the way for Britain's "Angry Young Men" to transform British cinema in the 1960s.

My purpose here is not to rail against dumbing down, but to consider why reviewers seem less useful to the public now than they did in 1950, when DeWitt described himself as "essential to the theater." I'm going to restrict myself to considering the role of the critic in the United Kingdom. The twin advantages of this restriction are the fact that the United Kingdom suffers from a high degree of philistinism, so the issues stand out in greater relief, and that Britain was arguably the place where the modern idea of the critic was first formed.

Tensions between the amateur and professional approaches to criticism go back to the late seventeenth and early eighteenth centuries, to the moment when literary discussion moved out of aristocratic salons and into the bourgeois public sphere. The idea of the critic developed from the notion of the gentleman observer and commentator as embodied by Joseph Addison (in the *Spectator*)

and Richard Steele (in *Tatler*). According to Terry Eagleton's *The Function of Criticism*, that public sphere was "animated by moral correction and satiric ridicule of a licentious, socially regressive aristocracy; but its major impulse is one of class consolidation." In Eagleton's view, "Criticism belongs with a traditional English concept of gentility which troubles the distinction between innate and acquired, art and nature, specialist and spontaneous."

Addison and Steele were of course talking to their equals. The Grub Street professional, in the form of Dr. Samuel Johnson, was just around the corner, though he too wrote only for his peers. As literacy spread and the reading public grew, so the need for critics to define themselves as experts grew—for they had to separate themselves from the masses they were writing for. (One means was for literary study to be accepted into the academy.) Criticism's fundamental weakness is arguably the dichotomy between the claim of special expertise—an outside perspective—and the wish to speak as a legitimizing part of the community. This is roughly the same territory as that disputed between the professional critic and the amateur blogger.

From the British film perspective it's fascinating to see the extent to which aspects of the gentleman amateur critic survived into the 1920s and 1930s, when cinema was taken seriously as an art form for the first time. Here is Graham Greene writing for this magazine [*Sight and Sound*—Eds.] in 1936:

> A critic concerned with an art needs . . . a mind which . . . is not prone to quick enthusiasms. . . . He is lucky if two or three films in the year can be treated with respect, and if week after week he produces an analysis of the latest popular film showing how the script-writer, the director, and the camera man have failed, he will soon lose readers and afterwards his job. He has got to entertain and most film critics find the easiest way to entertain is "to write big." Reviewing of this kind contributes nothing to the cinema. The reviewer is simply adding to the atmosphere of graft, vague rhetoric, paid publicity, the general air of Big unscrupulous Business.
>
> The film companies, of course, are not bribing the critics. No one is going to be bribed with a glass of sherry and a cigarette. The motive is less obvious and more kindly. The daily press is to a great extent controlled by advertisers. The film critics are not free to damn a bad film. Almost the only approach possible . . . is the satirical . . . to make a flank attack upon the reader, to persuade him to laugh at personalities, stories, ideas, methods, he has previously taken for granted. We need to be rude, rude even to our fellow reviewers, but not in the plain downright way.

The world Greene describes is frighteningly similar to that of today's film reviewers. It's as if the egalitarianism of the 1960s never happened. Greene's heirs can quickly be found: the *Guardian*'s Peter Bradshaw, for instance, who will often

resort to absurdist exaggeration when dealing with a very bad film, or Anthony Lane, whose ability to be elegantly mocking and vividly metaphoric in the *New Yorker* has seen him proclaimed at least once as the industry's favorite critic. In the spirit of Greene's injunction to be rude, I would describe both of them as supporters of the art of cinema but neither as a great champion. Great champions need more opportunities for passionate advocacy of the unknown than come their way.

The problem for the British reviewer in this vein is that the satirist can never get too passionately involved. Many people in the United Kingdom disagree with Greene's view that film is an art form (that includes many in the industry) and academic theorists seem happy to see films just as "texts." The film reviewer C. A. Lejeune, who haunted the pages of the *Observer* from 1928 to 1960, announced in 1947 that she was "ready to declare categorically that films are not an art . . . film-makers should leave all the pompous talk of art alone." This outcry was coolly batted away by one of my predecessors, Penelope Houston, in 1949 (things happened more slowly then). "No amount of debasement can alter the fact of art: if any film ever made can be called a work of art, then we are dealing with an art form."

To their credit, most British reviewers in the "quality press" continue to consider many films as works of art. As a collective breed, however, they behave in lamblike fashion when faced by the Hollywood blockbuster. Sometimes their editors collude against them. When they give low-star ratings to high-profile films, they sometimes find them altered. When they want to ignore a below-par superhero production and boost a foreign-language film, they are sometimes overruled.

Today's UK film reviewers may be far too nice a grouping to wrest back the respect (and fear) the late Alexander Walker of the *Evening Standard*, for instance, once commanded. Walker was a right-wing martinet who prosecuted his hobby-horse prejudices with implacable vigor (no one would dare smoke in his presence), but you couldn't doubt the passion of his advocacy or disavowal, even if you disagreed with him. With print circulations declining, few reviewers have such power. Peter Bradshaw is said to be perhaps the only one in the United Kingdom who can make or break a film. My feeling is that British film reviewers must stop pretending to represent the norm and take a more prominent stand against the Hollywood machine and its avalanche of poor films, and to stand for a broader view of film culture such as you see in the examples of good criticism that follow this article. But it's easy for me to say this.

I am to some extent echoing the most famous essay on criticism this magazine ever published. In "Stand up! Stand Up!" (*Sight and Sound*, Autumn 1956) Lindsay Anderson took issue with the dispassionate English school of film reviewing. Alistair Cooke of "Letter from America" fame reviewed films in the 1930s, and in

a 1934 article for the *Listener* he said, "However much I might want in private to rage or protest or moralize, these actions have nothing to do with criticism. . . . Moral judgments should be presented as what they are—personal, subjective tastes." For Anderson this was the worst kind of English cant. His view, on seeing Cooke's views reprinted in 1953, was "there is no such thing as uncommitted criticism, any more than there is such a thing as insignificant art. It is merely a question of the openness with which our commitments are stated. I do not believe we should keep quiet about them."

This is not a call for critical purity among official critics. Bloggers have the advantage over print film reviewers in really free speech: they have no professional responsibilities, or policy interventions to deal with. They can write at any length and access historical material that once was restricted to library collections. The web offers an opportunity for another golden age of film criticism, as long as its adherents can get access to new films. Today's print film reviewers are luckier than Graham Greene in one respect only—that there are more than two or three films a year to be treated with respect. Otherwise they may collude in their own extinction by becoming bloggers themselves. Whether or not they stay in print or migrate to the web, they will need the support of their editors to become truly distinctive again by making more than the occasional passionate noise.

14 ★ EXCERPTS FROM *CINEASTE'S* "FILM CRITICISM IN THE AGE OF THE INTERNET: A CRITICAL SYMPOSIUM"

THEODOROS PANAYIDES, KEVIN B. LEE, KARINA LONGWORTH, THE SELF-STYLED SIREN (FARRAN SMITH NEHME), AND STEPHANIE ZACHAREK

The editors of *Cineaste* posed the following questions to the respondents, suggesting that they could choose either to answer the individual questions, or to use them as departure points for their own essay:

1. Has Internet criticism made a significant contribution to film culture? Does it tend to supplement print criticism, or can it actually carve out critical terrain that is distinctive from traditional print criticism? Which Internet critics and bloggers do you read on a regular basis?
2. How would you characterize the strengths and weaknesses of critics' blogs? Which blogs do you consult on a regular basis—and which are you drawn to in terms of content and style? Do you prefer blogs written by professional critics or those by amateur cinephiles?
3. Internet boosters tend to hail its "participatory" aspects—for example, message boards, the ability to connect with other cinephiles through critics' forums and e-mail, etc. Do you believe this "participatory" aspect of Internet criticism (film critics form the bulk of the membership lists of message

boards such as a_film_by and Politics and Film) has helped to create a genu-
inely new kind of "cinematic community," or are such claims overblown?

4. Jasmina Kallay, writing in *Film Ireland* (September-October 2007), has
claimed that, in the age of the Internet, the "traditional film critic . . . is losing
his stature and authority." Do you agree or disagree with this claim? If you
agree, do you regard this as a regrettable or salutary phenomenon?

THEODOROS PANAYIDES: THEO'S CENTURY OF MOVIES

First of all, a line should be drawn between "film culture" and "film criticism."
The contribution of online criticism to the former can hardly be overstated—
but mostly because it's part of the explosion in film talk produced by the Internet
in general. Those of us in provincial towns or out-of-the-way places vividly recall
predigital days, when it was literally impossible to be part of a conversation on
nonmainstream cinema—except, if you were lucky, with a handful of fellow film
buffs, and a few times a year when *Sight and Sound* or *Film Comment* (or *Cineaste*,
though I never had access to the magazine) arrived in your mailbox. Cinephilia
slowly atrophied, or at best retreated into hard defensive little kernels of nostal-
gic narrow-mindedness. All that has changed—and the situation is immeasur-
ably better. Indeed, with film distribution increasingly closed off to adventurous
fare—or just ill-equipped to deal with the boom in films being made—the abun-
dance of websites calling one's attention to small, off-the-radar movies may be
our single best way of preserving the culture.

So much for the Internet and film culture. When it comes to film criti-
cism, however, the role of online writing is considerably murkier. The touted
advantages—the new terrain potentially carved out—are well known: critics
dispense with deadlines and word counts, write about whatever they want, allow
themselves to go more in-depth, et cetera. Even with established names, how-
ever, freedom is a mixed blessing. Just as good teachers don't necessarily make
good friends, a good critic won't necessarily make a good blogger; there are crit-
ics I actually think less of since they went online, due to snide remarks or strident
political rants included with their (still perceptive) film analysis. As for going
more in-depth, the sad truth is that Internet browsing—by its very nature—
doesn't lend itself to sustained attention. For me, at least, the temptation to skim
a piece and click on the next link is usually overpowering—unless of course (oh
the irony) I print it out and peruse it later.

An even greater problem is the blog format itself. Blogs are searchable of
course, but the diaristic approach means they live in the moment, each post
implicitly superseded by a new one. Not only does this create a more superfi-
cial film culture; it makes it difficult, as a practical matter, to engage with a new
critic. Reading a handful of arbitrary posts on whatever the writer happened to
be watching that week seldom elicits a real sense of their voice or worldview.

Emphasis therefore shifts onto whether they're entertaining—and, crucially, whether you agree with them.

That's the fallacy behind all the talk of "community": yes, the Internet has made film culture more interactive and participatory—but communities form among like-minded people, leading inevitably to ghettoization and segregation. One sees it in bloggers' irritating habit of praising each other to the skies, as if confirming their mutual good taste. There's a simple but significant change in the dynamic between reader and writer: when Writer X appeared in the paper every Sunday (or in the film magazine every month), one may not have agreed with him but kept checking in, just because he was there. When one visits Blogger X and disagrees with his opinion—with no easy way of getting a handle on his other opinions—one simply stops visiting. Message boards are everywhere, but tend to be for aficionados. Who but a horror fan would visit a board where horror fans debate "suspense versus gore"? (On the other hand, I was first exposed to Mario Bava through an Andrew Mangravite article I unexpectedly encountered in *Film Comment*.)

Speaking for myself, almost all the sites I visit on a regular basis are run by people I know personally—notably Michael Sicinski, Mike D'Angelo, and Dan Sallitt—meaning I already have an interest in their opinions. They also tend to be sites rather than blogs, since I can use them for reference instead of sticking to the subject du jour (though I do check GreenCine Daily, just to see what people are talking about); I also read a few professional critics' blogs (Dave Kehr, Michael Atkinson) but often find them less satisfying than reading those same critics in print. I'm sure I'm missing out on some fine writers—but there's just too much out there, and no easy way to separate the wheat from the chaff.

In sum, I find Jasmina Kallay's claim slightly off-target. The traditional film critic—namely, an expert offering authoritative opinions—hasn't been rejected per se. What people are doing online is indulging in film culture, not absorbing film criticism. There's no evidence that kibitzing with like-minded friends—which is what blogs and message boards essentially amount to—is viewed by serious film buffs as a substitute for reading a monograph, or essay, or indeed a specialized film magazine. The critic's basic function, to explain using expert knowledge, remains timeless—and a true critic, one who illuminates instead of just offering opinions, is as rare and valued in the age of the Internet as he or she ever was. At worst, the online revolution may result in the newsprint reviewer going the way of . . . well, newsprint. That would be a shame. But then most of us provincials didn't get to read many print reviews before the Internet came along anyway.

KEVIN B. LEE: SHOOTING DOWN PICTURES

The (to my mind, overblown) debate over online criticism and its contentious relationship to more conventional forms of film discourse says more about the

fragmentation of the film community than about the relative value of its differ-ent venues. When, in just a few years, the volume of criticism has expanded to mind-blowing quantities, how can anyone attempt a blanket statement to char-acterize what's out there when no one can possibly keep up with everything worth reading?

At this year's Moving Image Institute, no less an icon of the film critic estab-lishment than Andrew Sarris acknowledged that online criticism was where the vitality and innovative thinking that characterized his own groundbreaking writing of the 1960s could now be found.[1] He also expressed bewilderment at the overabundance of content and a lack of knowing which sites are worth his while to investigate. This, I think, is a much fairer critique of online film criticism than the broadside dismissals I've seen in print or heard in person, which are symptomatic reactions to the same vertiginous sensation of content overload. For established critics accustomed to their opinion holding court, it's a radical landscape shift amounting to an existential crisis. Hell is other critics. For them, three simple words apply: get over it.

Solving this problem of online content navigation and aggregation concerns me insofar as it would allow older critics like Sarris (who still types his reviews on a typewriter) to connect with their Internet successors, a linkage that could only benefit the future of film criticism. The closest thing I have for a silver bullet (especially for those who can't manage an RSS feed aggregator such as Google Reader) is the GreenCine Daily (daily.greencine.com), the fruit of David Hud-son's countless hours crawling the web for worthwhile cinema-related content, which he summarizes and links for the ease of cinephiles everywhere. While there are dozens if not hundreds of other sites worth mentioning (my own RSS aggre-gator tracks 112 sites and blogs), I feel comfortable singling out GreenCine Daily for praise because it does such a marvelous job at spotlighting everyone else.

Still, one website can only do so much to bring disparate sites together into a semblance of a community. A beauty and a challenge of the Internet is its spawning of virtual film communities collectively embodying a stunning array of cultures and interests, while also leading to enclaves of specialists engaged in lengthy threads of minutiae. While interests of all kinds are part of what is neces-sary to push the boundaries of cinema culture, the propensity of some online discourse toward a kind of tunnel vision and loss of perspective bothers me. One thing that I've learned from my time spent online is that even the most respected and established critics can become embroiled in petty bickering and trifling dis-cussions as much as anyone, poring over the trivial, mundane details of a film over dozens of posts.

For me, movies always have to come back to the world, which I suppose is why I've generally enjoyed conversing with everyday film buffs with lives outside the film world as much if not more than erudite film critics. I've enjoyed many

exchanges over the years on forums such as a_film_by, the Rotten Tomatoes Critics Discussion forum, and more recently, the visitor friendly blogs of Dave Kehr and Girish Shambu, among many others, where name-brand critics and many more experts check in regularly.

But my ideal experience of a film community remains my time spent on the IMDb Classic Film Message Board, where people aged sixteen to ninety from around the world gathered to share and discuss what films they saw (contemporary as well as classics). Among my favorite peers were the director of a major city library in Tennessee; a film professor in the United Kingdom who professed not to be able to discuss films with her colleagues because it was too much academic shop talk and not enough fun; the bored stay-at-home wife of a *New York Times* journalist; a San Diego high school student with a penchant for Marguerite Duras; and a nursing home resident who attended the Kansas City opening night of *Citizen Kane*. Their collective insight on any number of films from all eras and countries (thanks to the age of DVD) was, in my view, better than any film school (indeed, the board was my film school since I couldn't afford a formal graduate education), especially in that it wasn't ensconced in a limited perspective of cinema, academic or otherwise.

This to me is the full potential of online cinema culture: to be expansive and connected all at once. This is one of the guiding principles of my own blog, and is a reason why I invite a variety of individuals to collaborate on my video essays, each one lending a different voice and perspective to a given film. This perspective is all the more important to nurture if cinema culture itself is to have a future beyond the specialized online cul-de-sacs to which many cinephiles have already migrated, and maintain its relevance within culture at large.

KARINA LONGWORTH: SPOUT BLOG

Forgive me, *Cineaste*, for I have sinned. I wear the scarlet letter of the professional version of the home wrecker. I am a blogger.

One morning in June, I appeared on a panel at the Silverdocs Film Festival, called Main Street versus The Blogosphere. On my right sat a friendly acquaintance that has worked as a reporter and a critic for both online and print publications. On my left sat a reviewer who, just two weeks earlier, had accepted a buy-out from the newspaper at which he had been employed for twenty-five years. At a particularly heated point in the conversation, the man on my right accused me of "killing" the job of the man on my left. His tongue was clearly in cheek, and no one on the panel took the accusation at plain face value. But there was a kernel of authentic anxiety to the statement; that the panel had a "versus" in the title should be indication enough that the prevailing view holds that print critics and Internet critics can't coexist.

I've been working to combat that view every day of the past three and a half years. I started writing a film blog for a living in January 2005, when I was twenty-four years old. Through a combination of dumb luck, naiveté, misguided rebellion, and, very occasionally, shrewd calculation, I helped to plant the seeds for this debate, this rarely productive tug-of-war between, as it was worded in the invitation to participate in this symposium, "the cranky naysaying of anti-internet pundits and the undiluted enthusiasm of film buff 'Net Heads'" [*sic*]. For playing my part in this internecine war, I am truly regretful. But in my defense, I must say that it wasn't supposed to turn out this way.

When I got into this racket, there was a fledgling underground of interesting Internet film writers, whose generic interests and methods of approach had far more in common with highbrow mainstream media than with the so-called fanboy culture, at that time held up on one end by Film Threat and on the other by Harry Knowles's Ain't It Cool News. There was Indiewire for film news and festival coverage, Reverse Shot and Slant for sharp, unforgiving reviews of indie and indie-arm releases, Twitch for enthusiastic spelunking of obscure genre product, and a few handfuls of disparate blog voices, most of which languished in obscurity until swept up in the heroic collation efforts of David Hudson at GreenCine Daily.

That all of the sites named above are alive and thriving three years later should be evidence enough of their continued significance. But in 2005, when I was editing an early version of Cinematical and writing ten blog posts a day myself, the combined noise made by the established film websites in concert with us young upstarts seemed meek against the constant drone of corporate entertainment media. I saw very little material difference between what passed for film coverage in most mainstream outlets, whether it was *Access Hollywood* or the *New York Times*' Sunday Arts & Leisure section. Maybe the latter earned (and deserved) credibility for extending its promotional efforts past the multiplex, to tiny films, foreign films, retrospectives. But the available options failed to address what I thought (and still feel, perhaps now more than ever) was a major crisis for cinephiles. The bulk of entertainment "news" amounted to pure advertising (celebrity profiles, trailers-as-content, uncritical set visits . . . pretty much the entirety of *Entertainment Weekly*). Then there was a rarefied, highbrow space (film festivals, big-city rep houses, and, um, magazines like *Cineaste*), but this space was often inaccessible to the average person who really cared about movies. I knew too many people whose personal tastes fell somewhere in the middle.

I've always tried to give voice to that man in the middle, to offer skepticism and passion in equal doses, to use my platform to steer the conversation toward films that deserve extra attention whilst at the same time questioning received wisdom whenever it seemed appropriate (and often when it didn't). At first, I felt like I could get away with anything, because no one was paying attention—the

idea that I could have an audience as large and as dedicated as any newspaper critic's seemed completely laughable.

But sometime in late 2005, things started to change. Page views, on my blog and others, soared. Publicists started calling me at home, usually angrily. And long before jobs for print critics began to disappear, people like Peter Bart were writing ill-informed editorials, bemoaning the blogosphere as an orgy without protections, trying to run us out of town. "They'll just publish anything!" the detractors moaned. Well, yeah, but what's your point? We never said we were going to play by your rules. We never said that what we were doing was pure journalism.

No, I'm not being entirely facetious: what I do for a living sometimes looks like journalism (in my case specifically, it often looks quite a bit like criticism), but on any given day, I also play the roles of activist, stand-up comic, camp counselor, therapist, and DJ. Above all, I think of myself as a hunter—it's my job to go out in the world and look for prey to feed to my hungry community.

Just as I wouldn't be able to do my job were it not for film festivals, publicists, and, of course, filmmakers, I wouldn't be able to do it without print film critics and journalists. Internet film culture needs mainstream/print culture to survive. We need something to push and pull against; we need the established media to set the words for our conversation. The best hope of the online film community is not to replace traditional film criticism, but to eventually earn enough respect from that establishment to be seen not as upstarts, not as a nuisance, not as a threat, but as partners in the common goal of keeping a public conversation about cinema alive. Every time either side drops a "versus," an us-or-them binary opposition, we waste time and weaken both sides.

THE SELF-STYLED SIREN: CAMPASPE

The Internet has been a democratic revolution in film criticism, giving ordinary cinephiles an ability to be heard that didn't exist before. In terms of critical interaction, we are living in a golden age.

Even though I'm in New York, my odds of having James Wolcott respond to an opinion of mine, or exchanging views with Glenn Kenny, were slim indeed preweb. I never went to film school or took a cinema studies class. My qualifications consist of a lifetime of watching movies, reading and thinking about them. But I started a blog and gradually acquired readers, and now I can go back-and-forth with people ranging from renowned academics like David Bordwell, to director Raymond de Felitta, to professional critics like Kim Morgan and Jim Emerson, to the self-taught and fiercely intellectual Girish Shambu. The net gives me direct contact with Andrew Grant, Michael Guillen, Michael W. Phillips, Jonathan Lapper, Zach Campbell, Gerard Jones, Keith Uhlich, Peter Nelhaus,

Dan Callahan, Marilyn Ferdinand, John McElwee, Andy Horbal, Nathaniel Rogers, and so many others, all of them strong, intelligent, and provocative writers. And I have knowledgeable commenters, many of whom aren't critics and don't blog, but who show up from places I've never visited (and in some cases have barely heard of) to discuss the movies they love.

Criticism at the big media outlets usually has been release-driven, geared to reviewing a new movie in theaters or on DVD. Bloggers write about whatever we please, which I assume is why some professional critics blog on the side. In my case, the movies I care about are long, long past their release date. At the moment there's no mainstream print publication that will pay me to write about Jean Negulesco or three *Titanic* movies because I happen to feel like it. They probably wouldn't even let me do it free. That's the whole point. Good blogging should offer you something you can't get from the mainstream. The bloggers who interest me most aren't afraid to be idiosyncratic, like Noel Vera writing up Gerardo de Leon's vampire movies, Kimberly Lindbergs on pinky violence, Larry Aydlette doing a month of Burt Reynolds, or Dennis Cozzalio fearlessly working to resurrect *Mandingo*. Where in the big print publications are you going to find something like that?

One persistent complaint you hear from critics who dislike blogs is that blogs aren't edited. And yes, some bloggers are in desperate need of fact checking, not to mention proofreading. Still, serious bloggers take care with facts and writing. I don't see errors in the blogs I've named here any more often than I do in print outlets. Another oft-cited drawback is the "post in haste, repent at leisure" phenomenon, where someone offends you, and you throw up a boiling-hot web rant, and two hours later you realize you have started a fight you don't want. That's less likely to happen in an outlet where there is an editor to apply the brakes, but the web system is self-correcting. When a blogger goes seriously off the rails, there are usually commenters and other bloggers willing to shove him or her back on track. And those bewailing the persistent lack of civility in some comment sections can always change Internet neighborhoods.

I believe the "conflict" between traditional and web-based criticism has been overstated. Most of us play nice and enjoy each other's company. Look at the survey of foreign-film favorites conducted last year by blogger Edward Copeland. The idea was to respond to a "100 Best" list from the American Film Institute that many of us found dull and predictable. The AFI list had been followed by a blogger-compiled list that in some ways was worse. Copeland handed out nominating ballots to both bloggers and print critics, some with small audiences and some with very large ones, then threw open the voting to anyone with enough interest to send an e-mail. The resulting list accomplished what all lists do best—it started an argument. But even better was Copeland's compilation of the comments from the nominators and voters. We wound up with a far-ranging

survey of foreign film accompanied by remarks that were serious and jokey, erudite and lowbrow, exactly the kind of mix the Internet does best.

I think there are a lot of factors contributing to the traditional film critic's eroding influence, and the proliferation of amateur opinion on the net is far from the only one. The quote whores, willing to paste up come-hither adjectives like "COLOSSAL!" at the drop of a junket, surely have done as much to make people suspicious of reviewers as some awkwardly written blog posts. More importantly, print is in deep trouble. It's painful to see an excellent critic like Glenn Kenny jettisoned from *Premiere's* website, but what was worse was watching the print magazine decline in scope until it was shuttered. What we're seeing is a wholesale attempt to trim anything weighing down profits, like Gert Frobe in *Chitty Chitty Bang Bang* throwing first the sandbags and then the employees over the side of the balloon. Obviously I love blogs, but I don't want to see them replace more traditional outlets. Does anyone? Coexistence would be the ideal, but for print, things are tough all over, and not just for film critics.

So in economic terms, I can't say this is the best of all possible worlds. There are a lot of web writers producing a lot of good work, but few of us are getting paid for it. For any would-be professional critic, the web is both godsend and nightmare—intense, endlessly varied and renewable competition, offered free. I can't guess the end result of that, although I suspect it will end as most revolutions do, with a market-based counterrevolution. I'm just trying to enjoy this wide-open stage while it lasts.

STEPHANIE ZACHAREK: *SALON*

Internet criticism has made a significant contribution to film culture in that it's opened the door for a wide range of voices. But as we're all seeing, it's opened the door too wide. There are so many film enthusiasts—if not actual professional critics, either former or current—writing on the web that now we're faced with a great deal of noise. Let's not even talk about the zillions of film bloggers who aren't worth reading—who cares about them? The bigger problem is that many of the people writing about film on the web are knowledgeable and have pretty interesting ideas. Unless you're really systematic about checking up on all of them regularly, there are too many to even read, so good people get lost.

There's something else, too. Even the smart bloggers, the ones who are potentially good writers, often don't shape their pieces. That's the nature of a blog: it's a quick take, a reaction. I don't know that the Internet has done much to destroy the process of thinking seriously about film, but it's had very grave consequences when it comes to writing about film. So much of what you read on the web is reactive rather than genuinely thoughtful. There are web publications that still publish longer pieces—*Senses of Cinema*, for example. But as far as blogs go, even

though film bloggers are often "real" writers (or could be), what they're doing isn't "real" writing, in terms of rigorously thinking an argument through, of shaping a piece of writing into something that will be interesting, entertaining, and informative and possibly lasting—that is to say, worth reading ten or twenty years from now. That was the reason most of us wanted to become writers in the first place, or so I'd always thought: because we valued the craft itself. Now we're seeing a lot of "I have an opinion! I must state it NOW, before anyone else weighs in." There's a lot of "weighing in" going on, but not so much actual thinking. That's what I find tragic and disheartening.

As far as being a professional writer in this climate goes, of course, the jobs are drying up. And that's a tragedy too—not just for critics who are currently working, but also for serious bloggers who might otherwise dream of someday making a living at writing about film. Film criticism, as a profession, is disappearing. In print media, for years now a lot of editors have been saying, "We don't need a professional film critic—people can get all that stuff on the web for free." First of all, it's not really "free"—someone's doing the work of putting it out there, at some cost to his/her personal life, if nothing else. Also, it means we have a lot of "information" out there. But information doesn't equal knowledge. And it doesn't equal good writing.

Even though I'm primarily an Internet critic, I don't look at blogs/film websites all that often. I really need to filter out noise rather than add to it, which means I'm sure there are good ones that I'm missing (and some, I'm sure, that I'm simply forgetting to mention here). But I do like to look at The House Next Door and *Senses of Cinema*. I like De Palma a la Mod, an example of a very specialized site that attracts and/or acts as a sort of clearing house for people with some pretty interesting (though sometimes wild!) ideas. I'm also very fond of The Criterion Contraption (http://criterioncollection.blogspot.com/). I'm really not interested in obsessive loonies who need to prove how much they know about film. I gravitate more toward people who have genuine affection for film—a little obsessiveness is OK (we're all guilty of it), but even among film geeks you often find a kind of macho posturing, and that really turns me off.

In the early days of *Salon*, I loved the participatory aspect—the fact that people could write to me personally just by clicking a link to my e-mail address. And boy, did I get mail! A lot of wonderful, thoughtful stuff, from people all over the world. I've made some dear friends for life, just by corresponding with *Salon* readers. Of course, I used to get—and continue to get—hate mail too. Things like, "Girls shouldn't be allowed to write about movies based on comic books." (Amazingly, even in 2008, I still get that one a lot.) When I panned *Titanic* I got a lot of heartfelt letters from teenage girls who accused me of having no heart, of being incapable of receiving or giving love. I came to realize that a lot of these letters had some very strange syntax and spelling issues—because

they were coming from Japan! Apparently, there were lots of Japanese teenage girls who were nuts for that movie. They were very polite, but they were so upset that I hated it.

Now, *Salon* has an automated comments section, which means readers—I use the term loosely, because usually they read only the head and the deck of the piece—can post comments directly on the site. So you get a lot of people who have to be the first to post (generally with something idiotic or inflammatory), or people who are very transparently envious that I have a job writing film criticism and they don't. There are intelligent comments, but they're few and far between. It's mostly people who want to make themselves heard, even though they may have little worth saying. Very few people actually engage in discussion of the movie at hand. And so now I get fewer thoughtful, interesting, personal e-mails from readers (the real kind of readers, who actually read), and I miss them terribly. The idea of the web as a democratic, participatory medium is very grand, but the reality is a total mess. Kind of like democracy itself, come to think of it.

NOTE

1. This article was originally published in 2008; Andrew Sarris passed away in 2012.—Eds.

AFTERWORD

CECILIA SAYAD

The impact of new technologies on our personal and social experiences is more immediate than our ability to process and make sense of it. The relatively quick incorporation of the digital and the Internet in our personal and social lives has required a number of adjustments. New practices call for specific regulations, as well as new ways of understanding our modes of socialization (social networking, blogging) and consumption (from online purchases to streaming). This book's focus is on how these dynamics have been shaping film criticism, and though the collected essays range from the critic's relationship to audiences to new forms and activities, as well as changes in professional and institutional models, the questions they raise presuppose the notion that film criticism is in crisis.

This sense of crisis is not exclusive to the criticism of film nor to criticism alone. Digital technology has invited a rearticulation of the function, purposes, and practices of critics in other cultural spheres (literature, theater, music, fine arts), of journalists, and of institutions (from media conglomerates and critics associations to academia). Most pertinently for our purposes, the very medium of film is also in crisis, as is the broader concept of the cinema, which extends beyond the cultural artifact to encompass modes of production, distribution, and consumption. Titles such as *Cinema Futures, Audiovisions, The Cinema Effect, Death 24x a Second, The Virtual Life of Film,* and *What Cinema Is!* are among a long list accounting, in their own ways, for the changes that digital technology has brought to the cinema and, by extension, to our relationship with films.[1]

Early critics and theorists were invested in the discovery of the medium's specificities in prescriptive theories of what film should be; they sought the essence of film and identified it in specific practices—montage for the Soviets, deep-focus cinematography and long takes for André Bazin, and so on. Reacting

to a "recent agony of film theory, if not of cinema itself" in face of the switch from analog to digital, which dislodged not only the celluloid film stock but also "the camera, the movieola [sic] (editing bench), and the projector" as the material basis for the cinema, Dudley Andrew proposes to continue the quest for the true nature of the medium, stating his conviction that "we may still say something essential about it."[2]

Indeed, what constitutes an identity crisis, if not the search for an essence? Thomas Elsaesser's contribution to this volume longs precisely for the basic purposes of both film and criticism. Like the aforementioned books discussing the digital's impact on the cinema, the motor of this collection is the impact that a technology has had on the function, profession, and institutions of film criticism—the recuperation, as well as the reconfiguration, of the film critic in light of a technological shift. The criticism of film is partly shaped by transformations in the medium it purports to account for—Noah Tsika's discussion of how digital informed both the production and the criticism of Nigerian cinema clearly reflects on such causes and effects. In *The Virtual Life of Film* D. N. Rodowick draws a different kind of connection between the two, associating the birth of film studies with the "death of cinema," saying that "the emergence of professional film studies is coincident with what may now be understood as a long period of economic decline for the cinema, first in competition from broadcast television (1955–1975), and then from video and DVD (1986–present)." Like the commentators above, Rodowick argues that technological changes are crucial to investigations into the essence of cinema; from this we can infer that the advent of new technologies (sound, color, widescreen, digital) and support (video, DVD, streaming) offers fertile ground for criticism—both in academia and the media. Rodowick, in fact, asks if "perhaps the drive to understand film and cinema was fueled in direct proportion to its economic displacement and physical disappearance?"[3]

So criticism may flourish when the medium is in crisis. But as we know, criticism itself is being similarly affected by these technological transformations. What this book contemplates, after all, is what happens to critics in the aftermath of the profession's "economic displacement" (the redundancies tackled in Mattias Frey's introduction, in the chapter by Outi Hakola, and in the articles by critics and bloggers reprinted in the last section), which forces film criticism to rethink its function and remodel its public interface (Anne Hurault-Paupe's analysis of critics associations' websites). Equally central is the debunking of print publications as main vehicle, which may not be the exact equivalent of the imminent "disappearance" of celluloid (we have yet to find out the extent to which paper will be supplanted by electronic publications) but in any case echoes the anxieties prompted by a change in the material support for an activity: the concreteness of celluloid and paper gradually yields to the virtual existences of film and criticism in digital formats and on the web.

The instability of support is partly responsible for the need to recover the essences of both film and film criticism—though the question remains whether these essences ever were, or could be, "discovered." (Andrew reminds us of Bazin's understanding that "the cinema has not yet been invented" and that "cinema's existence precedes its essence.")[4] In the ambit of criticism this search translates into the question of the critic's function, which extends to matters of critical preferences (central to evaluation, and that inevitably configure ideology and tastes) and authority, questions that we have seen tackled in the chapters by Greg Taylor, myself, Daniel McNeil, Frey, Giacomo Manzoli and Paolo Noto, Maria San Filippo, Tsika, and Elsaesser. Interestingly, for a collection devoted to analyzing the transformations propelled by the digital age, most studies identify continuities between past and present practices. Continuities are evident in the persistence of auteurism tackled in my chapter, of the traditional critical approaches detected in the vlogs discussed by Manzoli and Noto, and in the web revival of vanguard criticism's celebratory impulses identified in Taylor's piece. They suggest that the digital era prompted not the death, but the reinvention, of the film critic, even because, as we know, the majority of critics working in print have either migrated to the Internet or have added online reviewing to their repertoire. The criteria for evaluation might vary according to critical ideology or taste, but they are not necessarily prompted by the new forms of web criticism discussed in the chapters by Taylor, Manzoli and Noto, Tsika, Frey, and San Filippo.

Though continuities may offer hope against the threat of extinction, in the current assessment of criticism, both in film and other areas, the death metaphor features prominently, and usually to divest the critic of authority. This is at least what is implied in Jasmina Kallay's article and in Rónán McDonald's *The Death of the Critic*, discussed by Frey. The title of McDonald's book is an explicit reference to Roland Barthes's "The Death of the Author" (1968), which obviously refers to literature. McDonald emphasizes Barthes's empowerment of the reader to the detriment of the author—that essay's "call for freedom and liberation," the sentencing of the author as a means to "heral[d] the 'birth of the reader.'" For McDonald the waning of the author's authority that accompanies the dismissal of authorial intention also does away with the critic, "or at least with the literary critic as public intellectual, a figure to whom a wide audience might look as a judge of quality or a guide to meaning."[5] The essence of criticism, as many (but not all) would argue, is specialized evaluation—its crisis, as this volume suggests, is in part the result of a presumed undermining of expertise.

But there is another way in which the analogy between Barthes's "death of the author" and the "death of the critic" can illuminate the crisis in criticism. Barthes's seminal essay is as much an antiauthoritarian manifesto for the acceptance of multiple readings as it is a treatise about a subject in crisis. In a structuralist vein Barthes attributes the author's death to the disconnection between

language and subject—"it is language which speaks, not the author," he says, and to write is "to reach that point where only language acts, 'performs,' and not 'me.'"[6] For Barthes the author is dead because the text cannot grant us access to a historical, biographical subject, to the author's individual essence, which in turn would hold the work's essence: "As soon as a fact is *narrated*, no longer with a view to acting directly on reality but intransitively, that is to say, finally outside of any function other than that of the very practice of the symbol itself, this disconnection occurs, the voice loses its origin, the author enters into his own death, writing begins."[7]

Barthes's relevance to this volume lies not with the disconnection between language and subject that he detects in artistic, disinterested writing "outside of any function other than that of the very practice of the symbol itself"—which doesn't really correspond to critical writing. This notion of authorial "death" is important to the crisis in criticism because the void left by the subject's disappearance invites the longing for an essence—both of the author and of his or her work.

Neither the author we imagine when reading a text nor this text's meaning can thus be referred back to a palpable subject—the death of the author signals a crisis resulting from this sense of fluctuation, of unanchorability, as do the deaths of film and of the critic. The technological changes that displaced the body of film (celluloid) invite the need to relocate the medium's "soul," its essence; meanwhile, the loosening of the boundaries that once defined the profession of film criticism stirs fears about the critic's disappearance, or death. Film criticism's essence, like that of film and of the author, can no longer be contained within a clearly demarcated territory (a single material support, an individual subject). This collection does not purport to erect new boundaries or demarcate a territory for criticism, nor does it claim to provide a single, definitive answer to the digital age's impact on this practice. The variety of perspectives gathered here suggests, on the contrary, that it is perhaps not the identification but the constant search for a presumably lost essence that best defines the work of the critic.

NOTES

1. See Thomas Elsaesser and Kay Hoffmann, eds., *Cinema Futures: Cain, Abel or Cable? The Screen Arts in the Digital Age* (Amsterdam: Amsterdam University Press, 1998); Siegfried Zielinski, *Audiovisions: Cinema and Television as Entr'actes in History* (Amsterdam: Amsterdam University Press, 1999); Sean Cubitt, *The Cinema Effect* (Cambridge, MA: MIT Press, 2004); Laura Mulvey, *Death 24x a Second: Stillness and the Moving Image* (London: Reaktion, 2006); D. N. Rodowick, *The Virtual Life of Film* (Cambridge, MA: Harvard University Press, 2007); and Dudley Andrew, *What Cinema Is!* (Malden, MA: Wiley-Blackwell, 2010).
2. Andrew, *What Cinema Is!* xxvi; xxv.
3. Rodowick, *The Virtual Life of Film*, 28.
4. Andrew, *What Cinema Is!* xxv.

5. Rónán McDonald, *The Death of the Critic* (London: Continuum, 2007), 3.

6. Roland Barthes, "The Death of the Author," in *Theories of Authorship: A Reader,* ed. John Caughie (London: Routledge and Kegan Paul, in association with the British Film Institute, 1981), 209.

7. Ibid., 208.

SELECTED BIBLIOGRAPHY

Anderson, Monica, Emily Guskin, and Tom Rosenstiel. "Alternative Weeklies: At Long Last, a Move Toward Digital." The State of the News Media 2012. http://stateofthemedia.org/2012/native-american-news-media/alternative-weeklies-at-long-last-a-move-toward-digital/.

Andrew, Dudley. "The Unauthorized Auteur Today." In Film and Theory: An Anthology, edited by Robert Stam and Toby Miller, 20–29. Malden, MA: Blackwell, 2000.

———. What Cinema Is! Malden, MA: Wiley-Blackwell, 2010.

Andrew, Dudley, and Hervé Joubert-Laurencin, eds. Opening Bazin. New York: Oxford University Press, 2012.

"Are Film Critics Really Needed Anymore . . . or Is It a Washed-Up Profession?" Variety, 25 April 2007. www.variety.com/article/VR1117963778?refCatId=1043.

Arnold, Matthew. "The Function of Criticism at the Present Time." In The Portable Matthew Arnold, edited by Lionel Trilling, 239–267. New York: Viking, 1949.

Astruc, Alexandre. "The Birth of a New Avant-Garde: La caméra-stylo." In The New Wave: Critical Landmarks, edited by Peter Graham, 17–23. London: Martin Secker and Warburg, 1968.

Bakker, Piet. "Free Daily Newspapers—Business Models and Strategies." International Journal of Media Management 4.3 (2002): 180–187.

———. "The Simultaneous Rise and Fall of Free and Paid Newspapers in Europe." Journalism Practice 2.3 (2008): 427–443.

Balázs, Béla. Theory of the Film: Character and Growth of a New Art. Translated by Edith Bone. London: Dennis Dobson, 1952.

Baldwin, James. Collected Essays. New York: Library of America, 1998.

———. "The White Man's Guilt." Ebony, August 1965.

Balogun, Françoise. "Booming Videoeconomy: The Case of Nigeria." In Focus on African Films, edited by Françoise Pfaff, 173–184. Bloomington: Indiana University Press, 2004.

Barats, Christine, ed. Manuel d'analyse du web. Paris: Armand Colin, 2013.

Barrot, Pierre. "'Video Is the AIDS of the Film Industry.'" In Nollywood: The Video Phenomenon in Nigeria, edited by Pierre Barrot, 1–15. Bloomington: Indiana University Press, 2008.

Barthes, Roland. "The Death of the Author." In Theories of Authorship: A Reader, edited by John Caughie, 208–213. London: Routledge and Kegan Paul, in association with the British Film Institute, 1981.

———. "The Rhetoric of the Image." In Image, Music, Text, edited and translated by Stephen Heath, 32–51. New York: Hill and Wang, 1977.

Baudrillard, Jean. Simulations. Translated by Paul Foss, Paul Patton, and Philip Beitchman. New York: Semiotexte, 1983.

Baumann, Shyon. Hollywood Highbrow: From Entertainment to Art. Princeton, NJ: Princeton University Press, 2007.

Bazin, André. "On the *politique des auteurs.*" *Cahiers du cinéma* 70 (1957): 2–11. Reprinted in *Cahiers du cinéma, the 1950s: Neo-Realism, Hollywood, New Wave,* edited by Jim Hillier, translated by Peter Graham, 248–259. Cambridge, MA: Harvard University Press, 1985.

———. *What Is Cinema?* Translated by Timothy Barnard. Montreal: Caboose, 2009.

Bell, Melanie. "Film Criticism as 'Women's Work': The Gendered Economy of Film Criticism in Britain, 1945–65." *Historical Journal of Film, Radio and Television* 31.2 (2011): 191–209.

Bellour, Raymond. "The Unattainable Text." *Screen* 16.3 (1975): 19–28.

Bergan, Ronald. "The Film Critic Is Dead. Long Live the Film Critic." *Guardian,* 7 April 2010. http://theguardian.com/film/filmblog/2010/apr/07/film-critic.

Berger, Maurice, ed. *The Crisis of Criticism.* New York: New Press, 1998.

Bisoni, Claudio. *La critica cinematografica: Metodo, storia e scrittura.* Bologna: Archetipolibri, 2006.

———. "La critica cinematografica tra la sopravvivenza dell'expertise e la logica di Google." In *Le nuove forme della cultura cinematografica,* edited by Roy Menarini, 17–32. Udine: Mimesis, 2012.

Bolter, Jay David, and Richard Grusin. *Remediation: Understanding New Media.* Cambridge, MA: MIT Press, 1999.

Boone, Steven. "In a World That Has *The Darjeeling Limited,* Sidney Lumet Should Be Imprisoned! A Conversation with Armond White, Part 1." *Big Media Vandalism,* 10 December 2007. http://bigmediavandal.blogspot.ca/2007/12/in-world-that-has-darjeeling-limited .html.

———. "Ten Armond White Quotes That Shook My World." *Slant,* 10 December 2007. www .slantmagazine.com/house/2007/10/white-power-ten-armond-white-quotes-that-shook -my-world.

Bordwell, David. "In Critical Condition." David Bordwell's Website on Cinema, 14 May 2008. www.davidbordwell.net/blog/2008/05/14/in-critical-condition/.

Bordwell, David, and Noël Carroll, eds. *Post-Theory: Reconstructing Film Studies.* Madison: University of Wisconsin Press, 1996.

Bordwell, David, and Kristin Thompson. *Minding Movies: Observations on the Art, Craft, and Business of Filmmaking.* Chicago: University of Chicago Press, 2011.

Bourdieu, Pierre. *Distinction: A Social Critique of the Judgment of Taste.* Translated by Richard Nice. Cambridge, MA: Harvard University Press, 1984.

Bourget, Jean-Loup. "Social Implications in the Hollywood Genres." *Journal of Modern Literature* 3.2 (1973): 191–200. Reprinted in *Film Genre Reader,* edited by Barry K. Grant, 51–59. Austin: University of Texas Press, 2003.

Bradshaw, Peter. "How Twitter Users Became the Industry's Favourite Critics." *Guardian,* 16 January 2013. www.guardian.co.uk/film/shortcuts/2013/jan/16/twitter-users-film -industrys-critics.

Budd, Malcolm. *Values of Art: Pictures, Poetry and Music.* London: Penguin, 1996.

Carey, John. *What Good Are the Arts?* London: Faber and Faber, 2005.

Carroll, Noël. "Art, Intention, and Conversation." In *Intention and Interpretation,* edited by Gary Iseminger, 97–131. Philadelphia: Temple University Press, 1992.

———. *On Criticism.* New York: Routledge, 2009.

Chamley, Santorri. "New Nollywood Cinema: From Home-Video Productions Back to the Big Screen." *Cineaste* 37.3 (2012): 21–23.

Charaudeau, Patrick, and Dominique Maingueneau. *Dictionnaire d'analyse du discours.* Paris: Seuil, 2002.

Clayton, Alex, and Andrew Klevan, eds. *The Language and Style of Film Criticism.* London: Routledge, 2011.

Cohen-Séat, Gilbert. *Essai sur les principes d'une philosophie du cinéma.* Paris: Presses universitaires de France, 1946.

Collin, Robbie. "Who Cares What Twitter Critics Think?" *Daily Telegraph,* 18 January 2013. www.telegraph.co.uk/culture/film/film-blog/9810807/Who-cares-what-Twitter-critics-think.html.

Colombo, Fausto. *La cultura sottile: Media e industria culturale italiana dall'ottocento a oggi.* Milan: Bompiani, 1998.

Comolli, Jean-Louis, and Jean Narboni. "Cinema/Ideology/Criticism," translated by Hugh Gray. In *Film Theory and Criticism: Introductory Readings,* 5th ed., edited by Leo Braudy and Marshall Cohen, 752–759. New York: Oxford University Press, 1999.

Crompton, Sarah. "Critics Are Important—Even in the Blogosphere." *Daily Telegraph,* 11 January 2013. www.telegraph.co.uk/culture/tvandradio/9795521/Critics-are-important-even-in-the-blogosphere.html.

Dahlberg, Lincoln. "The Internet and Democratic Discourse: Exploring the Prospects of Online Deliberative Forums Extending the Public Sphere." *Information, Communication and Society* 4.4 (2001): 615–633.

de Baecque, Antoine. *Cahiers du cinéma: Histoire d'une revue.* Vols. 1 and 2. Paris: Éditions Cahiers du cinéma, 1991.

————. *La cinéphilie: Invention d'un regard, histoire d'une culture, 1944–1968.* Paris: Fayard, 2003.

Decherney, Peter. *Hollywood and the Culture Elite: How Movies Became American.* New York: Columbia University Press, 2005.

Delorme, Stéphane. "Taking Issue: In Search of the Auteur." *Sight and Sound,* June 2013, 76–77.

Doherty, Thomas. "The Death of Film Criticism." *Chronicle of Higher Education,* 28 February 2010. www.chronicle.com/article/The-Death-of-Film-Criticism/64352.

Dort, Bernard. "Towards a Brechtian Criticism of Cinema." In *Cahiers du cinéma* 114 (1960): 33–43. Reprinted in *Cahiers du cinéma, the 1960s: New Wave, New Cinema, Reevaluating Hollywood,* edited by Jim Hillier, translated by Jill Forbes, 236–247. Cambridge, MA: Harvard University Press, 1986.

Douchet, Jean. "L'art d'aimer." *Cahiers du cinéma* 126 (1961): 33–37.

Dovey, Lindiwe. *African Film and Literature: Adapting Violence to the Screen.* New York: Columbia University Press, 2009.

Drufva, Juha. "Miten arvioida taiteen pirullisen ihanaa valtakuntaa?" *Kritiikin uutiset,* no. 3 (2004): 28.

————. "Taide on kulttuurin hiiva." *Kritiikin uutiset,* no. 2 (2010): 12–13.

Dyer, Geoff. *Ways of Telling: The Work of John Berger.* London: Pluto, 1986.

Eagleton, Terry. *The Function of Criticism: From the Spectator to Post-Structuralism.* London: Verso, 1984.

Ebert, Roger. *Awake in the Dark: The Best of Roger Ebert.* Chicago: University of Chicago Press, 2006.

————. "Death to Film Critics! Hail to the CelebCult!" Roger Ebert's Journal, 26 November 2008. www.rogerebert.com/rogers-journal/death-to-film-critics-hail-to-the-celebcult.

————. "Film Criticism Is Dying? Not Online." *Wall Street Journal,* 22 January 2011. http://online.wsj.com/article/SB10001424052748703583404576080392163051376.html.

————. "Not in Defense of Armond White." Roger Ebert's Journal, 14 August 2009. www.rogerebert.com/rogers-journal/not-in-defense-of-armond-white.

Edelstein, David. "David Edelstein on the Spirit of the Boston *Phoenix.*" Vulture, 14 March 2013. www.vulture.com/2013/03/david-edelstein-on-the-spirit-of-the-phoenix.html.

Elkins, James. *What Happened to Art Criticism?* Chicago: Prickly Paradigm, 2003.

Ellis, Cassandra M. "The Black Boy Looks at the Silver Screen: Baldwin as Moviegoer." In *Re-viewing James Baldwin: Things Not Seen*, edited by Daniel Quentin Miller, 190–214. Philadelphia: Temple University Press, 2000.

Elsaesser, Thomas, and Kay Hoffmann, eds. *Cinema Futures: Cain, Abel or Cable? The Screen Arts in the Digital Age*. Amsterdam: Amsterdam University Press, 1998.

Enemaku, Ogu S. "Ethical Foundations of the Nigerian Video Film: Towards a Reconstruction." In *African Video Film Today*, edited by Foluke Ogunleye, 69–80. Matsapha, Swaziland: Academic Publishers, 2003.

English, James F. *The Economy of Prestige: Prizes, Awards, and the Circulation of Cultural Value*. Cambridge, MA: Harvard University Press, 2008.

Fanchi, Mariagrazia. *Spettatore*. Milan: Il castoro, 2005.

Farber, Manny. *Farber on Film: The Complete Film Writings of Manny Farber*. Edited by Robert Polito. New York: Library of America, 2009.

———. *Negative Space: Manny Farber on the Movies*. Exp. ed. New York: Da Capo, 1998.

Fenton, Natalie. "Drowning or Waving? New Media, Journalism and Democracy." In *New Media, Old News: Journalism and Democracy in the Digital Age*, edited by Natalie Fenton, 3–16. London: Sage, 2010.

"Film Criticism or Op-ed Piece: Armond White and the Smugness of Torture Victims." *Filmbrain*, 29 June 2006. www.filmbrain.com/filmbrain/2006/06/film_criticism_.html.

Franklin, Bob. "The Future of Newspapers." *Journalism Practice* 2.3 (2008): 306–317.

Frey, Mattias. "The Critical Question: *Sight and Sound*'s Postwar Consolidation of Liberal Taste." *Screen* 54.2 (2013): 194–217.

———. *The Permanent Crisis of Film Criticism: The Anxiety of Authority*. Amsterdam: University of Amsterdam Press, 2015.

Frith, Simon. *Performing Rites: On the Value of Popular Music*. Cambridge, MA: Harvard University Press, 1996.

Gans, Herbert J. *Popular Culture and High Culture: An Analysis and Evaluation of Taste*. 2nd rev. ed. New York: Basic Books, 1999.

García, Yago. "Singuen influyendo las críticas de cine?" *Cinemanía*, 8 June 2013. http://cinemania.es/noticias-de-cine/siguen-influyendo-las-criticas-de-cine.

Gates, Henry Louis, Jr. "Black Demagogues and Pseudo Scholars." *New York Times*, 20 July 1992.

Geiger, Jeffrey. "Nollywood Style: Nigerian Movies and 'Shifting Perceptions of Worth.'" *Film International* 10.6 (2012): 58–72.

Gerard, Alexander. *An Essay on Taste (1759), Together with Observations Concerning the Imitative Nature of Poetry*. Delmar, NY: Scholars' Facsimiles and Reprints, 1963.

Ghezzi, Enrico. *Paura e desiderio: Cose (mai) viste, 1974–2001*. Milan: Bompiani, 1995.

Gleiberman, Owen. "Why Armond White Got Kicked Out of the Critics Circle." *Entertainment Weekly*, 13 January 2014. http://insidemovies.ew.com/2014/01/13/armond-white-kicked-out-of-ny-critics/.

Goldman, Alan H. "There Are No Aesthetic Principles." In *Contemporary Debates in Aesthetics and the Philosophy of Art*, edited by Matthew Kiernan, 299–312. Malden, MA: Blackwell, 2006.

Goldstein, Patrick. "The End of the Critic?" *Los Angeles Times*, 8 April 2008.

Goodman, Susan. "She Lost It at the Movies." *Modern Maturity*, March-April 1998.

Grasso, Aldo. *Storia della televisione italiana*. Milan: Garzanti, 2004.

Grieveson, Lee, and Haidee Wasson, eds. *Inventing Film Studies*. Durham, NC: Duke University Press, 2008.

Griswold, Wendy. "A Methodological Framework for the Sociology of Culture." *Sociological Methodology* 17 (1987): 1–35.

Guarini, Drew. "Netflix Accused of Cropping Films, but Company Says It's All a Big Mistake." *Huffington Post*, 18 July 2013. www.huffingtonpost.com/2013/07/18/netflix-cropping -aspect-ratio_n_3616774.html.

Haberski, Raymond J., Jr. *It's Only a Movie! Films and Critics in American Culture.* Lexington: University Press of Kentucky, 2001.

Hague, Barry N., and Brian D. Loader, eds. *Digital Democracy: Discourse and Decision Making in the Information Age.* London: Routledge, 1999.

Halonen, Katri. *Kulttuurintuottajat taiteen ja talouden risteyskohdassa.* Jyväskylä: University of Jyväskylä, 2011.

Hännikäinen, Timo. "Kritiikon on pudotettava kärryiltä." *Kritiikin uutiset*, no. 2 (2003): 12–13.

Hänninen, Ville. "Kritiikin tuho! Katso kuvat!" *Kritiikin uutiset*, no. 2 (2009): 8–9.

Harrow, Kenneth W. *Postcolonial African Cinema: From Political Engagement to Postmodernism.* Bloomington: Indiana University Press, 2007.

———. *Trash: African Cinema from Below.* Bloomington: Indiana University Press, 2013.

Hautamäki, Reetta. *Tilastoja / Facts & Figures 2004.* Helsinki: Suomen Elokuvasäätiö / Finnish Film Foundation, 2005.

Hautamäki, Reetta, and Petri Kemppinen. *Elokuvavuosi 2012 Facts & Figures.* Helsinki: Suomen Elokuvasäätiö / Finnish Film Foundation, 2013.

Haynes, Jonathan. "African Cinema and Nollywood: Contradictions." *Situations: Project of the Radical Imagination* 4.1 (2011): 67–90.

———. "Nollywood in Lagos, Lagos in Nollywood Films." *Africa Today* 54.2 (2007): 131–150.

Helin, Pekka. "Freelance-kriitikko." *Kritiikin uutiset*, no. 2 (2000): 22.

Hellman, Heikki, and Maarit Jaakkola. "Kulttuuritoimitus uutisopissa—Kulttuurijournalismin muutos Helsingin Sanomissa, 1978–2008." *Media & Viestintä* 4–5 (2009): 24–42.

Henderson, Lisa. "Simple Pleasures: Lesbian Community and *Go Fish.*" In *Chick Flicks: Contemporary Women at the Movies*, edited by Suzanne Ferriss and Mallory Young, 132–157. New York: Routledge, 2008.

Hermida, Alfred, and Neil Thurman. "A Clash of Cultures: The Integration of User-Generated Content Within Professional Journalistic Frameworks at British Newspaper Websites." *Journalism Practice* 2.3 (2008): 343–356.

Herring, Susan C., Lois Ann Scheidt, Elijah Wright, and Sabrina Bonus. "Weblogs as a Bridging Genre." *Information, Technology and People* 18.2 (2005): 142–171.

Herrnstein Smith, Barbara. *Contingencies of Value: Alternative Perspectives for Critical Theory.* Cambridge, MA: Harvard University Press, 1988.

Hess, John, Chuck Kleinhans, and Julia Lesage. "The Last Word: Fretting About Film Criticism." *Jump Cut* 52 (2010): www.ejumpcut.org/archive/jc52.2010/lastWordCriticism/index.html.

Hietala, Veijo. "Kritiikki—katoava luonnonvara." *Kritiikin uutiset*, no. 4 (2003): 6.

Hilderbrand, Lucas. *Inherent Vice: Bootleg Histories of Videotape and Copyright.* Durham, NC: Duke University Press, 2009.

Hindman, Matthew. *The Myth of Digital Democracy.* Princeton, NJ: Princeton University Press, 2008.

Hoberman, J. *Film After Film: Or, What Became of 21st Century Cinema?* London: Verso, 2012.

Holbrook, Morris B. "Popular Appeal Versus Expert Judgments of Motion Pictures." *Journal of Consumer Research* 26.2 (1999): 144–155.

hooks, bell. *Outlaw Culture: Resisting Representations.* London: Routledge, 1994.

Horkheimer, Max, and Theodor Adorno. *Dialectic of Enlightenment*. Translated by John Cumming. New York: Continuum, 1982.

Houston, Penelope. "The Critical Question." *Sight and Sound*, Autumn 1960, 160–165.

Hoveyda, Fereydoun. "Autocritique." *Cahiers du cinéma* 126 (1961): 41–47.

Huhtanen, Jouni. "Kritiikin arvoista ja arvojen kritiikistä." *Kritiikin uutiset*, no. 4 (2009): 10–12.

Ijioma, Nnaemeke. "Roger That! Nollywood Needs Film Critics." *YNaija*, 11 April 2013. www.ynaija.com/opinion-roger-that-nollywood-needs-film-critics/.

Itzkoff, Dave. "Rotten Tomatoes Halts Comments on 'Dark Knight.'" *New York Times*, 17 July 2012. http://artsbeat.blogs.nytimes.com/2012/07/17/rotten-tomatoes-halts-reader-comments-amid-dark-knight-furor/.

Jacobsen, Mark. "No Kiss Kiss, All Bang Bang." *New York Magazine*, 15 February 2009. http://nymag.com/movies/profiles/54318/.

James, Nick. "A Culture of Talk." *Sight and Sound*, May 2013, 9.

———. "Goodbye Mr French." *Sight and Sound*, November 2013, 5.

———. "Rip It Up: Revitalizing Film Criticism." *Film Quarterly* 62.3 (2009). http://filmquarterly.org/2009/03/rip-it-up-revitalizing-film-criticism/.

Jameson, Fredric. *Signatures of the Visible*. New York: Routledge, 1992.

Jenkins, Henry. *Convergence Culture: Where Old and New Media Collide*. New York: New York University Press, 2006.

———. *Textual Poachers: Television Fans and Participatory Culture*. Rev. ed. New York: Routledge, 2012.

Jokinen, Heikki. "Arvostelijoiden palkkiot ja olosuhteet vaihtelevat rajusti." *Kritiikin uutiset*, no. 2 (2001): 4–6.

———. "Free?" *Kritiikin uutiset*, no. 4 (2010): 5.

———. "Sanoma Newsin tapaus: mitä tapahtuu todella?" *Kritiikin uutiset*, no. 2 (2009): 3–5.

———. "Viimeinen väsytystaistelu?" *Kritiikin uutiset*, no. 2 (2012): 3.

Jokinen, Kimmo. *Arvostelijat—Suomalaiset kriitikot ja heidän työnsä*. Jyväskylä: Jyväskylän yliopisto, 1988.

Jones, Janet, and Lee Salter. *Digital Journalism*. Los Angeles: Sage, 2012.

Kael, Pauline. *The Age of Movies: Selected Writings of Pauline Kael*. New York: Library of America, 2011.

———. "Circles and Squares." *Film Quarterly* 16.3 (1963): 12–26.

———. "Whipped." In *Taking It All In*, 207–213. New York: Holt, Rinehart, and Winston, 1984.

Kantokorpi, Otso. "Kenen joukoissa seisot?" *Kritiikin uutiset*, no. 2 (2009): 1.

———. "Kritiikki on kulttuurilinnakkeen puolustamista." *Kritiikin uutiset*, no. 1 (2006): 5–7.

———. "Kritiikkiä voisi luonnehtia journalismin äpärälapseksi." *Kritiikin uutiset*, no. 1 (2007): 18–19.

Kastemaa, Heikki. "Vain muutos pysyy, vai pysyykö sekään." *Kritiikin uutiset*, no. 4 (2009): 8–9.

Kaye, Jeff, and Stephen Quinn. *Funding Journalism in the Digital Age: Business Models, Strategies, Issues and Trends*. New York: Peter Lang, 2010.

Keathley, Christian. "*La caméra-stylo*: Notes on Video Criticism and Cinephilia." In *The Language and Style of Film Criticism*, edited by Alex Clayton and Andrew Klevan, 176–191. Oxon: Routledge, 2011.

Keen, Andrew. *The Cult of the Amateur: How Today's Internet Is Killing Our Culture and Assaulting Our Economy*. London: Nicholas Brealey, 2007.

Kehr, Dave. *When Movies Mattered: Reviews from a Transformative Decade*. Chicago: University of Chicago Press, 2011.

Kellow, Brian. *Pauline Kael: A Life in the Dark*. New York: Viking, 2011.

Kermode, Mark. *Hatchet Job: Love Movies, Hate Critics*. London: Picador, 2013.

———. "Hatchet Jobs, Anonymity and the Internet: Being a Film Critic in the 21st Century." *Observer*, 29 September 2013.

Kirchhoff, Suzanne M. "The U.S. Newspaper Industry in Transition." *Congressional Research Service Report* 40700, 9 September 2010.

Kivimäki, Ari. "Elokuvajournalismin julkisuuspelit: Ideologiaa, odotuksia ja valtaa." *Lähikuva* 3–4 (1993): 61–68.

———. "Elokuvakritiikki kulttuurihistorian lähteenä." In *Kulttuurihistoria—Johdatus tutkimukseen*, edited by Kari Immonen and Maarit Leskelä, 281–302. Helsinki: Suomalaisen kirjallisuuden seura, 2001.

———. "Elokuvan selostajista tuomareiksi: Suomalainen elokuvajournalismi 1950-luvulla." In *Kriisi, kritiikki, konsensus: Elokuva ja suomalainen yhteiskunta*, edited by Hannu Salmi, 78–95. Turku: Turun yliopisto, 1999.

———. "Kriitikkoälymystön käsityksiä kansallisen elokuvakulttuurin suunnasta 1950-ja 1960-luvuilla." In *Kriisi, kritiikki, konsensus: Elokuva ja suomalainen yhteiskunta*, edited by Hannu Salmi, 96–119. Turku: Turun yliopisto, 1999.

Koerner, Leo, and Lisbet Rausing. "Value." In *Critical Terms for Art History*, 2nd ed., edited by Robert S. Nelson and Richard Shiff, 418–433. Chicago: University of Chicago Press, 2003.

Kolehmainen, Ritva. "Merkkipuhetta." *Kritiikin uutiset*, no. 4 (2006): 3.

———. "Onko kulttuuri kriisissä?" *Kritiikin uutiset*, no. 1 (2005): 24–25.

Kracauer, Siegfried. *From Caligari to Hitler*. Princeton, NJ: Princeton University Press, 1947.

Krings, Matthias, and Onookome Okome. "Nollywood and Its Diaspora: An Introduction." In *Global Nollywood: The Transnational Dimensions of an African Video Film Industry*, edited by Matthias Krings and Onookome Okome, 1–24. Bloomington: Indiana University Press, 2013.

Kuuskoski, Martti. "Arvostelukyvyttömyyden kritiikki." *Yliopisto* 49 (2001): 4.

Landow, George P. *Hypertext 3.0: Critical Theory and New Media in an Era of Globalization*. Baltimore: Johns Hopkins University Press, 2006.

Lant, Antonia, ed. *Red Velvet Seat: Women's Writing on the First Fifty Years of Cinema*. New York: Verso, 2006.

Levin Russo, Julie. "'The Real Thing': Reframing Queer Pornography for Virtual Spaces." In *C'Lick Me: A Netporn Studies Reader*, edited by Katrien Jacobs, Marije Janssen, and Matteo Pasquinelli, 239–252. Amsterdam: Institute of Network Cultures, 2007.

Levy, Emanuel. "Art Critics and Art Publics: A Study of the Sociology and Politics of Taste." *Empirical Studies of the Arts* 6 (1988): 127–148.

Linnavuori, Matti. "Mihin kritiikki joutuu, kun se häviää lehdestä?" *Kritiikin uutiset*, no. 1 (2011): 9–10.

———. "Moite katosi arvosteluista." *Kritiikin uutiset*, no. 4 (2008): 9.

Lopate, Phillip, ed. *American Movie Critics: An Anthology from the Silents Until Now*. New York: Library of America, 2006.

———. *Totally, Tenderly, Tragically: Essays and Criticism from a Lifelong Love Affair with the Movies*. New York: Anchor/Doubleday, 1998.

Lussier, Germain. "Has Armond White Been Kicked off Rotten Tomatoes?" */Film*, 15 November 2011. www.slashfilm.com/armond-white-kicked-rotten-tomatoes/.

Luzón Marco, Marià José. "A Genre Analysis of Corporate Home Pages." *LSP and Professional Communication* 2.1 (2002): 41–56.

Manzoli, Giacomo. *Da Ercole a Fantozzi: Cinema popolare e società italiana dal boom economico alla neotelevisione, 1958–1976*. Rome: Carocci, 2012.

Marcabru, Pierre. "Il reste un homme." *Cahiers du cinéma* 126 (1961): 28–29.

Martin, Adrian. Review of *American Movie Critics: An Anthology from the Silents Until Now.* *Film Quarterly* 60.2 (2006): 48–51.

———. "Superbad Critic." *De Filmkrant*, June 2008. www.filmkrant.nl/av/org/filmkran/archief/fk300/engls300.html.

McCarthy, Anna. "Ellen: Making Queer Television History." *GLQ* 7.4 (2001): 593–620.

McDonald, Rónán. *The Death of the Critic.* London: Continuum, 2007.

McKee, Alan. *The Public Sphere: An Introduction.* Cambridge: Cambridge University Press, 2005.

Means, Sean P. "The Departed—No. 55, Phil Villareal." *Salt Lake Tribune*, 7 May 2009. http://blogs.sltrib.com/movies/labels/disappearing%20critics.htm.

Mekas, Jonas. *Movie Journal: The Rise of a New American Cinema, 1959–1971.* New York: Collier, 1972.

Melander, Tommi. "Kritiikki vaatii ravistelua." *Kritiikin uutiset*, no. 4 (2010): 24.

Menarini, Roy, ed. *Le nuove forme della cultura cinematografica: Critica e cinefilia nell'epoca del web.* Udine: Mimesis, 2012.

Michael, John. *Anxious Intellectuals: Academic Professionals, Public Intellectuals, and Enlightenment Values.* Durham, NC: Duke University Press, 2000.

Miettunen, Helge. *Elokuva itsenäisenä taidelajina.* Helsinki: Helsinginyliopisto, 1950.

Moorman, Jennifer. "Gay for Pay, Gay For(e)play: The Politics of Taxonomy and Authenticity in LGBTQ Online Porn." In *Porn.com: Making Sense of Online Pornography*, edited by Feona Attwood, 155–167. New York: Peter Lang, 2010.

Moran, James M. *There's No Place like Home Video.* Minneapolis: University of Minnesota Press, 2002.

Na, Jin-Cheon, Tun Thura Thet, and Christopher S. G. Khoo. "Comparing Sentiment Expression in Movie Reviews from Four Online Genres." *Online Information Review* 34.2 (2010): 317–338.

Naremore, James. "Authorship and the Cultural Politics of Film Criticism." *Film Quarterly* 44.1 (1990): 14–23.

Nowell-Smith, Geoffrey. "The Rise and Fall of Film Criticism." *Film Quarterly* 62.1 (2008): 10–11.

Nowell-Smith, Geoffrey, and Christophe Dupin, eds. *The British Film Institute, the Government and Film Culture, 1933–2000.* Manchester: Manchester University Press, 2012.

O'Connell, Sean. "Shame on the New York Film Critics Circle for Keeping Armond White Around." *CinemaBlend*, 7 January 2014. www.cinemablend.com/new/Shame-York-Film-Critics-Circle-Keeping-Armond-White-Around-40986.html.

Ogunleye, Foluke, ed. *African Video Film Today.* Matsapha, Swaziland: Academic Publishers, 2003.

Okome, Onookome. "Nollywood and Its Critics." In Saul and Austen, *Viewing African Cinema in the Twenty-First Century*, 26–41.

O'Leary, Alan. "After Brunetta: Italian Cinema Studies in Italy, 2000 to 2007." *Italian Studies* 63.2 (2008): 279–307.

Oliver, Laura. "Journalism Job Losses: Tracking Cuts Across the Industry." Journalism.co.uk, 3 August 2010. www.journalism.co.uk/news-features/journalism-job-losses-tracking-cuts-across-the-industry/s5/a533044/.

Olmstead, Kenny, Jane Sasseen, Amy Mitchell, and Tom Rosenstiel. "Digital: News Gains Audience but Loses Ground in Chase for Revenue." The State of the News Media 2012. http://stateofthemedia.org/2012/digital-news-gains-audience-but-loses-more-ground-in-chase-for-revenue/.

Orr, Gillian. "Movie Posters: 'Great Film!'—Dave from the Internet." *Independent*, 9 January 2013. www.independent.co.uk/arts-entertainment/films/news/movie-posters-great-film-dave-from-the-internet-8444967.html.

Oso, Lai, and Umaru Pate, eds. *Mass Media and Society in Nigeria*. Lagos: Malthouse, 2012.

Owczarski, Kimberly. "From Austin's Basement to Hollywood's Back Door: The Rise of Ain't It Cool News and Convergence Culture." *Journal of Film and Video* 64.3 (2012): 3–20.

Palas, Rainer. "Mietteitä kritiikistä." *Kritiikin uutiset*, no. 4 (2004): 8–9.

Pantti, Mervi. "Elokuvakritiikki verkkojournalismin aikakaudella." *Lähikuva* 1 (2002): 85–106.

———. *Kaikki muuttuu . . . elokuvakulttuurin jälleenrakentaminen Suomessa 1950-luvulta 1970-luvulle*. Jyväskylä: Suomen Elokuvatutkimuksen Seura, 1998.

———. "Tehtävänä todellisuuden tutkiminen." *Kriisi, kritiikki, konsensus: Elokuva ja suomalainen yhteiskunta*, edited by Hannu Salmi, 120–134. Turku: Turun yliopisto, 1999.

Papacharissi, Zizi. *A Private Sphere: Democracy in the Digital Age*. Cambridge: Polity, 2010.

Pavlik, John V. *Journalism and New Media*. New York: Columbia University Press, 2001.

Pilkington, Ed. "*Newsweek* Goes Online but Leaves Lasting Print on the Newsstand." *Guardian*, 19 October 2012. www.guardian.co.uk/media/2012/oct/19/newsweek-online-only-print.

Polan, Dana. "Auteur Desire." *Screening the Past*, 1 March 2001. www.latrobe.edu.au/screeningthepast/firstrelease/fr0301/dpfr12a.htm.

———. *Scenes of Instruction: The Beginnings of the U.S. Study of Film*. Berkeley: University of California Press, 2007.

Postrel, Virginia. *The Substance of Style*. New York: Harper Perennial, 2004.

Randall, Eric. "Why Armond White Wasn't Our Most Cantankerous Critic." *Atlantic Wire*, 16 March 2012. www.theatlanticwire.com/entertainment/2012/03/why-armond-white-wasnt-our-most-cantankerous-critic/49997/.

Reed, Adolph. "The Curse of Community." *Village Voice*, 16 January 1996.

Reinstein, David A., and Christopher M. Snyder. "The Influence of Expert Reviews on Consumer Demand for Experience Goods: A Case Study of Movie Critics." *Journal of Industrial Economics* 53.1 (2005): 27–51.

Rivette, Jacques. "The Genius of Howard Hawks." *Cahiers du cinéma* 23 (1953): 16–23. Reprinted in *Cahiers du cinéma, the 1950s: Neo-Realism, Hollywood, New Wave*, edited by Jim Hillier, translated by Peter Graham, 126–131. Cambridge, MA: Harvard University Press, 1985.

Roberge, Jonathan. "The Aesthetic Public Sphere and the Transformation of Criticism." *Social Semiotics* 21.3 (2011): 435–453.

Roberts, Jerry. *The Complete History of American Film Criticism*. Santa Monica, CA: Santa Monica Press, 2010.

Römpötti, Harri. "Mekö muka journalisteja?" *Kritiikin uutiset*, no. 1 (2009): 5–6.

Rosen, Christopher. "Armond White's Better-Than List; or, Film Criticism as an Onion Article." *Huffington Post*, 9 January 2013. www.huffingtonpost.com/christopher-rosen/armond-white-better-than-list-2013_b_2440817.html.

Rosenbaum, Jonathan. *Goodbye Cinema, Hello Cinephilia: Film Culture in Transition*. Chicago: University of Chicago Press, 2010.

Rosenqvist, Juha. "Elokuvakritiikin nykytilasta." *Kritiikin uutiset*, no. 1 (2001): 5–6.

Rossmeier, Vincent. "Where Have All the Film Critics Gone?" *Brooklyn Rail*, June 2008. http://brooklynrail.org/2008/06/express/where-have-all-the-film-critics-gone.

Roud, Richard. *Decades Never Start on Time: A Richard Roud Anthology*. Edited by Michael Temple and Karen Smolens. London: British Film Institute/Palgrave, 2014.

———. "The French Line." *Sight and Sound*, Autumn 1960, 166–171.

Russo, Maria Cristina. *Attacco alla Casta: La critica cinematografica al tempo dei social media*. Recco: Le Mani, 2013.

Salminen, Kari. "Kriitikon täytyy myydä tyhjänpäiväisyyksiä." *Kritiikin uutiset*, no. 3 (2010): 22–23.

San Filippo, Maria. *The B Word: Bisexuality in Contemporary Film and Television*. Bloomington: Indiana University Press, 2013.

Sarris, Andrew. *The American Cinema: Directors and Directions, 1929–1968*. New York: E. P. Dutton, 1968.

———. "Billy Wilder Reconsidered." In Lopate, *American Movie Critics*, 307–311.

———. "Notes on the Auteur Theory in 1962." *Film Culture* 27 (1962–1963): 1–8.

Saul, Mahir, and Ralph A. Austen, eds. *Viewing African Cinema in the Twenty-First Century: Art Films and the Nollywood Video Revolution*. Athens: Ohio University Press, 2010.

Saurama, Matti. "Kohti keskustelua." *Kritiikin uutiset*, no. 2 (2003): 3.

Sayad, Cecilia. *Performing Authorship: Self-Inscription and Corporeality in the Cinema*. London: I. B. Tauris, 2013.

Scott, A. O. "A Critic's Place, Thumb and All." *New York Times*, 31 March 2010. www.nytimes .com/2010/04/04/movies/04scott.html.

Scuccimarra, Vincenzo. "Cinefili della rete: I nuovi barbari?" *Il sole 24 ore*, 18 September 2013. http://vincenzoscuccimarra.nova100.ilsole24ore.com/2013/09/cinefili-della-rete-i-nuovi -barbari.html.

Selfe, Melanie. "Circles, Columns and Screenings: Mapping the Institutional, Discursive, Physical and Gendered Spaces of Film Criticism in 1940s London." *Journal of British Cinema* 9.4 (2012): 588–611.

Selkokari, Antti. "Murinaa mediapäivillä." *Kritiikin uutiset*, no. 2 (2009): 6–7.

———. "Voiko vain pitkä kritiikki olla kritiikki?" *Kritiikin uutiset*, no. 4 (2003): 13.

Shepherd, Tamara. "Rotten Tomatoes in the Field of Popular Cultural Production." *Canadian Journal of Film Studies* 18.2 (2009): 26–44.

Shrum, Wesley. "Critics and Publics: Cultural Mediation in Highbrow and Popular Performing Arts." *American Journal of Sociology* 97.2 (1991): 347–375.

Siklos, Richard. "*The Village Voice*, Pushing 50, Prepares to Be Sold to a Chain of Weeklies." *New York Times*, 24 October 2005. www.nytimes.com/2005/10/24/business/24voice .html?pagewanted=all&_r=0.

Soikkeli, Markku. "Nettikritiikin toinen sukupolvi." *Kritiikin uutiset*, no. 4 (2005): 7.

Souriau, Étienne, ed. *L'univers filmique*. Paris: Flammarion, 1953.

Spinazzola, Vittorio. *Cinema e pubblico: Lo spettacolo filmico in Italia, 1945–1965*. Milan: Bompiani, 1974.

Stacey, Jackie. *Star Gazing: Hollywood Cinema and Female Spectatorship*. London: Routledge, 1993.

Stanfield, Peter. *Maximum Movies—Pulp Fictions: Film Culture and the Worlds of Samuel Fuller, Mickey Spillane, and Jim Thompson*. New Brunswick, NJ: Rutgers University Press, 2011.

Steiner, George. "'Critic'/'Reader.'" *New Literary History* 10.3 (1979): 423–452.

Surowiecki, James. "News You Can Lose." *New Yorker*, 22 December 2008. www.newyorker .com/talk/financial/2008/12/22/081222ta_talk_surowiecki.

Taylor, Greg. *Artists in the Audience: Cults, Camp, and American Film Criticism*. Princeton, NJ: Princeton University Press, 1999.

———. "Pure Quidditas or Geek Chic? Cultism as Discernment." In *Sleaze Artists: Cinema at the Margins of Taste, Style, and Politics*, edited by Jeffrey Sconce, 259–272. Durham, NC: Duke University Press, 2007.

Thompson, Anne. "Crix' Cachet Losing Critical Mass." *Variety*, 7 April 2008.

Toijonen, Siskotuulikki. "Ilmaiskritiikki—harmaata taloutta?" *Kritiikin uutiset*, no. 3 (2002): 31.

———. "Lausunto työryhmän esityksestä tekijänoikeuslain muuttamiseksi." *Kritiikin uutiset*, no. 4 (2009): 8–9.

———. "Rehellisyys objektiivisuuden edelle." *Kritiikin uutiset*, no. 3 (2010): 12–16.

Topelius, Taneli. "Kuka kaappasi elokuvajournalismin vallan?" *Kritiikin uutiset*, no. 4 (2003): 7–8.

Truffaut, François. "Aimer Fritz Lang." *Cahiers du cinéma* 31 (1954): 54.

———. "*Ali Baba* et la 'politique des auteurs.'" *Cahiers du cinéma* 44 (1955): 45–47.

———. *Le cinéma selon Alfred Hitchcock*. Paris: Editions Robert Laffont, 1966.

Truffaut, François, and Helen G. Scott. *Hitchcock/Truffaut: The Definitive Study of Alfred Hitchcock by François Truffaut*. New York: Simon and Schuster Paperbacks, 1984.

Tryon, Chuck. *Reinventing Cinema: Movies in the Age of Media Convergence*. New Brunswick, NJ: Rutgers University Press, 2009.

Tuominen, Maila-Katriina. "Mikä merkitys on ammattikriitikon teoreettisella taustalla." *Kritiikin uutiset*, no. 1 (2005): 22.

Tyler, Parker. *Sex Psyche Etcetera in the Film*. Harmondsworth: Penguin, 1969.

Ungari, Enzo. "Confessioni di un mangiatore di film di provincia." In *Schermo delle mie brame*, 9–23. Florence: Vallecchi, 1978.

Vadén, Tere. "Missä on kritiikin tulevaisuus?" *Kritiikin uutiset*, no. 4 (2010): 25.

"Vice Versa, by Lisa Ben: A Historic Project of Edythe Eyde." Queer Music Heritage. http://queermusicheritage.com/viceversa.html.

Virtanen, Reijo. "Keskustelua kritiikistä." *Kritiikin uutiset*, no. 1 (2000): 23.

Vuori, Suna. "Nuori kriitikko." *Kritiikin uutiset*, no. 2 (2000): 23–25.

Warner, Michael. *Publics and Counterpublics*. New York: Zone, 2005.

White, Armond. "Arts Editors: Influencing What Is Seen and Known." New York Public Library for the Performing Arts, 28 April 1994.

———. "Better-Than List." *City Arts*, 9 January 2013.

———. "Do Movie Critics Matter?" *First Things*, April 2010. www.firstthings.com/article/2010/03/do-movie-critics-matter.

———. "Embargo Blues: Reflections on the Film Critic Business." *City Arts*, 14 December 2011.

———. "What We Don't Talk About When We Talk About Movies." *New York Press*, 30 April 2008. http://nypress.com/what-we-dont-talk-about-when-we-talk-about-movies.

Wilde, Oscar. "The Critic as Artist." In *The Artist as Critic: Critical Writings of Oscar Wilde*, edited by Richard Ellmann, 340–408. Chicago: University of Chicago Press, 1969.

Witte, Karsten, ed. *Theorie des Kinos: Ideologiekritik der Traumfabrik*. Frankfurt: Suhrkamp, 1972.

Wolcott, James. *Lucking Out: My Life Getting Down and Semi-dirty in Seventies New York*. New York: Doubleday, 2011.

Yardley, William, and Richard Pérez-Peña. "Seattle Paper Shifts Entirely to the Web." *New York Times*, 16 March 2009. www.nytimes.com/2009/03/17/business/media/17paper.html.

Zielinski, Siegfried. *Audiovisions: Cinema and Television as Entr'actes in History*. Amsterdam: Amsterdam University Press, 1999.

NOTES ON CONTRIBUTORS

THOMAS ELSAESSER is professor emeritus of film and television studies at the University of Amsterdam and from 2006 to 2012 was visiting professor at Yale University. In 2012 he was senior research fellow at the IKKM in Weimar, Germany, and in 2013 taught at Columbia University. He has authored, edited, and coedited some twenty books; among his most recent as author are *Terror und Trauma: Zur Gewalt des Vergangenen in der BRD* (2007); *Hollywood Heute: Geschichte, Gender und Nation im postklassischen Kino* (2009); *Film Theory: An Introduction Through the Senses* (2010), with Malte Hagener; and *The Persistence of Hollywood* (2012).

MATTIAS FREY is a senior lecturer in film at the University of Kent. His articles have appeared in edited anthologies, reference works, and journals such as *Cinema Journal, Screen, New German Critique, Quarterly Review of Film and Video, Jump Cut*, and *Framework*. He has reviewed movies for the *Boston Phoenix*, and he regularly reports on film festivals for *Senses of Cinema*. Frey's books include *Postwall German Cinema: History, Film History, and Cinephilia* (2013); and *Cineethics: Ethical Dimensions of Film Theory, Practice, and Spectatorship* (2014).

OUTI HAKOLA has a doctoral degree in media studies from the University of Turku (Finland). She currently works at the Human Mortality project at the Helsinki Collegium for Advanced Studies. Her research focuses on representations of death, dying, and mourning in fiction films and television series. In addition she has taught film criticism at the University of Turku for several years and writes reviews as a freelancer for the largest Finnish online film journal, *Film-O-Holic*.

ANNE HURAULT-PAUPE is a lecturer in Anglophone film and literature at Paris 13 University. Her research includes the history of film criticism in the United States and American independent cinema. She is the author of an article on Pauline Kael published in *CinémAction* and an essay on the evolution of critics' discourses about the Sundance Film Festival in *Memory in/of English-speaking Cinema, Le cinéma comme vecteur de la mémoire dans le cinéma Anglophone* (2014). She has also published articles on road movies, Victor Nunez, and Stanley Kubrick's *Lolita*.

NICK JAMES is the editor of *Sight and Sound*. His book on Michael Mann's *Heat* (1995) was published in 2002; he was the presenter of the BBC documentary *British Cinema: The End of the Affair* that same year. In 2011 he received the Telluride Film Festival's special medallion on behalf of *Sight and Sound* for its outstanding work.

JASMINA KALLAY is a screenwriter, novelist, and lecturer in film and digital media, dividing her time between Ireland and Croatia. Her area of expertise is transmedia storytelling, and she is the author of *Gaming Film: How Games Are Reshaping Contemporary Cinema* (2013).

KEVIN B. LEE is a film critic, filmmaker, and producer of more than two hundred critical video essays on film and media. He is chief video essayist for Fandor and programming executive for dGenerate Films. He is a graduate student at the School of the Art Institute of Chicago.

KARINA LONGWORTH is the author of books on George Lucas, Al Pacino, and Meryl Streep. She is the host and creator of *You Must Remember This*, a podcast exploring the forgotten histories of twentieth-century Hollywood. The former film editor at *LA Weekly*, she has contributed to *Grantland, Slate, Vanity Fair*, and many other publications. She lives in Los Angeles.

GIACOMO MANZOLI is an associate professor of the history of Italian cinema at the University of Bologna. He was a visiting professor at Brown University, where he taught Modernity, Italian Style. He has written extensively on Italian cinema, Hollywood cinema, film auteurs, and literature. His research interests currently focus on the social history of popular Italian cinema from a cultural studies perspective.

DANIEL McNEIL is an associate professor of history at Carleton University. He has held a number of teaching posts in the United Kingdom, the United States, and Canada and served as the Ida B. Wells-Barnett Visiting Professor of African and Black Diaspora Studies at DePaul University between 2012 and 2014. His most recent book is *Sex and Race in the Black Atlantic: Mulatto Devils and Multiracial Messiahs* (2011), and he is currently completing a cultural history of diasporic intellectuals.

PAOLO NOTO completed a PhD at the University of Bologna, where he currently lectures. His main research topics include intertextuality and film, genre theory, and the history of postwar popular Italian cinema. He is the author of *Il cinema neorealista* (2010), a reader on Italian neorealism coedited with Francesco Pitassio; and *Dal bozzetto ai generi* (2011), a monograph on Italian genre cinema of the 1950s.

THEO PANAYIDES is a journalist and filmmaker living in Cyprus. He was among the first online film reviewers, and his personal website, Theo's Century of Movies, has been running since 1996.

MARIA SAN FILIPPO is the author of *The B Word: Bisexuality in Contemporary Film and Television* (2013). She has taught film and media studies and queer studies at Harvard University, MIT, UCLA, and Wellesley College. She is a 2013–2015 visiting assistant professor in gender studies at Indiana University, Bloomington.

CECILIA SAYAD is a senior lecturer in film at the University of Kent. She is the author of *Performing Authorship: Self-Inscription and Corporeality in the Cinema* (2013); and *O jogo da reinvenção: Charlie Kaufman e o lugar do autor no cinema* (2008); and her essays have appeared in a number of journals and edited collections. In the past she wrote film criticism as a full-time journalist for the daily newspaper *Folha de S. Paulo* (Brazil).

THE SELF-STYLED SIREN is a pseudonym of Farran Smith Nehme, who has been writing about classic film on her blog since 2005. She has been a freelance movie critic for the *New York Post* since 2012. Her film writing has appeared in the *Wall Street Journal*, *Barron's Magazine*, *The Baffler*, the *New York Times*, and *Moving Image Source*, as well as in essays for Criterion Collection releases and in web-based publications, including MUBI and Fandor. She is the author of the novel *Missing Reels* (2014).

GREG TAYLOR is the director of the Conservatory of Theatre Arts and Professor of Film at Purchase College, State University of New York. He is the author of *Artists in the Audience: Cults, Camp, and American Film Criticism* (1999), along with articles on film style, aesthetic evaluation, and the avant-garde.

NOAH TSIKA is an assistant professor of media studies at Queens College, City University of New York, where he teaches courses on Nollywood, media industries and access in today's West Africa, and queer globalizations. He is the author of *Gods and Monsters: A Queer Film Classic* (2009); and the forthcoming *The Soldier's Circle*; and his essays on Nollywood have appeared in a range of journals and anthologies.

ARMOND WHITE is editor-in-chief of *CityArts*, New York's review of culture. Previously, he was critic and arts editor of the *City Sun* and chief film critic at *New York Press*. He won the ASCAP-Deems Taylor Award for Music Criticism and served three tenures as chairman of the New York Film Critics Circle. His books include *The Resistance: Ten Years of Pop Culture That Shook the World* (1995); *Rebel for the Hell of It: The Art Life of Tupac Shakur* (2002); and *Keep Moving: The Michael Jackson Chronicles* (2009).

STEPHANIE ZACHAREK is the chief film critic for the *Village Voice*. She was a film critic at *Salon* for eleven years, and her writing on books and pop culture has also appeared in the *New York Times*, *New York Magazine*, the *Los Angeles Times*, *Rolling Stone*, and *Sight and Sound*. She is a member of the New York Film Critics Circle and the National Society of Film Critics.

INDEX

CPSIA information can be obtained at www.ICGtesting.com
Printed in the USA
BVOW04s0304270515

401950BV00001B/8/P